Raphael and his Circle

DRAWINGS FROM WINDSOR CASTLE

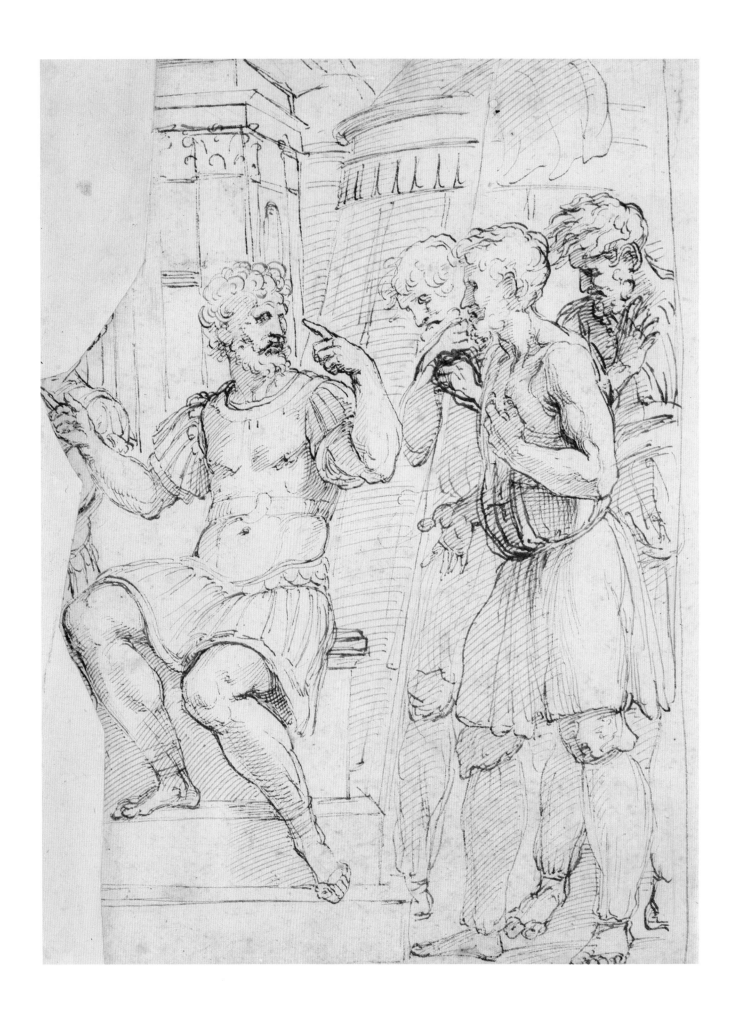

MARTIN CLAYTON

Raphael and his Circle

DRAWINGS FROM WINDSOR CASTLE

MERRELL HOLBERTON
PUBLISHERS LONDON

This book has been produced to accompany the exhibitions held at

The Queen's Gallery, London, 21 May 1999 – 10 October 1999
The National Gallery of Art, Washington, D.C., 14 May 2000 – 23 July 2000
The Art Gallery of Ontario, Toronto, 6 August 2000 – 15 September 2000
The J. Paul Getty Museum, Los Angeles, 31 October 2000 – 9 January 2001

Exhibition (paperback) edition first published in 1999 by Royal Collection Enterprises Ltd
Trade (hardcover) edition first published in 1999 by Merrell Holberton Publishers Ltd
Trade edition distributed in the USA and Canada by Rizzoli International Publications, Inc.
through St Martin's Press, 175 Fifth Avenue, New York, New York 10010

British Cataloguing in Publication Data
Clayton, Martin, 1967–
Raphael and his Circle : drawings from Windor Castle
1. Raphael, 1483–1520 – Criticism and interpretation
2. Drawing, Italian
3. Drawing, Renaissance
I. Title
741.9'45

ISBN 1 85894 076 1 (hardback)
ISBN 1 902163 19 2 (paperback)

Produced by Merrell Holberton Publishers Ltd,
Willcox House, 42 Southwark Street, London SE1 1UN

Designed by Matthew Hervey
Printed and bound in Italy

Jacket/cover: Raphael, *The Massacre of the Innocents* (detail), cat. 20
Frontispiece: Raphael, *The Judgment of Zaleucus* (detail), cat. 19v

CONTENTS

FOREWORD

The Print Room of the Royal Library at Windsor Castle houses the Royal Collection of over thirty thousand drawings and watercolours. Among these, Italian drawings of the Renaissance and Baroque periods are particularly well represented. Best known are the six hundred sheets by Leonardo da Vinci and the group of highly finished 'presentation drawings' by Michelangelo, and both these artists have been the subjects of recent exhibitions at The Queen's Gallery. It is now the turn of Raphael, the third member of that traditional High Renaissance triumvirate, whose twenty-five or so drawings in the Collection are less celebrated but are nonetheless of great beauty and importance.

Raphael very rarely drew as an end in itself. Nearly all his surviving sheets are preparatory studies, and those at Windsor cover almost the full span of his short but brilliant career, from a study for an altarpiece probably commissioned when he was not yet twenty to working drawings for the great projects executed at the height of his fame in Rome, such as the Stanza della Segnatura and the Sistine Chapel tapestry cycle. Unlike Leonardo and Michelangelo, Raphael cannot ever be studied in isolation; he had a great talent for assimilation and collaboration, the latter a skill that was increasingly important as his commissions multiplied towards the end of his life. Therefore, Raphael's own drawings are exhibited alongside those in the Royal Collection by his two principal masters, his father Giovanni Santi and Pietro Perugino; and over thirty by his assistants who went on to establish great careers of their own after Raphael's death, Giulio Romano, Perino del Vaga and Polidoro da Caravaggio.

The drawings by Raphael in the Collection have been well exhibited in the past, most recently as a group at the British Museum's exhibition in 1983 to celebrate the quincentenary of Raphael's birth. Those by his associates have been seen much less often: twenty-three included in the present selection have never been exhibited before, and a further fourteen have not been shown in Britain for at least twenty-five years. All these drawings have been conserved in preparation for this exhibition, resulting in much new technical information and some interesting discoveries on the versos of previously laid down sheets.

Following its showing at The Queen's Gallery, the exhibition will travel on to the United States and Canada, where it will be seen at the National Gallery of Art, Washington, D.C., the Art Gallery of Ontario, Toronto, and the J. Paul Getty Museum, Los Angeles. It has been a great pleasure to work with our colleagues in these institutions on the preparation and presentation of this exhibition, thus ensuring that a great number of people will be able to see these wonderful drawings on both sides of the Atlantic.

Oliver Everett
Librarian, Windsor Castle

ACKNOWLEDGEMENTS

This catalogue accompanies an exhibition of all the drawings in the Royal Collection believed by the author to be the work of Raphael and his principal associates, with the exception of one drawing by Perino del Vaga mounted in Cassiano dal Pozzo's Nettuno album (Blunt 1971, no. 472) and two now attributed to Giovanni da Udine mounted in the Vittoria album (*ibid.*, nos. 680f.). Copies and indeterminately 'circle of' drawings are omitted; in most cases little would have been added to Popham's Windsor catalogue of 1949, which is, of course, the basis of all the entries.

It is not a catalogue raisonné, as it would be unwieldy to discuss here each of the many differing views of scholars over the years, and baldly stating "Fischel: *echt*", for example, is not very enlightening. However, I have attempted to acknowledge significant differences of opinion, and to cite each substantive contribution in the bibliographic references; my apologies to those whose endeavours I have missed. The scale of the literature on Raphael induces a certain resignation to the fate of one's own efforts in decades to come.

I would like to thank for their help in various ways Giovanni Agosti, Carmen Bambach, Hugo Chapman, Daniela Clare, Achim Gnann, David Jaffé, Marianne Joannides, Paul Joannides, Matteo Lafranconi, Emma Laws, Daniela Marrese, Yukiko Oshio, Lisa Pon, Francis Russell, Edward Saywell, Luke Syson, Nicholas Turner, Catherine Whistler, Tristan Weddigen and Samuel Wythe. My many discussions about technical aspects of the drawings with Alan Donnithorne, Chief Restorer of Drawings at Windsor, have been invaluable.

Martin Clayton
October 1998

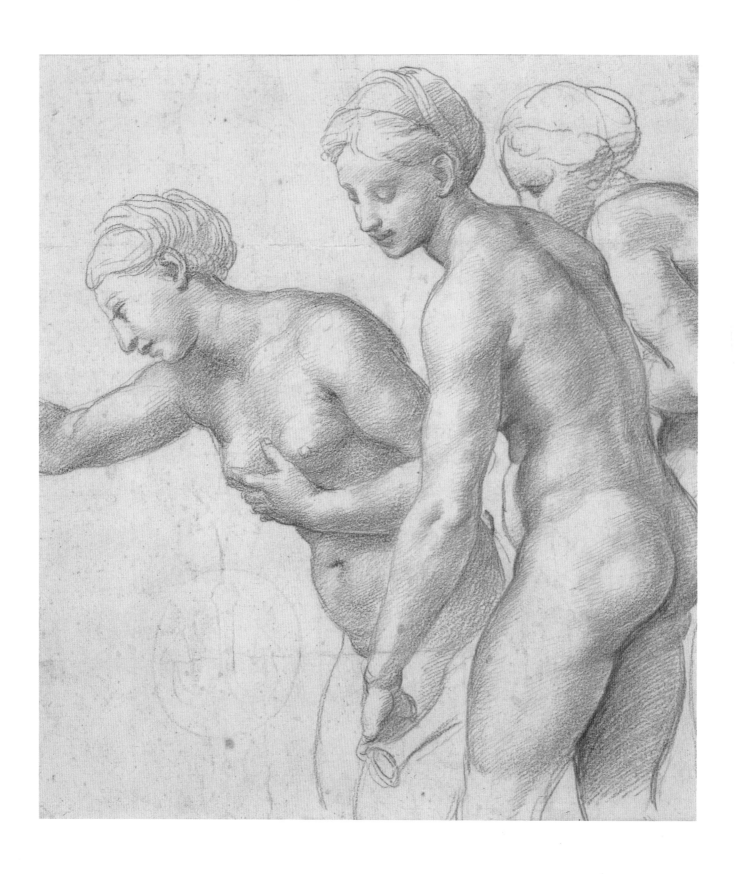

INTRODUCTION

Raphael's Early Life

Raphael (Raffaello Santi or Sanzio) was born in Urbino in 1483, the son of the painter Giovanni Santi (*ca.* 1435/40–1494). Through his adventurous patronage Federigo da Montefeltro (1422–1482) had created at Urbino, in the Marches seventy miles east of Florence, a cultural centre of a richness out of proportion to its importance as a city, and Santi would have encountered there the works of artists as varied as Piero della Francesca, Francesco di Giorgio and Justus of Ghent. Exposure does not necessarily lead to receptivity, but the clear echoes of both northern and Umbrian art in Santi's painting (the colouring of the former, the compositional modes of the latter, and the figure types of both) reveal an artistic personality open to new experiences, but always discriminating and adapting rather than thoughtlessly copying (cat. 1). Santi also seems to have been socially adept, cultivating contacts with influential patrons while not being tied to them in a formally exclusive relationship. Both traits were to be inherited by his son.

It seems certain that Raphael started his artistic career in his father's studio, but in the absence of primary documents all reconstructions of his early years are speculative. Vasari claimed that Santi eventually realised that his son could make no further progress under him and so placed the boy with Pietro Perugino (*ca.* 1450–1523), the leading painter in Umbria. This is probably, if excusably, inaccurate. Perugino was indeed the single most important influence on the young Raphael; he may have known Giovanni Santi personally and would certainly have known some of his work, a connection that would have eased Raphael's passage into Perugino's studio, for family traditions were as strong in fifteenth-century painting as in any other craft. But it is around 1502-03, when Raphael was approaching his twentieth year, that his paintings look most like those of Perugino. Perugino's influence before this date is strong, but not complete, and from the evidence of his earliest identifiable paintings and drawings it seems that Raphael did not have a conventional training in the sense of spending a long period of time with a single master.

It is likely that Raphael was still with his father at the time of Santi's death, when Raphael was aged eleven, and that he continued for a time to work in the studio maintained by Santi's collaborator Evangelista di Pian di Meleto (*ca.* 1458–1549). A decisive event may have been the return to Urbino around 1495 of Timoteo Viti (1469–1523). Then in his mid twenties, Viti was a well travelled artist who probably had wide contacts and whose eclecticism was on a par with that of Giovanni Santi, and he may have been the agent for Raphael's first move away from Urbino into the circle of Perugino. While it may seem fanciful to suppose that Raphael was, at his age, in a position to choose between masters in such a way, a theme of his whole career is ambition in the best sense, a ready grasping of new challenges. Viti's character would certainly have appealed more to the young Raphael than would that

of the limited, if able, Evangelista, but again this must remain speculation: Raphael's early drawings owe little or nothing to the example of Viti.

Attempts to identify Raphael's hand in such paintings as the predella of Perugino's altarpiece of 1497 in Santa Maria Nuova, Fano, are probably futile, and none of the few drawings associated with that project is (to this author) convincing as Raphael's. In 1500 Raphael was described as *magister* in the contract that he co-signed with his father's former collaborator Evangelista for the altarpiece of *The Coronation of St Nicholas of Tolentino* for Città di Castello, and Raphael's preparatory drawings for that project demonstrate (by their existence) that he was then the senior partner in his relationship with the much older Evangelista and (by their style) that he had had extensive contact with the immediate circle of Perugino in the later 1490s. Similarly, Raphael may have been the dominant designer in a collaboration with the older Bernardino Pintoricchio (*ca.* 1452–1513) on some of the frescos of the Piccolomini Library in Siena Cathedral around 1502–03, for, although the contract was with Pintoricchio alone, several surviving drawings for the scheme are by Raphael.

It therefore seems that, while still in his teens, Raphael was acting independently, collaborating on equal or senior terms with fully mature artists. Perugino was, however, always his dominant stylistic influence. Rather than maintaining a single, stable workshop, Perugino was intermittently active in a number of towns and probably recruited some assistants on an *ad hoc* basis. Many artists therefore had the opportunity to work directly under the master for short periods, and indeed much painting in Umbria, the Marches and western Tuscany at the end of the fifteenth century can be characterized without excessive simplification as Peruginesque.

Perugino and Raphael

Pietro Vannucci was born near Perugia (and is thus commonly known as Perugino) around 1450. Like the other most progressive Umbrian painters of the mid to late fifteenth century, Bartolomeo Caporali, Benedetto Bonfigli and Fiorenzo di Lorenzo, he was strongly indebted to contemporary developments in Tuscan art. In the 1470s Perugino apparently spent time in the workshops of both Verrocchio and Piero della Francesca (probably in that order), and he fused the sweetness of the former's painting style with the clarity of the latter's to create highly legible compositions populated with stock figures, whose simplicity of form and candour of intent shaped the next generation of Umbrian painting.

Although it is not immediately apparent that these equable figures are suitable for dramatic subjects such as the Crucifixion, they become conduits for the emotions of the viewer. The immediacy of this link between the spectator, the painting and the pious intent is all the more remarkable given Vasari's description of Perugino, at second hand but no doubt reliably, as "a person of very little religion ... [who] would have done anything for money". This avarice manifested itself in a tendency to accept more commissions than was good for his art and thus to economize on invention, repeating motifs from one project to another, for which he was (according to Vasari) criticized by his Florentine contemporaries.

To the modern viewer, Perugino's cloned Madonnas and identikit saints can indeed become tiresome. But our fatigue is in part a consequence of illustrated monographs and rapid travel between sites, of seeing too much Peruginesque art in

too short a time, and Perugino provided for his clients a very effective form of devotional art. Outside the circles of the most progressive painters and patrons, the workshop traditions of pattern books (cat. 1–2) and incessant copying by assistants (cat. 7) held firm in the late fifteenth century, leading to the dispersal of Perugino's types throughout central Italy (cat. 6). The recycling of motifs (cat. 3) was not disdained by Raphael, who would himself rarely let an idea go to waste: motifs discarded in the preparatory process, or devised for a project that was for some reason not executed, often reappear transformed in a new context (cat. 20).

Perugino died in 1523, twenty years after his style had been superseded by developments in Florence and subsequently in Rome in which his former pupil Raphael had been instrumental. His influence in Umbria, once so pervasive, soon waned. Although a few painters, such as Giambattista Caporali, continued to work in his mode, most of those who had absorbed the prevailing Peruginesque manner at the start of their careers (for example Domenico Alfani and Dono Doni) looked increasingly towards Florence for their inspiration, and Umbrian painting, so fertile in the fourteenth and fifteenth centuries, rapidly declined in importance to become a backwater of Italian art.

Perugino's drawings are unusually variable in their capacity to engage the viewer. At his best, with a vigorous and spiky pen line (fig. 2) or a metalpoint trace of genuine grace and sensitivity, he was a stimulating draftsman, but he drew thoughtlessly more often than most great artists; for all its beauty, cat. 3 does not investigate any problems or develop Perugino's vision in any significant way, and he was not blessed with the brimming inventiveness of Giulio Romano, whose drawing style could otherwise be similarly automatic. It was nonetheless in contact with Perugino – directly or indirectly – that Raphael developed the modes of draftsmanship that were to serve him until his move to Rome in 1508.

The dominant drawing types of Raphael's early career (poorly represented at Windsor) are compositional drafts, mostly in pen and ink (fig. 1); sketches of full-length figures, usually in pen and ink or metalpoint; studies of heads, in black chalk or metalpoint (cat. 9); and finished compositions in any of these media, often with the addition of wash to pen drawings (cat. 10). Raphael's handling of these media was indebted to the example of Perugino, with wiry contours and occasional dense hatching of the pen (cat. 13), broad cross-hatching of chalk or charcoal (cat. 4, 9) and elegant metalpoint lines (cat. 2, 3, 11). Particularly noticeable around 1502, the period of Raphael's closest affinity with Perugino, is a sudden rash of metalpoint figure studies from life, one of Perugino's most successful modes. This development was probably Raphael's direct response to practices in the elder master's studio and gave him a fluency in life drawing that was to be of vital importance in his future career.

It was in the mechanical possibilities of drawing that Raphael distinguished himself most clearly from Perugino. Throughout this early period Raphael pricked the outlines of drawings, for pouncing through chalk dust (see the British Museum *Knight's Dream* and two *St Georges* in the Uffizi); he squared up sheets for enlargement (the Pierpont Morgan *Journey of Aeneas Silvius Piccolomini* and the Louvre *Belle Jardinière*); and less commonly he incised the contours to transfer the lines to a fresh sheet of paper placed underneath (the Canigiani *Holy Family* at Chantilly). All of these techniques were in common use at the time, but it is in their assiduous application that Raphael reveals his deeply craftsmanlike approach to painting. Also noteworthy is his development of the so-called 'auxiliary cartoon', whereby heads

Fig. 1 Raphael, *The Virgin and Child with the Infant Baptist* (detail), pen and ink with touches of metalpoint, 254 × 216 mm. Oxford, Ashmolean Museum, Parker 501v

Fig. 2 Perugino, *The Adoration of the Magi*, pen and ink, 191 × 182 mm, arched. London, British Museum, inv. 1853-10-8-1

for paintings were studied in detail at full scale, another stage in an already laborious preparatory process. This is first seen in his meticulous preparations for the Vatican *Assumption and Coronation*, a commission for Perugia's leading family that would allow Raphael to step out of the shadow of Perugino: eighteen sheets survive for this project (including cat. 9), more than for any other early work by the artist.

The *Assumption and Coronation* was followed by *The Betrothal of the Virgin* of 1504 for Città di Castello, in many respects a response to Perugino's closely contemporary treatment of the same subject for the Cathedral of Perugia, which Raphael must have

seen in progress in Perugino's workshop. Raphael had learnt all he could from the elder master, and the natural next step in his burgeoning career was a move to Florence. Surrounded by the works of Leonardo, Michelangelo, Fra Bartolomeo and the great masters of the Quattrocento, he began another phase of his artistic education, copying and adapting (cat. 12), and striving to emulate their grandeur in his own products (cat. 14). Most of Raphael's paintings during this period were *Madonna*s and portraits, not, perhaps, because he was unable to obtain more substantial commissions but because such works did not tie him to a single project for months or years; a succession of small-scale paintings allowed continual progress, each a new development in the light of what he had seen in the intervening period.

The dominant medium of Raphael's drawings in his Florentine years was pen and ink (cat. 12–14). The flowing quality of an ink line and the frequently unanticipated nature of its traces encourages experimentation, and gradually in Raphael's sketches the relationship between the figures loosened up; he became less reliant on conventional compositional types and more intuitive in his arrangements. The many drawings for the Borghese *Entombment*, the most sophisticated project of his Florentine period (though it was executed in Perugia, 1506–07), show the full range of his penwork at this time, from hard-outline studies of pattern to intricately cross-hatched investigations of mass.

Although Florence was Raphael's base between 1504 and 1508, he continued to travel frequently, back to Perugia and Urbino and perhaps in 1506 or 1507 briefly to Rome (which he may already have visited *ca.* 1502–03). He retained strong links with the court in Urbino, executing paintings for Giovanna and Guidobaldo da Montefeltro, and this may have facilitated his decisive move to Rome, probably in the autumn of 1508: Pope Julius II was the uncle of Francesco Maria della Rovere, who earlier that year had become Duke of Urbino on the death of Guidobaldo.

Raphael in Rome

Our first record of Raphael's presence in Rome is a payment for work for the Pope on 13 January 1509. He was probably set to work in the Stanza della Segnatura as one of a team, but the pictorial intelligence of his solutions to the difficult spaces of the Stanza soon persuaded Julius to give the young artist control over the decoration of the room (cat. 15–19), and thereafter of the adjacent Stanze d'Eliodoro and dell'Incendio. Raphael's frescos and Michelangelo's contemporaneous work fifty metres away in the Sistine Chapel represent one of the most glorious moments in the history of Western art.

The Stanza della Segnatura was the pivotal undertaking of Raphael's career in several respects. On one level, it led to a marked rationalization of his drawing practice. The size of the project and the need to plan every detail caused him to break down the preparatory process into a number of discrete steps. His compositional drafts were often in brush and ink with wash and white heightening, giving a strongly painterly effect (cat. 16). Then followed figure and drapery studies, singly or in groups, in chalk (cat. 15, 17), pen and ink (cat. 18v), and occasionally metalpoint, and individual head studies were executed where necessary (cat. 18r). A full-scale black-chalk cartoon integrated all the studies, but these would still be referred to while painting. None of these drawing types was new in itself: what was new was the clarity of process. In Raphael's studies for the Borghese *Entombment* of 1506–07, for

instance, each drawing seen in isolation does not impart the stage of development of the composition, but in his work on the Segnatura it is clear from each drawing at what stage of development it must have been drawn. From analysis followed synthesis, and having in his mind broken the creative process down into component parts, Raphael could thereafter combine several stages in a single drawing (cat. 27, 34), allowing him to move towards a definitive solution with great speed and efficiency.

The Segnatura also established Raphael as the leading painter in Rome, and the amount of work commissioned from him increased inexorably. Although the city was astonished by the ineffable achievement of Michelangelo's Sistine Chapel ceiling, fully unveiled in 1512, it was clear that Raphael and Michelangelo were two very different artists. Michelangelo was temperamentally unable to make use of assistants in other than a menial capacity and, while he was himself capable of working at great speed, the pressure of too many commissions had already led to the abandonment of several undertakings. By contrast, Raphael's growing ability to marshal a team of assistants on several simultaneous projects exactly parallelled his ability to marshal pictorial components in the rapid development of a composition: both sprang from his remarkably lucid organizational intelligence, a gift for perceiving and ordering a large number of individual elements in relation to a complex whole.

The degree of Raphael's direct involvement in a project during the last decade of his life depended on many factors, including the pressure of other responsibilities, the prestige and visibility of the work, the complexity of the undertaking, the relative importance of pleasing the patron, and (as can probably be seen in the Stanza dell'Incendio) his own interest in the project. Although very prolific, his workshop did not function like some proto-industrial production line and the creative process was not systematic. The surviving drawings for the tapestry cartoons (cat. 25–28), for example, suggest that Raphael's development of compositions was pragmatic and varied from case to case. There would, of course, have been some division of labour, but the studio was loosely structured with assistants employed where necessary and specialist artisans engaged for decorative tasks (stuccos, floor-tiles and so on). The number of assistants probably grew rapidly after 1514, when, on the death of Bramante, Raphael was appointed chief architect for the rebuilding of St Peter's, a highly complex enterprise that must have taken much of his time; but only two assistants of importance seem to have worked with Raphael continuously over a period of years, Gianfrancesco Penni and Giulio Romano.

Gianfrancesco Penni

Penni is the single most perplexing element in attempts to understand the functioning of Raphael's later workshop. He may have entered the studio around 1511, perhaps in his mid teens; his nickname, *Il fattore*, implies that he was an executant rather than an originator, and indeed he seems to have had no significant creative personality. Vasari recorded that Penni's speciality was the production of finished drawings, probably fair copies of creative drafts by Raphael and others. The reconstruction of his oeuvre is thus almost entirely hypothetical (see cat. 32), but a large group of drawings produced in Raphael's workshop do share enough common traits to assign them to a single hand, and the probable function of those drawings accords with what we are told of Penni's role. He assimilated Raphael's methods of drawing to such a degree that the

Fig. 3 Attributed to Gianfrancesco Penni,
The Dormition and Coronation of the Virgin,
traces of black chalk, pen and ink, wash, white
heightening, 379 × 260 mm. London, British
Museum, inv. 1860-6-16-84

attribution of some sheets remains disputed between the two (cat. 25), and the
situation is further complicated by the existence of what might be termed 'retro-
spective *modelli*', so that it is not possible to cite one irrefutable example of a sketch by
Raphael and a subsequent *modello* by Penni towards a single composition.

Penni's pen style seems to be quite well defined. He lacked Raphael's variability
of focus and drew with a uniformity of effect compounded by a tendency to lose
concentration and fluff the details. Consequently his figures look like puppets and fail
to engage with our experience of the real world; the emotions expressed are always
vague and generic, and his renderings of compositions drift towards the bathetic. All
these features are present in the British Museum *Dormition and Coronation of the Virgin*
(fig. 3), a drawing that is puzzling in its function but in style and technique epito-
mizes our understanding of Penni's graphic character. This understanding has,
however, been compromised by the attribution to Penni of a number of stylistically

Fig. 4 Attributed to Raphael and
Gianfrancesco Penni, *Studies after the Antique*,
stylus underdrawing, red chalk, 415 × 283 mm.
Oxford, Ashmolean Museum, Parker 627

heterogeneous pen drawings associable with late Raphael (including cat. 33, 48, 49).
These attributions are usually negatively motivated – proposing Penni's name in
default of a supposedly more convincing alternative – and it is hoped that the
publication here of cat. 47 as a secure drawing by the young Perino del Vaga will
clarify this situation somewhat.

There is no drawing in chalk alone that is uniformly accepted as by Penni, and
again he is often put forward simply as an alternative to Raphael or Giulio. A sheet in
Oxford with two studies after the antique (fig. 4) may, however, cast some light on
Penni's red-chalk style. The *Apollo* on the left is drawn with richly expressive
modelling and tense, incisive outlines, and seems to this author convincing as a work
by Raphael of around 1512 (cf. cat. 21–22). The *Hercules* on the right is, by contrast,
spatially insecure, and emptily bombastic rather than potent; the closed facial
expression with featureless eyes and downturned mouth is that of many pen drawings
attributable to Penni. This may well be a sheet that served some didactic purpose
shortly after Penni entered Raphael's workshop, the pupil attempting to emulate the
master's chalk style on the same sheet. Penni's evident discomfort with the medium
might explain his subsequent reliance on pen and ink.

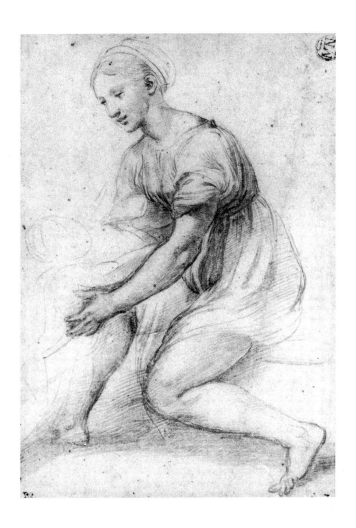

Giulio Romano

Giulio probably joined Raphael's workshop in 1516 or shortly before, though he is not mentioned by name in any document connected with the workshop before Raphael's death. Vasari (who knew him personally) asserted that Giulio was fifty-four on his death in 1546, giving a birth date of 1491–92; this was contradicted by the discovery of an archival record stating his age as forty-seven when he died on 1 November 1546, and thus giving a birth date of 1498–99, which has recently been widely accepted. But there is no reason, in principle, why the latter should be more reliable, and such a late birth date would give Giulio substantial responsibilities in Raphael's workshop while still in his teens. This is not in itself impossible (witness Raphael's own development), but a birth date around the middle of the decade is more probable.

Any attempt to reconstruct Giulio's oeuvre in this period must be based on an extrapolation backwards from his independent works of the 1520s, but his graphic personality was so strong that this can be done with confidence in most cases. His style was characterized by an emphasis on contour and pattern; in his pen drawings, the limbs are repeatedly outlined and often modelled with a series of short hooked strokes set a little way inside the line (cat. 33); his chalk drawings are similarly flattened in effect with respect to those of Raphael, and the contrast between fig. 5, by Giulio, and fig. 6, by Raphael for the same project (see cat. 34), typifies their respective sensibilities.

left
Fig. 5 Giulio Romano, *A study for the Holy Family of Francis I*, stylus underdrawing, red chalk, 173 × 118 mm. Paris, Louvre, inv. 3862

right
Fig. 6 Raphael, *A study for the Holy Family of Francis I*, stylus underdrawing, red chalk, 337 × 215 mm. Florence, Uffizi, inv. 535-E

Fig. 7 Raphael, A sketch for *Psyche and Venus*, red chalk, pen and ink, 105 × 80 mm. Oxford, Ashmolean Museum, Parker 655

When Giulio can first be identified in the studio his style is distinctively different from that of Raphael. The Albertina *Three dancing figures* and cat. 30, both of which were used for engravings dated 1516, show a much drier, more artificial approach to form than Raphael ever conceived, and it is very likely that Giulio received his early training in some other workshop. Over the next couple of years his chalk style, in particular, moved closer to that of Raphael, but there are very few drawings that are genuinely difficult to assign to one or the other; attempts to attribute on 'logical' grounds nearly all the Farnesina studies to Raphael, for instance (see cat. 31), cannot smooth over the fundamental differences between the graphic personalities of the two artists.

Raphael's late studio

Giulio rapidly became Raphael's most trusted assistant. Hartt's fantastically expansionist view, that he was "the draftsman who carried out his master's ideas almost from the moment of their inception in Raphael's mind", does not need to be swallowed to accept that by 1518 Giulio was producing, for some projects, creative drawings with the same function as those of Raphael. After about 1515 it becomes more and more difficult to define Raphael's role in his own workshop, but there can be no doubt that he remained not just its titular but also its creative head, and probably nothing left the studio without Raphael having had some decisive part in its conception. Any major project would have been devised by the master, the degree to which his assistants were responsible for developing and executing these ideas varying from case to case.

Small panels may have been merely sketched out by Raphael, the developmental drawings and execution being left entirely to pupils, perhaps with guiding comments or corrections along the way. Major schemes, such as the Vatican or Farnesina Logge (cat. 31–33), would have been planned overall by the master, but individual components were produced to a greater or lesser degree by assistants. The altarpiece of *The Transfiguration*, by contrast, pitted Raphael's reputation against that of Michelangelo through his proxy Sebastiano del Piombo, and Raphael himself developed the composition in great detail and executed much of the painting. The most important point is that there was no immutable division of responsibility, and the existence for several of these projects of drawings with the same function by Raphael and by his assistants testifies to the inadmissibility of any *a priori* analysis of his methods.

Some general points may nonetheless be made. Pen must have remained the principal medium for Raphael's first sketches, though there are few surviving examples of this type of drawing from late in his career (fig. 7). He continued to use metalpoint until at least 1515 (cat. 27), by which time it had already been widely discarded in favour of chalk in central Italy, and there is no evidence that it was ever widely adopted by members of the workshop. Red chalk was the favoured medium for figure studies in the mid-1510s, giving a light tonality and sharpness of outline suitable for the projects that predominated at that time (cat. 26, 30, 31).

Towards the end of the decade a wave of more dramatic subjects – *The Transfiguration*, *The Battle of the Milvian Bridge*, *The Stoning of St Stephen* – saw the resurgence of black chalk, a medium that encouraged a bolder chiaroscuro and a less intricate modelling, stressing the physical presence of the figures rather than their

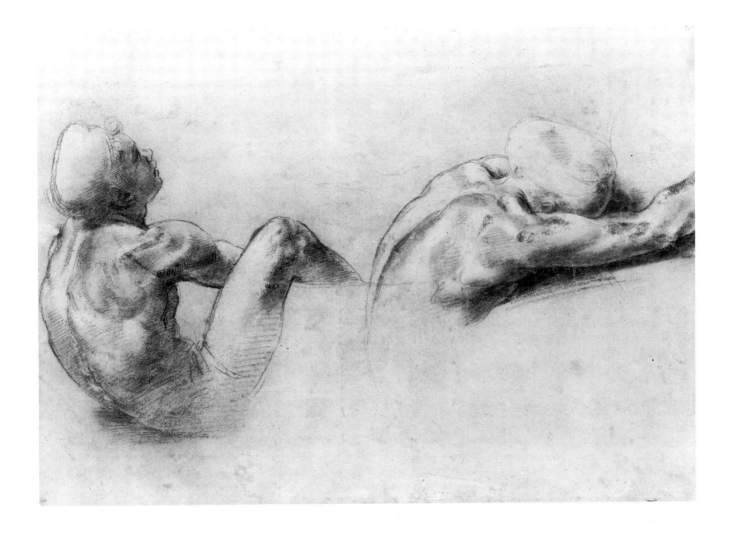

Fig. 8 Raphael, *Two nude studies*, black chalk, white heightening, 257 × 362 mm. Oxford, Ashmolean Museum, Parker 569

decorative qualities. A comparison between fig. 8 for the *Battle*, one of Raphael's last surviving drawings, and the closely contemporary study by Giulio Romano for the *Stoning* (cat. 35) is revealing. Raphael drew with absolute economy in fig. 8, not fretting over insignificant details but establishing the broad form as concisely as possible. By contrast, in cat. 35 there is a palpable tension between the wonderfully captured fall of light and the strong emphasis on outline; that one sheet encapsulates the essential difference between the formal concerns of Raphael and Giulio.

Giulio after Raphael's death

Raphael died after a short illness on 6 April 1520, aged thirty-seven, having attained a position of almost complete artistic dominance in Rome. Giulio and Penni inherited his studio along with the outstanding contracts that had been awarded during Raphael's lifetime, though Sebastiano del Piombo, with Michelangelo's support, attempted to wrest the commission for the Sala di Costantino in the Vatican from them. A decisive factor in his failure was probably the claim of Giulio and Penni that they held Raphael's preliminary drawings for the cycle, a neat illustration of the value that was attached to invention, as expressed through drawing, in the High Renaissance – this did not, however, inhibit Giulio from changing the form of *The*

Allocution of Constantine from that devised by Raphael (assuming the *modello* at Chatsworth preserves the original composition).

Giulio, as the senior creative partner in the workshop, soon found himself as pressured as Raphael had been during his lifetime. Although work on the Constantine cycle lapsed during the brief papacy of Adrian VI (1522–23), much of the studio's time was engaged with the Villa Madama, the Villa Lante and the Palazzo Stati, as well as with a number of easel paintings. On the election of Clement VII, work on the Sala di Costantino resumed, and shortly after its completion in 1524 Giulio accepted an offer of employment at the Gonzaga court in Mantua, where he was to spend the rest of his life.

Giulio's primary role in Mantua was that of designer – of everything from palaces to frescos to spoons; he was rarely utilized as a painter himself, and nearly all subsequent paintings were executed by assistants following his drawings, though last-minute retouching by the master ameliorated their defects. In different senses drawing became both less and more important in Giulio's workshop than it had been in Raphael's: less, because so much of the creative process took place in Giulio's head, and there is less searching for form in the drawings themselves; more, because there is no sense that Giulio's assistants had any significant creative input, and drawing thus became the principal means of control over the workshop in a more mechanical way than it had been in Raphael's studio.

Giulio produced many thousands of designs in his years at Mantua and he inevitably economized on the stages of this process. Nearly all of Giulio's drawings after 1520 employ pen and ink, the fastest medium. He traced designs from one sheet to another by rubbing the reverse of the first with chalk powder (or interposing a similarly treated sheet), going over the outlines with a stylus, then fixing the trace on the new sheet with the pen, to which he often added wash and white for greater explicitness. Life drawing virtually disappeared from Giulio's repertoire soon after Raphael's death (cat. 35), and he never attained, or even aimed at, Raphael's richness of observation and subtle manipulation of media. The attraction of his drawings lies in the brilliance of his invention and the panache of his pen-strokes, and there can thus be something rather one-paced about them, for they all seem to exist at the same level of unreality.

Penni was working with Giulio in Mantua in 1528 (see cat. 37); he had probably fled the disastrous Sack of Rome in 1527, but there is no record of his activities between Giulio's departure to Mantua in 1524 and the Sack. His renewed partnership with Giulio was not a success, perhaps because the structure of the workshop was so different from their Roman days, and he soon left, to die in obscurity in Naples at an uncertain date. Giulio, by contrast, enjoyed pre-eminence in Mantua for two decades until his death in 1546, and the many prints made after his designs ensured his fame all over Europe; he is, for example, the only post-antique artist mentioned by Shakespeare (*The Winter's Tale,* V.II).

Perino del Vaga

Of Raphael's many assistants, two others, Perino del Vaga and Polidoro da Caravaggio, went on to enjoy careers comparable in stature to that of Giulio, though their roles in Raphael's workshop were much less significant. Perino was born in Florence in 1501, training with Andrea de' Ceri and Ridolfo Ghirlandaio before

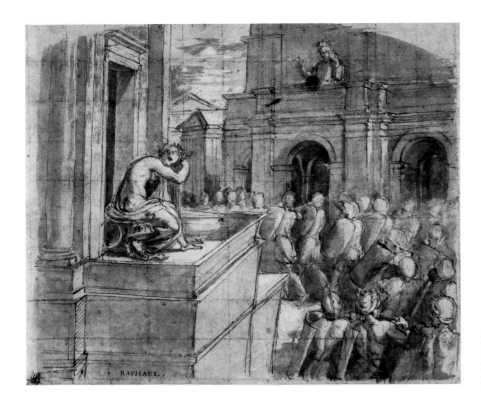

Fig. 9 Attributed to Perino del Vaga, *David and Bathsheba*, black chalk, pen and ink, wash, white heightening, squared in black chalk, 215 × 267 mm. London, British Museum, inv. 1900-6-11-2

moving to Rome around 1516 with an obscure painter named Vaga, from whom Perino took his familiar name. He entered Raphael's workshop soon after, and seems to have worked primarily on the Vatican Logge. Several frescos there are reasonably attributable to Perino, and a couple of drawings, such as the pen-and-wash *modello* in the British Museum for *David and Bathsheba* (fig. 9), show in coarse form many of the traits of the mature Perino; direct comparison of fig. 9 with the *Battle frieze* in the same collection, a drawing executed by Perino probably in the earlier 1520s, reveals unmistakably the same graphic personality.

On Raphael's death Perino probably worked independently of the studio while retaining a strong connection with it (see cat. 47–49). He quickly established himself as a specialist in fresco, executing works in the Sala dei Pontefici of the Vatican, Santo Stefano al Cacco, the Palazzo Baldassini (in collaboration with Polidoro), San Marcello al Corso (cat. 50), and the Trinità dei Monti. The continuing primacy of Raphael's compositional models was tempered by a growing response to the ambitions of Michelangelo's Sistine Chapel ceiling, and Perino cultivated an increasingly monumental figure style. A sojourn in Florence in 1522–23, escaping both the plague and Adrian VI's papacy, was the only interruption to seven years of success in Rome. This was abruptly halted by the Sack in 1527, during which Perino and his family were imprisoned and had to buy their freedom. The art market collapsed with the city's economy and in 1528 Perino left to enter the service of Andrea Doria in Genoa.

The principal work of Perino's Genoese period was the adornment of the Palazzo Doria, approaching Giulio's Palazzo Te in inventiveness while displaying a narrower expressive range and a more formalist approach to decoration, with bands of grotesques and strips of moulding dividing the vaults into independent compartments. His religious paintings were more conservative in type, including altar polyptychs, a form that was obsolete in Rome by the 1520s. Nonetheless Perino's

work in and around Genoa was central to the evolution of a distinctive Ligurian school in the sixteenth century.

After about 1534 Perino divided his time between Genoa and Pisa, and by 1538 he had returned to Rome, which had largely recovered from the devastation of the Sack. Perino's status as a representative of the heroic years of Raphael and the early 1520s put him in a perfect position to pick up the commissions beginning to flow forth again. Work for the Massimo family (cat. 52) and for Cardinal Alessandro Farnese brought him to the attention of the latter's uncle, Pope Paul III, and Perino was soon the leading decorative painter in Rome. His patrons' presumed faith in his training was not misplaced, for Perino ably controlled a studio approaching the size and complexity of Raphael's thirty years earlier. Among his many assistants were Pellegrino Tibaldi, who took Perino's decorative style, combined with a pronounced Michelangelism, back to Bologna, and Luzio Romano (cat. 54), a specialist stucco worker and painter of grotesques who had been Perino's decorative *alter ego* since their years together in Genoa, and who was to continue to execute elaborate and consistently popular interior schemes in an unchanging Perinesque style for decades to come.

Perino's later work in the Stanza della Segnatura (cat. 56) and Sala Regia (cat. 58) of the Vatican and in the papal rooms of the Castel Sant'Angelo (cat. 59) was central to the development of such painters as Francesco Salviati and Taddeo Zuccaro. Perino's death in 1547, was, however, blamed by Vasari directly on his success:

"Having to draw all day and all night to satisfy the needs of the [Vatican] Palace, and not only this but to provide designs for embroideries, for pennants, and for all the decorative caprices of the Farnese and of the other cardinals and *signori*, and having his mind always over-occupied, and being surrounded by sculptors, stucco workers, wood carvers, tailors, embroiderers, painters, gilders, and other similar workmen, he never had an hour's rest Worn out by his fatigues and exhausted by the disorders of his life ... his constitution was ultimately destroyed." (Vasari 1568, II, p. 369.)

Polidoro da Caravaggio

Polidoro sits uneasily with the artists discussed hitherto. He qualifies for inclusion in this catalogue by virtue of his period of work in Raphael's studio, but he comprehensively rejected his master's example in later years. He was born around 1499 in Caravaggio in Lombardy, then under Venetian control, and moved to Rome probably around 1515. According to Vasari, Polidoro was employed aged eighteen as a building labourer in the Vatican Logge and learned to draw by observing the works of the artists around him; some frescos in the window embrasures of the Sala dell'Incendio are very plausibly by Polidoro, suggesting that he was employed in Raphael's studio by 1517. A copy after (rather than a study for) figures in the *basamento* of the Loggia (fig. 10) seems to be Polidoro's earliest surviving drawing, showing the facial and proportional idiosyncrasies of his mature works in a style edging timidly towards that of Raphael's own red-chalk drawings (cf. especially cat. 19), and thus conforming perfectly with Vasari's account of his early education.

After Raphael's death Polidoro, like Perino, continued to collaborate sporadically with his former fellow pupils while striking out in a new direction of his own – his

frescos in San Silvestro al Quirinale are highly original in their romantic use of landscape. From around 1523 Polidoro worked with the enigmatic Maturino da Firenze: Vasari writes of them as inseparable partners, and it is almost impossible to reconstruct anything of Maturino's career. Their output consisted primarily of friezes on the façades of Roman *palazzi*, treating scenes from classical legend and myth in a chiaroscuro technique emulating relief sculpture. In the four years before the Sack they were enormously productive and must have employed many assistants, but façade paintings are naturally vulnerable to weathering and other damage, and very little remains of one of the most copied and widely known of all sixteenth-century bodies of work.

After the Sack, during which Maturino was killed, Polidoro fled south to Naples (cat. 62) and thence to Messina in Sicily, where he is documented in October 1528. Isolated from developments in central and northern Italy, his drawing and painting style evolved into a highly individual, expressive idiom totally opposed to Raphael's rationalism. Polidoro employed oil sketches for his major works, encouraging an accretional method of composition in which space is constructed from elongated, twisting figures and patches of strident colour leap out of a muddy tonality. We have few records of Polidoro's life in Sicily and his date of death is not known with certainty; Vasari stated that he was murdered in 1543 by an assistant for the savings that he had withdrawn in order to return to Rome, a tragic and dramatic end for this most dramatic of artists.

NOTES ON THE
CATALOGUE ENTRIES

All drawings are on white paper unless stated otherwise. Dimensions are given height before width. A provenance is stated only if this can be positively established (see pp. 211f.). Line drawings of all watermarks are reproduced on pp. 213ff. The bibliography does not include mere passing references to the drawings, *e.g.* for stylistic comparisons with another sheet. Drawings in other collections are referred to by the most recent catalogue of that collection or, failing that, by their inventory number. Raphael's drawings are also referred to by their numbers in the catalogue raisonné of Oskar Fischel (continued by Konrad Oberhuber), the fundamental catalogue of Raphael's drawings, and that of Paul Joannides, the most satisfactory and accessible catalogue in English, with the following abbreviations:

F. O. Fischel, *Raphaels Zeichnungen*, 8 vols., Berlin 1913–41

F.-O. K. Oberhuber, *Raphaels Zeichnungen: Abteilung IX*, Berlin 1972

J. P. Joannides, *The Drawings of Raphael, with a Complete Catalogue*, Oxford 1983

THE PRECURSORS

GIOVANNI SANTI

Born at Colbordolo, near Urbino, *ca.* 1435–40, to a wealthy family. Active mainly in Urbino, where in constant contact with the artists at the Montefeltro court. Most surviving works date from after 1480. From 1483 at the latest (the year of birth of his son Raphael) worked in collaboration with Evangelista di Pian di Meleto; from 1490 until his death in 1494 employed by Elisabetta Gonzaga, Duchess of Urbino. Also dabbled in literature, composing an epic poem on the life of Federico da Montefeltro.

PIETRO PERUGINO

Pietro Vannucci, born *ca.* 1450 at Città della Pieve, south-west of Perugia. Trained with Verrocchio in Florence and with Piero della Francesca; from 1479 in Rome, executing frescos in the Sistine Chapel. Back in Florence by 1482, and for the next two decades active mainly in Florence and Perugia but also travelling widely (Orvieto, Rome, Venice) and running at least one busy workshop. In the years around 1500, when his fame was at its height, frescoed the Collegio del Cambio in Perugia and Raphael probably entered the workshop. Thereafter Perugino's reputation waned and, until his death in 1523, he worked almost exclusively in Umbria.

GIROLAMO GENGA

Born in or around Urbino in 1476; stated by Vasari to have trained with Signorelli; around 1498–1501 probably in Perugino's workshop, where he would have met Raphael. Itinerant for the next two decades, often collaborating with Timoteo Viti; in Rome around 1520 (see cat. 21f.); from 1522 employed as court artist by Francesco Maria della Rovere in Urbino. Most of his subsequent projects were architectural in nature. Died in 1551.

I

GIOVANNI SANTI

A woman standing before rocks

ca. 1480

Off-green bodycolour preparation; stylus underdrawing; pen and
iron-gall ink; iron-gall wash; lead-white bodycolour
Verso blank
246 × 180 mm
Watermark: anchor in circle, cut
RL 12798
Provenance: George III (Inv. A, p. 14, *Albert Durer e Maestri Antichi
Div:si*, no. 6: "A Woman, Emblem of Imagination ... Adrea
Mantgna")

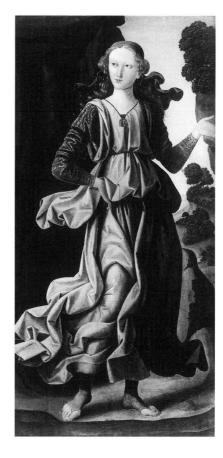

Fig. 11 Giovanni Santi,
The Muse Clio, panel,
820 × 390 mm.
Florence, Galleria
Corsini

Variants of this figure appear several times in the work of
Giovanni Santi. It corresponds most closely to the *Muse Clio*,
now in the Galleria Corsini, Florence (fig. 11), one of a series
of panels of Apollo and the Muses that decorated the Tempietto
delle Muse of Guidobaldo da Montefeltro in the Palazzo
Ducale at Urbino. The structure of the tiny Tempietto and its
adjoining rooms was apparently complete by 1480; the
paintings, by Santi and his assistant Evangelista di Pian di
Meleto, were probably begun shortly after this date, though
the cycle remained incomplete and Timoteo Viti finished the
work in the 1510s. Further adaptations of the figure are found
in the background of Santi's *Visitation* in Santa Maria Nuova,
Fano, and as the Archangel Raphael in two versions of *Tobias
and the angel* in Urbino – a panel in the Galleria Nazionale delle
Marche and a fragmentary fresco in the Oratorio di San
Giovanni.[1]

There are small but significant differences between the
figure as drawn and those as painted, most notably the wings
on the head here. Popham suggested that she might represent
the Cimmerian Sibyl, who is shown with comparable wings
on an anonymous Florentine engraving.[2] However this is not a
standard attribute of any sibyl; for example, none of those in a
contemporary set of drawings in the British Museum, attri-
buted to Girolamo di Benvenuto, bears wings.[3]

Joannides surmised that the Corsini *Clio* was a reworking
of the figure in the Fano *Visitation*, noting that the draperies in
the Fano painting are flatter and less sophisticated. This relative
dating is probably correct, but it might be more precise to state
that both figures are reworkings of the present drawing. Its
careful execution, with elaborate white heightening and small
sprigs of flowers in the background, indicates that it is not an
exploratory study for a single painting but rather served as a
finished drawing, a model to be referred to repeatedly and
adapted for use as appropriate. This practice was a continuation
of the medieval pattern-book tradition and a strong trait of late
Quattrocento Marchigian and Umbrian painting. Popham

puzzlingly deduced from Santi's multiple use of the motif that
the invention was not his own, and Fischel suggested that it
derived from the circle of Fiorenzo di Lorenzo. This is not
borne out by Fiorenzo's oeuvre, though Santi did elsewhere
reuse motifs from the circles of Fiorenzo and Perugino. For
instance, an angel in Fiorenzo's 1476 *Madonna della Misericordia*
(Perugia, Galleria Nazionale) was used by Perugino in his
destroyed altar fresco of the *Assumption* in the Sistine Chapel,
and was repeated endlessly in works by the followers of both
artists, especially Tiberio d'Assisi; Santi incorporated it with
slight modifications in his Buffi *sacra conversazione* of 1489
(Urbino, Galleria Nazionale), and a drawing of that angel,
technically and stylistically close to the present sheet and
probably Santi's workshop record of the motif, is in Berlin.[4]

NOTES
1. Dubos disputed the attribution of the present drawing to Santi on the
grounds that the jewel worn at the neck is not of the type (a square stone on a
gold disc) "which is repeated like a signature" on Santi's painted figures. This
is true, but it is hardly significant.
2. Hind 1938, no. C.II.4.
3. Popham and Pouncey 1950, nos. 76–85.
4. Fischel 1917, no. 209; Knab 1983, p. 23.

LITERATURE
Morelli 1892, p. 250 n.; Morelli 1893, p. 219; Calzini 1908, p. 228; Fischel
1917, no. 210; Popham and Wilde 1949, no. 28; Dubos 1971, pp. 131f.;
Ferriani 1983, pp. 150–58; Knab 1983, p. 23; Martelli 1984, p. 41; Gregori
1987, p. 652; Joannides 1987, p. 59; Urbino 1992, p. 370; Varese 1994,
pp. 243, 256

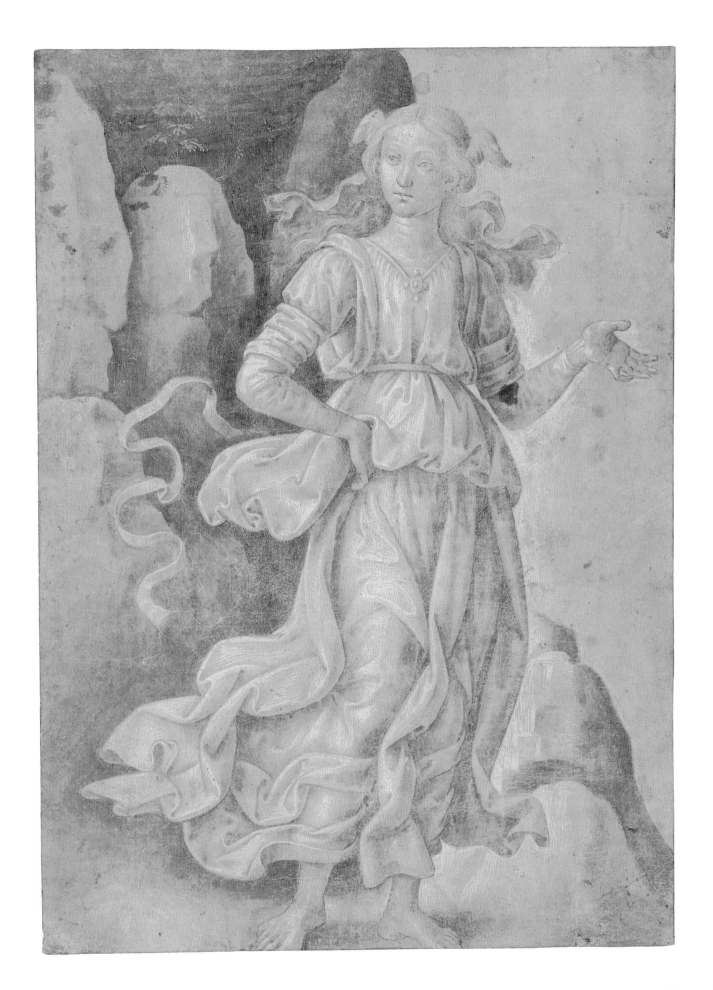

2

ATTRIBUTED TO PERUGINO

The head and shoulders of the Virgin

ca. 1480

Grey-brown ground-bone preparation; metalpoint; some pen and
iron-gall ink; lead-white bodycolour
Verso: a very faint brown outline, perhaps a skull in left profile (not
reproducible)
191 × 135 mm
No watermark
RL 12797

The Peruginesque character of this head is obvious, and
dispute has merely been over whether it is an autograph
drawing by Perugino or a faithful copy.[1] Steinmann noted that
the same head occurs with two others on one of the pages of
the so-called *Libretto di Raffaello* in the Accademia, Venice
(fig. 12). He suggested that the prototypes of all three
(including the Windsor drawing) were studies for Perugino's
destroyed fresco of *The Finding of Moses* in the Sistine Chapel, a
conclusion recently supported (in conversation) by Francis
Russell. Popham claimed it to be similar to the head of the
Madonna in the damaged *Adoration of the Magi* in San Girolamo,
Spello,[2] by an associate of Perugino, though that likeness is no
more than generic.

It appears to have escaped notice that the band of the
woman's smock in this drawing bears the letters *VMI* (the last
not altogether clear) picked out in white. This presumably
stands for *Virgo Maria Imperatrix* (or, less probably, *Immaculata*),
though the attitude of the woman is so generalized that she is
unlikely to have been a study for a particular composition. She
was more probably a figure of the pattern-book variety, some-
times given an arbitrary identity but deliberately non-specific
in type to allow inclusion in a variety of contexts. This was the
origin of many of the heads in the Venice *Libretto*: for example,
of four more on f.17v, indistinguishable in character, the lower
two have counterparts in the Sistine Chapel *Journey of Moses
and Circumcision of his Son*, and it is thus probable that the
frescoed heads were adapted from a pre-existing stock of
motifs. Thus, whether or not the present study was used in the
Finding of Moses is to some extent a redundant question, as it is
doubtful that it was made with that particular end in mind.

This makes the authorship of the present sheet rather more
difficult to determine. Such model drawings do not display the
signs of exploration usual in an autograph sheet, for even if
drawn by the master they are in themselves 'fair copies' of his

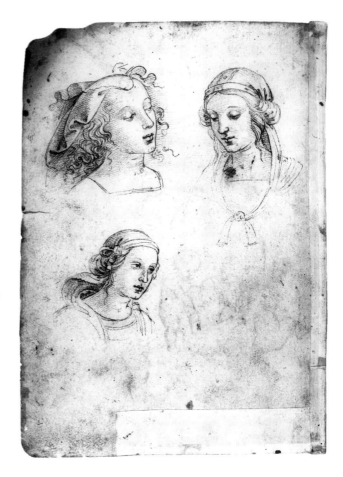

Fig. 12 Copy after Perugino (Domenico Alfani?), *Three heads*, black-chalk
underdrawing, pen and ink, 231 × 167 mm. Venice, Accademia, *Libretto di
Raffaello*, f. 20v

own inventions. Objective criteria are thus rarely applicable,
and only the occasional stylistic quirk or a judgement of
quality can distinguish between prototype and copy. Here the
intelligence of the facial modelling and of the structuring of
the planes would support an attribution to Perugino himself,
but it is quite possible that the drawing is a sensitive copy by a
particularly able member of his studio.

NOTES
1. Both Fischel and Popham catalogued the sheet as a copy after Perugino in
the style of his Sistine frescos; Blunt (in London 1972–73) attributed it to
Perugino himself on grounds of quality; Joannides attributed it tentatively to
Giovanni Santi as a copy after Perugino.
2. Fischel 1917, fig. 55.

LITERATURE
Steinmann 1901–05, I, p. 293; Fischel 1917, no. 181; Popham and Wilde 1949,
no. 24; London 1972–73, no. 159; Ferino Pagden 1984, p. 72; Joannides 1987,
p. 59

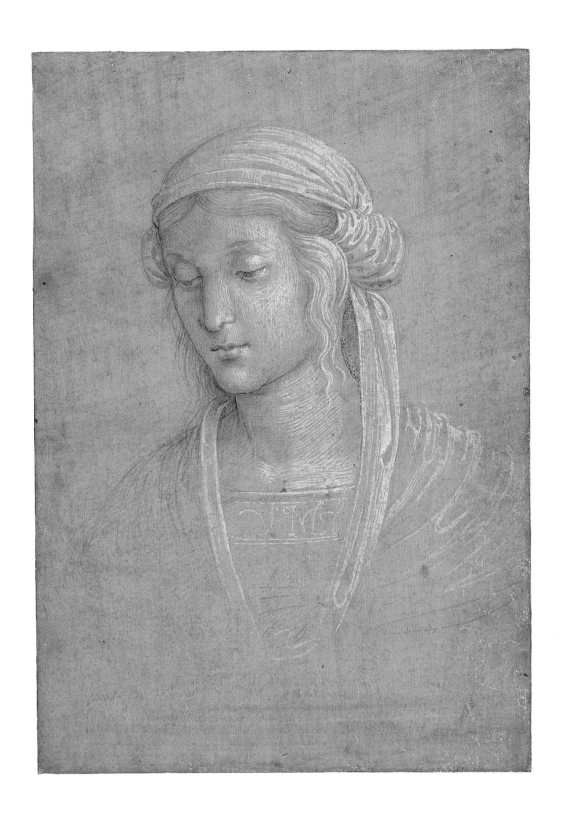

3

PERUGINO

A study for the head and foot of the Virgin

ca. 1492–93

Pale-peach ground-bone preparation; metalpoint; lead-white
bodycolour; heavily abraded
Verso blank
234 × 224 mm
Watermark: rampant goat, cut
RL 12744

This is a study for the head and left foot of the Virgin in
Perugino's altarpiece of *The Virgin enthroned between Sts John the
Baptist and Sebastian* in the Uffizi (fig. 13), signed and dated
1493, and painted for a chapel erected from 1488 for Donna
Cornelia di Giovanni Martini in the church of San Domenico,
Fiesole. The same head was used by Perugino with slight
alterations in two other closely contemporary altarpieces of the
Virgin enthroned with saints, dated 1493 (Vienna, Kunst-
historisches Museum) and 1494 (Cremona, Sant'Agostino)
respectively, suggesting that his workshop was briskly produc-
tive at this time.[1] A study for the figure of St Sebastian in the
Uffizi altarpiece is in the Cleveland Museum of Art, executed
on the same coloured ground in the same media, with the
addition of brown wash.[2]

Woodward wished the drawing to be a copy by Raphael
after Perugino's painting, but the subsequent attribution by
Fischel to Perugino himself has not been challenged. It is not a
true cartoon (the head as drawn is roughly three-quarters the
size of that painted), nor is it a simple study from a model in
the desired attitude, for the differences of detail between
drawing and painting are insignificant. The assurance of the
firm outlines came from repeated drawing of comparable
motifs over the years, for a handful of standard facial types –
Virgin/female saint, old bearded prophet/saint/magus, young
male saint/god and so on – served Perugino throughout his
maturity. If Perugino did refer to a live model when making
the drawing, to study the fall of light, he filtered this
observation through his idealizing vision to produce a motif
that is at once human and divine.

Studies as careful as this were rarely deployed once only
(see also cat. 1 and 5). As well as its reuse within Perugino's
studio for the Vienna and Cremona altarpieces, the continuous
recycling of this head by the so-called Maestro della Madonna
del Ponterosso suggests that that unidentified Umbrian artist
acquired the present drawing or a copy of it.[3]

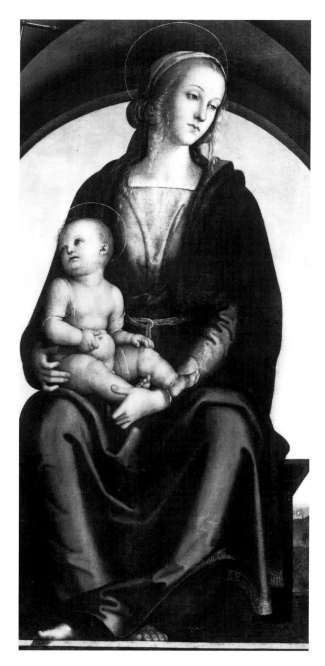

Fig. 13 Perugino, *The Virgin enthroned between Sts John the Baptist and
Sebastian* (detail), panel, 1780 × 1640 mm. Florence, Uffizi

NOTES
1. Scarpellini 1984, nos. 51, 52, 60.
2. Dunbar and Olszewski 1996, no. 17.
3. Todini 1989, figs. 1275–78.

LITERATURE
Woodward 1870, p. 35; Fischel 1917, no. 44; Gnoli 1923, p. 80; London 1930,
no. 589; Popham 1931, no. 104; Popham and Wilde 1949, no. 22; Ames-
Lewis and Wright 1983, no. 73; Ferino Pagden 1984, p. 149; Roberts 1988,
no. 3; Florence 1992, no. 4.16; Clayton 1993–94, no. 5; Dunbar and
Olszewski 1996, p. 88

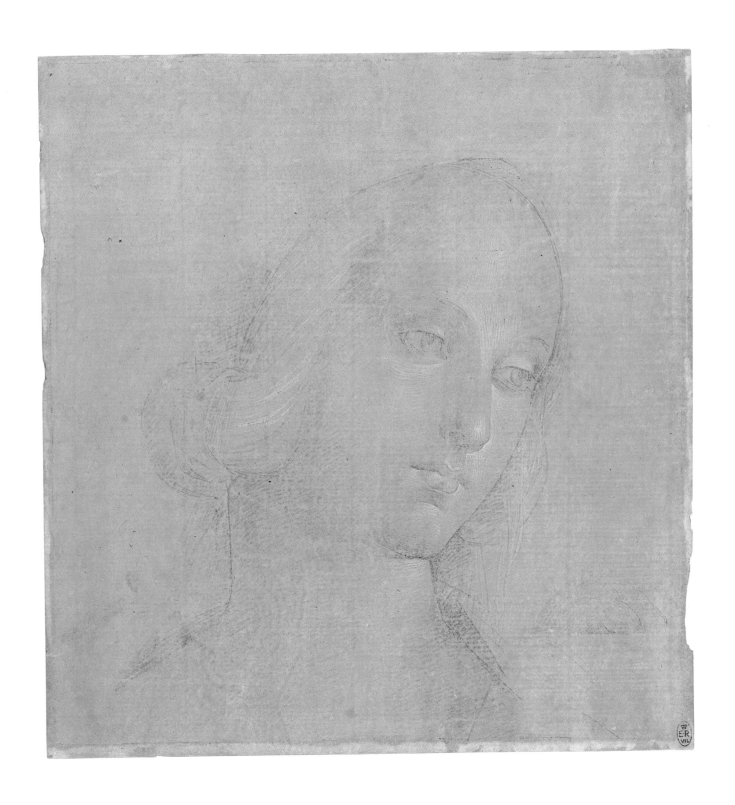

4

ATTRIBUTED TO PERUGINO

A head of a man

ca. 1495–1500

Charcoal; lead-white bodycolour

Verso: A fragment of a design: a left arm

Charcoal pounce-marks; squared in charcoal at 58–61 mm

235 × 224 mm

Watermark: eagle displayed

RL 061

No generally accepted attribution has been proposed for this drawing. Popham's record of an inscription of *P. Perugino* on the verso seems to have been an error, for until recently the sheet was laid down on a solid mount and no inscription was revealed when it was lifted. Berenson first published the drawing as by Alvise Vivarini; this (and any other Venetian association) was rejected by the Tietzes, and Berenson later allowed his attribution to lapse. Popham cautiously accepted the anonymous attribution to Timoteo Viti then written on the mount; Pouncey (reported by Antal) gave the drawing to Lo Spagna.

Both Viti and Lo Spagna were active in the immediate orbit of Perugino around 1500, and indeed this mode of broad hatching and cross-hatching in chalk or charcoal was a common trait of Umbrian draftsmanship at that time. The features are not closed and bounded enough for either, however, lacking Viti's inherent softness of form and very regular hatching and Lo Spagna's taut outlines.[1] The style is close in its simultaneous breadth and attention to precise accents to that of the young Raphael, though he was always more decisive in the contours, as seen in cat. 9 below and in the Louvre *Mother suckling a child*.[2]

The drawing is identical in conception and style to a study of the head of a youth in profile in the Fogg Art Museum (fig. 14).[3] With long strokes of cross-hatching, fluidly drawn hair, shallow-set eyes, and the rim of the hat repeatedly

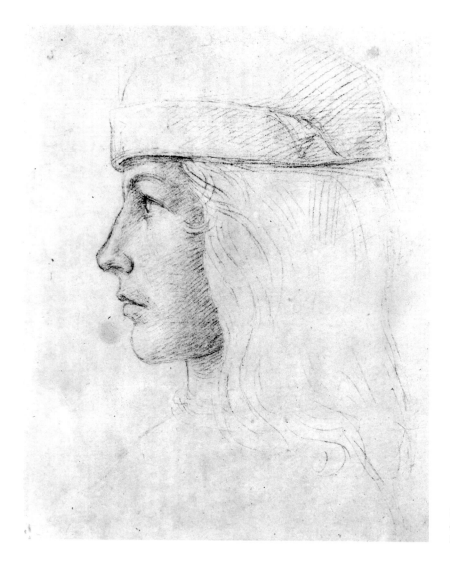

Fig. 14 Attributed to Perugino, *Head of a youth*, charcoal, 290 × 201 mm. Cambridge MA, Fogg Art Museum, inv. 1936.120

4r

4v

outlined, the two are surely by the same hand at the same date. The Fogg drawing is usually (but not always) given to Perugino, for it is on the verso of a metalpoint sketch of a standing music-making angel that is wholly typical of Perugino's most confident style. However, the different media of the two sides of the sheet make a direct comparison of recto and verso impossible, and there is no analogous portrait drawing certainly by Perugino in chalk or charcoal. Among his few portrait paintings, the 1494 *Francesco delle Opere* (Uffizi) displays a very similar perception of facial structure, especially in the treatment of the mouth, jaw and neck. The technique here is generally that of the Christ Church cartoon fragment of the head of Joseph of Arimathea for the Pitti *Lamentation*,[4] though the decisive handling of form required for a cartoon makes it hazardous to compare its style with that of the present sheet, and similar qualifications must attach to the British Museum *Head of a man*, perhaps for the Cambio *David*.[5] In sum, there is no compelling proof that the present drawing is by Perugino, but the weight of evidence would support an attribution to him. If not by the master it must be the work of one of his immediate circle, and in any case demonstrates the source of Raphael's early chalk style.

<p style="text-align:center">★ ★ ★</p>

The verso of the sheet bears pounce-marks that were part of a much larger design, showing that the portrait was drawn on a recycled fragment of a cartoon of some sort. The pattern can be read in part as the elbow of a crooked left arm with scalloped armour at the biceps, but beyond this it is illegible. Such a motif would be appropriate for a St Michael or a St George, and is close to that of a *St Michael* attributed to Andrea d'Assisi formerly at Leipzig,[6] but this crooked-arm pose was common in the wider circle of Perugino (see cat. 6) and, in the absence of an exact correspondence with a painting, any attribution of such mechanical traces is meaningless.

The purpose of this cartoon is enigmatic. To pounce dots on to a secondary sheet would imply the intention to work over the pattern and refine the detail, as with Raphael's 'auxiliary cartoons' (cat. 9). Although this was not done here, the sheet was also squared. In the absence of further material evidence this combination of two transfer techniques with no intermediate elaboration cannot be explained.

NOTES
1. See, for example, the group of Viti's drawings in the British Museum (Pouncey and Gere 1962, nos. 255, 261–64); Lo Spagna's *Head of the Virgin* in the Uffizi (1318-f; Ferino Pagden 1982, no. 41) or his *God the Father* in the Louvre (2284; Fischel 1917, no. 128).
2. Cordellier and Py 1992, no. 22v; F. 45v; J. 20v.
3. Fischel 1917, no. 95; Mongan and Sachs 1940, no. 29; J. 5.
4. Byam Shaw 1976, no. 8.
5. Popham and Pouncey 1950, no. 190.
6. Scarpellini 1984, fig. 27c.

LITERATURE
Berenson 1901, p. 93; Tietze and Tietze Conrat 1944, no. A2250; Popham and Wilde 1949, no. 1040; Antal 1951, p. 32; London 1972–73, no. 160

5

PERUGINO

A man in armour

ca. 1490–93

Blue ground-bone preparation; metalpoint; a little pen and iron-gall ink; lead-white bodycolour
Inscribed lower right, pencil, *Massaccio*
Verso blank
250 × 189 mm
No watermark
RL 12801
Provenance: George III (Inv. A, p. 14, *Albert Durer e Maestri Antichi Div:si,* no. 13: "Man in armour, call'd of Masaccio")

This figure corresponds (excepting the head) to Perugino's *St Michael* in the National Gallery, London (fig. 15), a panel from an altarpiece commissioned around 1496 for the Certosa di Pavia. With more fanciful armour he is also found as Lucius Sicinius among the *Antique heroes* in the Cambio, Perugia, painted around 1498, and as St Michael in the Vallombrosa *Assumption with Saints,* dated 1500, in the Accademia, Florence. The pose is based on that of Donatello's marble *St George* (Bargello, Florence), but it is not a copy after that sculpture in the manner that Raphael used it in his Ashmolean drawing of *Four standing warriors*:[1] the armour is here more detailed, the legs are planted further apart, and the arms and shoulders pulled further forward to create a more explicitly intrepid image.

The character of the drawing is rather different from that of most of Perugino's preparatory sheets. In addition to the pose of the body, Perugino would usually establish the attitude and type of the subject's head from the outset, as can be seen in two other studies for the Pavia altarpiece, *Tobias and the Angel* in the Ashmolean and the angel supporting Christ in Stockholm.[2] The head here is much more severe and individualized than that of the *St Michael* as painted, and it is probable that the drawing was not made directly as a study for the Pavia altarpiece. It (or a replica) was copied by a studio hand in a sheet in the Wessenberg Gemäldegalerie in Konstanz (fig. 16, p. 38), alongside a youth in armour who is also reproduced in cat. 6 below, and it is thus likely that cat. 5 and the lost prototype of cat. 6 were drawn as a pair. The *terminus ante* of 1493 for the prototype of cat. 6 would then also apply to cat. 5.

The armour worn by the figure is contemporary and probably north Italian in origin. It is functional, not merely for show, and as a full suit it would have been worn by one of high rank; almost identical armour is seen on the statue of Francesco Sforza in the Museo Civico, Vicenza. Such a suit is unlikely to have been one of Perugino's studio props, and he must have made special arrangements to pose a model dressed

Fig. 15 Perugino, *St Michael,* panel, 1270 × 580 mm.
London, National Gallery

in this armour. The sheet would then serve as a workshop model for future and repeated reference, and was pressed into service when Perugino received the commission for the Pavia altarpiece.

NOTES
1. Parker 1956, no. 523; F. 87; J. 88.
2. Respectively Parker 1956, no. 27, and Magnusson 1992, no. 2.

LITERATURE
London 1877, no. 849; Fischel 1917, no. 54; Gnoli 1923, p. 80; *Vasari Society,* VII, 1926, pl. 4; London 1930, no. 580; Popham 1931, no. 106; Popham and Wilde 1949, no. 21; Parker 1956, p. 19; London 1972–73, no. 28; Ferino Pagden 1982, p. 29; Knab 1983, p. 28; Ferino Pagden 1984, p. 144; Scarpellini 1984, pp. 46, 101; Milan 1986, pp. 44–46, 49–51; Gardner von Teuffel 1995, p. 310; Meyer zur Capellen 1996, pp. 128f.

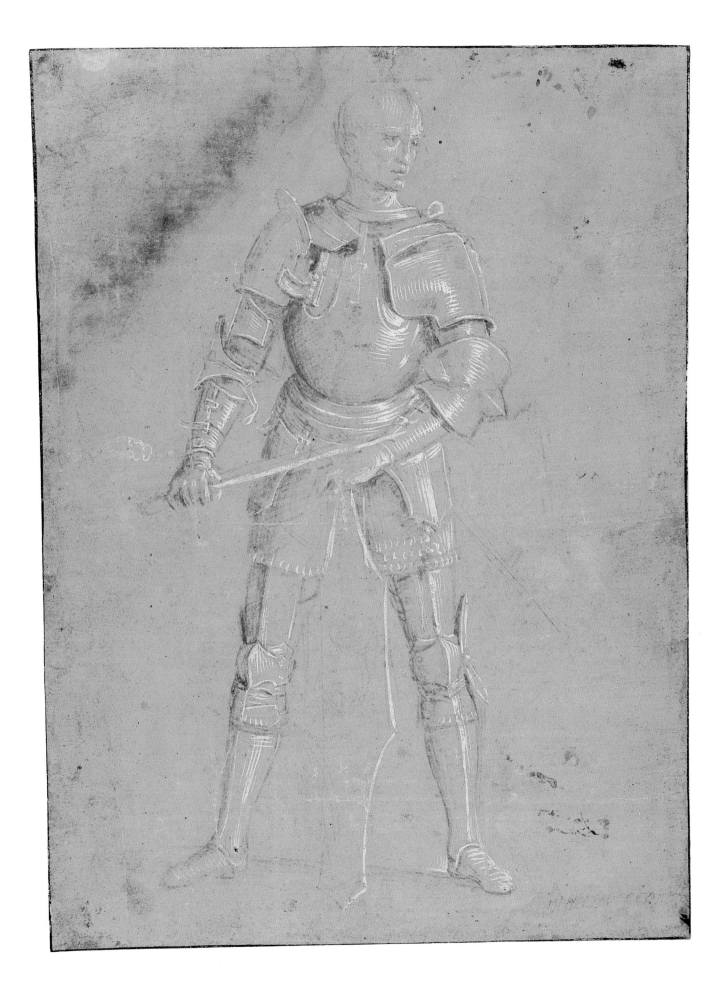

6

COPY AFTER PERUGINO

St George standing on the dragon

ca. 1500 (?)

Dull blue-green paper; black chalk; lead-white bodycolour; touches
of red chalk
Verso blank
305 × 186 mm
No watermark
RL 0696
Provenance: George III (Inv. A, p. 14, *Albert Durer e Maestri Antichi
Div:si*, no. 14: "S¹: George treading on the Dragon, by Francia")

This is a modified copy from a figure of a warrior found
repeatedly in works from the circle of Perugino and
Pintoricchio. He occurs in several drawings,[1] and as St
Michael, with the armour generalized to a decorative *all'antica*
type, in Perugino's *Virgin in Glory with saints* in the Pinacoteca
Nazionale, Bologna, a work of the late 1490s.[2] A study by
Perugino of a *garzone* in this pose but in everyday dress is in the
Lehman Collection, New York.[3]

Hind also noted the connection between the present
drawing and an anonymous (Venetian?) engraving, inscribed
GUERINO DIT MESCHI[NO] and dated by him
ca. 1490–1500. Meschino was the chivalric hero of an Italian
romance of the fifteenth century, printed in several editions;
according to Ferino Pagden one of these, published in 1493, is
furnished with a woodcut frontispiece that reproduces the
same design.[4] The prototype for all these versions must,
therefore, have been created no later than 1493. A copy in
Konstanz (fig. 16) shows the warrior alongside another copied
from the drawing by Perugino, cat. 5 above. The armour of
the two is identical in all essentials, and it is probable that cat. 5
and the prototype for cat. 6 (and for the many other versions)
were a pair of drawings by Perugino, drawn at the same time
from the same model and intended to serve the same function
as visual resources in the studio.

There is a clear disjuncture in the present drawing between
the robust body and the weak head, quite different in character
from the Peruginesque versions listed above – the copyist's
powers of invention were not equal to his model. Popham
stated that the drawing is "quite obviously Venetic", suggesting
it might be by "some Veronese like Bonifazio [de' Pitati] or by
Jacopo Bassano in his youth or even by Giulio Campi". The
traditional attribution of the drawing to Francesco Francia is
intriguing, for, although its style bears little resemblance to the
few drawings known by that Bolognese painter, figures wearing
this armour do occur in his oeuvre. That in a panel of *St George*

Fig. 16 Copy after Perugino, *Two warriors*, black-chalk underdrawing, pen
and ink, 274 × 208 mm. Konstanz, Wessenberg Gemäldegalerie, inv. 37/108

and St Sebastian in Detroit is identical in almost every respect,
showing the figure rotated to the right; the St George in the
Manzuoli altarpiece (Pinacoteca, Bologna) corresponds to the
present drawing from the waist down, the arms being
rearranged and a cloak worn over the shoulders, and the head
is of a much more Peruginesque type than here. Given the
wide circulation of the motif it is likely that Francia knew
some version of it, for in the later stages of his career he
showed an increasing awareness of Umbrian art, and an early
connoisseur must have observed the correspondences with
Francia's paintings and deduced that this drawing was by him.

NOTES
1. Accademia, Venice, inv. 174 (Ferino Pagden 1984, no. 55); Louvre, inv.
3451 (Fischel 1917, no. 101); Uffizi, inv. 280-E (Fischel 1917, fig. 269);
Wessenberg Gemäldegalerie, Konstanz, inv. 37/108.
2. Scarpellini 1984, no. 115.
3. Szabo 1983, no. 18.
4. Cited by C. Bertelli in Milan 1984, p. 38.

LITERATURE
Hind 1938, I, p. 281; Popham and Wilde 1949, no. 1165

7

STUDIO OF PERUGINO
(BERTO DI GIOVANNI?)

Three sleeping Disciples

ca. 1500

Some black chalk underdrawing; pen and iron-gall ink

Verso: A sleeping Disciple

Media as recto

215 × 273 mm

Watermark: eagle displayed, cut (tail only)

RL 12792

Provenance: George III (Inv. A, p. 14, *Albert Durer e Maestri Antichi Div:si*, no. 15: "The three Disciples a sleep")

The drawings on the two sides of this sheet correspond exactly to figures in a composition by Perugino of *The Agony in the Garden*, known through a workshop copy in a private collection (fig. 17).[1] Another studio version of the painting is in the J. Herron Art Museum, Indianapolis, with the figures of the Disciples altered slightly, and at one further remove is Lo Spagna's painting in the National Gallery, London, in which the Disciples are in very similar poses without any motif being identical. A drawing by Perugino himself for the two lateral figures in the composition is at Weimar.[2]

The present recto and verso are clearly copies rather than creative studies. Many copies after Perugino in this manner survive, their technique derived from his own wiry, robust pen style but with all the stresses suppressed, leaving unaccented outlines, painstakingly regular cross-hatching, and the folds of the drapery smoothed into even, rounded furrows. These drawings are often attributed to Berto di Giovanni, a semi-detached member of Perugino's workshop who in 1505 co-signed with Raphael the contract for the Monteluce *Coronation of the Virgin*.[3] While there is a rational basis for attributing some of these drawings to Berto the group is not homogeneous in style, and it is probable that they are the work of several individuals in Perugino's circle.[4]

As Ferino (1979) suggested, drawings in this manner probably fulfilled a particular role in Perugino's studio, perhaps as a teaching method. It is instructive to compare a pair of drawings of a standing saint in the Uffizi, one a beautiful drawing by Perugino in metalpoint with white heightening, the other a pen-and-ink version in the closely hatched manner.[5] The latter is not strictly a copy (in the sense of a facsimile) but an interpretation, and seems to have functioned as a drawing exercise. The present sheet may have served the same purpose, or may have been a workshop *ricordo* of a

Fig. 17 Workshop of Perugino, *The Agony in the Garden*, panel, 560 × 410 mm. Italy, private collection

successful motif for future use: the central figure of St Peter recurs in the background of Perugino's Foligno *Last Supper*,[6] and as St Joseph in a tondo of *The Nativity* by a follower of Perugino formerly in the Rospigliosi collection.[7]

NOTES

1. Fischer, Lucerne, 12 June 1970, lot 23, attributed to Eusebio di San Giorgio.
2. Fischel 1917, no. 22.
3. See Gualdi 1961, p. 255.
4. See Peronnet 1997, p. 81. The Key Register at Windsor carries an attribution in the hand of Sir Owen Morshead (Royal Librarian 1926–58) to "?Giannicola di Paolo Manni".
5. Inv. 108-F, 409-E; Ferino Pagden 1982, nos. 14f.
6. Scarpellini 1984, no. 45.
7. Sold at auction in 1932, attributed to Antonio del Massaro (Il Pastura); ill. Todini 1989, fig. 1247; see Russell 1974. An exact but weak copy of this figure, probably done from the present drawing, is at Besançon. A workshop copy of the figure at the left, not done from the Weimar sheet or cat. 7, was at Christie's, 5 April 1977, lot 44.

LITERATURE

London 1877, no. 583; Fischel 1917, p. 41; Van Marle 1922–37, XIV, p. 394; Gnoli 1923, p. 80; Popham and Wilde 1949, no. 23; Russell 1974, p. 166 n.; Gualdi Sabatini 1984, pp. 30, 110–12, 305

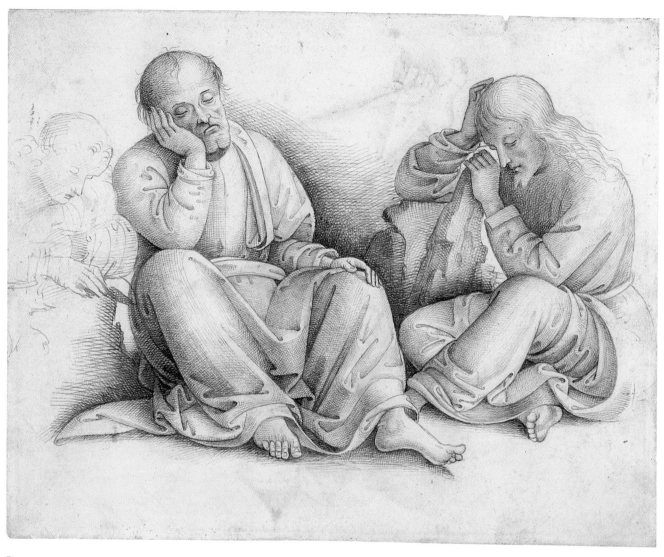

7r

7v

8

GIROLAMO GENGA

A fragment of a design for a salver with a mythological composition

ca. 1525–45

Charcoal underdrawing; pen and iron-gall ink
307 × 193 mm, on two pieces of paper joined vertically
Inscribed lower left, pen and ink, *H. Groinger*
Verso blank
No watermark
RL 0473
Provenance: Nicholas Lanier (?) (Lugt 2885, and the associated inscription)

This drawing is in the typical closely hatched, densely figurated style of Genga, whose name was apparently still attached to the drawing when it arrived in England in the seventeenth century: the inscription *H. Groinger* must be a corruption of Hieronymus (*i.e.* Girolamo) Genga. It is a fragment, the centre-left portion of a circular composition about 450 mm in diameter of which the centre-right portion is in the Biblioteca Ambrosiana, Milan (fig. 18). The subject has eluded interpretation. The two fragments together show a colossal woman at the centre, over whose recumbent body swarm nude men brandishing what appear to be thunderbolts and spears. At her right shoulder stands a larger man who holds a lock of her hair and drives back the horde. In the left foreground is an equally colossal river-god; at upper left a man holding a many-headed snake in his right hand seems to give darts to a group of kneeling men. Friesen related the drawing to another large fragment in Chicago, suggesting that both may be connected in subject-matter with the cult of Cybele, the Great Mother of the Gods, but without a textual source this must remain a very tentative hypothesis.[1]

The circular format of the design and the articulation of the pictorial space entirely through the figuration suggest that the drawing is a study for metalwork, presumably a large display salver. Other such designs by Genga include a drawing for a sauce-boat very similar in style and spirit in the British Museum[2] and four studies for a swing-handle bucket in the Metropolitan Museum, one of which also features a river-god.[3] As a court artist in Urbino Genga would probably have produced such designs over many years (see cat. 43 for the comparable case of Giulio Romano); Vasari referred to designs in wax by Genga for drinking vessels for the Bishop of Sinigaglia and for the Duke of Urbino, but without giving any context that might allow a dating. Drawings by Genga are comparatively rare and his pen style varied little from the densely hatched mode that he assimilated in the circles of Perugino and Viti and which also characterizes some of Raphael's earlier sheets (see cat. 7, 13). This apparent lack of stylistic development and a paucity of reference points make it impossible to date the present drawing at all closely.

NOTES
1. See Folds McCullagh and Giles 1997.
2. Gere and Pouncey 1983, no. 378.
3. New York 1997, pp. 68–71.

LITERATURE
Woodward 1863, p. 165; Popham and Wilde 1949, no. 341; Joachim and Folds McCullagh 1979, p. 23; Gere and Pouncey 1983, p. 231; Colombi Ferretti 1985, p. 73; Folds McCullagh and Giles 1997, p. 115

Fig. 18 Girolamo Genga, *A fragment of a design for a salver with a mythological composition*,
charcoal underdrawing, pen and ink, 299 × 215 mm. Milan, Biblioteca Ambrosiana

RAPHAEL

Raffaello Santi (or Sanzio), born in Urbino in 1483, son of Giovanni Santi. Probably trained with several masters, most importantly Perugino around 1500–02; between 1504 and 1508 active mainly in Florence. Called to Rome in late 1508, working first on the Stanza della Segnatura, and subsequently the Stanze d'Eliodoro (1511–14) and dell'Incendio (1514–17). Other major works include the cartoons for the tapestry cycle *The Acts of the Apostles* (*ca.* 1514–16), many altarpieces and portraits, designs for the Chigi chapels in Santa Maria della Pace (*ca.* 1511–12) and Santa Maria del Popolo (*ca.* 1512–16), and for the Logge of the Vatican (*ca.* 1516–19) and of the Villa Farnesina (*ca.* 1517–18), relying increasingly on a large workshop. Appointed architect of St Peter's in 1514; designed the Villa Madama by 1518. Died on Good Friday 1520 and buried in the Pantheon, Rome.

9

RAPHAEL

The heads of two Apostles

ca. 1503

Stylus underdrawing; charcoal pounce-marks; black chalk
Verso blank
234 × 185 mm
No watermark
RL 4370
Provenance: possibly Carlo Maratti; George III (Inv. A, p. 110, *Carlo Maratti Tom. VI*, "Two old Heads")

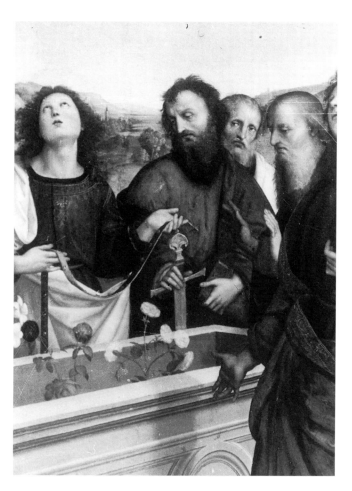

Fig. 19 Raphael, *The Assumption and Coronation of the Virgin* (detail), canvas transferred from panel, 2670 × 1630 mm. Vatican, Pinacoteca

This is a study for the heads of the two Apostles standing to the right of the central figure of St Thomas in Raphael's *Assumption and Coronation of the Virgin* executed for San Francesco, Perugia, and now in the Vatican (fig. 19). Vasari stated that the painting was commissioned by Maddalena degli Oddi, a member of one of Perugia's most prominent families;[1] by 1512 a contract with Perugino for another painting referred to the *Assumption and Coronation* as in the ownership of "*Alexandrae Simonis de Oddis*", who can be identified as Leandra, wife of Simone di Guido degli Oddi and sister-in-law of Maddalena.[2]

For much of the early sixteenth century the men of the Oddi family were exiled from Perugia by their rival family, the Baglioni, and it is significant that Vasari and the 1512 document mention women as the commissioner and owner of the painting respectively. From January to September 1503 this exile was rescinded while the Oddi, under the protection of Cesare Borgia, were briefly in the ascendancy over the Baglioni, and this may have been the catalyst for the commission. But eight months is a short period in which to plan and execute an altarpiece, and the picture was probably completed after the reimposition of the exile, in late 1503 or early 1504; the figure types and degree of spatial sophistication place the *Assumption and Coronation* between the National Gallery *Crucifixion*, dated 1503 on that altarpiece's original substructure in San Domenico, Città di Castello, and the Brera *Betrothal of the Virgin*, dated 1504.

Cat. 9 agrees in size and pose with the corresponding heads in the painting, though there they are more individualized. The feathery cross-hatching in black chalk derives strongly from contemporary Umbrian practice, in particular that of Perugino (see cat. 4; whether or not one accepts that attribution, the general point still holds). The method of construction of the sheet is puzzling. The lines of pounced charcoal dots would place the drawing in the category termed "auxiliary cartoon" by Fischel:[3] having prepared and pricked a full-size cartoon for a painting, the artist could pounce the

whole design on to the painting support and also details on to individual sheets of paper. These details could then be refined on the same scale as the painting and referred to during the execution of the panel. However, there is here substantial stylus underdrawing throughout both heads, and the pounce-marks on the left head (lines of dots across the forehead, down the side of the nose and down the shoulder) do not correspond to the contours of the drawing.

It is therefore possible that the present sheet saw a major revision of the pose of the left head. Bambach Cappel (1988) noted that the head is essentially a reversal of that of St Jerome in a panel of *The Virgin and Child with Sts Jerome and Francis* in Berlin, painted by Raphael around 1501; that the head of the other Apostle is likewise close in attitude and internal proportions (but not in characterization), and again reversed, to St Francis in the same panel; and that the insecure spatial relationship of the two heads here suggests that they were 'collaged' together. The heads in the Berlin painting (and in a black chalk study for the *St Jerome* at Lille)[4] are smaller than in cat. 9, and it is thus improbable that the heads here were generated from

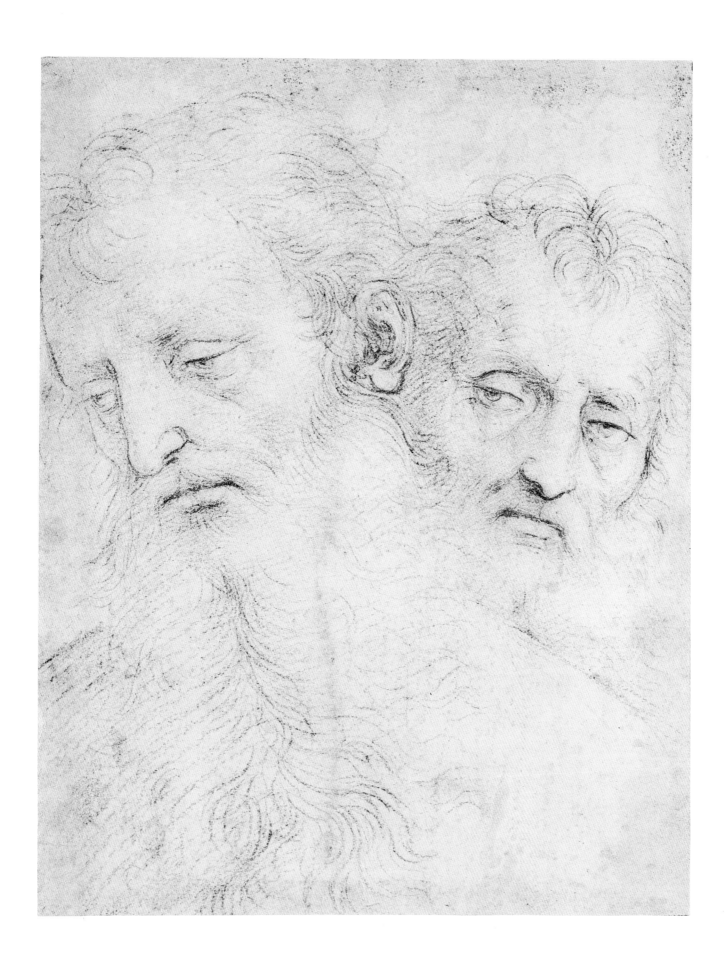

studies for those in the Berlin painting by some mechanical procedure. Nonetheless, it does seem inherently likely that there is a concrete relationship, and perhaps offsets from earlier sheets served as the models for the heads here, redrawn on an appropriate scale.

The drawing was found by Popham among the many drawings at Windsor by Carlo Maratti (1625–1713). Maratti was a devout admirer of Raphael and a collector of drawings, including a number supposedly by Raphael himself, but it is odd that this very un-Marratesque study should at some stage have been mixed up with his own drawings.

NOTES
1. Vasari 1568, II, p. 65.
2. See Luchs 1983.
3. Fischel 1937; but see Bambach Cappel 1988, I, pp. 373–95, arguing against the implications of Fischel's term.
4. Brejon de Lavergnée 1997, no. 512; F. 44; J. 25.

LITERATURE
Popham 1937–38; Popham and Wilde 1949, no. 788; London 1950–51, no. 242; Pouncey and Gere 1962, p. 6; Forlani Tempesti 1968, pp. 319–21, 417 n. 12, 419 nn. 40, 43; Pope-Hennessy 1970, p. 44; Dussler 1971, p. 10; London 1972–73, no. 61; Gere and Turner 1983, no. 24; Joannides 1983, no. 49; Oberhuber and Ferino Pagden 1983, no. 49; Paris 1983–84a, p. 190; Città di Castello 1983–84, pp. 73–75; Ferino Pagden 1984, p. 58; Rome 1984–85, p. 16; De Vecchi 1986a; Bambach Cappel 1988, II, no. 228; Krems 1996, p. 41

10

ATTRIBUTED TO RAPHAEL

A battle of nude men

ca. 1503

Traces of charcoal underdrawing; pen and iron-gall ink; bistre wash; the outlines of some of the figures indented
Inscribed upper left, pen and ink, *1192*; lower right, *129*
Verso inscribed towards the centre, pen and ink, *amenco* (?)
203 × 433 mm
No watermark
RL 059

Attributions for this drawing have ranged from autograph Antonio Pollaiuolo to autograph Raphael, with all shades of opinion in between.[1] The generally Pollaiuolesque nature of the composition is immediately obvious. Berenson considered the sheet to be a variant of a drawing in Turin,[2] itself an augmented weak copy of the so-called *Hercules and the Giants* known primarily through an engraving of *ca.* 1500 based on Pollaiuolo's design. In fact the only figure common to both compositions is the fallen warrior in the foreground of the present composition, though they possibly share a common source; as Hind pointed out, a variant of the figure is found in an engraving of *The Death of Orpheus* of *ca.* 1470–80,[3] and all are probably based ultimately on some antique prototype.

Most recent commentators have recognized that the style of the drawing is a little later than that of Pollaiuolo (who died in 1498), and shows the traits of the period shortly after 1500

when the vigour of that artist's motifs was being overlaid by a certain daintiness: the style might be characterized as the vitality of Pollaiuolo filtered through the sensibilities of Perugino. Although their temperaments may seem very different, Perugino and his followers were alert to the strengths of Pollaiuolo, and there are several surviving copies by Umbrian artists from what must have been one of Pollaiuolo's most esteemed compositions, of a prisoner led before a judge.[4] Here, the classical, slightly immature structure of the bodies is reminiscent of Perugino's warriors, but the strongest connections are with the early drawings of Raphael.

The facial and physical types are very close to a study of *Hercules and the Lion* in the Venice sketchbook, apparently a copy after a lost Raphael (fig. 21),[5] and the same types recur in Raphael's *Siege of Perugia* (fig. 20)[6] – neat hands with small square fingernails, and meticulous facial expressions, especially the hook-nosed man in the background at centre left who is virtually repeated at the centre of the *Siege of Perugia*. The young Raphael used wash almost exclusively in *modello*-type sheets, such as the Louvre *Annunciation*[7] and the ruined *Agony in the Garden* in the Pierpont Morgan Library.[8] Allowing for the difference in scale, the figure types, penwork and delicate wash of Raphael's two large *modelli* for the Piccolomini Library, the Uffizi *Journey of Aeneas Silvius Piccolomini to Basle* and the Pierpont Morgan *Meeting of Frederick II and Eleanor of Portugal*,[9] are also very close to those of the present sheet.

Raphael was periodically interested in the motif of the nude in action during his late Umbrian and Florentine periods.

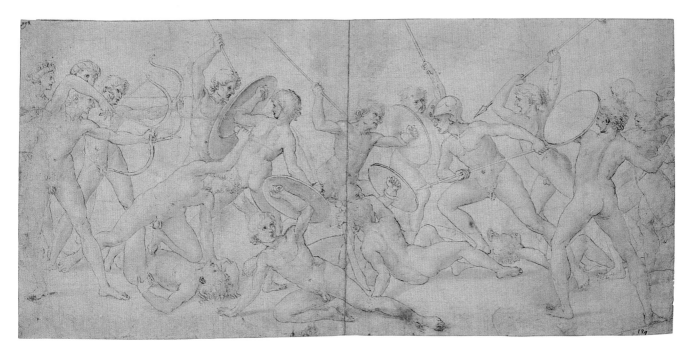

10

At least ten drawings survive on this theme, and there is a rapid evolution from the unemphatic models of Perugino to the more serpentine and tightly knit method of composition seen in a pair of sheets in the Ashmolean.[10] None of these drawings, of a range of dates, types and formats, can be related to a known project. The relatively large *Siege of Perugia* may have been intended as a model for transfer to some other medium; the present drawing possibly served the same purpose, for it is indented with the stylus around some of its contours (these lines were made after the penwork, not as underdrawing). The verso is not rubbed with chalk or charcoal, and any transfer of the outlines to another support must have been effected by placing a second, blackened, sheet between this drawing and the support, in the manner of carbon paper.

The two numbers inscribed on the sheet, probably in the seventeenth century, show that it passed through the same collections as a drawing by Raphael in the Nationalmuseum, Stockholm (a study of *The Adoration of the Magi* for the predella of the Vatican *Assumption and Coronation*), that bears numbers in the same hands and positions, *1193* at top left and *73* at bottom right.[11] The former is consecutive with the number here, *1192*, and as the subjects of the drawings are so different this may indicate that an (unidentified) collector placed the drawings together in the belief that both were by Raphael. Although this does not in itself prove anything, nor is it irrelevant.

NOTES

1. Popham and Wilde 1949 as Pollaiuolo, though Popham later retracted this view and accepted a date around 1500; Ragghianti 1954 as circle of Raphael; Ames-Lewis and Wright 1983 as "Pollaiuolo (?)"; Ferino Pagden 1984 as Raphael; Antonio Natali in Florence 1992 as "Maso Finiguerra (?)". Van Marle 1929, Berenson 1938, Antal 1951 and Ames-Lewis and Clegg 1987 saw the sheet as a post-1500 adaptation, varying in perceived nature, of Pollaiuolesque motifs. Recent works on Pollaiuolo have rejected the attribution to that artist.

2. Inv. 15592; Bertini 1958, no. 18.

3. Hind 1938, no. E.III.17. The motif of a soldier slumped against a hillock, with a shieldsman standing over him, recurs in a sketch of a combat in the Uffizi (349-EV, as "Pintoricchio (?)"). A study by Raphael in the Louvre of a man's head (Cordellier and Py 1992, no. 10v; F. 10; J. 18v) has been associated with this figure of a fallen warrior, but the connection is not strong and probably coincidental.

4. See Popham and Pouncey 1950, p. 138.

5. Ferino Pagden 1984, no. 42.

6. Cordellier and Py 1992, no. 34; F. 96; J. 93.

7. *Ibid.*, no. 18; F. 28; J. 51.

8. F. 66; J. 83.

9. Respectively inv. 520-E; F. 62; J. 56; and F. 65; J. 59.

10. Parker 1956, nos. 537f.; F. 193–95; J. 185f.

11. Magnusson 1992, no. 21; F. 29; J. 52.

LITERATURE

Van Marle 1922–37, XI, pp. 356–60; Berenson 1938, II, under no. 1950A; Ortolani 1948, p. 175; Popham and Wilde 1949, no. 27; Antal 1951, p. 35; Ragghianti 1954, pp. 594f.; Blunt 1971, p. 109; Ames-Lewis and Wright 1983, no. 51; Ferino Pagden 1984, pp. 118, 151f.; Ames-Lewis and Clegg 1987; Ettlinger 1987, p. 161; Joannides 1987, p. 60; Cordellier and Py 1992, pp. 10, 46; Florence 1992, no. 1.3; Rome 1992, pp. 52, 81

10 (detail)

Fig. 20 Raphael, *The Siege of Perugia*, pen and ink, 267 × 405 mm. Paris, Louvre, inv. 3856

Fig. 21 Copy after Raphael (Domenico Alfani?), *Hercules and the Lion* (detail), stylus underdrawing, pen and ink, wash, 232 × 168 mm. Venice, Accademia, *Libretto di Raffaello*, f. 43r

RAPHAEL

The Virgin and Child with the Infant Baptist

ca. 1505

Pink-buff ground-bone preparation; metalpoint (much faded); lead-white bodycolour
Verso blank
139 × 121 mm
No watermark
RL 12743
Provenance: Bonfiglioli; Sagredo; Consul Smith; George III (Inv. A, p. 49, no. 8)

The original metalpoint of this drawing has faded almost to invisibility, and the syrupy white heightening renders the forms quite crudely on such a small scale. Perhaps for this reason the traditional attribution to Raphael lapsed for much of the twentieth century, but photography in ultraviolet light recovers the strength of the metalpoint and confirms the drawing as a typical work by Raphael in his early Florentine years.[1] The composition is circular, with the head of the Madonna close to the upper edge of the circle. The features of the Madonna and the position of her left hand supporting Christ are clarified, and the extreme subtlety of modelling of

the Baptist's body can be seen. The ribbon held by the children, just a streak in visible light, is revealed as a complex, sinuous scroll. A rudimentary landscape is also indicated, with lightly sketched hills on either side of the Madonna.

Raphael worked on many *Madonna and Child* compositions between 1504 and 1508. These should not be viewed as a sequence of isolated projects, with each painting the result of a discrete group of studies, for although many of the drawings can be associated with a particular painting it is more fruitful to see the whole series of drawings and paintings as an ongoing formal investigation. The painting that relates most closely to the present sheet is the Terranuova *Madonna* in Berlin (fig. 22), probably of 1505, with which it shares the circular format, the iconography of the *Ecce Agnus Dei* scroll, the landscape background and the figure types. In that painting, however, the Child is shown sprawled across the Madonna's lap, like that in a drawing at Lille (fig. 23) that also incorporates flanking half-lengths of St Joseph and an angel.[2] The motif of the Madonna's raised left hand in the Terranuova *Madonna* does not appear in the Lille drawing, but is found in a workshop variant in Berlin[3] that presumably records a development by Raphael of the Lille sheet. Use was made of the present drawing's motif of the standing Child, his rear supported by the Madonna's left hand and his raised left leg by her right, in the closely contemporary Uffizi sketch for the *Madonna del*

11 in ultraviolet light

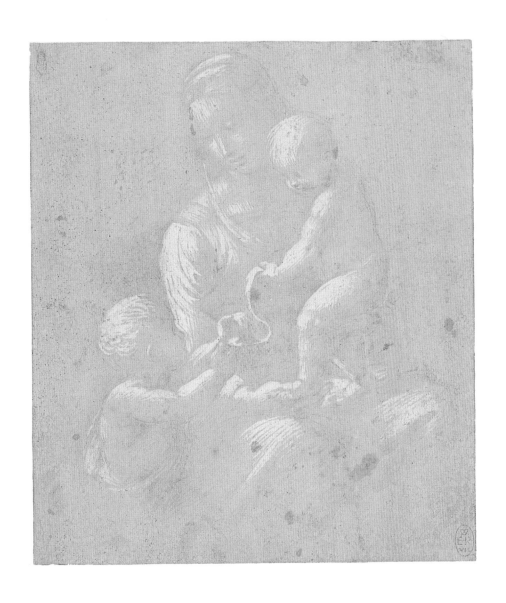

Fig. 22 Raphael, Terranuova *Madonna*, panel, diameter 860 mm. Berlin-Dahlem, Gemäldegalerie

Granduca (the Madonna's attitude as painted is different) and in the Small Cowper *Madonna* in Washington.

Such observations can be spun ever outwards in the web of connections that characterize the *Madonna*s of Raphael's Florentine years. These few are perhaps sufficient to illustrate his visual fertility at a time when, still in his early twenties, he was exploring the formal possibilities of the genre with such verve that within two years he would arrive at the sophistications of the Bridgewater *Madonna* in Edinburgh.

NOTES

1. All scholars accepted the traditional attribution until Fischel (1898) described the sheet as a copy, later proposing the name of Franciabigio; Pouncey (accepted in Popham and Wilde 1949) suggested Granacci as the draftsman, followed by Berenson. In 1983 both Joannides and Oberhuber/ Ferino Pagden reinstated the drawing as a work by Raphael.
2. Brejon de Lavergnée 1997, no. 521; F. 54; J. 69.
3. Bacou and Béguin 1983–84, p. 200; F. p. 68.

LITERATURE

Passavant 1836, II, p. 123; Passavant 1839–58, II, no. 294, III, no. 827; Waagen 1854, II, p. 445; Passavant 1860, II, no. 428; Ruland 1876, p. 92; Crowe and Cavalcaselle 1882–85, II, pp. 477f., 555; Fischel 1898, no. 457; Fischel 1913–41, III, p. 136; Popham and Wilde 1949, no. 392; Berenson 1961, no. 1009G; Joannides 1983, no. 103; Oberhuber and Ferino Pagden 1983, no. 243; Vienna 1983, p. 28; Cordellier and Py 1992, p. 524; Birke and Kertész 1992–97, I, p. 118.

Fig. 23 Raphael, *The Holy Family with the Infant Baptist and an angel*, pen and ink, 167 × 159 mm, arched. Lille, Palais des Beaux-Arts, inv. 431

RAPHAEL

Leda and the Swan

ca. 1507

Black-chalk underdrawing; pen and iron-gall ink
Verso inscribed upper left, pen and ink, *peze 16*
310 × 192 mm
Watermark: three hills
RL 12759
Provenance: George III (Inv. A, p. 51, no. 37)

During the first two decades of the sixteenth century Leonardo da Vinci worked on two variants of a composition of *Leda and the Swan*, one in which the woman kneels, the other in which she stands. The kneeling version was under way by 1504, when Leonardo sketched her contorted figure three times on a sheet at Windsor that also contains a study for *The Battle of Anghiari*.[1] Fully worked, highly sinuous drawings of the kneeling Leda, of extreme contrivance and instability, are to be found at Chatsworth and Rotterdam. This format was apparently abandoned without a cartoon or painting having been made, and Leonardo turned instead to the alternative of a standing Leda. He did execute a painting of this version, probably begun around 1514–15 and still in his studio at his death in 1519; the painting was destroyed around 1700 but its composition is known through numerous copies (fig. 24).

Cat. 12 is a copy by Raphael after the latter variant. Although Raphael could have seen Leonardo's designs for the *Leda* during the time they were both in Rome, from late 1513 to late 1516, the style of the present sheet indicates that it was executed before he left Florence in 1508, and as such it gives the earliest secure date for Leonardo's work on the standing *Leda*. Raphael's model was almost certainly a drawing rather than a painting: the 'bracelet' modelling, with lines curving around the forms of the woman, is conspicuously different from his usual straight hatching and was based on Leonardo's favoured mode at that time. Indeed the many copies of this composition agree generally in the forms of Leda and the swan but differ greatly in the backgrounds and the children, suggesting that most were made from a cartoon or other drawing in which these elements were barely indicated, rather than from the finished painting.

Another manifestation of Raphael's knowledge of Leonardo's drawings for the *Leda* is a study in the British Museum for the 1507 Borghese *Entombment*,[2] which includes studies of fantastic hairstyles strongly reminiscent of Leonardo's own elaborations of Leda's coiffure. The rhythms found in cat. 12 recur throughout Raphael's studies for the *Entombment*; on the verso of one such sheet, also in the British Museum,[3] is an

Fig. 24 Copy after Leonardo da Vinci, *Leda*, red chalk, 280 × 175 mm. Paris, Louvre, inv. 2563

adaptation by Raphael after Michelangelo's unfinished statue of *St Matthew*, abandoned when the sculptor left Florence for Bologna in November 1506, that is very close in style, size and technique to the present drawing.

It must be emphasized that Raphael's *Leda* is also an adaptation of its model and not a faithful copy. A red-chalk drawing in the Louvre (fig. 24),[4] probably made from the same original, records the serpentine neck of the swan that Raphael reduced to a more columnar goose's neck. The ambivalence of Leonardo's design, with Leda both embracing and squirming away from the swan (and looking away from the spectator), is replaced in cat. 12 by a calm and balanced *contrapposto*, with the legs and arms correspondingly adjusted. As has been repeatedly noted, the *Leda* from the waist down served three or so years later as the model for the Eve in Raphael's *Temptation* on the Segnatura ceiling. These controlled torsions were also the basis

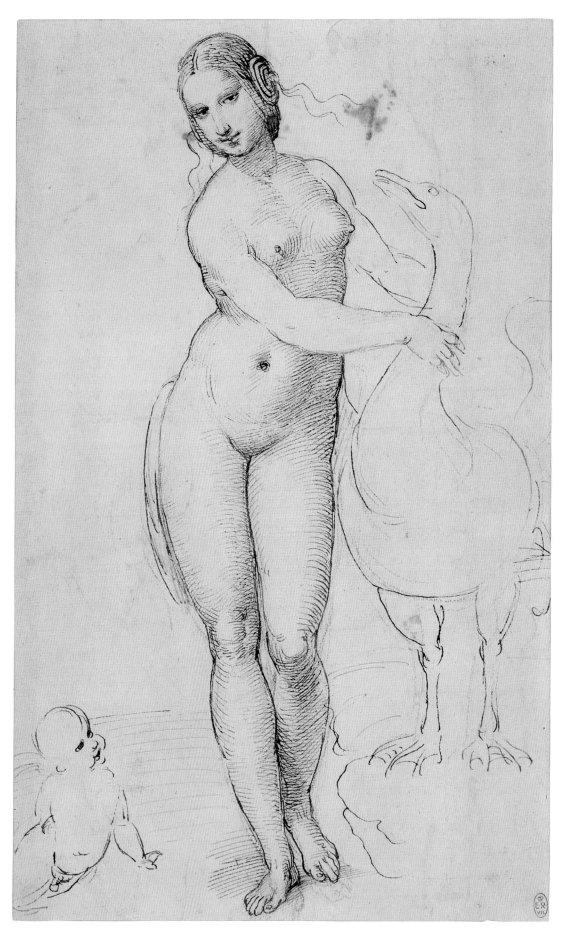

of contemporary designs such as the Bridgewater *Madonna* and the London *St Catherine*, to be intensified a few years later in the Farnesina *Galatea* and her twin sister, the British Museum *Venus*,[5] though never losing the rationalism that Raphael imposed on Leonardo's dark eroticism.

A drawing in Edinburgh[6] is a tracing after cat. 12, probably by F.C. Lewis in preparation for his etching first published in 1809.

NOTES
1. Clark and Pedretti 1968–69, no. 12337.
2. Pouncey and Gere 1962, no. 11; F. 178; J. 139.
3. *Ibid.*, no. 12; F. 171f.; J. 133.
4. Inv. 2563; Meyer zur Capellen 1996, pp. 112f.

5. Pouncey and Gere 1962, no. 27; J. 286.
6. Andrews 1968, no. D1645.

LITERATURE
Chamberlaine 1812, pl. 46; Passavant 1836, II, pp. 125f.; Passavant 1839–58, II, no. 302, III, no. 836; Waagen 1854, II, p. 446; Passavant 1860, II, no. 438; Morelli 1892, p. 155; Fischel 1898, no. 508; Gronau 1902, p. 37; Fischel 1913–41, II, no. 79; Popham and Wilde 1949, no. 789; London 1950–51, no. 245; Hoogewerff 1952, pp. 173ff.; Andrews 1968, p. 103; Clark and Pedretti 1968, pp. 65f., 91, 138 (with earlier literature on the Leonardo composition); Forlani Tempesti 1968, pp. 337, 421 n. 71; Cocke 1969, no. 16; London 1972–73, no. 54; Oberhuber 1982, p. 36; Cuzin 1983, pp. 51f., 79; Gere and Turner 1983, no. 40; Joannides 1983, no. 98; Jones and Penny 1983, p. 29; Oberhuber and Ferino Pagden 1983, no. 114; Vienna 1983, p. 34; Florence 1984a, p. 38; Florence 1984b, no. 95; Gould 1984, p. 10; Rome 1984b, p. 51; Thoenes 1986, p. 67; Chastel 1987, p. 340; Roberts 1988, no. 17; Meyer zur Capellen 1996, pp. 108–13

13

RAPHAEL

The Virgin and Child with St Elizabeth and the Infant Baptist

ca. 1507

Some black-chalk underdrawing; pen and pale iron-gall ink; a little retouching in carbon-black ink
Verso blank
232 × 180 mm
No watermark
RL 12738
Provenance: Bonfiglioli; Sagredo; Consul Smith; George III (Inv A., p. 49, no. 10)

Fischel described this drawing as one of a group of studies towards the Canigiani *Madonna* in Munich, probably of 1507,[1] but the only passage identical in both drawing and painting is the upper body of the Madonna, and the other figures are different in all but their general arrangement. More pertinent is a drawing in the Louvre (fig. 25),[2] also one of Fischel's Canigiani group but much closer to the present composition: St Elizabeth is almost identical, the Madonna half-rises with the Child held in her arms, and the Baptist's pose is an exaggeration of that seen here. The Louvre drawing is carefully executed in wash and white and has often been described as a copy, but it has all the qualities of Raphael's more finished drawings and is probably an autograph *modello*.

There is no record of a painting by Raphael with this composition. Several engravings (some crediting Raphael with the invention) and paintings (some anciently attributed to Raphael) do exist that correspond in composition to the Louvre drawing,[3] but the paintings all seem to be of the seventeenth century or later and are probably derived from one or other of the engravings, in turn based on the Louvre drawing or some variant of that sheet.[4]

The question is therefore whether the Windsor and Louvre drawings were originally for the Canigiani *Madonna*, or whether they were from the start studies for an independent composition. The Canigiani *Madonna* was reportedly commissioned to celebrate the wedding of Domenico Canigiani and Lucrezia di Girolamo Frescobaldi in 1507, and the contract for that painting would have specified the size and presumably the iconography. The Louvre drawing records a fully cogitated, tightly self-contained design; to open out the figure group and add a standing St Joseph, as in the painting, changes the concept fundamentally. A damaged drawing in the British Museum[5] seems to be a copy of a lost study for the Canigiani *Madonna* at the same level of detail as the present sheet. It would be most unlike Raphael to develop a composition to this level of detail twice for a single project, and it is probable that the Windsor and Louvre drawings are closely contemporary developments from the Canigiani *Madonna*.

This is one of the many sheets that Fischel judged to have been substantially reworked by another hand. With the

exception of a few obvious touches with a different ink in the hair and halos of Christ and the Baptist and around the face of St Elizabeth, all the penwork is of a piece, and there is no justification in this case (or in general) for this vagary of Fischel's eye and method, a feature of the hypercriticism prevalent in the decades after Morelli.

NOTES
1. F. 130–136.
2. Cordellier and Py 1992, no. 70; F. 131; J. 152.
3. Most recently listed in Cordellier and Py 1992, p. 80.
4. But see Meyer zur Capellen 1996, p. 235 n. 138, contending that in these copies the landscape has the richness of the *Holy Families* produced in Raphael's late Roman studio, and that the prototype for the copies and engravings may thus have been a painted pastiche from this period.
5. Pouncey and Gere 1962, no. 40.

LITERATURE
Chamberlaine 1812, pl. 49; Passavant 1836, II, p. 124; Passavant 1839–58, II, no. 293, III, no. 829; Waagen 1854, II, p. 445; Passavant 1860, II, no. 427; Robinson 1870, p. 151; Ruland 1876, p. 82; Crowe and Cavalcaselle 1882–85, I, pp. 298f.; Morelli 1891–92, p. 547; Fischel 1898, no. 73; Fischel 1913–41, III, no. 130; Popham and Wilde 1949, no. 790; London 1950–51, no. 248; Forlani Tempesti 1968, pp. 354, 423 n. 97; Cocke 1969, no. 35; Pope-Hennessy 1970, p. 201; Dussler 1971, p. 19; London 1972–73, no. 53; Gere and Turner 1983, no. 58; Joannides 1983, no. 151; Oberhuber and Ferino Pagden 1983, no. 244; Sonnenburg 1983, under no. 14; Paris 1983–84a, p. 318; Gere 1987, no. 9; Cordellier and Py 1992, pp. 78, 80; Rome 1992, p. 110; Meyer zur Capellen 1996, p. 192

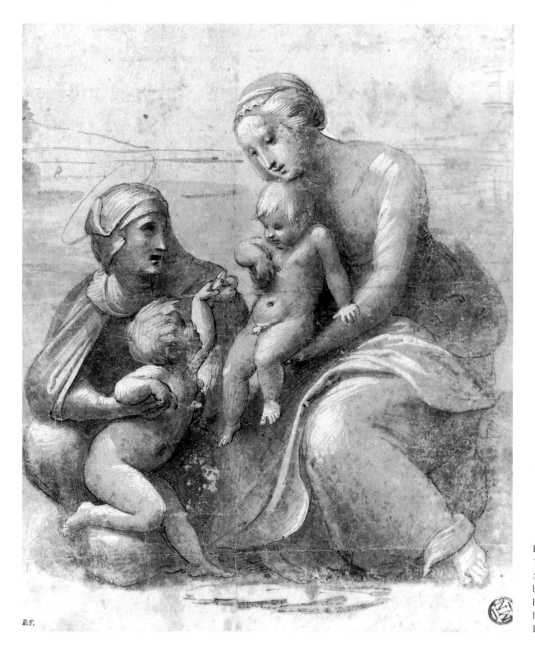

Fig. 25 Attributed to Raphael, *The Virgin and Child with St Elizabeth and the Infant Baptist*, black-chalk underdrawing, pen and brown ink, brown wash, white heightening, 222 × 186 mm. Paris, Louvre, inv. 3949

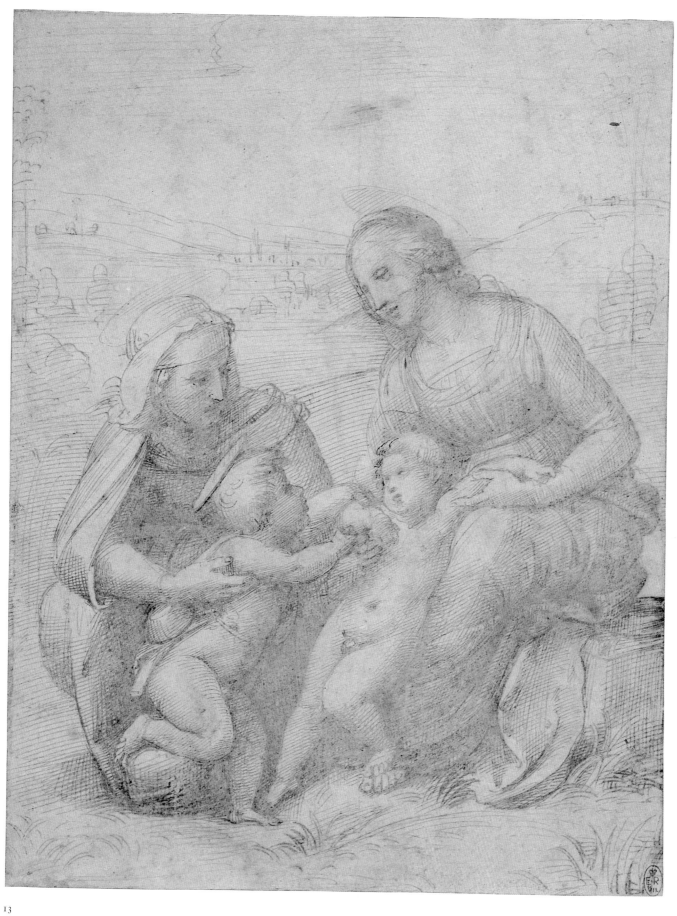

13

14

RAPHAEL

Hercules and the Hydra

ca. 1508

Black chalk (or charcoal?); pen and iron-gall ink

Verso: Hercules and the Nemean Lion

Media as recto
389 × 273 mm
No watermark
RL 12758
Provenance: George III (Inv. A, p. 133, *A Large Portfolio of Drawings*, no. 17, "Hercules destroying the Hydra, on the reverse Hercules destroying the Nemean Lion, in pen and ink," unattributed)

This is one of a number of large and vigorous figure drawings dating from the end of Raphael's Florentine period. Other examples include figure studies for a *Deposition* and a *Crucifixion*,[1] a copy after Michelangelo's *David*,[2] a standing *écorché* known through a reliable copy,[3] and three battles of nude men.[4] In all of these are found the same overdrawn contours, muscles outlined with thin strokes, and blocks of coarse hatching and cross-hatching, usually straight but occasionally hooked around the contours of the body. The unaccustomed size of these drawings suggests that Raphael was making an effort to aggrandize his style in response to the drawings of his contemporaries, especially Michelangelo. Their manifest weaknesses can be explained by Raphael overreaching himself and working on a scale that did not come naturally to him; this was perhaps a necessary phase in the development of such an ambitious artist.

Although this period saw Raphael's penwork at its most self-consciously robust, elements of this style can be seen throughout his career, in such drawings as the British Museum *Nude seen from the rear*[5] of around 1500 or the *Judgment of Zaleucus* (cat. 19) of eleven years later. As Joannides noted (1996), this mode was also the basis for some of the most emphatic drawings produced by Raphael's followers (with a decorative flourish), such as the youthful pen drawings of Giulio Romano (cat. 33) and the *modello*-type sheets produced by the draftsman identified here as Perino del Vaga (cat. 48f.).

En suite in all respects with the present sheet is a study of *Hercules and the Centaur* in the British Museum.[6] A smaller, less grotesque and more carefully drawn version of the verso is in the Ashmolean Museum, showing the full extent of Hercules's outstretched right leg (fig. 26).[7] Also in the Ashmolean is a small sketch of *Hercules and Cerberus*,[8] a drawing with a chequered critical history but the attribution of which to Raphael is supported by comparison with his sketch in the same collection for the Segnatura *Theology*.[9]

The purpose of these *Hercules* drawings is unknown. The large scale of the British Museum sheet and of the recto and verso here suggests that they are not merely drawing exercises or *concetti* with no end in mind. The bodies of Hercules and the lion are carefully placed within the perfect square of the more formal Oxford sheet, the elegant arabesque of Hercules's cloak billowing into an otherwise vacant upper corner. It would therefore appear that Raphael was thinking in compositional terms. Joannides (1996) suggested that the *Hercules* drawings were possibly studies for a cycle of relief sculpture, noting that, as Michelangelo was commissioned in 1508 to carve a *Hercules* as a pendant to his *David*, Raphael's drawings may in some way reflect discussion of the project in Florence just before that date, while Michelangelo was still in Bologna.

NOTES

1. Louvre, Cordellier and Py 1992, no. 56; F. 183f.; J. 143; Florence, Biblioteca Marucelliana 84-E; J. 92.
2. British Museum, Pouncey and Gere 1962, no. 15; F. 187; J. 97.
3. Lille, Brejon de Lavergnée 1997, no. 559; F. 188.
4. Ashmolean, Parker 1956, no. 537f.; F. 193–95; J. 185f.
5. Pouncey and Gere 1962, no. 1; F. 4; J. 7.
6. *Ibid.*, no. 22; F. 189; J. 188.
7. Parker 1956, no. 540, doubting that the two were by the same hand and thus in accepting the Oxford version implicitly rejecting the Windsor sheet; F. 191; J. 190. Utz (1971) attributed all these drawings (and Michelangelo's *Three Labours of Hercules*, Popham and Wilde 1949, no. 423) to Vincenzo de' Rossi, without mentioning Raphael's name.
8. *Ibid.*, no. 463, as Peruzzi.
9. *Ibid.*, no. 554; F. 225; J. 246.

LITERATURE

Robinson 1870, p. 179; Ruland 1876, p. 128; Fischel 1913–41, IV, no. 190; Fischel 1948, p. 360; Popham and Wilde 1949, no. 791; Parker 1956, p. 287; Pouncey and Gere 1962, p. 22; Utz 1971, p. 353; Gere and Turner 1983, no. 66; Joannides 1983, no. 189; Oberhuber and Ferino Pagden 1983, nos. 229f.; Ferino Pagden 1984, p. 118; Ames-Lewis 1986, pp. 42–44; Turner 1986, p. 41; Harprath 1987, p. 397; Cordellier and Py 1992, p. 629; Joannides 1996, no. 29

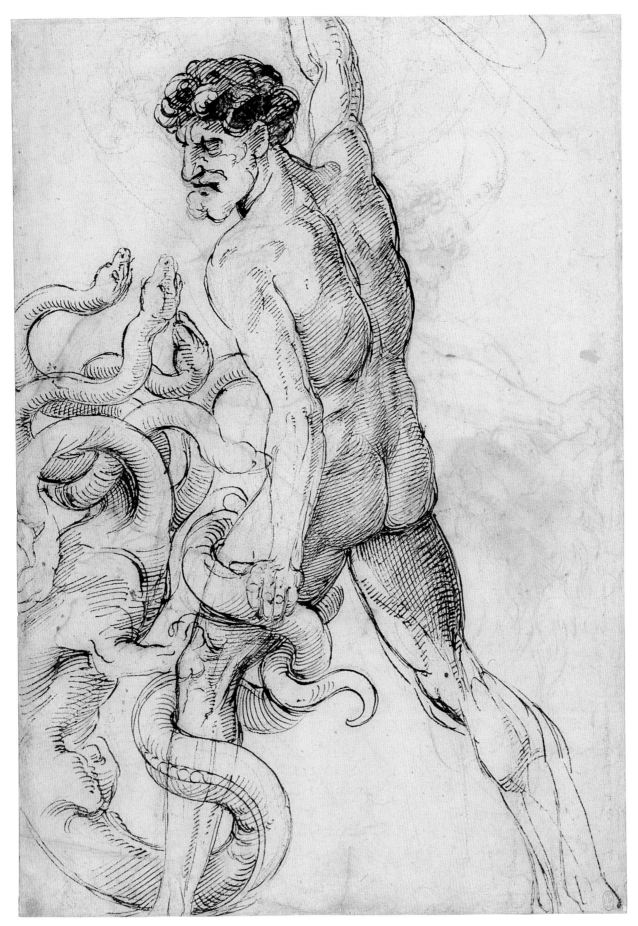

14r

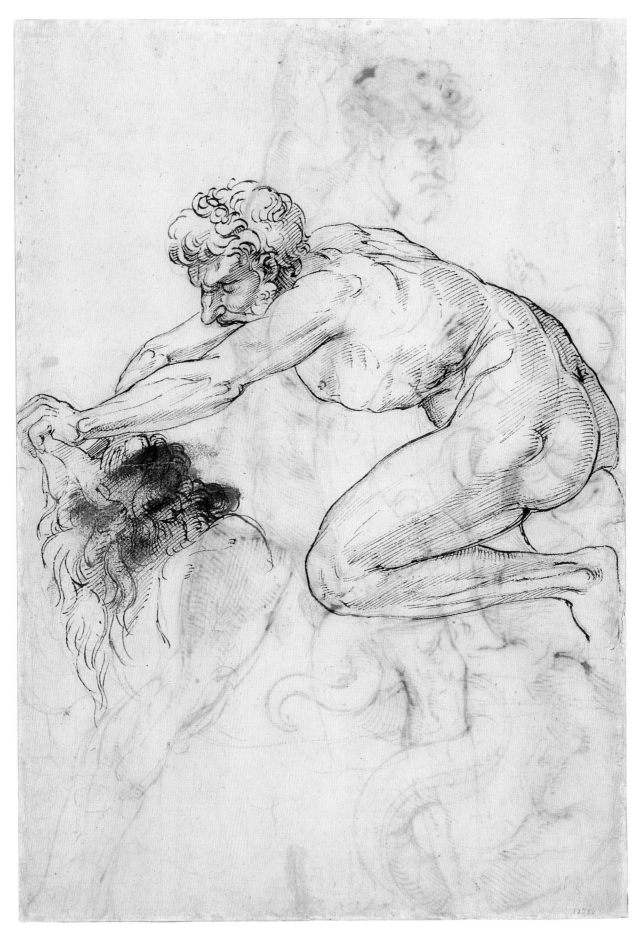

14V

Fig. 26 Raphael, *Hercules and the Nemean Lion*, stylus underdrawing, pen and ink, 262 × 262 mm. Oxford, Ashmolean Museum, Parker 540

15

RAPHAEL

Poetry

ca. 1509–10

Stylus underdrawing; black chalk; squared in black chalk at 57 mm
Verso blank
359 × 227 mm, upper left corner chamfered
Watermark: mermaid in circle
RL 12734
Provenance: Possibly Charles I and/or Charles II; George III (Inv. A, p. 49, no. 7)

This is a study for an allegorical figure (fig. 27) painted by Raphael in the vault of the Stanza della Segnatura in the Vatican Palace (the room was used for the papal *signatura* for only a short spell during the 1540s, but Vasari's nomenclature has been universally adopted). The decoration of the Segnatura was Raphael's first major undertaking in Rome; he frescoed each wall and much of the vault on the themes of three of the branches of knowledge – Theology, Philosophy and Jurisprudence – together with Poetry. The physical layout of the room, the iconography of these decorations, and the absence of any other room in which the decorations would conform to such a use indicate beyond reasonable doubt that

the Segnatura was occupied by Julius II's library.[1]

Around a central octagon in the vault are four large tondi, each featuring an allegorical figure of the subject of that side of the room, as here; four interjacent squared fields continue their themes (*The Temptation* to the left of *Theology*, *The Judgment of Solomon* next to *Justice*, *Astronomy* by *Philosophy* and *Apollo and Marsyas* by *Poetry*). The principal frescos on three of the walls depict an assemblage of protagonists of the relevant discipline: for Theology, the *Disputa*, representing divine knowledge and thus set against an open sky (see cat. 16–17); for Philosophy, the so-called *School of Athens*, representing humane knowledge and thus against pure architecture; and for Poetry, *Mount Parnassus* (see cat. 18), with grisailles below of *Alexander depositing the works of Homer in the coffer of Darius* and *Augustus preventing the burning of the Aeneid*. The Jurisprudence wall was also divided into three, a lunette of *Fortitude, Prudence and Temperance* and, either side of the window, *Pope Gregory IX delivering the Decretals* and *Justinian proclaiming the Pandects*. The lower edges of these frescos probably corresponded to the top of Julius's bookcases. Effaced grisailles in the window embrasures completed Raphael's decorations (see cat. 19).[2]

In his *Life* of Raphael, Vasari called the present figure Polyhymnia, sometimes identified as the Muse of lyric poetry, which would accord with the lyre held by the figure, but in his

Life of Marcantonio Raimondi he called her Calliope, the Muse of epic poetry.[3] The Muses had no stable iconography and their domains depend on the source consulted; the phrase *NUMINE AFFLATUR* (Divinely inspired) on the tablets held by flanking putti in the painting could apply to any of the Muses, and indeed to the *Parnassus* as a whole, in which all branches of poetry are represented. It is thus most probable that she was intended simply to be a non-specific figure of *Poetry*.

The pose and the lower drapery of cat. 15 agree almost exactly with the figure as painted, but here she is nude to the waist. The fluid stylus underdrawing shows the figure sketched out as fully nude, to capture the proportions and pose of the legs rather than as a first idea for the figure. The tilt and accoutrements of her head are also different; despite the squaring that might suggest that the present drawing was enlarged to a full-size cartoon, these adjustments were probably not improvised at full scale, for an engraving by Marcantonio records a lost study still closer to the final design.[4]

The ceiling of the Segnatura was apparently begun under the direction of Sodoma before the arrival in Rome of Raphael, who is first documented there (in a payment for work for the Pope) on 13 January 1509. Sodoma would have been responsible for the design of the coffering of the vault, the ribs of which were decorated by his assistant Johannes Ruysch with grotesques, and Sodoma himself painted at least the central octagon and four pairs of small scenes between the *tondi*. Vasari implied in a somewhat confused account of the Segnatura that further paintings by Sodoma in the larger fields of the vault were destroyed to make way for Raphael's frescos there. Pope-Hennessy (1970) contested that this element of Raphael's work was painted after the completion of the walls, when a stylistic incompatibility with Sodoma's pre-existing vault would have become apparent. While it is indeed improbable that Julius would have allowed an untried artist to destroy freshly completed ceiling decorations as his first act in the Segnatura, it is equally improbable that his very first assignation, when only twenty-six years old and with little experience in fresco, would have been the large and challenging *Disputa*, usually claimed as his earliest Roman work. It seems more likely that Raphael began work in the Stanza as a collaborator of Sodoma, and was given responsibility for the principal frescos after demonstrating his technical ability and pictorial intelligence in the vault.

A supposed increase in the maturity of drawings such as cat. 15 over the preparatory studies for the wall frescos is also sometimes adduced to justify a later dating. While this may be argued with respect to those for the *Disputa*, there is nothing in the few studies for the vault that represents an advance over

Fig. 27 Raphael, *Poetry*, fresco. Vatican, Stanza della Segnatura

the sophisticated figures of the *Parnassus* and the *School of Athens*; a comparable pen drawing in the Albertina[5] for the *Judgment of Solomon* in the vault, for example, does not display the fluidity of equivalent studies for the *Parnassus*. To place the execution of Raphael's vault frescos after that of the *Disputa* would not contradict Vasari's account of the destruction of Sodoma's frescos, but such a destruction would require a reason other than stylistic incompatibility, for there is no striking disharmony between the surviving ceiling compartments painted by Sodoma and those by Raphael, and a few years later Raphael would leave untouched the much more discordant ceiling paintings by Perugino in the Stanza dell'Incendio.

If this destruction did take place, a more plausible explanation could be an expansion or refinement of the iconographic programme of the Stanza. It is not known what Sodoma's lost frescos might have depicted, but the mythological and historical subjects of his surviving small compartments seem unrelated to Raphael's scheme. A scenario whereby a decision was made only *after* the completion of the *Disputa* to develop the four-fold scheme on the ceiling as well as on the walls would harmonize Vasari's account with the stylistic evidence, but this must remain a hypothesis.

NOTES

1. See Shearman 1971 for a discussion of the changing functions of the Stanze.
2. For the decorative scheme of the Segnatura see especially Wind 1938, Shearman 1965a, and Shearman 1993.
3. Vasari 1568, II, pp. 70, 300.
4. Bartsch XIV, p. 291, no. 382. A drawing in the Louvre (Cordellier and Py 1992, no. 86) has been published as a study for the head of *Poetry* – Joannides (1993, p. 18) saw it instead as a study for a Muse in the *Parnassus* – but it is weak, purposeless and hard to reconcile with Raphael's incisive work at this time, and appears rather to be a copy. Its recently uncovered verso (Rome 1992, no. 41v) seems to confute rather than support an attribution to Raphael.
5. Birke and Kertész 1992–97, I, no. 189; F. 131; J. 252v.

LITERATURE

Chamberlaine 1812, pl. 43; Passavant 1836, II, p. 120; Passavant 1839–58, II, p. 111, no. 296, III, no. 833; Waagen 1854, II, p. 444; Passavant 1860, II, p. 88, no. 430; Woodward 1870, pp. 43f.; Ruland 1876, p. 195; Crowe and Cavalcaselle 1882–85, II, pp. 22, 25; Fischel 1898, no. 163; Fischel 1913–41, V, no. 228; Venturi 1920, p. 150; Venturi 1926, p. 190 n.; Venturi 1927, no. 25; London 1930, no. 481; Popham 1931, no. 133; Fischel 1948, p. 360; Popham and Wilde 1949, no. 792; London 1950–51, no. 253; Parker 1956, p. 298; Forlani Tempesti 1968, pp. 362, 423 no. 105; Cocke 1969, no. 62; Pope-Hennessy 1970, p. 148; Dussler 1971, p. 72; London 1972–73, no. 54a; De Vecchi 1981, p. 34; Shoemaker and Broun 1981, p. 110; Cuzin 1983, p. 106; Gere and Turner 1983, no. 110; Joannides 1983, no. 248; Oberhuber and Ferino Pagden 1983, no. 334; Paris 1983–84a, p. 333; Cordellier 1985, p. 99; Massari 1985, pp. 10, 42; Ames-Lewis 1986, pp. 20, 113; Gere 1987, no. 15; Monbeig Goguel 1987, p. 380 n.; Cordellier and Py 1992, p. 101; Rome 1992, p. 127

16

RAPHAEL

A study for the left half of the Disputa

ca. 1509

Off-white paper; some stylus construction lines and pointing; stylus underdrawing in the central register; traces of charcoal underdrawing; brush and bistre ink; lead-white bodycolour; very lightly squared in black chalk at 26 mm
Verso inscribed left edge, pen and ink, [...]*lino* (?)
276 × 283 mm
No watermark
RL 12732
Provenance: George III (Inv. A, p. 17 sub Tom. VI, and p. 49, no. 5)

17

RAPHAEL

A study for the lower half of the Disputa

ca. 1509

Black chalk
Inscribed lower centre, pen and ink, *Sch.Uo*
Verso blank
202 × 403 mm
Watermark: eagle in circle with crown
RL 12733

Cat. 16–17 are preliminary studies for the composition of the *Dispute on the Holy Sacrament* (fig. 30), commonly known as the *Disputa*, probably the first of the large wall frescos to be painted by Raphael in the Stanza della Segnatura (see cat. 15). Thirty sheets of studies survive for this one fresco (and many more have been lost), more than for any other work in Raphael's oeuvre, reflecting both the difficulties of a recondite subject in an awkward space and his concern that his first independent work in Rome should be a triumph.

Cat. 16 is the earliest surviving drawing for the fresco, and shows the left half of what must, from the outset, have been planned as a symmetrical composition. A drawing in the same technique in the Louvre (fig. 28)[1] is possibly a copy of a still earlier study for the celestial zone, showing God the Father (in the same pose as in cat. 16) flanked by angels, the upper tier of which is close to that as executed in the fresco. Relative to the edges of the sheet, God the Father is on a much larger scale than in cat. 16, and would have been oppressively huge if painted thus in the Segnatura. Nonetheless, it does seem that Raphael was having some initial difficulties with the appropriate scale for the figures: the curved edge of the composition of cat. 16 is underdrawn in stylus with the compass, but there are two other stylus arcs, 26 mm and 3 mm inside the final line, suggesting that he was expanding the composition and thus reducing the scale of the figures as he worked. (These are only two of many stylus lines and points on the sheet, but the purpose of very few can be elucidated.) In many cases Raphael's early drafts for the frescos in the Stanze are known from facsimile-like copies that preserve his brush-and-ink technique, and, though fig. 28 is conceivably a pastiche, its composition is coherent and the putti at lower centre are consistent with the subject, holding books and a scroll and looking down while gesturing upwards to God.

Cat. 16 is much more ambitious than fig. 28 and is laid out in fundamentally the same way as in the final composition, a group of theologians with two tiers of celestial figures above. The lower cloud supports a pair of figures at either end, presumably the Evangelists; in the centre is another pair,

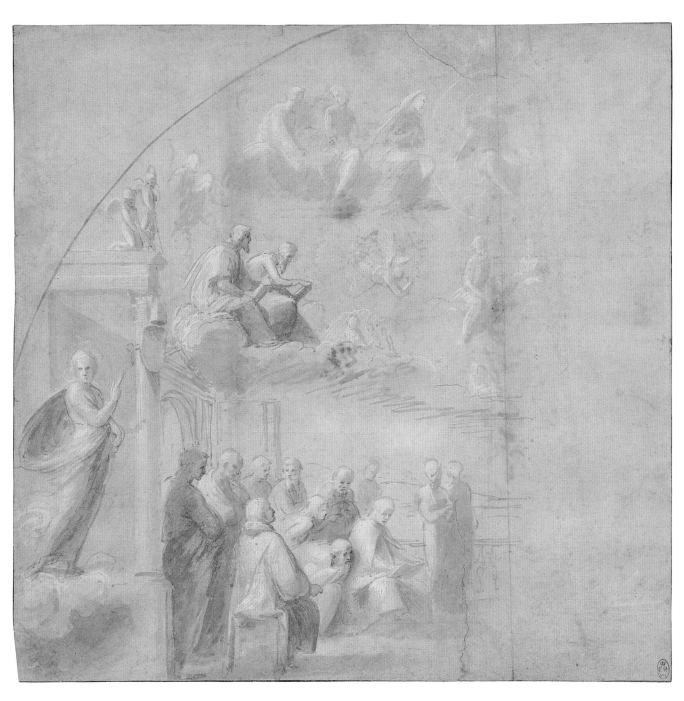

16

identifiable in succeeding drawings as Sts Peter and Paul, and above is Christ in Glory, flanked on his right by the Madonna and two male saints. A major difference between cat. 16 and the fresco is the role played by architecture. Raphael defined the space here as a square courtyard enclosed on two sides by arched screens (the high base of which would accommodate the door-frame on the right of the fresco) and at the back by a balustrade. This structure has no narrative purpose: it is purely a formal device to give spatial coherence to the assembled figures, and while the drawing is in this respect more logical than the fresco, it is less successful as flat pattern. Raphael also used a paler wash for the figures placed further back in space, a form of atmospheric perspective that serves the cloud-borne figures in the way that linear perspective serves the theologians.

The subsequent development of the composition centred on the gradual suppression of overt spatial illusionism and the development of a clear surface arrangement, partly non-rational but internally consistent, that transmits the meaning of

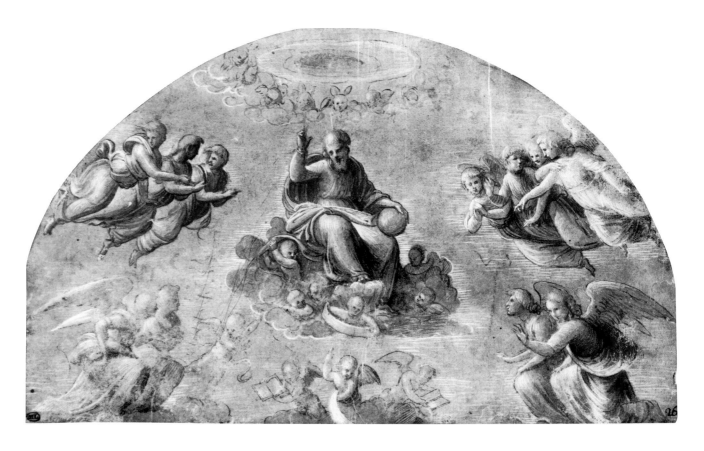

Fig. 28 Copy after Raphael (?), *God the Father with angels*, paper washed brown, brush and ink, pen and ink, brown wash, white heightening, 154 × 263 mm. Paris, Louvre, inv. 3890

the fresco by contrasting the divine order above with the human commotion below. In cat. 16 the theologians are, if anything, more calmly disposed than the clutter of celestial figures and clouds. Several terrestrial figures are derived from Leonardo da Vinci's unfinished *Adoration of the Magi*, then probably in the house of Amerigo Benci and accessible to Raphael when he had been in Florence. Most notable is the mysterious cloud-borne figure at the extreme left of the composition, looking out at the spectator and pointing upwards, either to the Della Rovere arms of Julius II attached to the column or to the divine mystery. This rather outmoded device mutated into one of the Evangelists in later studies, before finally returning to earth as a youth attempting to draw the attention of a fellow theologian to the scene in the heavens.

The next stage of the design is seen in two drawings in the same media, possibly fragments of a single sheet, of the heavenly zone at Oxford and of the theologians at Chantilly (fig. 29).[2] The composition of cat. 17 corresponds in most respects to that of fig. 29, but the central figures common to cat. 16 and fig. 29 are changed in cat. 17, which thus appears to have come after, not before, the Chantilly sheet. Peronnet (1997) made the persuasive suggestion that the four principal

seated figures in the Chantilly drawing are the Fathers of the Church, and in cat. 17 three mitres or tiaras (for Sts Ambrose, Augustine and Gregory) and a cardinal's hat (for St Jerome) can be seen on the ground by their feet. These four can be identified in the fresco, seated closest to the altar.

The two groups of theologians have been moved closer together in the Chantilly drawing and in cat. 17, but their lack of compositional or narrative interaction might lead one to suppose that they are two distinct studies of separate groups were it not for the balustrade that connects them. This disturbing weakness in the design was resolved by Raphael in subsequent studies and in the fresco by the introduction of the altar with the Host. This gives a context for the actions of the theologians and a focus for the entire composition, on an axis with the Trinity above. It also changes the subject of the fresco, and what had begun as a *Dispute on the Trinity* became a less common *Dispute on the Holy Sacrament*. It therefore appears that the subject and composition of the *Disputa* evolved in tandem, and it would be fascinating to know the degree of the patron's involvement in this.

Shearman (1965) suggested that a *Dispute on the Trinity* had also been the intended subject of Raphael's earlier fresco in

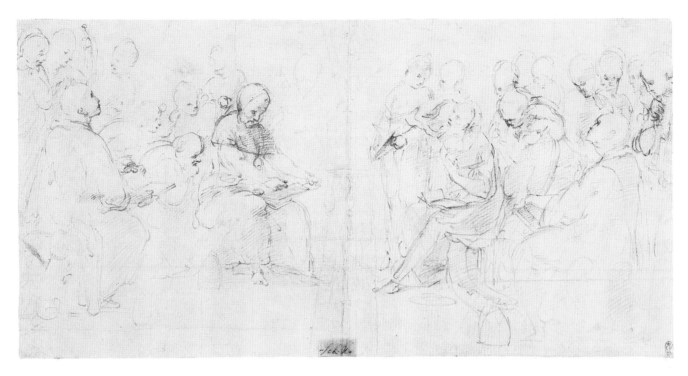

17

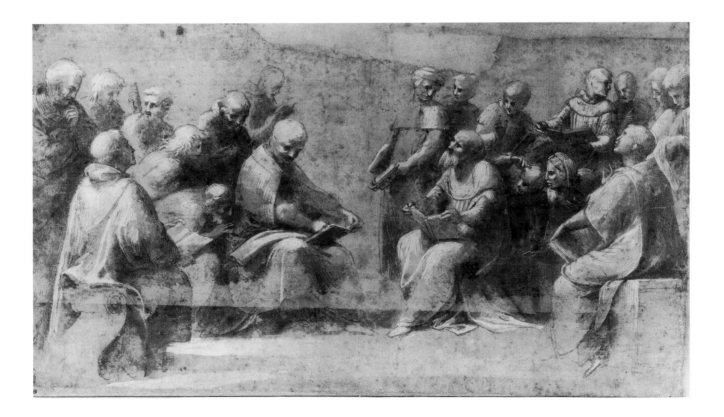

Fig. 29 Raphael, *Study for the lower portion of the Disputa*, pen and ink, wash, white heightening, squared in black chalk, 231 × 407 mm.
Chantilly, Musée Condé, inv. 53(45)

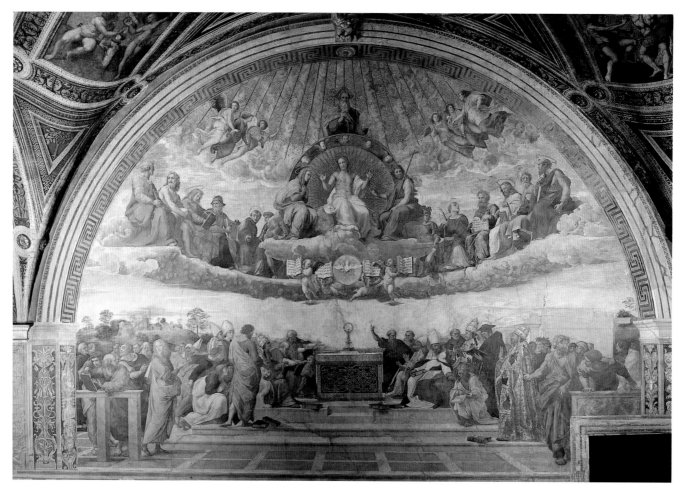

Fig. 30 Raphael, *Disputa*, fresco. Vatican, Stanza della Segnatura

San Severo, Perugia (1505–06), before its completion by
Perugino in 1521 with a mundane row of standing saints. The
compositional dependency of the *Disputa* on the San Severo
fresco is often noted. There Raphael's interest in covert
asymmetry can already be seen, placing the two lines of saints
at differing angles to the viewer and disguising this by
variations in the draperies and in the angles from which the
identically posed angels are seen. Raphael also displayed in that
fresco an acute awareness of the structural possibilities of
colour, the interplay of white, green and gold articulating the
surface independently of the illusion of space. These skills were
deployed to great effect in the *Disputa*, where the broken
rhythms of the bands of figures give a measured coherence to a
composition that could easily have degenerated into a tedious
series of friezes. The eventual placing of the altar on wide steps
also allowed some differentiation among the theologians –
they were no longer a single massed group – and the pictorial
value of this device, ranging the figures on a steadily rising
stage, was vital to the success of the next frescos in the
Segnatura, the *School of Athens* and the *Parnassus*.

NOTES
1. Cordellier and Py 1992, no. 93.
2. Respectively Parker 1956, no. 542, and Peronnet 1997, no. 6; F. 259f.;
J. 198f.

LITERATURE
Passavant 1836, II, pp. 119f.; Passavant 1839–58, II, p. 96, no. 295, III, p. 106,
no. 831; Waagen 1854, II, p. 444; Passavant 1860, II, p. 75, no. 429;
Robinson 1870, p. 187; Ruland 1876, pp. 180, 182; Crowe and Cavalcaselle
1882–85, II, pp. 29, 33; Morelli 1891–92, p. 546; Morelli 1892, p. 146; Fischel
1898, nos. 123, 134; Fischel 1913–41, VI, nos. 258, 261; Venturi 1920,
pp. 154f.; Venturi 1926, p. 199 n.; Venturi 1927, no. 26; Fischel 1948,
pp. 81f., 231; Popham and Wilde 1949, nos. 794f.; London 1950–51, nos.
243f.; Parker 1956, p. 289; White 1961, pp. 233f.; Pouncey and Gere 1962,
p. 29; Shearman 1965, pp. 158–62; Forlani Tempesti 1968, pp. 370–75, 424
nn. 111, 113; Cocke 1969, nos. 84f.; Pope-Hennessy 1970, pp. 59–67; Dussler
1971, p. 72; London 1972–73, nos. 60, 63; Pfeiffer 1975, pp. 77, 81f.; De
Vecchi 1981, pp. 36–39; Oberhuber 1982, pp. 56, 70; Cuzin 1983, p. 109;
Gere and Turner 1983, nos. 85f.; Joannides 1983, nos. 197, 200; Jones and
Penny 1983, pp. 58–60; Oberhuber and Ferino Pagden 1983, nos. 278, 280;
Vienna 1983, pp. 80, 84; Paris 1983–84a, p. 240; Rome 1984–85, p. 188;
Ames-Lewis 1986, p. 76; Winner 1986, pp. 30ff.; Ettlinger 1987, p. 91; Gere
1987, no. 13; Birke and Kertész 1992–97, I, p. 131; Shearman 1993, p. 24;
Winner 1993, p. 252; Bell 1997, pp. 103–05; Peronnet 1997, pp. 51f.

18

RAPHAEL

The heads of Homer, Dante and another poet

ca. 1509–10

Pen and iron-gall ink

Verso: Dante's robe

Media as recto

270 × 186 mm

No watermark

RL 12760

Provenance: George III (Inv. A, p. 51, no. 30)

The two heads at the left of this sheet correspond closely to those of Dante and Homer, among the group of epic poets to the upper left of Raphael's fresco of *Parnassus* (fig. 31) in the Stanza della Segnatura (see cat. 15). The former was a standard type for portraits of Dante; the latter was based on the head of the recently discovered *Laocoön*, placed in the Belvedere of the Vatican in 1506, the expression of agony in the sculpture transformed into that of the blind Homer reciting his verses to the scribe seated to his right.

The identity of the head at upper right is less certain. He is now usually described as a study for the poet, perhaps

Anacreon, standing above Sappho in the group of lyric poets in the left foreground, but the nineteenth century had no doubt that it was the head of Virgil, immediately to the right of Homer. In favour of his identification as Virgil is the adjacency of the three figures in the fresco; and a study in the Fondazione Horne, Florence,[1] which clearly *is* for the putative Anacreon, bears a much more gentle expression than the rather stern countenance of the drawing, as would befit the styles of lyric and epic respectively by which Anacreon and Virgil are grouped in the *Parnassus*. However, Virgil is usually represented as clean-shaven, as he was in the fresco, where Anacreon is bearded.[2] In 1722, Jonathan Richardson wrote:

"A Friend of mine has seen (in the Hands of *Cav. Pozzo* at *Rome*, about 25 Years ago) an Original Letter of *Raffaele* to *Ariosto*, the Business of which was to desire his Help in the Picture of Theology, as to the Characters of the Persons that were to be introduc'd, their Countreys, or whatever Other Particularities related to them in order to represent Them severally as Perfectly as possible, and as they Ought to be represented."[3]

This letter has not been traced and may well have been a forgery; but regardless of its authenticity Raphael was surely

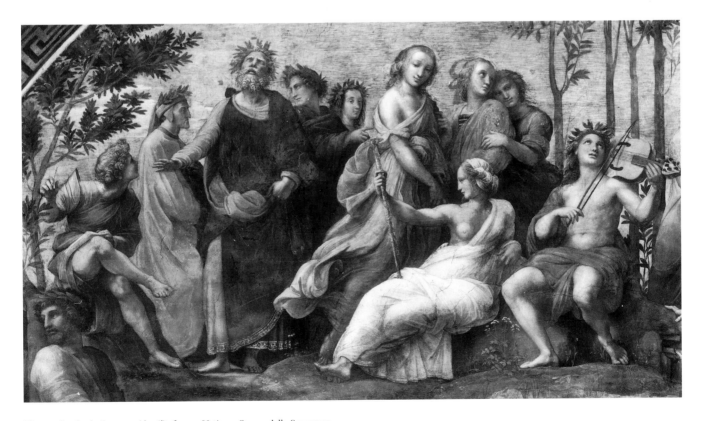

Fig. 31 Raphael, *Parnassus* (detail), fresco. Vatican, Stanza della Segnatura

given advice in his representations of the poets in the *Parnassus*, and it is thus improbable that he would have depicted Virgil bearded in conflict with the antique sources. In sum, the head studied here is more likely to be that of the poet standing above Sappho.

The verso of the sheet bears a study of the drapery of Dante, his hands holding a book, a feature that is barely visible in the fresco. This is one of several extant pen studies for the draperies of the *Parnassus* figures, including those for Homer on two sheets at Lille and for Virgil in the Ashmolean.[4] Ames-Lewis (1986) noted the preponderance of pen drawings in the surviving studies for the *Parnassus*, suggesting that contour was more important than shading in the figures as the scene was to be lit frontally, as if from the window in the facing south wall of the Stanza. If this had been Raphael's intention from the outset he had modified it by the time he came to paint the fresco, where the figures are lit from the left.

An early copy of this sheet in the Albertina combines the head of Dante on the recto with his drapery on the verso.[5]

NOTES
1. Inv. 5878; J. 242.
2. Virgil is, however, not always clean-shaven – he is bearded in Botticelli's *Dante* illustrations and in a medal by Valerio Belli. Unhelpfully, in an engraving by Marcantonio Raimondi (Bartsch XIV, p. 200, no. 247) that probably records an early design for the whole wall, neither Virgil nor 'Anacreon' is bearded.
3. Richardson 1722, p. 199.
4. Brejon de Lavergnée 1997, nos. 537v, 538 and Parker 1956, no. 541; F. 243–44, 249; J. 236–38.
5. Birke and Kertész 1992–97, I, no. 241.

LITERATURE
Passavant 1836, II, pp. 120f.; Passavant 1839–58, II, p. 100, no. 297, III, no. 832; Waagen 1854, II, p. 444; Passavant 1860, II, p. 78, no. 431; Woodward 1863, p. 164; Ruland 1876, p. 186; Crowe and Cavalcaselle 1882–85, II, pp. 84f.; Morelli 1891–92, p. 546; Fischel 1898, nos. 114f.; Gronau 1902, p. 36; Fischel 1913–41, V, nos. 246f.; Fischel 1948, p. 88; Popham and Wilde 1949, no. 795; London 1950–51, no. 256; Forlani Tempesti 1968, pp. 384, 425 n. 125; Cocke 1969, no. 76; Pope-Hennessy 1970, p. 144; Dussler 1971, p. 75; London 1972–73, no. 55; De Vecchi 1981, p. 47; Cuzin 1983, pp. 127–29; Gere and Turner 1983, no. 106; Joannides 1983, no. 241; Oberhuber and Ferino Pagden 1983, nos. 369, 371; Paris 1983–84a, p. 254; Vienna 1983, p. 160; Cordellier 1985, p. 98; Roberts 1987, no. 18; Birke and Kertész 1992–97, I, p. 143

19
RAPHAEL
The Doctrine of the Two Swords

ca. 1511

Red chalk

Verso: The Judgment of Zaleucus

Black-chalk underdrawing; pen and iron-gall ink
264 × 362 mm (max.), shaped and made up down the right (from recto) side
Watermark: crossbow in circle (identical to cat. 22)
RL 3720
Provenance: Possibly Bonfiglioli (see text; and thus Sagredo, Consul Smith); George III (Inv. A, p. 20, *Bolognesi Moderni Tom. IV*, no. 1, unattributed)

Both recto and verso of this sheet are studies for compositions in the window embrasures of the southern (Jurisprudence) wall of the Stanza della Segnatura (see cat. 15), usually hidden by the opened window-shutters (figs. 32 and 33). The poor condition of the paintings and their unusual technique, gold and black streaks on a grey ground, make their authorship difficult to judge – large parts of *Zaleucus* are legible only through the indented lines by which the design was transferred to the wet plaster. There can, however, be no doubt that Raphael was responsible for the designs.

The story of Zaleucus is recounted by Valerius Maximus (*Dictorum Factorumque Memorabilium Exempla*, VI, 5). In the

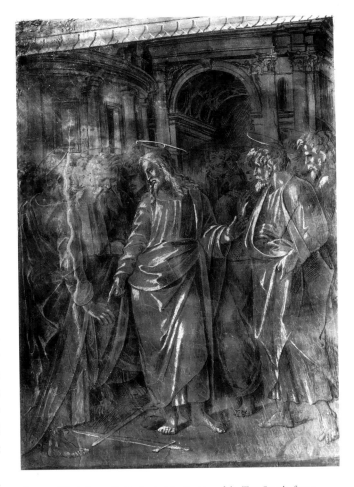

Fig. 32 (Workshop of?) Raphael, *The Doctrine of the Two Swords*, fresco. Vatican, Stanza della Segnatura

19r

sixth century BC Zaleucus devised a code of laws for the Greek colony of Locris Epizephyrii in southern Italy. His son was subsequently convicted of adultery, the penalty for which was blinding. The citizens pleaded with Zaleucus to remit the punishment, but he would agree only to a compromise in which one of his son's eyes was put out and one of his own. The *Doctrine of the Two Swords* is taken from a cryptic line in Luke (22:38), interpreted as supporting the Church's (*i.e.* Julius's) claim to both spiritual and temporal authority – this is the theme of the whole wall, the *Two Swords* being on the embrasure by *Pope Gregory IX delivering the Decretals* and *Zaleucus* by *Justinian proclaiming the Pandects*.

In the study for *Zaleucus* the son and his guards have been carefully cut away, presumably by Raphael himself, with the intention of patching on an alternative (cf. cat. 26, and the British Museum *Venus*[1]). A drawing of a nude model in the pose of Zaleucus in the British Museum[2] is clearly copied from a lost life drawing by Raphael, demonstrating the care taken by

the artist over even the least prominent parts of the Segnatura's decoration. In keeping with the subject-matter, the handling of the pen in the *Zaleucus* shows Raphael working in what might be termed his heroic style (as opposed to the lyric style of the pen studies for the *Parnassus*). It is instructive to compare the *Zaleucus* with the *Hercules*, cat. 15: many of the bold mannerisms are the same, but here, three or four years later, Raphael could control their effects to modulate the pictorial flow of the narrative, rather than producing a drawing that is vigorous but almost uniform in emphasis.

The study for the *Two Swords* is wider in its proportions than the composition as painted, and Raphael had to move the figures closer together and eliminate a couple of background heads in the final design to accommodate the group in the narrower field of the fresco. It is a notably weaker drawing than the *Zaleucus*, and Popham registered his misgivings before accepting it as by Raphael. An explanation for its disagreeable effect might be that it is essentially an underdrawing, intended

to be worked up to the same degree as the contemporary study in the Ashmolean for *Alexander depositing the works of Homer in the coffer of Darius*[3] but instead finished with summary rapid hatching. The Ashmolean drawing, for a grisaille on the facing wall of the Segnatura, is on the same scale and employs the same vocabulary of slightly awkward gestures and physiognomies; it has often been doubted as a work of Raphael, but the present author feels sure that it is autograph, and is an early example of Raphael's dry red-chalk style.

The decoration of the embrasures has been dated as late as 1514, three years after the completion of the main scheme of the Segnatura, when Raphael was supposedly required by Leo X to modify the decorations of the Stanza following the removal of Julius II's library. But this modification took the form of replacing the shelving with intarsia panels by Fra Giovanni da Verona, and there is no reason why anything above shelf height should have been altered. An inscription with the date 1511 is to be found on the upper embrasure of the same window, and nothing about the style of these drawings contradicts the reasonable proposition that the embrasure scenes were contemporary with the main frescos of the Jurisprudence wall, finished in mid-1511.

The sheet was discovered by Popham at the front of an album of seventeenth-century Bolognese drawings. Jonathan Richardson saw framed in the Palazzo Bonfiglioli in Bologna, "*Raffaele*. Several Figures in Red Ch. manner of my Father's *Zoroaster*", which may conceivably have been the present drawing.[4]

Fig. 33 (Workshop of?) Raphael, *The Judgment of Zaleucus*, fresco. Vatican, Stanza della Segnatura

NOTES
1. Pouncey and Gere 1962, no. 27; J. 286.
2. *Ibid.*, no. 46.
3. Parker 1956, no. 570; F.-O. 417; J. 259.
4. Richardson 1722, p. 30.

LITERATURE
Popham and Wilde 1949, no. 797; London 1950–51, no. 246; Hirst 1961, pp. 175f.; Pouncey and Gere 1962, p. 38; Forlani Tempesti 1968, pp. 385, 426 n. 129; Cocke 1969, nos. 80f.; Dussler 1971, p. 77; Oberhuber 1972, nos. 418f.; London 1972–73, no. 65; Gere and Turner 1983, no. 113; Joannides 1983, no. 257; Oberhuber and Ferino Pagden 1983, p. 117, nos. 495f.

19v

20

RAPHAEL

The Massacre of the Innocents

ca. 1510

Charcoal pounce-marks; stylus and black-chalk underdrawing; red chalk

Verso: A design for a salver, with marine deities

Pen and iron-gall ink (the circles drawn with compasses)
246 × 413 mm
Watermark: mermaid in circle
RL 12737
Provenance: Bonfiglioli; Sagredo; Consul Smith; George III (Inv. A, p. 51, no. 29)

The recto of cat. 20 is a study for an engraving known in two principal versions, distinguished most readily by the presence or absence of a fir tree in the right distance.[1] Pentimenti in the torso of the central standing child probably establish that that with the fir tree (fig. 34) is the earlier. It seems that both plates were engraved by Marcantonio Raimondi, the first under contract from Raphael and his agent, Il Baviera, the second possibly (and surreptitiously) on Marcantonio's own initiative, to gain from the popularity of a print that he had engraved but which was then out of his control.[2]

The composition seems to have sprung from a rejected idea for *The Judgment of Solomon* in the vault of the Stanza della Segnatura. A study in Vienna for that fresco has the mother as painted together with the swordsman in the pose of the principal soldier on the left here, but not so balletically poised; a companion sheet also in Vienna repeats that swordsman, but with the mother rushing her child away from him as in the *Massacre*.[3] It is therefore probable that the composition of the *Massacre* is contemporary with the ceiling of the Segnatura.[4]

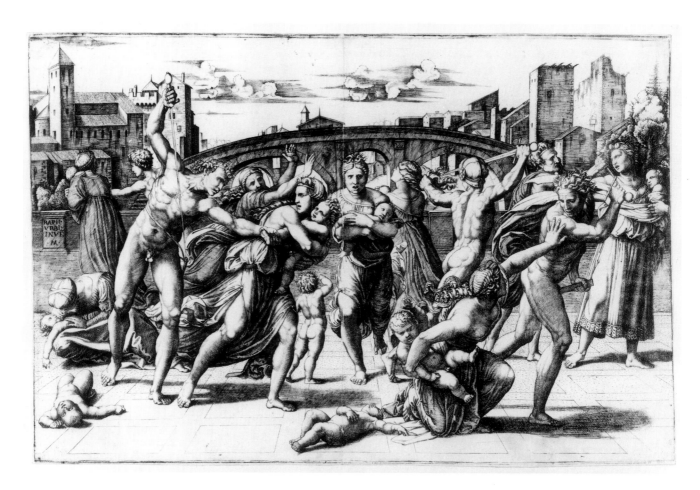

Fig. 34 Marcantonio Raimondi after Raphael, *The Massacre of the Innocents*, engraving, 283 × 434 mm (Bartsch XIV, p. 19, no. 18). London, British Museum

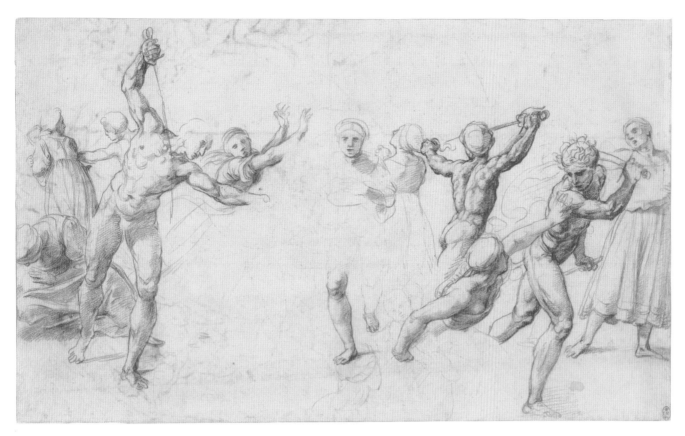

20r

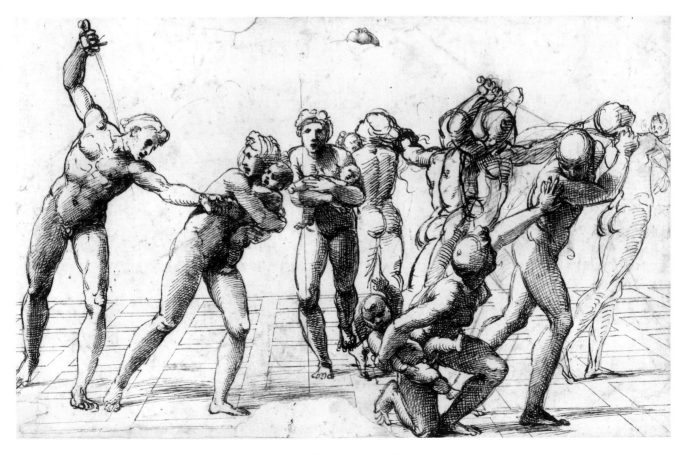

Fig. 35 Raphael, *The Massacre of the Innocents*, pen and ink, some red chalk, the outlines pricked, 232 × 377 mm. London, British Museum, inv. 1860-4-14-446

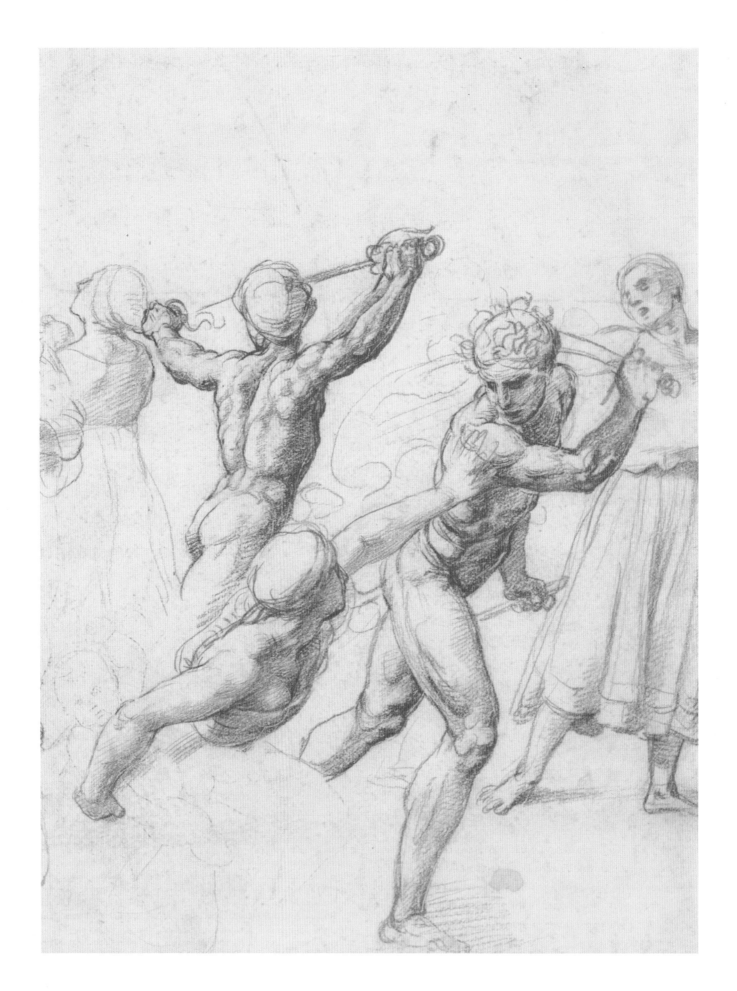

It is also probable that the *Massacre* was intended from the outset for engraving, for it is too even in its figuration and narrative emphasis to function well as a painting. In that medium Raphael always focussed attention on one dominant motif that conveyed the significance of the scene; here the multiple, equally weighted centres of attention are more suited to an object to be held in the hands and perused at leisure. The *Massacre* has a good claim to be the first print produced as a collaboration between Raphael and Marcantonio, but rather than being moved by such ideals as a wish to propagate Raphael's compositions or, more generally, a High Renaissance aesthetic, the two participants may simply have had a financial motivation.

The present drawing corresponds closely, so far as it goes, to the composition as engraved. An earlier pen study in the British Museum (fig. 35)[5] likewise corresponds in scale and motif, but there the figures are nude, and the group of the soldier pulling back the mother by the hair is placed further to the right, over a red-chalk underdrawing and turned through ninety degrees. This alternative would have thrown the composition out of the right-hand side of the sheet and was rejected by Raphael, and the outlines of the figures drawn in pen only were pricked and transferred by pouncing to the present sheet.[6] Several figures are left here as a pattern of dots, connected by direct drawing with a stylus that has dragged out the charcoal powder along the contours. Some details were then clarified with faint black chalk, and the background figures not studied in the British Museum sheet were underdrawn in stylus and a little black chalk only (and, of course, no pounce-marks). The subsequent red-chalk work is not mere repetition of the British Museum sheet – the figures are adjusted throughout to tip them into unstable equilibrium and enhance the sense of stylized and bloodless violence.

The final stage of Raphael's work known to us is probably a highly finished pen drawing in Budapest in which all the figures are as found in the engraving, except the two dead infants lying in the foreground.[7] The draftsmanship of that sheet seems lively and varied, but it may be a good partial copy after the *modello* for the engraver. Certainly it is not itself the final model – of the background, only the parapet is drawn in, and it is inconceivable that Raphael would leave Marcantonio to devise the setting with the Ponte Quattro Capi, so important for the rhythm of the whole composition.

Jonathan Richardson saw what was no doubt the present drawing in 1719 in the Palazzo Bonfiglioli, Bologna: "*Raffaele. Slaughter of the Innocents, first lightly sketch'd out in Bl. Ch. and then finish'd.*" It was listed in the 1696 Bonfiglioli inventory as "*Un dissegno rappresentante la stragge degl'Innocenti di mano di Raffaele con cornice dorata e suo vetro.*" Reveley's implication that this drawing was still in the Palazzo Bonfiglioli in 1820 seems to be nothing more than a century-old quotation taken from Richardson.

★ ★ ★

The verso of the sheet bears a sketch of battling marine creatures that must have been conceived as a study for metalwork. The motif of a sea-centaur pulling back by the hair another who is abducting a nymph is derived directly from the rejected alternative for the soldier pulling back the mother in the British Museum *Massacre* (fig. 35). A more finished design for a sea-creature salver is at Oxford (fig. 36), in the same taste and with the nymph embracing a sea-centaur here repeated in reverse.[8] That sheet has generally been attributed to Gianfrancesco Penni, but the details are worthy of Raphael in their liveliness and intelligent density; the drawing may well be a development by the master of another sheet of the same date as cat. 20v.

At Dresden is a design of sea-creatures for an entire salver, with the same character as the Windsor and Oxford studies but apparently a copy, perhaps after a drawing *en suite* with fig. 35.[9] A more elaborate pair of marine salver designs, at Lille and again in the Ashmolean, have some successful passages but the characterization has the vapidity associable with Penni, and they are possibly by that draftsman following Raphael's sketches.[10]

On 10 November 1510 Cesare Rossetti acknowledged an advance for two bronze salvers for Agostino Chigi, each four *palmi* (about 920 mm) in diameter, to be decorated with flowers in relief after designs by Raphael.[11] Although the decorative motif does not agree with that studied here, this document does demonstrate that Raphael was providing designs for metalwork by 1510, the proposed date for the *Massacre* on the recto of the sheet, and the verso may well have been towards a Chigi commission. Marine subjects were a common choice for tableware (see cat. 43) and Chigi may have had a particular interest in the theme – the *Galatea* painted by Raphael a couple of years later in the river loggia of Chigi's villa (now the Farnesina) is shown in a marine context, rather than in the embrace with Acis that the juxtaposition with Sebastiano's *Polyphemus* would warrant.

NOTES
1. Respectively Bartsch XIV, p. 19, no. 18, and p. 21, no. 20.
2. See Landau and Parshall 1994 for an engrossing account of this problem.
3. Birke and Kertész 1992–97, I, nos. 188r–89r; F. 232, 236; J. 252v–53v.
4. Ferino Pagden (1987) published a drawing now in the Cleveland Museum of Art (inv. 88.28), misattributed to Berto di Giovanni, that she interpreted as a copy of an earlier design by Raphael for the composition showing echoes of Ghirlandaio and Leonardo and of the Borghese *Entombment*, and as establishing that Raphael had started work on the composition while still in Florence. The Cleveland drawing does incorporate elements that occur almost precisely in the engraving but it is deeply incoherent, suggesting rather that it is a later

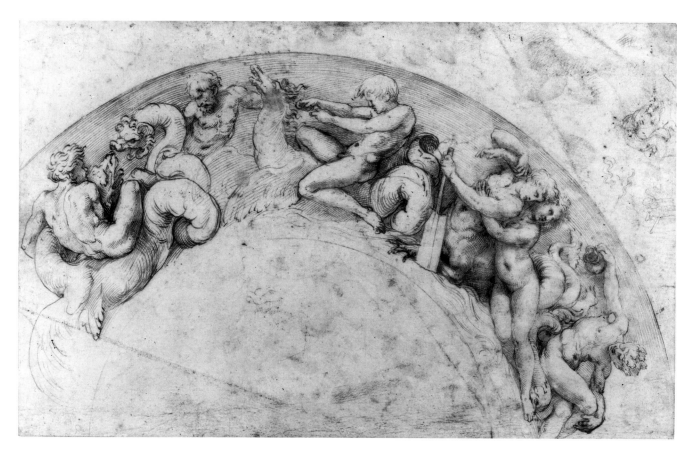

Fig. 36 Attributed to Raphael, *A design for the border of a salver*, pen and ink, 232 × 369 mm. Oxford, Ashmolean Museum, Parker 572

pastiche of Raphael's design. Supposed prefigurations of the *Massacre* in Raphael's Florentine drawings are merely generic.

5. Pouncey and Gere 1962, no. 21; F. 233; J. 287.

6. It should be noted, however, that Lisa Pon, who is preparing a study of this problem, does not believe that the Windsor drawing was pounced from the British Museum sheet (or from its 'substitute cartoon').

7. Inv. 2195; J. 289; a good reproduction in Oberhuber 1972, p. 23.

8. Parker 1956, no. 572; J. 290. That sheet also bears a mermaid watermark (appropriately), but the sheet is laid down and it is impossible to check whether the watermark is the same as that of cat. 20. Red-chalk scribbles on the Oxford sheet that include a cartouche with the date 152(2?) are later additions by a different hand.

9. Ruland 1876, p. 308.

10. Respectively Brejon de Lavergnée 1997, no. 474, and Parker 1956, no. 245 (Macandrew 1980, p. 262).

11. Golzio 1936, pp. 22f.

LITERATURE

Richardson 1722, p. 30; Reveley 1820, p. 6; Passavant 1839–58, III, no. 822; Waagen 1854, II, p. 446; Passavant 1860, II, no. 421; Woodward 1863, p. 164; Ruland 1876, p. 35; Crowe and Cavalcaselle 1882–85, II, p. 119; Morelli 1891–92, p. 546; Fischel 1898, no. 379; Fischel 1913–41, V, nos. 234f.; Venturi 1921, pp. 49f.; London 1930, no. 471; Popham 1931, no. 134; Middeldorf 1945, no. 51; Fischel 1948, pp. 77, 177, 360; Popham and Wilde 1949, no. 793; London 1950–51, no. 252; Pouncey and Gere 1962, pp. xvi, 18f.; Vienna 1966, under nos. 133f.; Forlani Tempesti 1968, pp. 364, 424 n. 108; Cocke 1969, nos. 68f.; Pope-Hennessy 1970, p. 156; Blunt 1971, p. 110; London 1972–73, no. 62; Shoemaker and Broun 1981, pp. 96f.; Brown 1983, p. 167; Cuzin 1983, pp. 131–33; Dresden 1983, under no. 118; Gere and Turner 1983, no. 123; Joannides 1983, no. 288; Jones and Penny 1983, p. 92; Oberhuber and Ferino Pagden 1983, pp. 106f., nos. 341f.; Vienna 1983, p. 67; Emison 1984; Florence 1984b, no. 17; Rome 1984–85, pp. 334, 346; Cordellier 1985, p. 103 n. 21; Massari 1985, p. 172; Ames-Lewis 1986, pp. 6–8; Roberts 1986, no. 19; Thoenes 1986, p. 67; Dillon 1987, p. 554; Gere 1987, no. 19; Bambach Cappel 1988, II, no. 258; Zentai 1991, pp. 32–34; Birke and Kertész 1992–97, I, p. 107; Cordellier and Py 1992, p. 160; London 1993, no. 74; Landau and Parshall 1994, pp. 123ff.

21
RAPHAEL
Two nude figures crouching

ca. 1512

Black chalk
Verso blank
266 × 224 mm (max.), a strip cut from most of the right side
Watermark: crossbow in circle
RL 12736
Provenance: George III (Inv. A, p. 51, no. 32)

22
RAPHAEL
A nude figure staggering

ca. 1512

Black chalk on pale buff paper

Verso: Sketches of cattle

Pen and iron-gall ink
320 × 254 mm
Watermark: crossbow in circle (identical to cat. 19)
RL 12735
Provenance: George III (Inv. A, p. 51, no. 33)

Fig. 37 Raphael, *Studies for a Resurrection*, pen and ink, some stylus, 345 × 265 mm. Oxford, Ashmolean Museum, Parker 559v

Several composition and figure studies by Raphael can be connected with an unexecuted *Resurrection* for which no document or other early reference is known. The earliest sheet of the series (fig. 37), at Oxford,[1] must have come at the very start of the design process. It is one of Raphael's most dynamically inventive drawings, and concentrates on a group of soldiers at the lower right of the composition. The initial sketch is hidden within the densest tangle of figures and comprises a soldier bracing himself against a flagstaff bent with the force of Christ's emergence; another staggering away from the tomb, head down; a third thrown backwards on the ground; and maybe one more now lost in the tangle of lines. The first two of these were studied again, rather larger, immediately to the left of the first sketch, where they were joined by another soldier literally shielding his face; the third was studied in nine further variants on the sheet (one in stylus alone). There are also sketches for, at lower left, a group of angels to flank the emerging Christ and, at centre, a kneeling figure who found no further development.

The next extant drawing, at Bayonne,[2] is the only study of an entire composition, with an angel seated on the edge of an open sarcophagus gesturing upwards at Christ. The lower right portion of the composition retains the staggering figure and the soldier falling backwards, and adds two soldiers at lower left raising their shields and a third seated cowering on the

plinth of the sarcophagus. In the final surviving compositional sketch (fig. 38), also at Oxford,[3] the lower right of the composition is little changed from the Bayonne study, but the lower left is completely different. A soldier seated on a rock and seen from behind flings his right arm upwards in alarm; beyond him are two figures repeated from the earlier studies, one crouching and shielding his face, another at top left, in beautiful *contrapposto*, apparently holding on to a standard.

Four of these were to be studied from the life in a series of beautiful black-chalk drawings that show Raphael at his most Michelangelesque. Cat. 22, for the staggering figure, had changed little since the start of the design process;[4] cat. 21 was developed from the single kneeling figure at the centre of the left edge of fig. 38; and again at Oxford are studies for the sprawling soldier at lower right and (on the verso of the first compositional sketch) for the seated figure seen from behind.[5]

In 1990 Franklin published a small painting, untraced since 1904, as a fragment of a *Resurrection* by Raffaellino del Colle, which includes three of these four figures (excluding the staggering guard) arranged roughly as in the second Oxford sketch; the two foreground guards also recur in Raffaellino's *Resurrection* altarpiece in the Duomo of Sansepolcro. Raffaellino was born *ca.* 1494–97 and probably

Fig. 38 Raphael, *A study for a Resurrection*, pen and ink, 208 × 262 mm. Oxford, Ashmolean Museum, Parker 558

arrived in Rome shortly after Raphael's death, becoming a pupil of Giulio Romano, one of Raphael's heirs. He thus would have had access to many of Raphael's drawings, and the fact that the soldiers in his paintings are in the same relationship to each other as in the Oxford sketch indicates that Raffaellino knew them as an ensemble, not as individual study sheets alone.

It would be reasonable to suppose that the Raffaellino fragment recorded to some degree the lower part of Raphael's design but for the existence of three further studies of guards, none of whom is prefigured in the surviving compositional sketches. One in the British Museum shows a twisting seated figure holding his arms around his head, though he might be discernible in the densest part of fig. 37;[6] another at Chatsworth is of three figures sprawling to the left, whose spatial relationships are ambiguous.[7] The London figure (in the same sense) and two of the figures from the Chatsworth sheet

(reversed) are found combined in an engraving of vintagers by the Master HFE.[8] Finally, at Besançon and Frankfurt[9] are two versions of a seventh study, a variant on cat. 22, the figure turned a little to the left, stooping less, and raising his right hand further to clutch his head. Both were routinely dismissed as copies before Gere and Turner (1983) raised the possibility that one or both might be originals; the autograph or other nature of these drawings is unimportant here, for even if both are copies they still demonstrate that Raphael did study a figure in this pose.

The existence of these three other studies is very problematic. It is impossible to see how Raphael could have fitted all ten figures (and there may well have been still more figure studies, now lost) into a single composition without it becoming hopelessly overcrowded – the second Oxford sketch (fig. 38) and the Raffaellino fragment have a fully satisfactory complement of figures. Further, the head and shoulders of the

21

figure at the left of the Chatsworth drawing repeat those of the Oxford seated soldier seen from behind, and the Besançon/Frankfurt figure is essentially the same as cat. 22, seen from a different angle. Raphael would never have allowed such repetition in a single composition.

We are therefore left with two scenarios. Either Raphael resolved the composition to a degree that warranted careful individual figure studies, and then scrapped and completely redesigned at least the lower part of the composition; or he designed two separate compositions of the *Resurrection*, the lower part of one comprising the Windsor and Oxford figures, as recorded in part by the Raffaellino fragment, that of the other including the London, Chatsworth and Besançon figures. (Beyond the Bayonne sketch we have no indication of the upper portion of the *Resurrection*.) The first option would be wholly out of character, for among all of Raphael's executed projects there is no example of a figure studied from the life with such care that was subsequently left out of the final composition – he simply could not afford to waste time in this way. The second has, to my knowledge, not previously been proposed, and it is thus necessary to examine the circumstantial evidence surrounding this putative project.

In a carefully argued article of 1961, Hirst contended that the intended destination of Raphael's *Resurrection* was the chapel of Agostino Chigi in Santa Maria della Pace, Rome. The external (nave) wall of that chapel was frescoed with *Sibyls* by Raphael and *Prophets* probably by Timoteo Viti to Raphael's design. Vasari stressed that the painting was executed after Raphael had seen Michelangelo's Sistine Chapel ceiling through the agency of Bramante but before it was fully unveiled (on 31 October 1512);[10] sketches for the Pace prophets on a study in the Ashmolean for the *Expulsion of Heliodorus*[11] would confirm a date of late 1511 or early 1512 for the planning of the Pace decorations.

These Sibyls and Prophets bear tablets and scrolls with inscriptions alluding to the Resurrection which would make programmatic sense only in the presence of an altarpiece of that subject. There is a reference of 1521 to a gilded frame "*per la tavola daltar che andava alla pace*" made to Agostino Chigi's orders and thus surely ordered during Raphael's lifetime (Raphael died on 6 April 1520, Chigi on 10 April). In December 1520, Leonardo Sellaio reported in a letter to Michelangelo that Sebastiano del Piombo would set to work on "*la tavola alla Pace sotto le fighure di Raffaello*", but apparently nothing was done during the 1520s. On 1 August 1530 Sebastiano signed a contract with Agostino's heirs to paint altarpieces in the Chigi chapels of both Santa Maria del Popolo and Santa Maria della Pace. The subject of the Pace altarpiece was to be the Resurrection. All this evidence supports the con-tention that Raphael designed an altarpiece of the *Resurrection* for the Chigi chapel of the Pace around 1512, that he painted nothing, and that the commission was given to Sebastiano after Raphael's death. (Sebastiano in turn failed to discharge his obligations, and the chapel now houses a sculptural assemblage of the seventeenth century.)

Objections to the idea that all Raphael's *Resurrection* drawings were for this site centre around the size of a painting necessary to incorporate all the figures studied from the life without them being demeaningly small. Gould (1992) pointed out that the available space in the Pace was only about 1500 × 1250 mm; suggesting instead a two-figure group of the *Pietà* for the Pace chapel, he proposed that the intended site of Raphael's *Resurrection* was the Chigi chapel in Santa Maria del Popolo, where the space for the altarpiece is much larger.

In a twin article to Hirst's, Shearman (1961) gave a full account of the Popolo chapel, which was to be the burial place of Agostino Chigi. Building work began to Raphael's designs probably in 1512 or 1513 and was completed in 1516. The figural elements of the chapel that stem from the original scheme comprise two marble sculptures of the Prophets *Jonah* and *Elijah* in niches and a bronze relief of *Christ and the Adulterous Woman*, initially in the base of Agostino's pyramidal wall-tomb and now installed as the altar frontal, all by Lorenzetto, and mosaics of *God the Father creating the celestial universe* in the cupola. The mosaics in their entirety, and the sculptures to varying degrees, depend on designs by Raphael.

The extant altarpiece is a *Nativity of the Virgin* by Sebastiano del Piombo. The 1530 contract for this between Sebastiano and Agostino's heirs, mentioned above, refers to an earlier (and now lost) contract of 12 March 1526 for the altarpiece. Although there is no mention in the 1530 document of a change of subject, Shearman proposed that a *modello* by Sebastiano of *The Assumption of the Virgin* (Rijksmuseum, Amsterdam) was his 1526 design for the altarpiece, and that two otherwise contextless drawings by Raphael of the *Assumption* were in turn *his* studies for the originally planned altarpiece of the chapel.[12]

An altarpiece of the *Assumption* would indeed accord better with the design and iconography of the Popolo chapel than does Sebastiano's *Nativity*. On these grounds, however, the subject of the Resurrection would be still more appropriate for the chapel than would the *Assumption*. This was to be the burial chapel of Agostino and his heirs. The Prophets Jonah and Elijah can both be read as antetypes of the Assumption of the Virgin, but their principal type was Christ – Jonah of Christ of the Resurrection and Elijah of Christ of the Ascension – and seen together it is this association that any sixteenth-century viewer would first have made.

Fig. 39 Girolamo Genga, *The Resurrection*, panel, 3360 × 2230 mm. Rome, Santa Caterina da Siena

It therefore appears that, on iconographic grounds, the *Resurrection* would have been the most appropriate subject for the altarpieces of the Chigi chapels in both the Pace and the Popolo (and while it was common for an altarpiece to reflect the dedication of its chapel, in the case of the Popolo to the Blessed Virgin of Loreto and Sts Augustine and Sebastian, this was by no means universal).

Here one must bring in the *Resurrection* by Girolamo Genga in the Roman church of Santa Caterina da Siena (fig. 39). This was also painted for Agostino Chigi, according to a biography written by a descendant, Fabio Chigi, a century after Agostino's death, and was thus commissioned before April 1520. In 1519 the Sienese community in Rome (of which Agostino Chigi was a prominent member) founded a congregation dedicated to their patron saint, Catherine of Siena, based in the church of San Nicolò in the via Giulia. They did not obtain the title to the site of the church until 1526, when the old edifice was torn down and the present church of

Santa Caterina begun. It has been suggested that Genga executed his painting only in the late 1520s,[13] even though he had left Rome in 1522 to enter the service of Francesco Maria della Rovere in Urbino, thereafter turning his attentions primarily to architecture. To propose that Genga's *Resurrection* was intended for its present site would require Chigi to commission, and Genga to paint, a large altarpiece[14] for a church that would not be begun for at least six years, and at Agostino's death it is unlikely that there was any certainty that the congregation would obtain the rights to the plot.

It is therefore suggested here that Genga's *Resurrection* was in fact painted for the Chigi chapel in Santa Maria del Popolo. In August 1519, Chigi's will briefly charged Raphael and the metalworker Antonio da Sanmarino with responsibility for overseeing the completion of the chapel in the Popolo, but the altarpiece was not mentioned. Both Raphael and Genga were from Urbino, and Genga would have benefited from the same *campanilismo* that led Bramante to show Michelangelo's Sistine ceiling to Raphael before its unveiling. They had worked together in their early years (see cat. 8), and it was probably Raphael who introduced Genga to Chigi. His *Resurrection* is large enough for the demanding space in the Chigi chapel and, while nothing suggests that it was designed by Raphael, it does bear strong echoes of what would have been the effect of Raphael's nocturnal composition and clear derivations in a couple of the figures, implying that Genga knew Raphael's studies for the project.

The scenario proposed is as follows. Around 1511–12, Raphael frescoed the façade of the Chigi chapel in Santa Maria della Pace and designed a *Resurrection* for its altarpiece. Before he could begin work on this, Chigi switched Raphael's attentions to his other, mortuary, chapel in the Popolo, requiring designs for the architecture and another altarpiece. Raphael therefore planned a second *Resurrection*, still with the intention of painting the Pace altarpiece at some stage, and therefore not reusing the figures from the first. Owing to other commitments this painting was not begun either, but around 1519 a push was made to begin the figuration of the lower part of the chapel in the Popolo, and Genga was engaged instead to paint a *Resurrection*. In 1526 the building of the church of Santa Caterina commenced, and the Chigi family transferred Genga's painting to that church, commissioning Sebastiano in the same year to execute a replacement for the Popolo. Although this scenario would leave two sketches of the *Assumption* by Raphael still unexplained, there are a number of similarly contextless compositions from this period[15] and it seems preferable to the proposal that all of Raphael's *Resurrection* studies were for a single altarpiece designed twice.

22v (detail)

On the verso of cat. 22 is a rapid sketch of cattle, a natural observation of a freshness that is rarely found in Raphael's oeuvre. Ferino Pagden (in Florence 1984a) suggested that these cows were connected with the background of the engraved *Morbetto* (see cat. 24).

NOTES

1. Parker 1956, no. 559v; F. 389; J. 306v.

2. Inv. 1707; F. 387; J. 304.

3. Parker 1956, no. 558; F. 388; J. 305.

4. David Ekserdjian noted (in conversation) that most of the ineptly drawn axe is almost certainly a later addition, to give some context to what would have been a small portion of a staff as a studio prop in the original drawing.

5. Respectively Parker 1956, nos. 560, 559r; F. 391, 390; J. 309, 306r.

6. Pouncey and Gere 1962, no. 34; F. 395; J. 310.

7. M. Jaffé 1994, no. 317; F. 394; J. 311.

8. Bartsch XV, p. 464, no. 5. This inconsistent directional relationship between drawings and engraving might be explained by the engraver knowing the original in one case and an offset in another. Raphael was experimenting at the time with the reversal of such poses: the figure in cat. 22 appears reversed as one of the guards in *The Liberation of St Peter* in the Stanza d'Eliodoro. This figure is also found in the background of the Sistine Chapel tapestry of the *Conversion of Saul* and, slightly altered, in an engraving by Cherubino Alberti of the *Resurrection* (Bartsch XVII, p. 58, no. 24), based on a design by a follower of Raphael (Polidoro?).

9. Respectively Besançon inv. 2301 and Frankfurt inv. 381v; F. 395a; J. 255v, on the verso of a study by Raphael for *Justinian proclaiming the Pandects* in the Segnatura.

10. Vasari 1568, II, p. 73.

11. Parker 1956, no. 557v; F.-O. 399; J. 333v. Another sketch in the Ashmolean for these *Prophets* (Parker 1956, no. 553v; J. 228v) is on the verso of a figure study for *The School of Athens*, but some time must separate the recto and verso of this sheet.

12. Ashmolean, Parker 1956, no. 554v; F. 380; J. 246v; and Stockholm, Magnusson 1992, no. 34; F. 381; J. 317. Shearman also contended that the lower half of the Monteluce *Coronation* (Vatican, Pinacoteca) is a cannibalized portion of a panel painted by Raphael's shop after his death for the Popolo but not delivered; the objections to this were summarized by Joannides 1993, pp. 27ff.

13. See Petrioli Tofani 1964.

14. I am very grateful to Tristan Weddigen for measuring this altarpiece for me.

15. *E.g.* J. 318–23, 328–31.

LITERATURE

Passavant 1836, II, p. 125; Passavant 1839–58, II, p. 370, nos. 299f., III, nos. 837f.; Waagen 1854, II, p. 446; Passavant 1860, II, pp. 135, 301f., nos. 436f.; Woodward 1863, pp. 164f.; Robinson 1870, pp. 276, 284; Woodward 1870, pp. 41f.; Ruland 1876, pp. 40, 203; Crowe and Cavalcaselle 1885, II, pp. 142 n., 196 n., 543; Fischel 1898, nos. 179, 397, 399, 592f.; Fischel 1913–41, VIII, nos. 392f.; Venturi 1920, p. 178; Fischel 1925, p. 198; Venturi 1926, p. 251 n.; Venturi 1927, nos. 39, 41; Fischel 1948, pp. 97, 362; Popham and Wilde 1949, nos. 798–99; London 1950–51, nos. 257, 259; Parker 1956, pp. 301–03; Bean 1960, under no. 132; Freedberg 1961, pp. 167f.; Hirst 1961, pp. 172ff.; Pouncey and Gere 1962, p. 30; Forlani Tempesti 1968, pp. 401–04, 427 n. 152; Cocke 1969, no. 118; Blunt 1971, p. 110; Dussler 1971, p. 95; London 1972–73, nos. 59, 56; De Vecchi 1981, pp. 66–68; Cuzin 1983, pp. 199f.; Gere and Turner 1983, nos. 168, 170; Joannides 1983, nos. 307f.; Oberhuber and Ferino Pagden 1983, p. 124, nos. 476, 480f.; Florence 1984a, p. 309; Florence 1984b, no. 117; Gould 1984, p. 9; Ames-Lewis 1986, pp. 8, 101–10; De Vecchi 1986b, p. 95; Roberts 1986, no. 20; Gere 1987, p. 125; Roberts 1987, no. 19; Roberts 1988, no. 18; Franklin 1990, pp. 147f.; Cordellier and Py 1992, pp. 209, 302; Landau and Parshall 1994, p. 124; M. Jaffé 1994, p. 189; Joannides 1996, no. 36

23
RAPHAEL

The Virgin and Child with
St Elizabeth (?) and another female saint

ca. 1512

Pale-buff ground-bone preparation; metalpoint; lead-white
bodycolour
Verso blank
210 × 146 mm
No watermark
RL 12742
Provenance: Bonfiglioli; Sagredo; Consul Smith; George III
(Inv. A, p. 49, no. 9)

This is a study for the *Madonna dell'Impannata*, commissioned by
Bindo Altoviti and now in the Palazzo Pitti (fig. 41). The
common name of the panel comes from the paper window-
blind, the *impannata*, seen in the right background. The facial
type of the kneeling woman is that typically used for St Elizabeth
(the Baptist's mother; see cat. 13), though she has also been
described as St Anne (the Virgin's mother), for she supports the
Christ Child rather than the Baptist. The identity of the standing
female saint, who bears no attribute, is not known.

The panel is generally agreed to have been painted by
Raphael's assistants to his design, though the master may well
have been responsible for some of the work in the faces,
particularly of the Christ Child. The status of the present
drawing has been disputed,[1] but the searching interplay of
structural outlines and areas of densely modulated shadow, the
casual brilliance of the details, and the dramatic white – not
crude but bold, and precise in its effects – all speak of
Raphael's hand alone.

The style of Raphael's metalpoint drawings evolved less
rapidly than did that of his pen drawings, there being a
narrower range of effect possible with the stylus. Nonetheless,
his approach to form here is looser and more expansive than in
the metalpoint drawings of around 1510, and the form is less
classically structured than in the few late metalpoint studies for
the Sistine Chapel tapestries (such as cat. 27). The closest
comparison is with a study in Frankfurt for a horseman in the
first project for *The Repulse of Attila*,[2] conceived before the
death of Julius II in February 1513; both drawings display the
same combination of delicate and emphatic effects and a
strongly helical movement within the figures, and thus a date
around 1512 is most probable for the present sheet.

In addition to the four figures sketched in cat. 23, the
painting includes the young Baptist seated in the lower right
corner. However, X-rays of the panel show in earlier layers of
paint in this area the seated figure of Joseph, his head in left

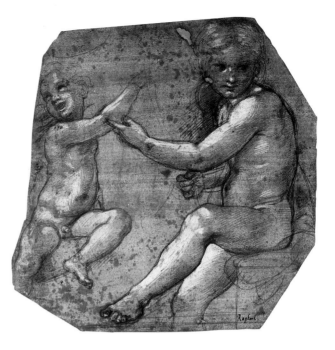

Fig. 40 Raphael, *Studies of Christ and the Infant Baptist*, grey prepared paper,
metalpoint, white heightening, 210 × 208 mm (max.). Berlin-Dahlem,
Kupferstichkabinett, inv. 2231

profile, and in his lap a younger Baptist turning to look up at
him (slight adjustments to the outlines of the central figure
group, also visible in X-rays, are of little significance).[3] A sheet
in Berlin (fig. 40) includes a further study for the Christ Child
posed as here, and a study of the Baptist as finally painted.[4]
These two figures are identical in style and must have been
drawn at the same date. The Berlin drawing thus suggests that,
while refining the figure of Christ, Raphael devised a Baptist
that was subsequently rejected, only to be reinstated later when
the painting of the panel was well advanced. Such major
revisions are very unusual in Raphael's paintings, and here
support the idea that the panel was executed over a prolonged
period. Some scholars have claimed that the panel is as late as
1516, though studio works are harder to date on grounds of
style alone than autograph pieces, for there can be no linear
(and thus interpolable) development of style within a group of
works with varying degrees of involvement by members of a
workshop.

Fischel (1939) proposed that several groups of drawings by
Raphael were the surviving sheets of dismantled sketchbooks.
Among those claimed to be from a putative Roman *taccuino*
were the present drawing, cat. 24, and the Frankfurt study for
the *Repulse of Attila* mentioned above. However, the physical
evidence advanced – damaged right corners, size and prep-
aration colour – rarely stands up to close scrutiny. The
preparation of cat. 23 (described by Fischel as "brownish-
purple") is significantly lighter than that of cat. 24, and even if

23

the preparations were identical, that would be a natural consequence of several sheets being prepared at the same time. Moreover it seems very unlikely that studies of the nature of cat. 23 would be made in a sketchbook. Such an exercise in 'objective' connoisseurship could only be tendentious, for the drawings thus grouped were those that stylistic considerations would associate anyway.

NOTES
1. For instance, Fischel (1898) attributed the drawing to Penni; Sanpaolesi (1937–38) argued that it was worked up by another hand over autograph outlines; the anonymous reviewer of Sanpaolesi in *Critica d'Arte*, III, 1938, pp. xxxiif., suggested that the sheet was a copy or a heavily revised *estensione*; Fischel (1913–41) claimed that the whites were renewed, Ettlinger (1987) that they were added later.

2. Inv. 1797; F.-O. 406; J. 339.
3. See Sanpaolesi 1937–38, and Florence 1984a, pp. 265–67.
4. Inv. 2231; F. 374; J. 326.

LITERATURE
Passavant 1836, II, pp. 124f.; Passavant 1839–58, II, p. 394, no. 292, III, no. 828; Waagen 1854, II, p. 446; Passavant 1860, II, p. 328, no. 426; Ruland 1876, p. 81; Crowe and Cavalcaselle 1882–85, II, p. 171; Fischel 1898, no. 330; Sanpaolesi 1937–38, pp. 496–501; Fischel 1939, p. 182; Fischel 1913–41, VIII, no. 373; Fischel 1948, p. 364; Popham and Wilde 1949, no. 800; London 1950–51, no. 250; Freedberg 1961, pp. 172–74; Forlani Tempesti 1968, pp. 405, 428 n. 154; Marabottini 1968, pp. 210, 276 n.; Cocke 1969, no. 105; Pope-Hennessy 1970, p. 219; Dussler 1971, p. 38; London 1972–73, no. 64; Cuzin 1983, pp. 197–99; Gere and Turner 1983, no. 135; Joannides 1983, no. 325; Oberhuber and Ferino Pagden 1983, no. 425; Florence 1984a, pp. 168–70; Ettlinger 1987, pp. 158f.; Gere 1987, no. 21; Cordellier and Py 1992, p. 198

Fig. 41 Workshop of Raphael,
The Madonna dell'Impannata, panel,
1580 × 1250 mm. Florence, Palazzo Pitti

24

RAPHAEL

A landscape with figures and the ruins of a column

ca. 1512

Buff ground-bone preparation; metalpoint; lead-white bodycolour;
much creased and abraded
Laid down
210 × 141 mm
No watermark visible
RL 0117

This striking drawing depicts a lane in bright sunlight, the drums of an antique column scattered in the foreground and large plain buildings beyond. The highly evocative use of thick white heightening to capture the strength of the sunlight has obscured some of the metalpoint drawing, but at least nine figures can be made out: three silhouetted to the right; a bearded man leaning on a stick to the left; a corpulent man in the middle of the lane; just to his right and mostly hidden by a

rise in the ground, a figure seen in bust length; another man standing, apparently by a barrel; and to his right, a woman walking to the left followed by a child. It has been claimed that the Coliseum is visible in the left background, but examination under magnification shows that what appear to be two orders of arcading are in fact the branches of a tree, standing before a façade, the cornice brackets and attic windows of which can be seen close to the edge of the sheet. Although the lack of any other distinctive buildings probably makes a precise identification impossible, the suggestions of one or other of the Roman fora are plausible.

The drawing was adapted for the right background of an engraving by Marcantonio Raimondi, traditionally known as *Il morbetto* (fig. 42), which bears the inscription *INV*[ENTOR] *RAP*[HAEL] *UR*[BINAS].[1] The print depicts the plague that struck Phrygia while Aeneas and his companions were in Crete, and the apparition of the Penates to Aeneas during the night, as described in the *Aeneid* (III, 140 and 148). In the Uffizi is a study for the whole composition (fig. 43),[2] on the same scale as, and reversed with respect to, the engraving.

Fig. 42 Marcantonio Raimondi after Raphael, '*Il morbetto*', engraving, 194 × 250 mm (Bartsch XIV, p. 314, no. 417). London, British Museum

There is no good reason to question Marcantonio's ascription of the whole design to Raphael, and the Uffizi drawing, although wrecked by damp and tears, seems certainly to be his *modello* for the engraver.

Cat. 24 is consistent in style and technique with Raphael's metalpoint drawings around 1512 and is a unique example of a pure landscape study by the master of figural composition. It was probably not made expressly for the engraving, but as a coherent and self-sufficient study; it lacks the sinister mood of the print or indeed any suggestion in its composition that Raphael had in mind its subsequent integration into a larger context. The changes from this drawing to the Uffizi *modello*, most notably the replacement of the corpulent figure by a dead horse (reminiscent of the cattle sketched on the verso of cat. 22), were Raphael's adaptations to the requirements of a narrative. The disturbing dichotomy of the print's design perhaps reflects the independent origin of one half of the composition, but Landau and Parshall (1994) suggested that this dichotomy was deliberate, dividing the print equally into a day scene and a night scene, and that the consequent demonstration of the engraver's skill was one of the subtexts of the print.

NOTES

1. Bartsch XIV, p. 314, no. 417.
2. Uffizi 525-E; J. 349. Ravelli (1978) attributed cat. 24 to Polidoro, as a "personal critique" of the left half of Raphael's composition with a Venetian dramaticism and lugubriousness. Gere (1985–86) rejected this, while acknowledging that the sheet is without parallel in Raphael's oeuvre, and suggested that some intervention of Polidoro in the composition was worth considering. While this is implausible – Polidoro can have been no older than his mid teens when the engraving was designed – Gere astutely cited Ravelli's no. 77 (Louvre, inv. 82) as a drawing that *does* show Polidoro's later response to the mournfulness of the *Morbetto*.

LITERATURE

Vasari Society, XII, 1931, no. 6; Fischel 1939, p. 182; Middeldorf 1945, no. 76; Popham and Wilde 1949, no. 801; Forlani Tempesti 1968, pp. 405, 428 n. 156; Blunt 1971, p. 110; Shearman 1972, p. 109 n.; London 1972–73, no. 67; Cambridge 1974, under no. 15; Ravelli 1978, p. 96, no. 6; Shoemaker and Broun 1981, p. 118; Cuzin 1983, p. 164; Gere and Turner 1983, no. 139; Joannides 1983, no. 350; Jones and Penny 1983, p. 132; Oberhuber and Ferino Pagden 1983, no. 450; Paris 1983–84a, p. 337; Emison 1984, pp. 262–67; Florence 1984a, p. 309; Forlani Tempesti 1984, p. 382; Rome 1984a, no. 3.1.1; Rome 1984–85, p. 336; Massari 1985, p. 233; Gere 1985–86, p. 67; Gere 1987, no. 22; Cordellier and Py 1992, p. 302; Landau and Parshall 1994, pp. 124f.

Fig. 43 Raphael, '*Il morbetto*', traces of black chalk, pen and ink, wash, 200 × 249 mm. Florence, Uffizi, inv. 525-E

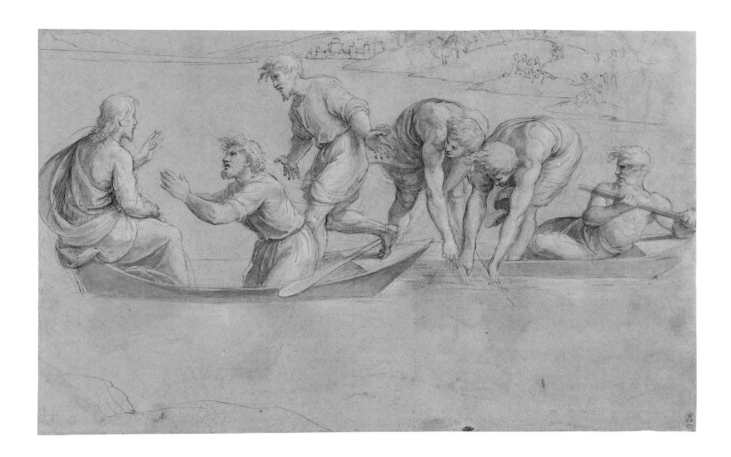

25
ATTRIBUTED TO RAPHAEL
The Miraculous Draft of Fishes

ca. 1514

Paper washed pale buff; black-chalk underdrawing; some red chalk;
pen and iron-gall ink; iron-gall wash; lead-white bodycolour
Verso inscribed lower left, pen and ink, *siculo*
200 × 339 mm
Watermark: anchor in circle with seven-pointed star (identical to
cat. 29)
RL 12749
Provenance: Possibly Charles I and/or Charles II; George III
(Inv. A, p. 49, no. 2)

Cat. 25–28 are preparatory for the series of tapestry cartoons
commonly called *The Acts of the Apostles*, executed by Raphael
and his studio for Pope Leo X and transported to Flanders,
where the tapestries were woven in the workshop of Pieter
van Aelst. Seven of the cartoons survive, now in the Victoria
and Albert Museum on loan from Her Majesty The Queen;
the ten original tapestries, intended to be hung in the Sistine
Chapel on feast days, are housed in the Vatican Museums. The
date of the commission is unknown and only two payments to
Raphael are recorded for work on the project, on 15 June
1515 and 20 December 1516, the second apparently a final

settlement. Seven of the tapestries had reached Rome by 26
December 1519 and the remainder by 1521. A statement of
1517 by a visitor to the weavers' workshop that sixteen
tapestries were intended cannot be verified by other accounts,
nor by Raphael's preparatory drawings, though this number
would have accorded better with the existing decoration of the
Sistine Chapel.[1]

The present drawing is a study for the tapestry illustrating
the calling of the fishermen Peter and Andrew on the Lake of
Galilee (Luke 5:1–10). It corresponds closely, so far as it goes,
to the cartoon (fig. 44), though there the reclining oarsman is
placed significantly closer to the two fishermen hauling in their
net. The drawing lacks the elaboration of the landscape and
figure groups on the far shore, and three cranes in the foreground
and the haul of fish in the boats, still-life elements that were
probably painted in the cartoon by Giovanni da Udine.[2]

Cat. 25 is often attributed to Gianfrancesco Penni, probably
Raphael's principal assistant before the entry into the studio of
Giulio Romano, and is generally of the style, technique and
figure type of a number of finished workshop drawings. The
drawing cited by Popham as a stylistic comparison for the
present sheet, the *Dormition and Coronation of the Virgin* in the
British Museum (fig. 3, p. 15), is one of those, identical in
technique, with an underdrawing of the same general character

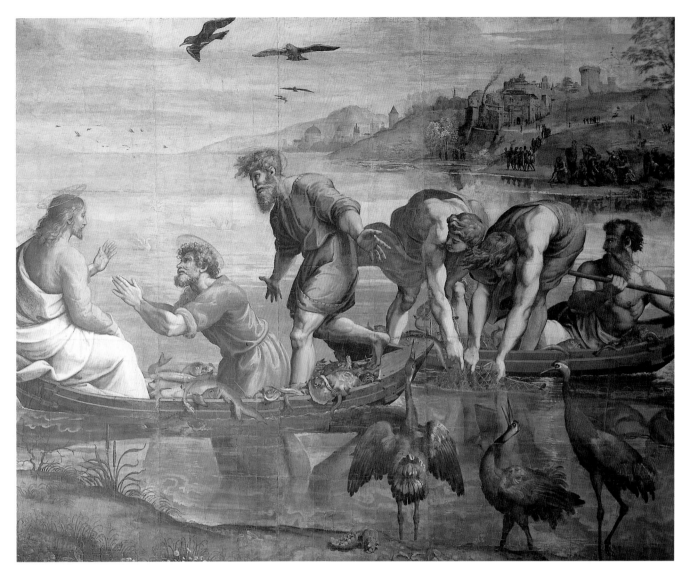

Fig. 44 Raphael and workshop, Cartoon for *The Miraculous Draft of Fishes*, bodycolour on paper, mounted on canvas, 3190 × 3990 mm. Royal Collection, on loan to the Victoria and Albert Museum, London

and the wash applied both broadly and in small discrete strokes.[3] But there is, in that drawing, a fundamental disparity between conception and execution: there are many passages where the sketchiness loses all structure, the heads are facile with a tendency to caricature, and the individual strokes lack the complexity and differentiation found in the *Miraculous Draft*. Here the execution is fully congruous with the invention. Every mark has a purpose, as seen most dramatically under magnification, and the media are combined with an intelligence that gives profound structure to the forms. Subjective arguments can never give universal satisfaction, but for the present author the high quality of cat. 25 justifies an attribution to Raphael himself.

Two pentimenti are visible in the underdrawing, most significantly in the form of Christ's cloak, which falls steeply in

the underdrawing but billows in a loop in the pen and wash, and also in the knot of drapery sketched from the thigh of the standing figure (infra-red examination shows that this detail was still being pondered in the underdrawing for the cartoon itself). If the drawing is judged as not by Raphael, we would have to accept either that Raphael would effect in a painting (and his hand is surely dominant in the cartoon) compositional decisions made by one of his assistants; or that the underdrawing is by Raphael and the working-up by an assistant; or that the studio hand responsible made an underdrawing which was corrected by Raphael before the pen-and-wash work was executed; or that it is a facsimile-type copy, so painstaking as to record pentimenti in the underdrawing. None of these can be supported on the available evidence.

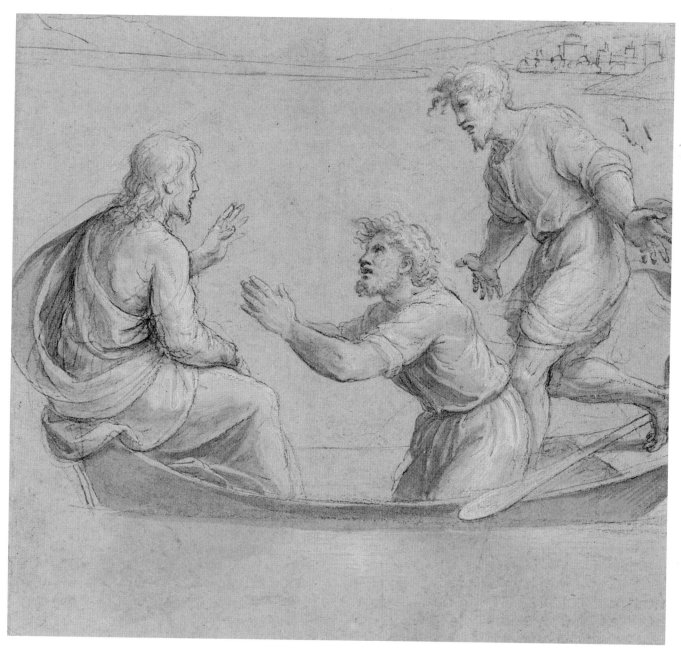

25 (detail)

Excepting a drawing for the cranes by Giovanni da Udine, the only other sheet preparatory for the final composition is in the Albertina, Vienna.[4] On its verso (fig. 46) is a large rapid sketch, now usually accepted as by Raphael, agreeing essentially with cat. 25 but with the boats further apart and the second fisherman punting the boat rather than gazing towards Christ with hands held wide. On the recto of the Vienna sheet is a variant of the composition (fig. 45) with the boats in the background at upper right and a dense group of foreground figures. That drawing is certainly not by Raphael and is most reasonably attributable to Gianfrancesco Penni by virtue of its facileness of detail.

Taken in isolation, the composition of fig. 45 appears incoherent. At least three men stand around the left edge of the sheet, possibly alluding to Christ's sermon by the lake that preceded the Miraculous Draft; the principal element is relegated to the background, and two seated women pay no heed to either group. Given the extensive underdrawing, mostly worked up without any apparent searching for form and in places left merely as outline, it would be reasonable to dismiss the composition as a pastiche. But it is important to consider the intended position of the tapestry, between the altarpiece and the right wall of the Sistine Chapel. The first tapestry on the right wall was to be *Christ's Charge to Peter*, for

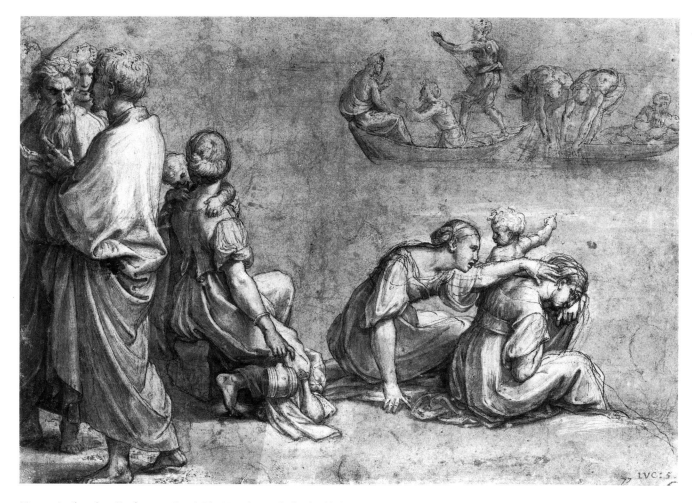

Fig. 45 Attributed to Gianfrancesco Penni, *The Miraculous Draft of Fishes*, black-chalk underdrawing, pen and ink, brown wash, white heightening, 228 × 327 mm. Vienna, Albertina, inv. SR 226r

which we have an early scheme recorded in cat. 26. Allowing for the final direction of each composition, reversed with respect to fig. 45, it can be seen that a group of standing figures would have been continuous across the corner of the chapel if the compositions of both fig. 45 and cat. 26 had been followed in the tapestries.

It is therefore possible that the recto of the Albertina sheet records, to some degree and for an unknown purpose, a first design by Raphael for the *Miraculous Draft* at a stage when he planned to run the pictorial space on from one tapestry to the next. This interplay of illusory and real space is difficult to realize successfully in tapestry, where the tonally subdued nature of the medium, the vagaries of the weaving process, and the contingencies of subsequent hanging limit the artist's control over visual effects. The point at which Raphael changed the overall design of the tapestry cycle from an interlinked sequence to a series of self-contained images may be recorded in the rapid sketch on the verso of the Albertina

sheet, when he took the essential motif and expanded it to the full scale of the tapestry.

Cat. 25 was reproduced in a chiaroscuro woodcut by Ugo da Carpi.[5] Use of an overlay confirms that the size and contours are identical, and thus that cat. 25 (or a mechanically derived sheet) served as the direct model for the print. Ugo had arrived in Rome by 1518, the year that he published a woodcut after another of Raphael's tapestry designs, *The Death of Ananias* – or rather after Agostino Veneziano's engraving of Raphael's design. Most of Ugo's prints were derived from the engravings of others and the chiaroscuro of the *Miraculous Draft* is unusual in being based directly on an original work.[6]

The inscription on the verso, *siculo*, possibly refers to Jacopo Siculo (died 1544), an obscure Sicilian painter sometimes said to have worked in Raphael's studio and who was probably responsible for a compositionally unrelated fresco of the *Miraculous Draft* in the Cappella dell'Assunta of Spoleto Cathedral. Early ascriptions to minor artists are generally more

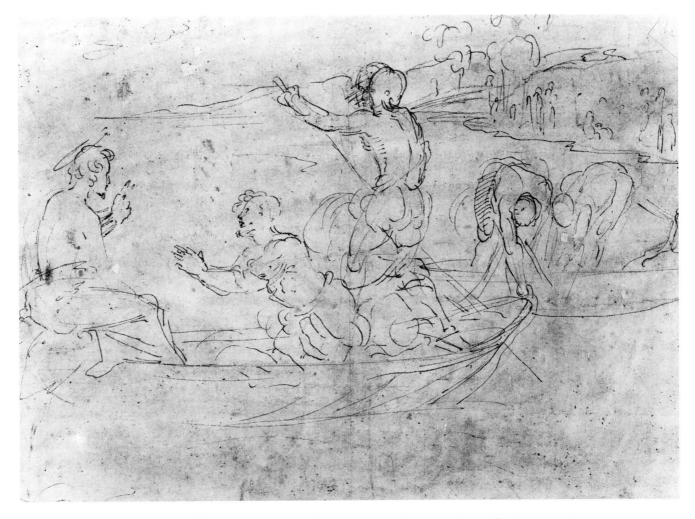

Fig. 46 Raphael, *The Miraculous Draft of Fishes*, black-chalk underdrawing, pen and ink, 228 × 327 mm. Vienna, Albertina, inv. SR 226v

reliable than those to the star names, but the quality and style of the present drawing fit so well with those certainly by Raphael that it is not possible to give this early attribution (if that is what it is) any weight.

Copies of the present drawing are to be found at Windsor, the Ashmolean and the Uffizi.[7] There are also many copies after the woodcut, and thus in reverse.[8]

NOTES

1. For the full history of the tapestries see Shearman's definitive study of 1972. Gilbert's speculations on the intended number of tapestries (1987) should also be taken into account.

2. A study of two of the cranes is found on a sheet of sketches by Giovanni da Udine, location unknown, repr. Shearman 1972, fig. 40.

3. Pouncey and Gere 1962, no. 68.

4. Birke and Kertész 1992–97, I, no. 192; F.-O. 438–39; J. 356.

5. Bartsch XII, p. 37, no. 13.

6. Landau and Parshall 1994, p. 154, speculate on a direct collaboration between Raphael and Ugo with respect to two other *chiaroscuri*.

7. Respectively Popham and Wilde 1949, no. 850; Parker 1956, no. 665a; and inv. 1223-E.

8. *E.g.* in Berlin (inv. 493) and the Louvre (Cordellier and Py 1992, no. 377), both attributed to the so-called Calligraphic Forger.

LITERATURE

Dalton 1787, p. 854; Reveley 1820, p. 5; Passavant 1839–58, II, under no. 289, III, no. 824; Passavant 1860, II, p. 194, no. 423; Robinson 1870, p. 257; Woodward 1870, pp. 39f.; Ruland 1876, p. 243; Lübke 1878–79, II, p. 317; Crowe and Cavalcaselle 1882–85, II, p. 275 n.; Springer 1883, II, p. 68; Morelli 1891–92, p. 547; Müntz 1897, p. 11; Fischel 1898, no. 238; Popham and Wilde 1949, no. 808; London 1950–51, no. 247; Parker 1956, p. 353; Hartt 1958, p. 20 n.; Shearman 1959, p. 457; Oberhuber 1962, p. 32; Pouncey and Gere 1962, p. 56; Shearman 1965, p. 35; Blunt 1971, p. 111; Dussler 1971, p. 101; Oberhuber 1972, no. 440; Shearman 1972, *passim*; Cuzin 1983, p. 170; Gere and Turner 1983, no. 187; Joannides 1983, no. 357; Oberhuber and Ferino Pagden 1983, pp. 135, 137; Paris 1983–84a, p. 388; Massari 1985, pp. 13, 129; Gere 1987, no. 49; Thomas 1989, p. 1; Birke and Kertész 1992–97, I, p. 110; Cordellier and Py 1992, pp. 263, 267; Joannides 1993, pp. 12f.

26

OFFSET AFTER RAPHAEL

Christ's Charge to Peter

ca. 1514

Offset from a drawing in red chalk over stylus
Inscribed lower right, pen and ink, *R[...]*
Verso: staining through from the recto, and some indeterminate
black-chalk lines
258 × 375 mm
Watermark: crossbow in circle
RL 12751
Provenance: Bonfiglioli; Sagredo; Consul Smith; George III (Inv. A,
p. 48, *Michael Angelo, Fra: Bartolomeo, And: del Sarto &c., Tom. III,*
no. 49: "Study of Christs charge to Sᵗ: Peter, the Heads are noble
Ideas, but the Christ and Sᵗ: Peter are very disagreeable, being half
Studys only of the naked Body. The thought stolen from Raphael's
design in the Cartoon")

This is an offset from a preparatory drawing for the tapestry
cartoon (fig. 49) of *Christ's Charge to Peter* (see cat. 25), made
by laying a blank, slightly dampened sheet of paper over a
chalk drawing and pressing the two to produce a reversed
impression. Three fragments of the original drawing survive,
the figure of Christ in the Louvre (fig. 47) and the heads of the
Disciples in Washington (fig. 48).[1] Statements that the offset is
reworked are without foundation: it corresponds line for line
with the fragments of the original, and Hartt's attribution
(1958) of the original drawing to Giulio Romano, claiming
(following Fischel 1913–41) that Raphael reworked the offset,
shows the deleterious effect on the eye of an *a priori* analysis of
Raphael's working methods.

Offsets were often used in Renaissance studios to monitor
the final effect of a composition when the end product itself
reversed the design, as with tapestries (which are woven from
the back), mosaics and prints. The present offset may have
been made by Raphael for this purpose, for all his studies for
the Sistine Chapel cycle are in the direction of the cartoons
and not of the tapestries,[2] but this is the only surviving example
of an offset made in connection with the tapestries; other
extant offsets made in Raphael's studio have no relevance to
the creative process and were probably made only as records.

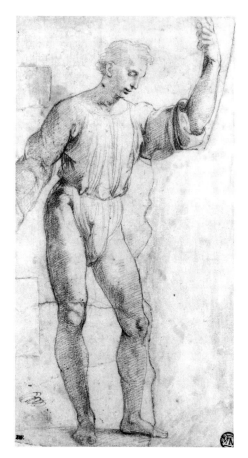

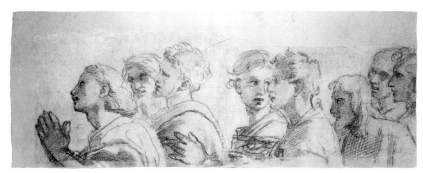

Fig. 47 Raphael, *Christ's Charge to Peter* (fragment), red chalk over stylus,
253 × 134 mm (max.). Paris, Louvre, inv. 3854

Fig. 48 Raphael, *Christ's Charge to Peter* (two fragments mounted as one),
red chalk over stylus, 81 × 232 mm overall. Washington, D.C., National
Gallery of Art, Woodner Collection, inv. 1993.51.2

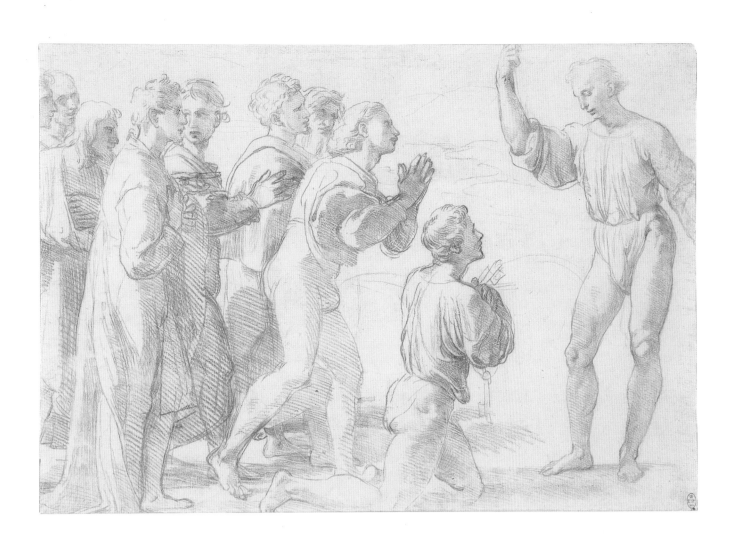

The original drawing was a life study of workshop assistants in contemporary dress, to fix the poses before adding the classicizing drapery. The Disciples in the tapestry correspond closely in pose to those in the present drawing, so far as they go, but the figure of Christ was wholly revised. In the final design he stands more frontally, pointing to the keys held by Peter and with his other hand to a flock of sheep in the background, thus conflating two passages from the Gospels, Matthew 16:19: "And I will give unto thee the keys of the kingdom of heaven: and whatsoever thou shalt bind on earth shall be bound in heaven: and whatsoever thou shalt loose on earth shall be loosed in heaven"; and John 21:17: "Peter was grieved because he said unto him the third time, Lovest thou me? And he said unto him, Lord, thou knowest all things: thou knowest that I love thee. Jesus saith unto him, Feed my sheep."

Although Christ's right hand cannot be seen in cat. 26, the angle of his arm does suggest a gesture towards something behind him. The inelegance and possible ambiguity of Christ simultaneously pointing to heaven and behind himself to sheep would suggest a reason for the change in Christ's pose, seen for the first time in the *modello* in the Louvre (fig. 50),[3] a drawing in poor condition, the authorship of which has been disputed in the past but which is of high quality and worthy of Raphael himself. Shearman (1972, p. 97) suggested instead that the change in Christ's pose may have been necessitated by an amplification in the iconography, with the introduction of the sheep only after the execution of the present drawing, and that it was the adjustments in the figure group following this change that led Raphael himself to divide the original study. In this scenario, the lowering of Christ's arm created too wide a gap between him and the Disciples, which was closed by adding a figure beyond John, the foremost standing figure. Now the first group of Disciples would have been denser than the second, and so Raphael moved the central figure in the whole group forward a little, eliminating the gap between them. These alterations correspond to the division of the original study. It may be that Raphael cut the figure of Christ from this drawing, divided the Disciples down the centre, made another life study in the revised pose of Christ, and then made a composite offset from the three sheets to see the effect. Collaging to refine a composition is not unknown in Raphael's oeuvre (see cat. 19); this may, however, be too ingenious an explanation, for the irregular edge of the Louvre sheet suggests

an attempt by a later collector to salvage presentable fragments from a damaged sheet rather than dismemberment in the studio.

Pope-Hennessy (1970) argued that *Christ's Charge* is less sophisticated than the rest of the series and may have been designed around 1512 as a trial cartoon, then modified in 1514–15 when the commission for the rest of the cycle was placed. It is unlikely that Raphael would have worked on several of the very large cartoons simultaneously and a sequential development within the cartoons themselves could therefore be argued, but stylistic differences within the small group of preparatory studies are very difficult to judge because of their varied techniques and cannot support this proposal of a distinct earlier phase of the project.

The drawing was recorded in the 1696 Bonfiglioli inventory as "*Un Dissegno con Christo egl'Apostoli mano di Raffaele in Cornice e Cassetta dorata con vetro*", later seen by Richardson in the Palazzo Bonfiglioli: "Feed my Sheep, an Excellent Design of *Raffaele*; Sketch Red Ch. manner of the Baptism my Father has". After entering the Royal Collection, however, it was thought to be a derivation after Raphael, and was thus not bound in George III's Raphael album or mentioned in Dalton's article of 1787 on the tapestry cartoons.

NOTES
1. Cordellier and Py 1992, no. 379, and Washington 1995–96, no. 34; F.-O. 442–44; J. 358.
2. Cf. the procedure of Giulio Romano in his Scipio series (cat. 37), where the tapestries were designed in their intended directions and the compositions were reversed only after the *modello* stage to prepare the cartoons.
3. Cordellier and Py 1992, no. 381; F.-O. 445; J. 360.

LITERATURE
Richardson 1722, p. 31; Passavant 1836, II, p. 122; Passavant 1839–58, II, p. 239, no. 291, III, no. 826; Waagen 1854, II, p. 445; Passavant 1860, II, p. 196, no. 425; Woodward 1863, p. 165; Ruland 1876, p. 245; Lübke 1878–79, II, p. 319; Crowe and Cavalcaselle 1882–85, II, p. 289; Grimm 1886, p. 397; Dollmayr 1895, pp. 255f.; Müntz 1897, p. 11; Fischel 1898, no. 243; Fischel 1913–41, I, p. 21; *Vasari Society*, v, 1924, no. 7; Venturi 1926, p. 313 n.; Oppé 1944, pp. 85f.; Fischel 1948, pp. 256, 365; Popham and Wilde 1949, no. 802; London 1950–51, no. 251; Hartt 1958, pp. 20, 286; White and Shearman 1958, pp. 308f.; Shearman 1959, p. 457; Freedberg 1961, pp. 273f.; Stridbeck 1963, p. 63f.; Forlani Tempesti 1968, pp. 411, 429 n. 165b; Marabottini 1968, pp. 216, 276 n. 7; Cocke 1969, no. 122; Pope-Hennessy 1970, pp. 119, 163, 282 n.; Blunt 1971, p. 110; Dussler 1971, p. 101; Oberhuber 1972, no. 441; Shearman 1972, *passim*; London 1972–73, no. 58; Cuzin 1983, pp. 169, 171; Gere and Turner 1983, no. 155; Joannides 1983, no. 359; Oberhuber and Ferino Pagden 1983, p. 125, no. 513; Shearman 1983, pp. 47f.; Paris 1983–84a, p. 282; Massari 1985, p. 130; Ames-Lewis 1986, p. 131; Gere 1987, no. 26; Thomas 1989; Cordellier and Py 1992, pp. 264, 267; Rome 1992, pp. 191f.; Edinburgh 1994, p. 76; Washington 1995–96, p. 159; Fermor 1996, p. 84

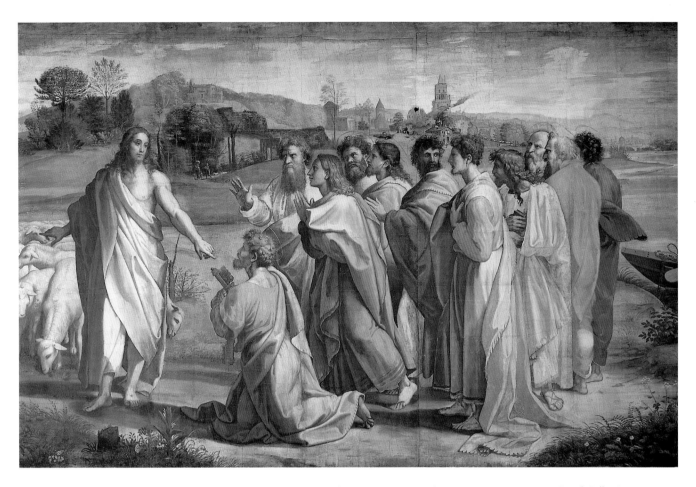

Fig. 49 Raphael and workshop, Cartoon for *Christ's Charge to Peter*, bodycolour on paper, mounted on canvas, 3430 × 5320 mm. Royal Collection, on loan to the Victoria and Albert Museum, London

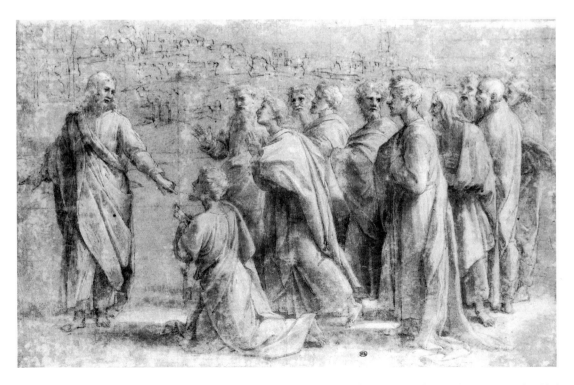

Fig. 50 Raphael, *Christ's Charge to Peter*, black-chalk underdrawing, pen and ink, brown wash, white heightening, squared in black chalk, 221 × 354 mm. Paris, Louvre, inv. 3863

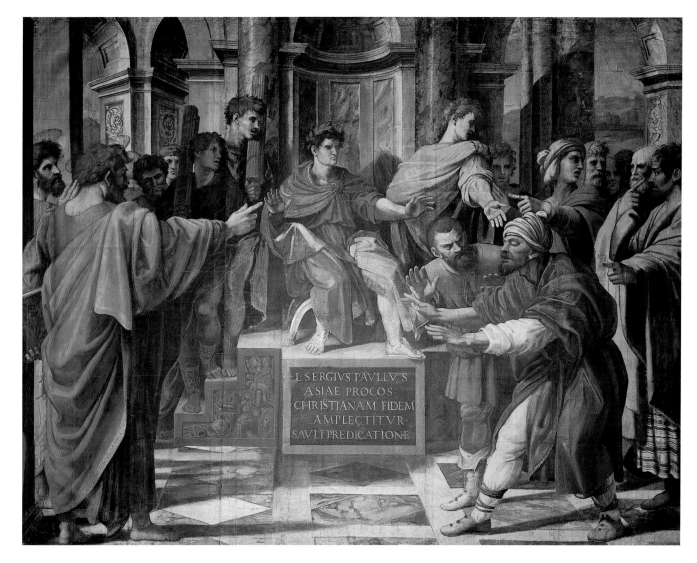

Fig. 51 Raphael and workshop, Cartoon for *The Conversion of the Proconsul Sergius Paulus*, bodycolour on paper, mounted on canvas, 3420 × 4460 mm. Royal Collection, on loan to the Victoria and Albert Museum, London

27

RAPHAEL

The Conversion of the Proconsul Sergius Paulus

ca. 1514

Pale-buff ground-bone preparation; stylus lines and pointing; black-chalk underdrawing; metalpoint; bistre wash; lead-white bodycolour; pen and iron-gall ink; abraded
Inscribed by the artist at lower centre, pen and iron-gall ink,
L. SERGIVS PAVLLVS/ ASIAE PROCOS:/ CHRISTIANAM FIDEM/ AMPLECTITVR./ SAVLI PREDICATIONE
Verso: scribbles from testing the pen
269 × 354 mm
No watermark visible
RL 12750
Provenance: Queen Christina of Sweden; George III (Inv. A, p. 49, no. 1)

This elaborate drawing corresponds almost exactly to the cartoon (fig. 51) for the tapestry of *The Conversion of the Proconsul Sergius Paulus* (see cat. 25), often imprecisely called *The Blinding of Elymas*. The presence of an inscription, uniquely among the tapestry designs, identifies the emphasis of the scene: "Sergius Paulus, Proconsul of Asia, embraces the Christian faith through the preaching of Saul". The episode is described in Acts (13:6–12): the magician Elymas tried to prevent Sergius Paulus from hearing the preaching of Paul and Barnabas; Paul struck Elymas blind, and thereby the proconsul was converted.

Both the authorship of the sheet and its preparatory role have been questioned in the past. These doubts have focussed both on the care taken over the execution of the sheet, with a detailed perspective grid drawn in metalpoint and an elaborate combination of several media, and on its exact correspondence

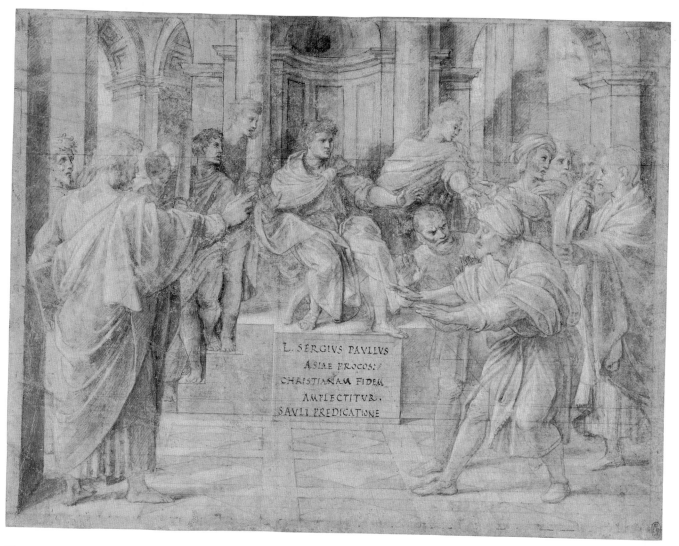

27

with an engraving dated 1516 by Agostino Veneziano in size and in all details, including the number of heads to the right of the composition – the principal difference between drawing and cartoon.[1]

The former objection is largely due to a prejudice that any time-consuming drawing could not be the work of the supposedly overburdened Raphael. This is too static a view of the distribution of labour in his workshop, and neglects the great flexibility shown by the master in prioritizing his workload. As has been seen with the *Coronation of the Virgin* (cat. 9) and the *Disputa* (cat. 16f.), Raphael would devote great attention to projects important to his career or reputation. The tapestries for the Sistine Chapel would inevitably be compared with Michelangelo's frescos above, completed just a couple of years earlier, and it is inconceivable that Raphael would entrust any part of the design process, other than the most mechanical aspects, to a studio assistant.

In fact, the delicacy and thoroughgoing intelligence of the drawing can only be attributable to Raphael. His oeuvre provides the most brilliant demonstration of the versatility of the difficult medium of metalpoint, which seems hardly to have been used by Raphael's assistants and was then rapidly going out of fashion in favour of chalk. The metalpoint drawing was comprehensively worked over with brown wash, and again there is nothing that indicates the hand of anyone other than Raphael. The crude touch of another hand can be seen only in the pen reinforcement of some outlines, of the head at far left and in the background architecture (which is not fully reconstructible in three dimensions and was conceived primarily as a foil to the figural composition).[2]

The elaborate technique of the drawing also rules out the possibility that it was made expressly for Agostino Veneziano's engraving. Raphael's few such drawings (*e.g.* cat. 29) are much more economical in their modelling and expression of form,

and most engravings after his designs would have been based on recycled working drawings, probably with Raphael's co-operation in many cases. But this sheet is also very different in technique from most *modelli* produced in Raphael's workshop, and despite its degree of cogitation it may not have been the definitive *modello* for the composition, being instead one of Raphael's investigative sheets that combined several elements of the creative process (the perspective, the architecture, the draperies, the facial expressions) and served as the basis for a more explicit, less suggestive pen-and-wash *modello*. As Shearman suggested (1972, p. 103), it is possible that the few inept pen outlines are the abandoned beginnings of an assistant's attempt to convert this drawing into such a *modello*.

The tapestry itself goes further than both drawing and cartoon in including to the left (corresponding to the right here) a pillar decorated with two herms supporting a frieze, above which rises an arched niche containing an antique statue. This strip corresponds to the position of the papal throne in the intended site for the tapestry in the Sistine Chapel; some such non-narrative element must have been planned from the outset, for it returns the proportions of the tapestry to those of the others designed for the side walls of the chapel and centralizes the vanishing point of the perspective above the right hand of the proconsul. Two drawings on either side of a sheet in the Ashmolean were utilized for this pillar: on the recto, a caryatid, and on the verso, a quick sketch of a herm (fig. 53, p. 113).[3] The caryatid was probably conceived for the dado of the Stanza d'Eliodoro (though none there is in exactly this form) and subsequently converted into the tapestry statue. The herm may also have been devised for the Stanza, but the fact that it appears to be urinating suggests

that the drawing was merely Raphael thinking aloud, albeit in an unusually droll way.

The drawing is probably to be identified with one seen in 1688 by Nicodemus Tessin in the collection of Queen Christina of Sweden.[4] If so, it would have passed after 1689 through the hands of Cardinal Decio Azzolino and his nephew, Marchese Pompeo Azzolino, thence probably to Livio Odescalchi, on whose death in 1713 the collection was partially dispersed; the note in Inventory A at Windsor, "This drawing was bought in Rome", does imply that it was purchased singly by one of George III's agents and not as part of a large collection.

NOTES
1. Bartsch XIV, p. 43, no. 48.
2. See Oberhuber in Rome 1984a, adducing some parallels and possible sources for the forms.
3. Macandrew 1980, no. 569B; F.-O. 413–14; J. 346.
4. "... vom Raffael Paulus mit dem blinden vor dem Keijsser, worbeij diese wörter geschrieben stunden: L. Sergius Paulus christianem fidem amplecitur Pauli praedicatione [*sic*]." Stockholm 1966, p. 449.

LITERATURE
Dalton 1787, p. 854; Reveley 1820, p. 5; Passavant 1839–58, II, p. 246; Passavant 1860, II, p. 201; Ruland 1876, p. 250; Lübke 1878–79, II, p. 321; Crowe and Cavalcaselle 1882–85, II, p. 320 n.; Springer 1883, II, p. 82; Morelli 1891–92, p. 547; Müntz 1897, p. 16; Fischel 1898, no. 253; Popham and Wilde 1949, no. 803; London 1950–51, no. 255; Hartt 1958, pp. 20, 286; Shearman 1959, p. 457; Freedberg 1961, pp. 273f.; Stockholm 1966, no. 1090; Forlani Tempesti 1968, pp. 412, 429 n. 167; Pope-Hennessy 1970, pp. 121, 164–67; Blunt 1971, p. 110; Dussler 1971, p. 103; Oberhuber 1972, no. 448; Shearman 1972, *passim*; London 1972–73, no. 66; Macandrew 1980, p. 62; Cuzin 1983, p. 174; Gere and Turner 1983, no. 158; Joannides 1983, no. 363; Oberhuber and Ferino Pagden 1983, p. 127, no. 524; Rome 1984a, no. 2.1.9; Rome 1984–85, pp. 338, 365; Massari 1985, pp. 13, 132; Ames-Lewis 1986, p. 136; Gere 1987, no. 27; Cordellier and Py 1992, pp. 263f.; Rome 1992, p. 190; Landau and Parshall 1994, pp. 128–31; Fermor 1996, p. 84

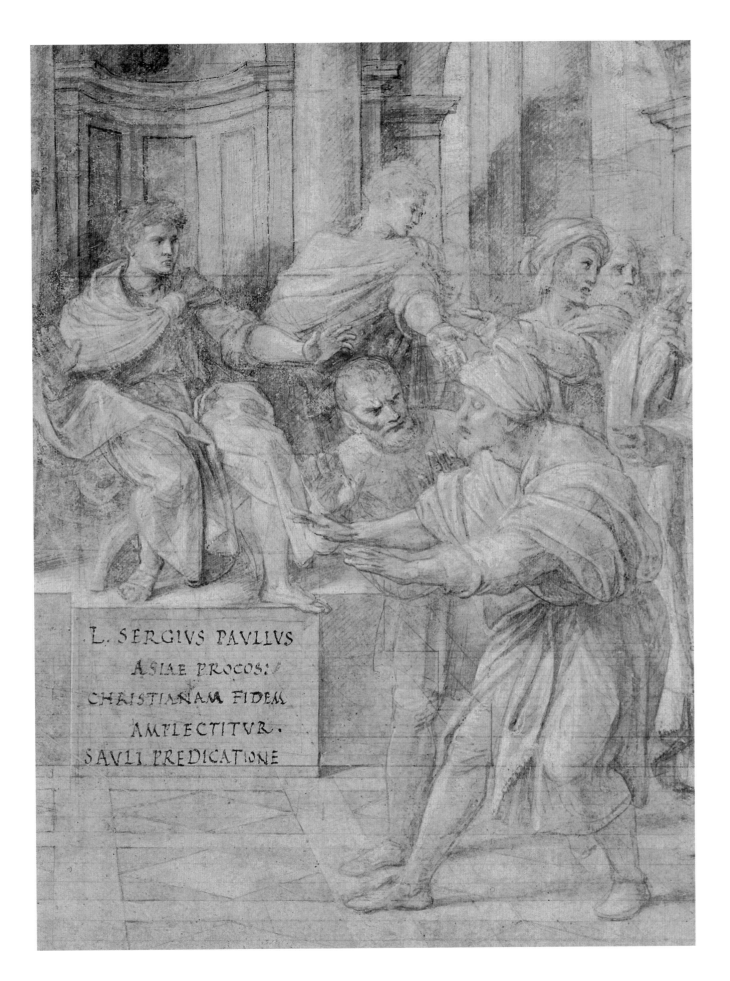

L. SERGIVS PAVLLVS
ASIAE PROCOS:
CHRISTIANAM FIDEM
AMPLECTITVR.
SAVLI PREDICATIONE

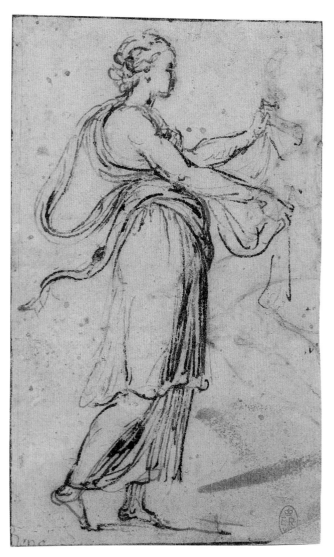

28r

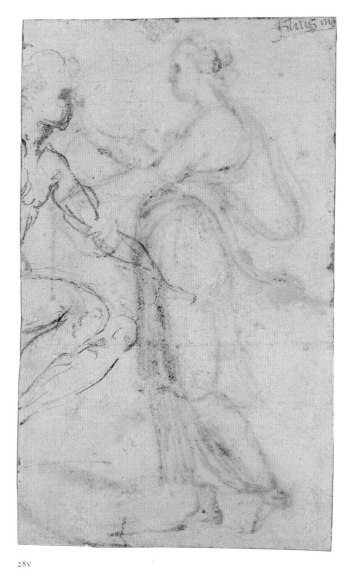

28v

28

RAPHAEL

A woman standing in profile: Florentia

ca. 1514

Pen and iron-gall ink
Inscribed lower left, pen and ink, *Bene* (?)

Verso: A seated male nude

Media as recto
Inscribed upper right, pen and ink, *filius mo[...]*(?)
140 × 85 mm, lower right corner restored
No watermark
Inscribed on a label attached to the back of the old mount, *Rafaele/ D. Chigi Roatti* (?)
RL 0337

This hitherto neglected drawing corresponds, in reverse, to the allegorical figure of Florentia welcoming the Cardinal in *The Entry of Cardinal Giovanni de' Medici into Florence on 10 March 1492* (fig. 52), the frieze-like scene below *The Stoning of St Stephen* in the Sistine Chapel tapestries.

Raphael designed the principal scenes in the direction of the cartoons, not of the tapestries, and it is reasonable to assume that this was true of the narratives below, though no other direct preparatory drawing survives for these friezes. The differences of detail – the position of the right hand and the more elaborate drapery of the tapestry figure – are too significant for the drawing to be a copy after the lost cartoon for that scene, and the assurance and rapidity of the penwork demonstrate that it is not a copy of some lost study. The style of the drawing is that of the very fastest sketches of Raphael's maturity, especially three sheets in the Ashmolean Museum: the sketch of a herm utilized in the *Conversion of the Proconsul*

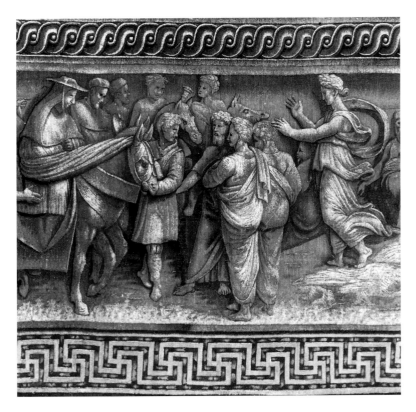

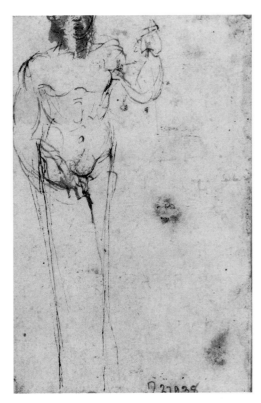

Fig. 52 Workshop of Pieter van Aelst after Raphael, *The Entry of Cardinal Giovanni de'*
Medici into Florence (detail), tapestry. Vatican, Pinacoteca

Fig. 53 Raphael, *Study of a herm*, pen and ink,
146 × 98 mm. Oxford, Ashmolean Museum, Parker 569BV

(fig. 53), the frenetic sheet of studies for the *Resurrection* (fig. 37, p. 86), and the sketch for the Farnesina pendentive of *Psyche and Venus* (fig. 7, p. 18).[1]

The only other known drawing by Raphael connected with the tapestry friezes is a copy in Munich of a relief on the Arch of Constantine, used with little change for the border of the *Conversion of St Paul*.[2] A drawing in the Louvre of the whole composition of the *Entry of Cardinal Giovanni* is in the same sense as the tapestry and is presumably a copy after the tapestry itself.[3] There are also several extant copies after a single adaptation of the composition, which is condensed widthways to more normal proportions, with a deeper disposition of the figures in space and a landscape background.[4] It is not known what function this adaptation may have served.

The figure probably had some antique source of the type of the Borghese *Dancers*, also adapted in a small lead oval attributed to Valerio Belli, known in a single example in the Kress collection.[5]

The fragmentary sketch on the verso of cat. 28, uncovered when the drawing was lifted from its old mount for the exhibition, shows a seated man with his legs tucked beneath him and his left arm held out. Although even more coarse than the recto, it is clearly by the same hand and must be an extreme example of Raphael's most summary manner, closely comparable with the Oxford *Psyche and Venus* mentioned above. No corresponding figure has been found in Raphael's work.[6]

NOTES
1. Respectively Macandrew 1980, no. 569BV; F.-O. 414; J. 346v; Parker 1956, no. 559v; F. 389; J. 306v; and *ibid.*, no. 655; J. 413.
2. Harprath 1977, no. 75; J. 348.
3. Cordellier and Py 1992, no. 421.
4. Listed in Ruland 1876, p. 247, and Oberhuber 1972, p. 140.
5. Pope-Hennessy 1965, no. 27.
6. The figure resembles the youthful Saul in the background of an engraved *Stoning of St Stephen* by a follower of Marcantonio (Bartsch XV, p. 23, no. 2), in which two other figures are apparently developed from a drawing by Raphael in the Albertina (Birke and Kertész 1992–97, I, no. 211; F.-O. 446; J. 261) that has occasionally been claimed as a first thought for the tapestry of the same subject, but which must date from a few years earlier than that project. The connection of both the recto and (tenuously) the verso of cat. 28 with the tapestry of the *Stoning of St Stephen* can be no more than a coincidence.

LITERATURE
Popham and Wilde 1949, no. 1136

29

RAPHAEL

The Last Supper

ca. 1514

Stylus lines and pointing; pen and iron-gall ink; the outlines
indented; badly faded, the paper discoloured and abraded
Verso blank
306 × 465 mm
Watermark: anchor in circle with seven-pointed star (identical to
cat. 25)
RL 12745
Provenance: Possibly Bonfiglioli (see text; and thus Sagredo, Consul
Smith); George III (Inv. A, p. 51, no. 41)

This ruined drawing corresponds very closely to engravings by
Marcantonio Raimondi and Marco Dente da Ravenna
(fig. 54), and is in the same direction and on the same scale.[1]
Although they are not inscribed as such, these have always
been recognized as being after a design by Raphael. The
drawing extends a little further than the engravings at the right
and below, and fold-lines here correspond with the edges of
the composition as engraved. Several drawing-pin holes (most
clearly visible at upper right) are symmetrical about the folds,
indicating that the sheet was at some stage secured to a surface
when folded, defining exactly the area to be engraved (this
may have been necessitated by a discrepancy between the sizes
of the drawing and the copper plate). Further, the architecture

is constructed with many stylus lines and compass points.
There is a vanishing point visible in the lower part of the
central window, well above Christ's head, and although the
function of some of the compass points is obscure it is clear
that the draughtsman was responsible for the invention of the
architecture.

Cat. 29 must thus have been a working model rather than a
copy. These considerations alone do not prove that it is a
modello by Raphael rather than a drawing by the engraver
made on the basis of studies provided by the artist, but it is
improbable that Raphael would design the figures only and
leave the invention of the architecture to the engraver (or to
some assistant). The poor state of the sheet has, however, led
many modern scholars to doubt the unanimous nineteenth-
century attribution of the drawing to Raphael. Fortunately,
photography in ultraviolet light recaptures much of the
intensity of the iron-gall ink and allows one to see the original
strength of the drawing (see over). While not exuberant or
experimental – this would go against the function of the sheet
– the draftsmanship is decisive and varied and, crucially, the
facial types are individually characterized. The drawing has all
the vigour that we would expect of Raphael, and an attri-
bution to the master seems secure.

The main difference between the drawing and the
engravings is the still life at the far left of the table, where a
knife disappears and the wine carafe becomes a jug. In Marco

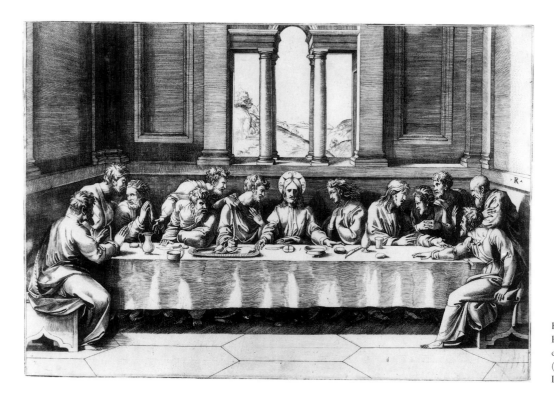

Fig. 54 Marco Dente after
Raphael, *The Last Supper*,
engraving, 294 × 436 mm
(Bartsch XIV, p. 33, no. 27).
London, British Museum

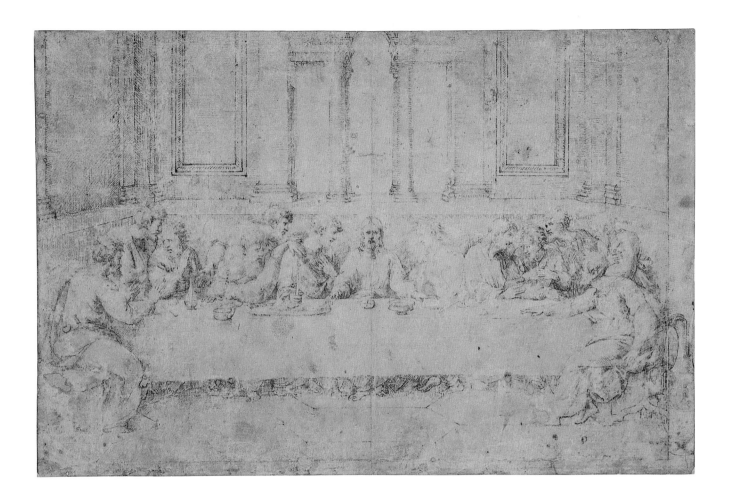

Dente's version, light drypoint lines, not gone over with the burin, can be seen there that follow the details of the drawing. Why he should deviate from Raphael's drawing here and here alone is unclear, but it proves that his version was executed first, working from the drawing, and that Marcantonio's version was copied from Marco Dente's and not from the drawing.[2]

The watermark of cat. 29 is identical to that found on the study for the *Miraculous Draft* (cat. 25), suggesting a date of around 1514 that is perfectly compatible with the compositional and figural style of the drawing: the Disciples here might have stepped straight out of the *Miraculous Draft*. Raphael's motivation for designing such a print at a time when he was heavily involved with the tapestry cartoons and the designs for the Stanza dell'Incendio is not known, and the *Last Supper* cannot be shown to have derived from some abandoned project. There is no substantial connection with a sketch of the same subject in Vienna that must date from five or so years earlier.[3]

The sheet's condition, with faded ink, discoloured and dirty paper, old insect damage and abrasion to the surface, indicates that it was once framed and was displayed for many years, probably unglazed. It might be identical with either of two drawings (assuming the second was not a duplication) listed in the 1696 Bonfiglioli inventory: "*Un Dissegno con la Cena di Christo egl'Apostoli di mano di Rafaele in cornice dorata e suo vetro*," or "*Un dissegno con la Cena di Christo agl'Apostoli similmente di Raffaele con cornice e cassetta dorata, e suo vetro*". No such drawing was described by Richardson (1722).

NOTES
1. Bartsch XIV, p. 33, nos. 26–27.
2. See Landau and Parshall 1994.
3. Birke and Kertész 1992–97, I, no. 195; F. 220; J. 264v.

LITERATURE
Passavant 1836, II, p. 123; Passavant 1839–58, III, p. 271; Passavant 1860, II, no. 425; Ruland 1876, p. 37; Crowe and Cavalcaselle 1882–85, II, p. 529; Popham and Wilde 1949, no. 805; Ragghianti 1954, p. 594; Gualdi 1961, p. 261; Blunt 1971, p. 111; Oberhuber 1972, p. 24; London 1972–73, no. 70; Shoemaker and Broun 1981, p. 116; Oberhuber and Ferino Pagden 1983, no. 451; Vienna 1983, p. 94; Paris 1983–84b, p. 256; Rome 1984–85, p. 350; Massari 1985, pp. 12, 174f.; Dillon 1987, pp. 554f.; Gould 1989, p. 51; Zentai 1991, p. 39; Cordellier and Py 1992, pp. 169f.; Landau and Parshall 1994, pp. 138–41

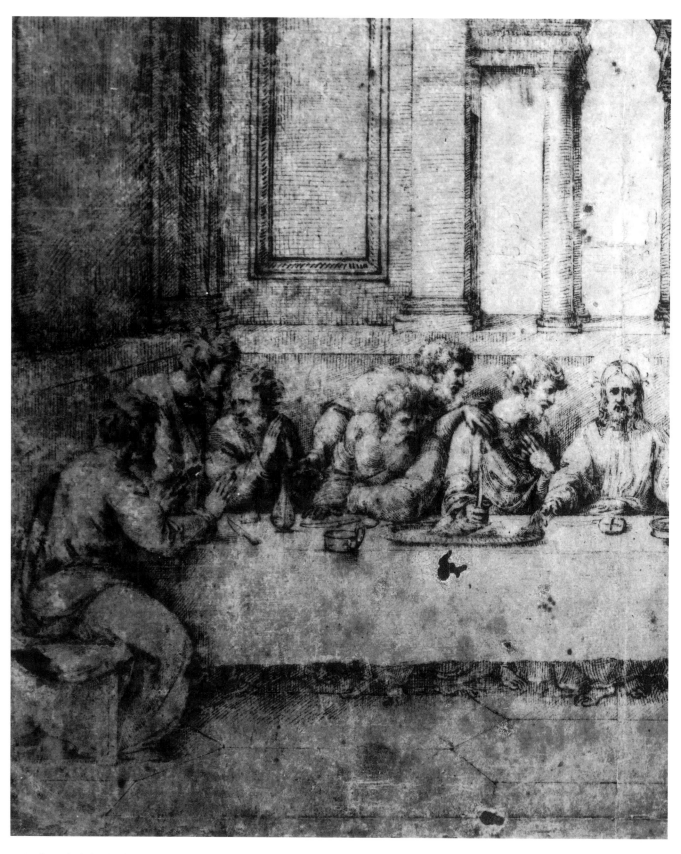

29 in ultraviolet light (detail)

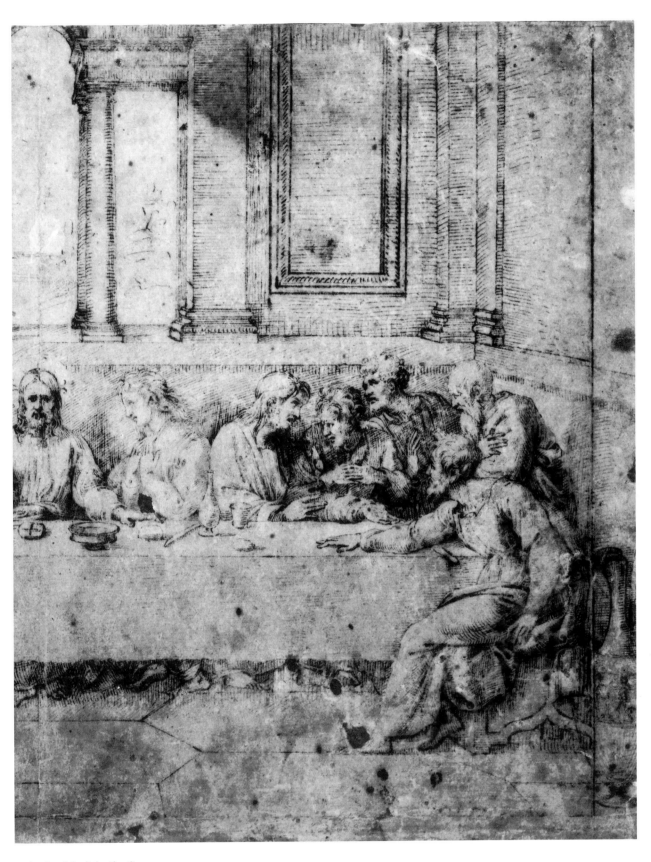

29 in ultraviolet light (detail)

30

WORKSHOP OF RAPHAEL
(ATTRIBUTED TO GIULIO ROMANO)

Venus and Cupid

1516

Stylus underdrawing; red chalk; much rubbed and tattered
Verso blank
211 × 172 mm
No watermark
RL 12757
Provenance: George III (Inv. A, p. 51, no. 31)

The composition corresponds to that of a fresco on the south
wall of the Stufetta (heated bathroom) of Bernardo Dovizi,
Cardinal Bibbiena (1470–1520), on the third floor of the
Vatican over the Logge. Letters sent by Cardinal Bembo to
Bibbiena, who was then absent from Rome, relate the progress
of the decorations, painted by Raphael's assistants (none of
whom is mentioned by name) and completed in June 1516.[1]

These letters establish that the sequence of small frescos was
designed by Raphael to Bibbiena's specifications, the theme of
Venus complementing a small antique statue of the goddess
that was intended to fill a niche in the Stufetta (but was never
installed).[2] Dollmayr associated the present composition with a
scene from the tenth book of Ovid's *Metamorphoses*, in which
Venus was wounded by Cupid's arrow when he kissed her,
causing her to fall in love with Adonis.[3] In his left hand Cupid
holds an arrow, pointing at Venus's right breast, though the
elongated mark between her open fingers cannot be read as a
wound and there is no other significant mark on her body. As
noted by Bober and Rubinstein, the figure of Venus was
closely based on an antique sculpture of the seated goddess,
which in its unrestored state lacked its head, right arm, left
forearm and left foot but had a very similar organization of the
drapery and disposition of the legs.

The handling of the present sheet is too superficial to be by
Raphael himself. Although there is stylus underdrawing that
appears experimental in places, the drawing must depend on
the work of another artist, for the draftsman has here
misunderstood the position of Venus's right arm – her hand is
laid over Cupid's shoulder but the upper and lower arm are
completely out of alignment, despite an attempted correcting
stroke of chalk in the angle above the wrist. The drawing is
too lively, however, to be a straightforward copy, having none
of the mechanical shading seen in a version in the Albertina
that almost certainly is a copy of cat. 30.[4] It therefore seems
plausible that Raphael provided a sketch for the composition,
and that this is a workshop development that served as the
definitive *modello* for the fresco, although it bears no evidence

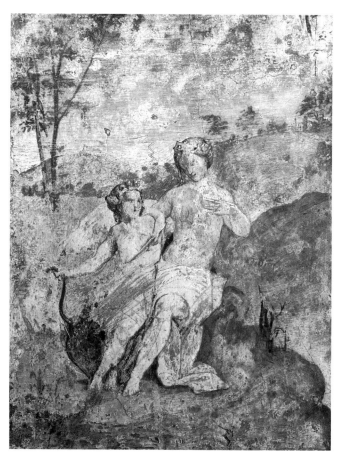

Fig. 55 Workshop of Raphael, *Venus and Cupid*, fresco.
Vatican, Stufetta di Cardinal Bibbiena

of mechanical transference such as squaring.

It is probable that more than one of Raphael's assistants was
involved in the painting of the Stufetta; the frescos are usually
attributed to Giulio Romano,[5] but their ruined state makes any
attribution on grounds of style hazardous. The present drawing
has also been generally attributed to Giulio.[6] The linearity and
insistence on flat pattern of the better preserved parts of the
sheet (Cupid's wing and arm, Venus's left side) support this, as
do two other studies for the project, *en suite* with cat. 30, for
Pan and Syrinx (in the Louvre)[7] and for *Venus and Adonis* (in
the Albertina),[8] the latter of which shows the characteristic
female facial type of Giulio. A red-chalk offset in the British
Museum records a highly finished study for *Venus Anadyomene*
that appears to have been by a different, less idiosyncratic
hand.[9] Oberhuber (1986) claimed that the Albertina *Venus and
Adonis* was more relief-like than the other drawings and was
thus a composition devised by Giulio himself, but such
differences are more probably due to the degree to which the
elaborating assistant was able to impose his own character on
the compositions, it being inherently probable that Raphael
provided the initial designs in every case.

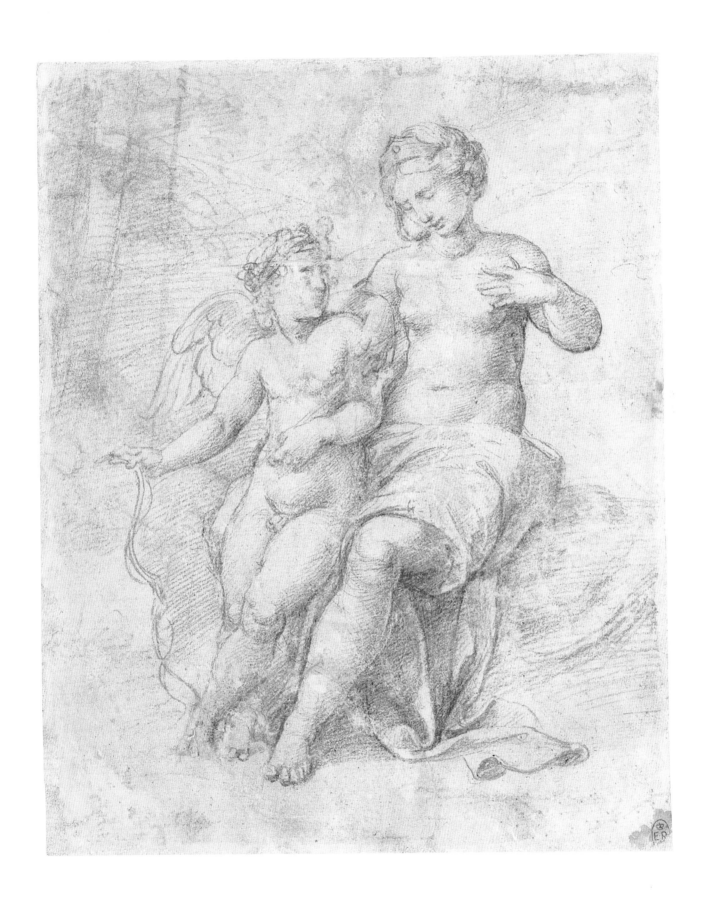

Two fragments of cartoons in the Albertina and the British Museum correspond to the heads of Venus in *Venus and Adonis* and *Venus and Cupid* respectively but are on a larger scale than in the Stufetta.[10] They are, however, on the same scale as a sequence of frescos in the Hermitage, detached from the loggia of the Villa Stati on the Palatine. These frescos have been heavily overpainted, probably several times, and thus the contours do not correspond exactly with those of the cartoons, nor can the original authorship of the frescos themselves be determined. The London fragment is weak in handling but the Vienna fragment is clearly by Giulio, and as Cristoforo Stati was a patron of Giulio in the early 1520s[11] it seems probable that the cycle in the Villa Stati was executed by Giulio and his assistants shortly after Raphael's death, reusing the compositions from the Stufetta of Bibbiena (who had also died in 1520 and thus could not have objected to this plagiarism of 'his' designs).

Cat. 30 seems also to have served as the model for an engraving by Agostino Veneziano, in which a landscape background (unrelated to that in the fresco) was added.[12] The scale of the print is smaller that that of the drawing, and numerous differences of detail and proportion suggest that the design was transferred freehand rather than mechanically. All but one of the Stufetta compositions were engraved by Agostino, Marcantonio or Marco Dente;[13] the print after cat. 30 is dated 1516, the year of the Stufetta's execution, and although Raphael is not credited as the *inventor* on any of these engravings it is probable that they were produced with his co-operation.

NOTES

1. For these letters see Golzio 1936, pp. 48ff.
2. See Malme 1984.
3. Dollmayr 1890, p. 279.
4. Birke and Kertész 1992–97, I, no. 215. A little stylus work can also be seen in the Vienna version, a useful reminder that this technical feature does not always indicate that a drawing is an original sketch.
5. Dacos 1986b, however, attributed the fresco of *Venus and Cupid* on stylistic grounds to Pellegrino da Modena.
6. Though Oberhuber and Ferino Pagden 1983 gave it to "Raphael or Gianfrancesco Penni".
7. Cordellier and Py 1992, no. 478.
8. Birke and Kertész 1992–97, IV, no. 17632.
9. Pouncey and Gere 1962, no. 282.
10. Respectively Birke and Kertész 1992–97, IV, no. 17633, and Pouncey and Gere 1962, no. 50.
11. See Frommel in Mantua 1989, pp. 294f.
12. Bartsch XIV, p. 218, no. 286.
13. Listed by Cordellier and Py 1992, p. 325.

LITERATURE

Passavant 1860, II, no. 434; Ruland 1876, p. 277; Crowe and Cavalcaselle 1882–85, II, p. 335; Springer 1883, II, p. 158; Fischel 1898, no. 288; Popham and Wilde 1949, no. 810; Marabottini 1968, p. 283, no. 65; Oberhuber 1972, no. 454; Shoemaker and Broun 1981, p. 194; Gere and Turner 1983, no. 189; Oberhuber and Ferino Pagden 1983, no. 534; Redig de Campos 1983, p. 239; Vienna 1983, p. 180; Bacou and Béguin 1983–84, p. 36; Malme 1984, p. 42; Rome 1984–85, p. 206; Massari 1985, p. 61; Bober and Rubinstein 1986, p. 62; Oberhuber 1986, p. 200; Mantua 1989, p. 249; Birke and Kertész 1992–97, I, pp. 125f., IV, p. 2176; Massari 1993, p. 12

31

RAPHAEL

The Three Graces

ca. 1517–18

Some stylus underdrawing; red chalk
Verso inscribed, pen and ink, with an unidentified paraph
203 × 258 mm, the corners chamfered
Watermark: anchor in circle with six-pointed star
RL 12754
Provenance: George III (Inv. A, p. 51, no. 28)

This is a study for the group sprinkling a libation over the married couple at the right of *The Wedding Feast of Cupid and Psyche*, one of two fictive tapestries frescoed in the vault of the garden loggia of Agostino Chigi's villa on the banks of the Tiber, now known as the Villa Farnesina (fig. 56). The two main fields and their pendentives represent celestial episodes from the story of Psyche; other scenes in the lunettes were never executed, and the constant threat of flooding from the adjacent river seems to have precluded frescos on the walls. Although early sources credit Raphael with the invention of the compositions (and their lucidity supports this), the frescos themselves were painted entirely by his assistants, evident in a coarseness and inconsistency of effect that attracted negative comment from an early date. Passages in several of the pendentives are of notably higher quality, however, than those in the crown of the vault (which would have been painted first), suggesting that the master became aware of this lapse and took more control over the execution of the later parts.

The study is from a single model in three consecutive poses, and corresponds to the fresco in all essentials except for the obscuring of the amphora by the wing of Cupid and for the handling of light, which degenerates from clear and harmonious in the drawing to harsh and incoherent in the painting. It is one of very few studies for the project that have hardly ever been denied to Raphael himself, while several other of the red-chalk studies present perhaps the most difficult problem of attribution in the whole of Raphael's oeuvre.[1] The

Paraph on verso of 31

issue is confused by the high competence of drawings by members of the studio, by the practice of taking offsets (which can deaden the appearance of the originals) and by the existence of very good copies after lost originals. The present author's opinion is that the other drawings by Raphael himself are: a very rapid small sketch, in red chalk and pen, in the Ashmolean for the pendentive of *Psyche and Venus* (fig. 7, p. 18);[2] studies for two putti in Dresden;[3] the sublime life study for *Psyche and Venus* in the Louvre;[4] the *Kneeling woman* in Edinburgh;[5] and the study of *Two female figures* in Haarlem.[6] All of the red-chalk studies are the work of an artist with a seemingly effortless understanding of bodily form, fully in control of his medium, taking the drawing as far as necessary and no further, defining highlights simply by leaving areas of paper blank.

In the assistants' drawings, by contrast, the forms are generally deadened by over-emphasis. The areas of light are passed over with chalk and then buttressed by building up the shadows still further, and the limbs are repeatedly outlined and isolated with dense and meaningless background hatching. These dozen or so red-chalk drawings probably by studio assistants are not uniform in quality, and for a couple (such as the Haarlem *Hebe and Proserpina*)[7] an attribution to Raphael himself is not implausible; others are highly competent but strangely drained of life in places, and the majority may be attributed to Giulio Romano with some confidence, as they display the graphic traits that distinguish Giulio's mature works. The most interesting aspect of all these studies, and that which has caused the most difficulty in attributing them, is that there seems to be no difference in function between the life studies by Raphael himself and those by his assistants: Raphael must have been involved in preparing at least some of the scenes at the most routine manual level.

There is little evidence of the progress of the commission, and the most valuable document, ironically, is a letter from Leonardo Sellaio to Michelangelo in Florence opining that the frescos were "a disgrace for a great artist". They were thus open to view when the letter was sent, but it is unclear whether its date of 1 January 1518 was according to the Roman (*i.e.* modern) calendar or the Florentine calendar, which would be 1519 modern style; the latter appears more likely, and in either case establishes that the frescos, so far as they go, were finished by the end of 1518. The preparatory drawings may thus most reasonably be assigned to 1517–18.[8]

As mentioned above, several of the drawings for the Farnesina have suffered from having offsets taken. The effects of this can be seen here at upper right, where the chalk lines have been slightly blurred by pressing against damp paper.[9] Offsets from the drawing are to be found at Chatsworth[10] and

Fig. 56 Workshop of Raphael, *The Wedding Feast of Cupid and Psyche*, fresco. Rome, Villa Farnesina

in the Uffizi,[11] the latter of which forms part of a sheet of studies produced in the studio of Perino del Vaga in the 1540s, suggesting that Perino was in possession of Raphael's drawing over twenty years after the master's death.[12]

NOTES

1. For discussions of this problem see especially Shearman 1964 and Oberhuber 1986. Cat. 33 was attributed by Hartt (1944) to Penni, and by Fischel (1948) to Giulio, "with livening touches of Raphael's own hand". Popham (1949) implied that a lack of stylus underdrawing was an argument against Raphael's authorship; such underdrawing is, however, visible around most of the contours, most clearly along the back of the right-hand figure. Dussler's proposal (1971) that in the Louvre *Ganymede* (J. 404) and the Haarlem *Hebe and Proserpina* (J. 402) the stylus work is by Raphael and the chalk by Giulio is an unwarranted complication. The statement that "it is hard to resist the logical conclusion that [all the Farnesina studies] are by Raphael" (Turner, Hendrix, Plazzotta 1997, p. 51) seems an abdication of connoisseurship.

2. Parker 1956, no. 655; J. 413.

3. Inv. W.189/190; J. 417.

4. Cordellier and Py 1992, no. 548; J. 414.

5. Edinburgh 1994, no. 47; J. 420.

6. Inv. A68; J. 421.

7. Inv. A62; Edinburgh 1994, no. 46; J. 402.

8. In expanding Raphael's role and attributing most of the red-chalk nude studies to Raphael himself, Oberhuber (1986) dated a first group of studies to 1514–15 with a lacuna before a return to the project in 1517, thus accounting

for the stylistic differences between drawings that are usually taken to be by different hands. This complicating theory is neither supported by the documentation nor justified by the drawings.

9. There are, however, no clear signs of subsequent retouching, as claimed by Shearman (1964).

10. M. Jaffé 1994, no. 311; J. 409.

11. Inv. 1651-ov; Rome 1981, no. 105.

12. Later in the sixteenth century Jacopo Strada claimed to have received from Perino's widow two boxes of drawings by both Perino and Raphael (preface to *Il Settimo Libro d'Architettura di Sebastiano Serlio Bolognese ...*, Frankfurt-am-Main 1575).

LITERATURE

Passavant 1836, II, pp. 121f.; Passavant 1839–58, II, p. 347, no. 298, III, no. 835; Waagen 1854, II, p. 444; Passavant 1860, II, p. 285, no. 433; Woodward 1863, p. 165; Crowe and Cavacaselle 1882–85, II, p. 418 n.; Morelli 1891–92, p. 547; Morelli 1892, p. 144 n.; Fischel 1898, no. 266; Venturi 1920, p. 196; London 1930, no. 483; Popham 1931, no. 142; Hartt 1944, p. 77 n.; Fischel 1948, pp. 185, 192, 366; Popham and Wilde 1949, no. 804; London 1950–51, no. 254; Freedberg 1961, p. 326; Shearman 1964, *passim*; Forlani Tempesti 1968, p. 415; Marabottini 1968, p. 283 n. 76; Pope-Hennessy 1970, p. 172; Blunt 1971, p. 111; Dussler 1971, p. 97; Oberhuber 1972, p. 68; London 1972–73, no. 57; Schwartzenberg 1977, p. 111; De Vecchi 1981, p. 75; Gere and Turner 1983, no. 162; Joannides 1983, p. 118, no. 408; Oberhuber and Ferino Pagden 1983, no. 553; Vienna 1983, p. 130; Harprath 1984, pp. 419f.; Rome 1984b, p. 55; Ames-Lewis 1986, p. 121; Oberhuber 1986, *passim*; Roberts 1986, no. 18; Davidson 1987, p. 510; Roberts 1987, no. 17; Cordellier and Py 1992, p. 480; Joannides 1993, p. 22; Edinburgh 1994, p. 98; M. Jaffé 1994, p. 182; Peronnet 1997, p. 59

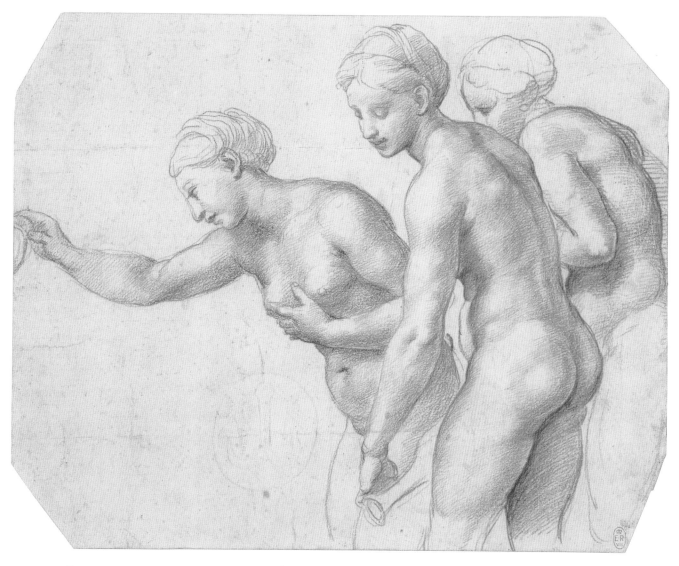

31

WORKSHOP OF RAPHAEL
(ATTRIBUTED TO
GIANFRANCESCO PENNI)

The Expulsion from Paradise

ca. 1516–18

Black-chalk underdrawing; faint remains of bistre (?) ink and lead-
white bodycolour; squared in black chalk at 27 mm
Verso blank
243 × 276 mm
No watermark
RL 12729
Provenance: Possibly Queen Christina of Sweden; George III
(Inv. A, p. 49, no. 4, "From the same Collection with [cat. 27]")

The Logge (or Loggia) di Raffaello of the Vatican Palace
stretches south from the Sala di Costantino, looking eastwards

over the Cortile di San Damaso. The building of the thirteen
bays was completed probably in 1516, and their decoration was
carried out by a large number of craftsmen over the next three
years. Maiolica flooring was provided by the Della Robbia
workshop; Giovanni da Udine co-ordinated the execution of
the vast quantity of stucco work and decorative painting; and
Raphael's assistants frescoed four biblical scenes in the vault of
each bay, with a monochrome frieze-like scene at the base of
the back wall in most of the bays.

Raphael's hand is not present in these frescos, and
stylistically it is clear that a number of assistants were
responsible for their execution. In 1568 Vasari listed Giulio
Romano, Perino del Vaga, Gianfrancesco Penni, Polidoro da
Caravaggio, Tommaso Vincidor, Pellegrino da Modena and
Vincenzo Tamagni as having worked on the frescos of the
Logge, attributing specific scenes to the first two. Though
these attributions are not wholly reliable, nor are they arbitrary,

Fig. 57 Workshop of Raphael, *The Expulsion from Paradise,* fresco. Vatican, Logge di Raffaello

32 photographed in 1857

and Vasari presumably had first-hand information about the Logge execution from Giulio and Giovanni da Udine, both of whom he met in later years. But contemporary sources, Vasari's accounts, and indeed the conspicuous intelligence of most of the compositions insist on Raphael's responsibility for the overall design of the frescos.[1] They were probably painted between early 1518 and May 1519, concurrently with several other projects for which Raphael's workshop was responsible (including the adjacent Sala dei Palafrenieri), and it is unlikely that work on the Logge proceeded at a regular pace without interruption.

This sheet is a study for the fresco of *The Expulsion from Paradise* in the second bay of the Logge. The figures of Adam and Eve are closely based on those in Masaccio's *Expulsion* in the Brancacci Chapel, Santa Maria del Carmine, Florence; the beautifully poised angel is surely Raphael's invention. The sheet is squared and probably served as the *modello*, the final compositional drawing ready for enlargement to a full-scale cartoon. Many of these *modelli* for the Logge survive, and even more copies of lost ones. Most are executed in pen and wash over black chalk, a few in pen only, and their status has been debated since Raphael first became the subject of scholarly study in the mid nineteenth century.

The narratives in the first and last bays are contained within fictive coffering and have lozenge-shaped ends. Those in the other eleven bays are set within a patterned ground of grotesques and decorative friezes or framed illusionistically as if against an open sky, and these can be rectangular or have arched tops. There is little correlation between the shapes of the preparatory drawings and of their corresponding frescos: sometimes they agree; in some cases arched drawings prepare rectangular frescos (the British Museum *David and Bathsheba*, fig. 9, p. 21); in others, rectangular drawings prepare arched frescos (the Muncie (Indiana) *Lot and his Daughters*, the Albertina *Abraham before the Angels*, the Victoria and Albert Museum *Finding of Moses*, and cat. 33 below). The Uffizi *Moses striking the Rock* is drawn as a rectangular composition but has an arched line superimposed, allowing either option. This strongly suggests that the compositions were worked out before the form of the stucco decoration was finalized, and it is likely that Raphael supervised the production of a set of *modelli* which were adapted as necessary by his assistants as work on the vaults proceeded.

There is a clear division between those *modelli* which display a creative process, showing searching for form and significant pentimenti in the underdrawing, and those in which all the compositional decisions have been made in advance. For example, the study attributable to Perino del Vaga for *David and Bathsheba* (fig. 9, p. 21)[2] displays no experimentation

in the underdrawing, and Perino must in this case have been working from some pre-existing study, requiring no decisions, only elaboration. A study in the Louvre for *Moses receiving the Tablets of the Law*,[3] however, displays numerous lively pentimenti in the underdrawing and is also squared for enlargement. It appears that all the creative processes for that composition were contained in the one drawing, from first sketch to *modello*. The Louvre drawing is one of only two that are usually given to Raphael himself (the other being a study in the Albertina for *David and Goliath*, discussed under cat. 33). But the existence of at least one *modello*-type drawing by Raphael must prompt reconsideration of others that show signs of creativity.

As Tristan Weddigen has pointed out (in conversation), the study in the Uffizi for *Moses striking the Rock*[4] shows in its underdrawing a figure to the left of the composition that was not worked up in the pen-and-wash completion of the drawing. Whoever drew the *modello* was finally responsible for the composition. More importantly, in that drawing there is profound psychological characterization of the protagonists and an unerring sense of the spatial relationships within and between the groups. It seems probable that the sheet is by Raphael, and to it should be added the British Museum *Dream of Jacob*,[5] which displays the same vigorous conception of form, quite opposed to the insipid doll-like figures of the other pen-and-wash *modelli*. These two drawings do, however, appear to have the same function as the *modelli* of lower quality. This parallels the situation with the contemporary work on the Farnesina loggia (cat. 31), where drawings at the same point in the design process could be executed either by Raphael or by his assistants.

The present drawing was badly damaged in the nineteenth century and is thus the most difficult to judge of the *modelli*. It was originally executed in pen and ink with bistre wash and white heightening over the black chalk visible today, as can be seen in a photograph taken in 1857 (see preceding page). Ruland's catalogue of the Prince Consort's Raphael collection (1876), however, listed photographs of the drawing before and after a drastic cleaning, the latter "showing the first sketch, in black chalk, by Raphael's own hand". It has entered the literature that the removal of the pen, wash and white from the drawing was an act of scholarly vandalism, intended to eliminate a pupil's penwork and reveal the supposedly original underdrawing by Raphael. That this was not the case is established by Woodward's overlooked account of 1870:

"The Expulsion from Paradise, in the Royal Collection, was slightly drawn in pen and bister, and finished by bister-wash, heightened with white. This, however, was always looked

upon with some suspicion, and critics believed that they saw in it the heavy hand of Julio Romano, to whom the cupola in which the subject occurs was entrusted. Accidentally, and by what also seemed at first a most lamentable accident, in the process of preparing this drawing for remounting, the whole of the pen and bister work was washed off, where there appeared beneath that coarser work a sketch of the figures in black chalk, very slight, but of such gracefulness of outline as to prove that it could be the work of none other than Raphael himself. This is an experiment for the recovery of Raphael's genuine drawings which no one would venture to repeat, but the knowledge gained by it might be confirmed by a very careful examination of studies in the same manner, and the original work of Raphael, upon which they are grounded, might probably be detected."[6]

Thus arose the theory that Raphael provided chalk underdrawings to be worked up by his assistants, accounting for a perceived discrepancy between the free underdrawing (which was assumed to be Raphael's) and the supposedly un-Raphaelesque pen and wash, there being little secure basis for the attribution to Raphael of pen drawings after about 1515. This theory has been intermittently championed in the succeeding century,[7] but in the absence of documentary evidence that it was the practice in *any* Renaissance workshop for a master to provide underdrawings to be worked up by his assistants on the same sheet, such an ingenious procedure can be posited only on the most compelling visual evidence. Even here, when we have an opportunity to compare the underdrawing with a photograph of the original state of the drawing, there is no substantial reason to believe that the sheet was the work of more than one draftsman.

The underdrawing of cat. 32 lacks the individualization that would allow it to be attributed to one draftsman with any degree of certainty; it is perhaps impossible in many cases to judge authorship from an underdrawing alone – the Ashmolean *Angel appearing to Joachim*,[8] certainly by Raphael and in which the underdrawing is unusually visible, would hardly be attributable to the master had he not worked up his black-chalk sketch. The penwork seen in the pre-damage photograph was much tamer than in those drawings argued above as by Raphael, though it is consistent with many of the other pen-and-wash *modelli* for the Logge, all of which must be by the same studio hand. This hand was not responsible, however, for the few pen-only drawings such as cat. 33, and if the attribution of that drawing to Giulio Romano is accepted then the most obvious candidate for the pen-and-wash *modelli* is Gianfrancesco Penni, who, along with Giulio, was Raphael's principal assistant in the later 1510s. It must be emphasized that, as Penni had no significant independent career, all attributions of drawings to him are conjectural, but he does seem the most reasonable choice in this case.

NOTES
1. Vasari 1568, II, pp. 81, 324f., 351f. See also Michiel in Golzio 1936, p. 104.
2. Pouncey and Gere 1962, no. 66, and F.-O. 469, as Penni; Freedberg 1962, p. 415, "unequivocally" as Perino.
3. Cordellier and Py 1992, no. 698; F.-O. 465; J. 389.
4. Inv. 509-E; F.-O. 464.
5. Pouncey and Gere 1962, no. 65; F.-O. 460.
6. Woodward 1870, pp. 37f.
7. *E.g.* by Morelli (1891–92) and Dollmayr (1895); Fischel (1948) cited the British Museum *Dream of Jacob* as another example "over a preliminary drawing by Raphael"; Oberhuber (1962) accepted the chalk as by Raphael, later modifying his position towards Penni.
8. Parker 1956, no. 563; F. 386; J. 331.

LITERATURE
Reveley 1820, p. 5; Passavant 1836, II, p. 121; Passavant 1839–58, II, p. 212, no. 284, III, no. 818; Waagen 1854, II, p. 444; Passavant 1860, II, p. 174, no. 418; Woodward 1870, pp. 37f.; Ruland 1876, p. 214; Lübke 1878–79, II, pp. 310f.; Crowe and Cavalcaselle 1882–85, II, p. 503; Springer 1883, II, p. 147; Morelli 1891–92, p. 547; Dollmayr 1895, p. 290; Fischel 1898, no. 215; Venturi 1920, p. 203; Venturi 1926, p. 319 n.; Fischel 1948, p. 367; Popham and Wilde 1949, no. 806; Parker 1956, p. 347; Gere 1957, p. 162; Freedberg 1961, p. 414; Oberhuber 1962, p. 59; Pouncey and Gere 1962, pp. 51–54; Blunt 1971, p. 111; Dussler 1971, p. 89; Oberhuber 1972, no. 457; Gere and Turner 1983, no. 191; Oberhuber and Ferino Pagden 1983, p. 136, no. 582; Vienna 1983, p. 132; Florence 1984a, p. 290; Andrus-Walck 1986, pp. 199–201; Dacos 1986a, pp. 158f.; Parma Armani 1986, p. 248; Gere 1987, no. 43

33

WORKSHOP OF RAPHAEL
(ATTRIBUTED TO GIULIO ROMANO)
The Distribution of Lands by Lottery

ca. 1516–18

Pen and iron-gall ink; squared in black chalk at 28 mm
204 × 297 mm
Verso blank
Watermark: crossbow in circle with star
RL 12728
Provenance: George III (Inv. A, p. 17, Tom. VI, and p. 50, no. 17)

The composition corresponds to that of a fresco (fig. 58) in the tenth vault of the Vatican Logge (see cat. 32), in which Joshua and Eleazar supervised the drawing of lots to determine the division of the Promised Land among the tribes of Israel (Joshua 14).[1] It is generally agreed that Perino painted the corresponding fresco.

This and two other studies for the Logge – the British Museum *Baptism of Christ*[2] and the Uffizi *Moses and the Burning Bush*[3] – are distinct from the other Logge studies in style and technique, being executed in pen and ink only without any underdrawing (the Windsor and Uffizi drawings are also squared in black chalk).[4] This sets these sheets apart from most of the others for the Logge, where the status of the black-chalk underdrawing has been closely debated for over a century (see cat. 32). The absence of underdrawing implies that the draftsman was either a paragon of decisiveness, capable of devising a composition without significant pentimenti, or that he was working from a pre-existing drawing in which the basic design had been determined. The British Museum sheet demonstrates that the latter was the case, for the wings and draperies of the angels at upper right terminate along the line of the lozenge-shaped end of the field in a manner quite unnatural for a draftsman sketching out a composition *ab initio*.

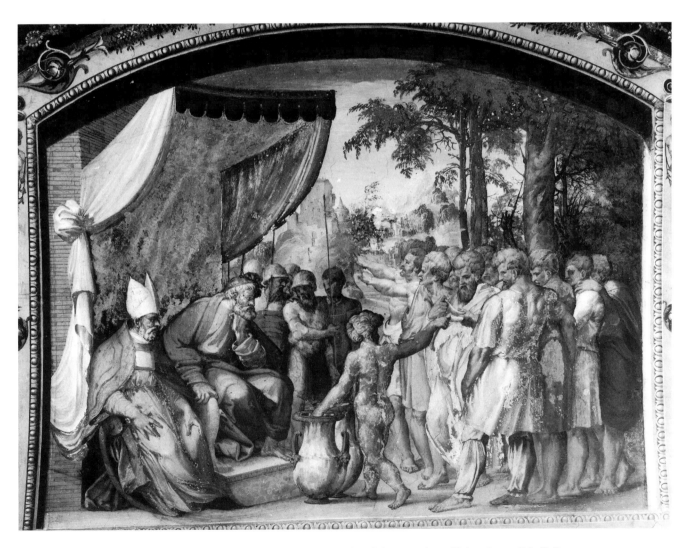

Fig. 58 Workshop of Raphael (attributed to Perino del Vaga), *The Distribution of Lands by Lottery*, fresco. Vatican, Logge di Raffaello

Loeser (1897) first noted that this drawing is by the same hand as a *Toilet of Venus* in the British Museum[5] and a study of *Pope Sylvester I carried on the Sedia Gestatoria* divided between the Louvre (fig. 59) and Stockholm,[6] and attributed all three to Penni. All have blank faces, distinctive deep-shadowed eyes, vigorous hatching and strangely uncertain background lines, and all must be by the same hand.[7] The Louvre/Stockholm drawing is now universally accepted as by Giulio Romano: figures such as the halberdier at the far left have all the features of his mature style. Likewise, laying the British Museum sheets of the *Baptism* and the *Toilet of Venus* alongside sheets from Giulio's early maturity reveals unmistakably the same graphic sensibility. Few contours are drawn with a single stroke: Giulio habitually built up his outlines with repeated passes, then modelled within the contour, leaving a small gap between the area of hatching and the outline. The details are never tight and knotted, as was to be typical of the mature Perino, but always retain a loopiness even on the smallest scale. The conclusion that cat. 33 is by Giulio seems unavoidable when considered in the context of the group of pen-only drawings described above.

The lack of underdrawing or of pentimenti indicates that this is not an inventive drawing, but the squaring does demonstrate that it is a working sheet, and its function was probably to elaborate a study by Raphael into a definitive composition suitable for enlargement to a cartoon. Raphael's studies for the Logge were varied in nature: the pen-and-wash *modelli* attributed to Raphael under cat. 32 above probably required no embellishment before enlargement to a cartoon; fundamentally different is his careful drawing in the Albertina for *David and Goliath*,[8] studying the two protagonists and one soldier only; the contrast between the sophistication of these figures and those filling out the composition as frescoed is almost embarrassing.

Fig. 59 Giulio Romano, *Pope Sylvester I carried on the Sedia Gestatoria*, stylus and black-chalk underdrawing, pen and ink, 419 × 286 mm. Paris, Louvre, inv. 3874

NOTES

1. For the subject see Erickson 1985.

2. Pouncey and Gere 1962, no. 67; F.-O. 470.

3. Inv. 1222-E; F.-O. 462.

4. A study for *The Triumph of David* in Budapest (inv. 2194; F.-O. 468a) is also in pen only but seems distinct in style from the three discussed here. That sheet was first attributed to Perino by Oberhuber (1966, p. 175), claiming, in support, the oral observation of Davidson and Shearman that it is similar in style to an early drawing by Perino in the British Museum (Pouncey and Gere 1962, no. 272); but it does seem to be by a different hand from the British Museum *David and Bathsheba* (fig. 9, p. 21), which is surely by Perino.

5. Pouncey and Gere 1962, no. 69.

6. Respectively Cordellier and Py 1992, no. 937, and Magnusson 1992, no. 45; both J. 448.

7. Fischel (1898) also connected cat. 33 with the *Sylvester* drawing, though did not nominate which pupil of Raphael he thought might have been responsible. Popham (1949), however, stated, "I am not convinced that [the

Louvre/Stockholm sheet] is either by Giulio or by the same hand as the Windsor drawing", and Gere (1987) claimed that the resemblance was "superficial, limited to the similarity of technique".

8. Birke and Kertész 1992–97, I, no. 178; F.-O. 468; J. 390.

LITERATURE

Passavant 1836, II, p. 121; Passavant 1839–58, II, no. 286, III, no. 821; Waagen 1854, II, p. 444; Gruyer 1859, p. 152; Passavant 1860, II, p. 181, no. 420; Woodward 1870, pp. 37f.; Ruland 1876, p. 223; Lübke 1878–79, II, p. 312; Crowe and Cavalcaselle 1882–85, II, p. 521; Springer 1883, II, p. 147; Dollmayr 1895, p. 290; Koopmann 1897, no. 182; Loeser 1897, p. 348; Fischel 1898, no. 232; Venturi 1921, p. 54; Venturi 1926, p. 319 n.; Popham and Wilde 1949, no. 807; Freedberg 1961, p. 415; Pouncey and Gere 1962, pp. 51, 55, 57; Marabottini 1968, pp. 262, 291 n. 120; Blunt 1971, p. 111; Dussler 1971, p. 90; Oberhuber 1972, no. 467; Gere and Pouncey 1983, p. 225; Gere and Turner 1983, no. 193; Andrus-Walck 1986, pp. 348f.; Dacos 1986a, pp. 83, 193f.; Dacos 1986b, p. 234; Gere 1987, no. 47; Cordellier and Py 1992, p. 488

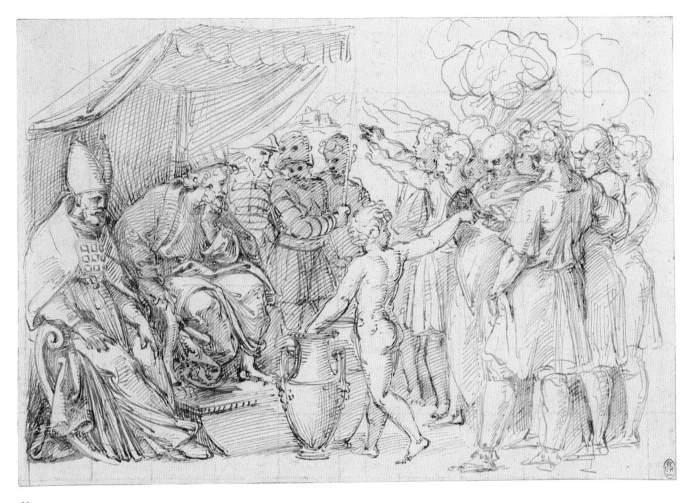

33

34

ATTRIBUTED TO RAPHAEL

The Virgin and Child with St Elizabeth and the Infant St John

ca. 1518–19

Stylus underdrawing; red chalk (two shades)
Verso blank
267 × 223 mm, the lower corners restored
No watermark
RL 12740
Provenance: George III (Inv. A, p. 51, no. 27)

The figures in this drawing correspond to those in the panel of the so-called Small *Holy Family* in the Louvre (fig. 60), where the rockface behind the group in the drawing is rendered as an illegible mass of dark paint set somewhat uneasily against an extensive landscape.[1] This is one of a number of *Madonna and Child* compositions painted in Raphael's studio towards the end of his life. The style of the Small *Holy Family* is consistent throughout with that of the distinctive hand of Raphael's principal assistant in his late panel paintings, almost certainly to be identified as Giulio Romano. In the mid seventeenth century the panel was stated to have been given by Raphael to Adrien Gouffier, Cardinal of Boissy, the papal legate at the French Court in 1519, to thank him for representing the artist's interests there. There is no earlier evidence to support this tradition.

Ruland classed the drawing as by Raphael, but most other earlier scholars (including Popham) dismissed it as a copy; recently it has been usual to attribute both painting and drawing to Giulio Romano. First, it must be noted that the drawing is not a copy. The closely hatched red chalk cannot disguise the very free stylus underdrawing with numerous pentimenti, most clearly visible in the arm of St Elizabeth and the leg of St John. This is a creative sheet in which many important details of the interrelationship of the figures were determined, and whoever made this drawing was finally responsible for the composition. But invention and execution in Raphael's late workshop were two distinct processes, and attributing the painting to Giulio (or to any other assistant) does not necessitate an attribution to that assistant of the drawing as well.

A contemporary painting for which we have more preparatory drawings to examine the creative process is the larger *Madonna of Francis I*, also in the Louvre, signed and dated 1518. The two pertinent studies, in red chalk, are both for the figure of the Madonna, with the outlines of the Child merely sketched in. The first, again in the Louvre (fig. 5, p. 17),[2] is a study of pose, drawn from a workshop model in

contemporary dress. The second, in the Uffizi (fig. 6, p. 17),[3] concentrates on the drapery of the Madonna in the form in which it was painted. Aside from their different functions, those two drawings display fundamentally different graphic characteristics.

The Louvre drawing concentrates on pattern, the limbs repeatedly outlined and flattened against the plane of the paper, the shading added in long strokes passing across the forms: these are the traits of Giulio Romano's chalk drawings, as seen in cat. 35, and fig. 5 is surely by him as an assistant in Raphael's workshop. The Uffizi sheet refines the rudimentary pose into a complex three-dimensional structure, and elaborates the drapery as a wonderfully bold mass of shining material. The more lightly indicated areas there, the body of the child and the hair and arm of the Madonna, are identical in handling to the *Three Graces* (cat. 31), one of the few late red-chalk drawings almost universally ascribed to Raphael himself. The Uffizi sheet is undoubtedly by the master, and the two sheets together demonstrate how Raphael could entrust important preparatory stages of a composition to an assistant, but would intervene at a crucial stage to ensure the success of the design.

The present study for the Small *Holy Family* is indistinguishable in style and technique from the Uffizi drawing, with the same searching stylus lines and the same solid, vibrant hatching in dark red chalk defining the dense drapery. It must also be by Raphael himself, as a brilliantly economical development of a composition on a single sheet of paper, ready to be handed to a member of the studio to be worked up as a painting. The correspondence between drawing and painting is close but not exact – there are numerous small differences of detail, the internal proportions vary, and the figures in the painting are a little larger than those in the drawing. It is clear that there was no mechanical transfer of the outlines and that the composition was transcribed freehand on to the panel support of the painting; this would explain the occasional weaknesses in the figuration of the panel, particularly in the faces of Christ and St Elizabeth. This reluctance to square the sheet or indent the outlines was perhaps due to a wish to preserve the model undamaged.

The composition was engraved by Gian Giacomo Caraglio, signed *IACOBUS VERONESIS F* and with the initial *R*, presumably to credit Raphael with the invention.[4] The figural details of the print conform to those of drawing and painting but the internal proportions are markedly different from either, and it is impossible to say with certainty whether Caraglio took the design from the present drawing or from some other version. Descriptions of the present drawing as a *modello* made explicitly for the engraver[5] depend on an *a priori* expectation of the appearance of such a *modello*, as

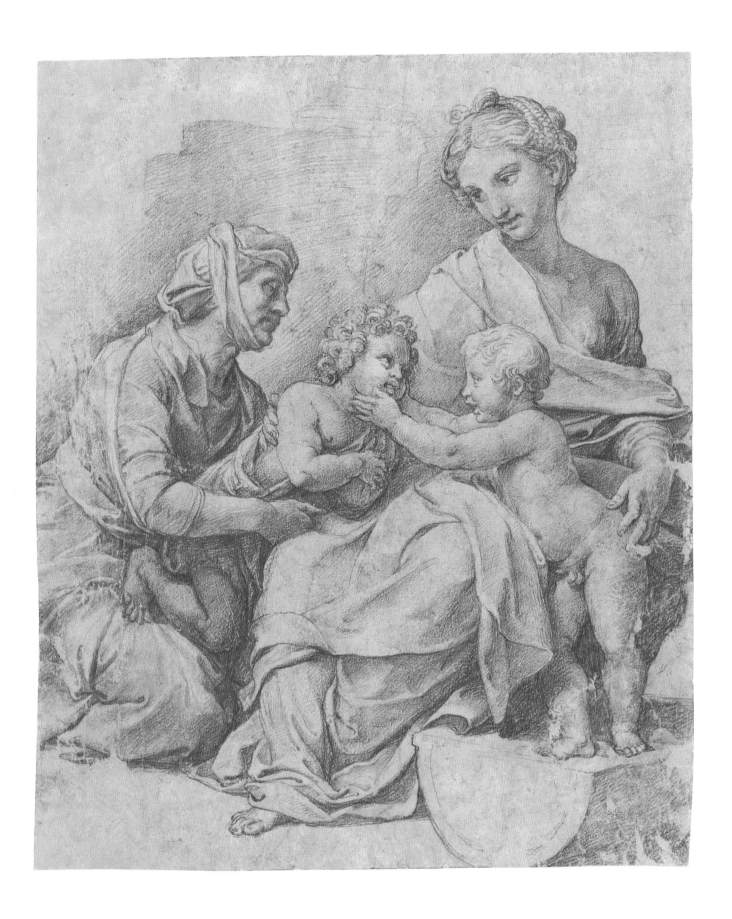

distinct from one for a painter, and pay no heed to the particulars of this case.

A copy of this drawing (rather than of Caraglio's engraving) by Rubens is in the Louvre;[6] another, earlier, copy was at Phillips, 5 July 1995, lot 154.

NOTES

1. Béguin (1990) claimed to see the head of Joseph lightly sketched between those of St Elizabeth and the Virgin, and argued that the drawing could therefore not be preparatory for the painting. In the original there is no sign of this head, the angular stylus underdrawing corresponding fully with the red-chalk lines in the background.
2. Cordellier and Py 1992, no. 875; F. 378a; J. 393.

3. Inv. 535-E; F. 377; J. 394.
4. Bartsch XV, p. 69, no. 5.
5. *E.g.* Shearman 1965, Oberhuber 1983.
6. Cordellier and Py 1992, no. 880.

LITERATURE

Passavant 1860, II, p. 493; Ruland 1876, p. 80; Crowe and Cavalcaselle 1885, II, p. 553; Fischel 1898, no. 327; Fischel 1913–41, VIII, no. 379A; Fischel 1948, p. 366; Popham and Wilde 1949, no. 833; Dussler 1971, p. 50; Oberhuber 1972, pp. 30ff.; Cuzin 1983, p. 226; Gere and Turner 1983, no. 200; Oberhuber and Ferino Pagden 1983, p. 141; Paris 1983–84a, p. 107; Oberhuber 1986, p. 200; Gere 1987, no. 58; Monbeig Goguel 1987, p. 379 n.; Mantua 1989, pp. 70, 251; Béguin 1990, p. 45; Cordellier and Py 1992, pp. 245, 507f.; Massari 1993, p. 63; Cirillo Archer 1995, p. 87

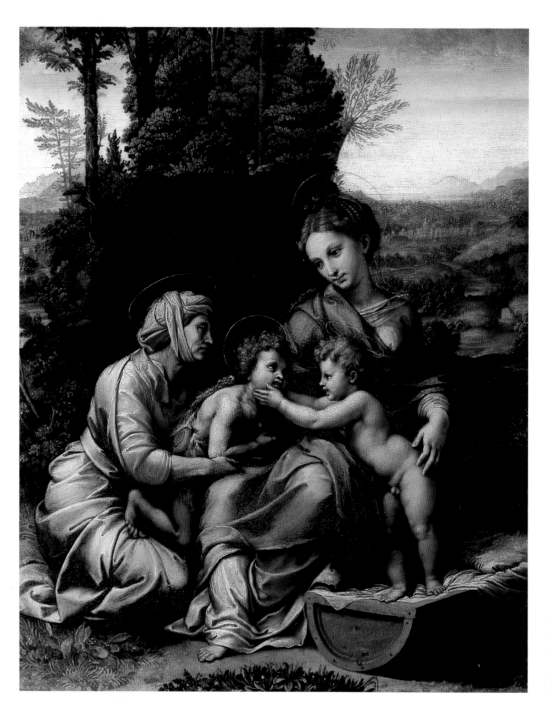

Fig. 60 Attributed to Giulio Romano, *The Virgin and Child with St Elizabeth and the Infant St John* (the Small *Holy Family*), panel, 380 × 320 mm. Paris, Louvre

GIULIO ROMANO

Giulio Pippi, born around 1496 (?) in Rome; entered Raphael's workshop probably in 1516, soon becoming his most trusted assistant. Inherited the workshop along with Gianfrancesco Penni on Raphael's death, taking over such major commissions as the Sala di Costantino. In 1524 moved to Mantua into the service of Federico Gonzaga, where he worked primarily as a designer rather than executant; major works include the Palazzo Te, apartments in the Palazzo Ducale, and the Scipio Africanus tapestry cycle. Died in 1546.

35

GIULIO ROMANO

Study of a nude man hurling a rock

ca. 1519–20

Buff (washed?) paper; black chalk
Verso blank
389 × 124 mm, a large restored area at lower right
No watermark
RL 0339
Provenance: George III (Inv. A, p. 51, no. 36)

Popham's hypothesis that this drawing might be a rejected study for Giulio Romano's *Stoning of St Stephen* (Santo Stefano, Genoa) was confirmed by the discovery of a copy of a lost *modello* for the painting in the Ecole des Beaux-Arts, Paris (fig. 61). The *modello* copy and the painting correspond generally in the upper half of the design, the figure of St Stephen, and the group in the left foreground, while differing completely in the figures of the councillors stoning the saint in the middle ground and to the right. This is a life study for the figure in the right foreground of the *modello*. There are two pentimenti in the position of the left arm, originally held across the chin as in the *modello*, then raised, and finally raised a little more at the elbow, accounting for the unresolved articulation of shoulder and elbow. The strengthening lines on the right hand differentiate the fingers while greatly reducing the plasticity of the hand; they may be later additions, but the chalk there seems identical to the rest of the drawing and they could be the final strokes to what was, after all, intended to be a functional study.[1]

The *Stoning* was painted for the papal councillor Giovanni Matteo Giberti, whose appointment as commendator of the church of Santo Stefano in 1519 was almost certainly the motive for the commission. An inscription on the now lost frame read *LEONI X P. M. FRATRISQU. JULII CARD. MEDICES BENEFICIO TEMPLO PRAEF*, establishing that the painting was finished before Giuliano de' Medici was created Pope Clement VII in October 1523, and also implying that it was completed during the pontificate of Leo X, his brother, who died in December 1521. The differences between the *modello* copy and the painting suggest strongly that it was initially commissioned from and designed by Raphael, on whose death in April 1520 Giulio Romano (who jointly inherited the workshop and its outstanding contracts) altered the composition to his own tastes. The changes can be seen in the cartoon by Giulio in the Vatican Museums,[2] and it is thus likely that nothing had been painted before Raphael's death. However, there is a clearly visible vertical join to the right of the saint in the cartoon, and this area (although

Fig. 61 Copy after Raphael, *The Stoning of St Stephen*, black-chalk underdrawing, pen and ink, wash, white heightening, 320 × 248 mm. Paris, Ecole des Beaux-Arts, inv. 334

stylistically indistinguishable) may have been patched on; these changes would then date from a very late stage in the preparatory process.

There is a marked difference in emotional pitch between the *modello* and the painting. Raphael's design, though violent, was balanced and self-contained; Giulio's alterations isolate the saint in the foreground in such a way that the mob hurl their stones outwards into the viewer's space. These figures lose their elegant proportions and become cruel grotesques, and the whole effect is more hysterical and emotionally involving: we see the temperamental difference between Raphael and the young Giulio, and the way in which the pupil transformed his master's ideals.

It therefore appears that cat. 35 was drawn to Raphael's design before his death. It cannot be by the same hand as, for instance, the closely contemporary Oxford study of two soldiers for *The Battle of the Milvian Bridge* (fig. 8, p. 19), drawn in a highly economical style in which the figures were blocked out in broad masses, worrying little about inessential details and with single assured strokes for the contours. That drawing

is surely by Raphael, and shows the same fundamental artistic temperament as the life studies for the *Resurrection* (cat. 21f.) of some eight years earlier.

There are very few black-chalk studies securely by Giulio with which cat. 35 might be compared, but the graphic traits of the present drawing – the strong emphasis on outline and flat pattern, the heavy accents – are those found throughout his career. Notwithstanding the differences of date, the morphology of the arm and slender hand is exactly that of the wind-god in cat. 41 below, and fundamentally different from the robust anatomy rendered by Raphael in cat. 21f. Cat. 35 seems undoubtedly to be by Giulio, and shows again, as in the cases of the Farnesina and the Vatican Logge, that Raphael and his most trusted assistants were working as a genuine team in the preparation of paintings towards the end of his life.

In the Louvre is a second black-chalk study (fig. 62)[3] for the Genoa *Stoning*, of one of the figures that in the painting replaced the lapidator of cat. 35. To the lower right there is also a study for a hand holding a rock; though it resembles that of the figure of cat. 35, the angle of the wrist is wrong, and it seems impossible that there was a point during the alterations to the composition at which both figures were to be included. The characterization of fig. 62 is quite unlike that of cat. 35: classicism has been replaced by the squat, almost degenerate aspect of the martyrizers in the painting, and it is at first sight hard to reconcile the style of the two drawings. But there are enough points of similarity, particularly in the modelling of the arm and legs, to support an attribution of this sheet, too, to Giulio, and the differences testify rather to the liberation of his artistic personality on Raphael's death. Fig. 62 was to be one of the last chalk drawings by Giulio and one of his last studies from the life, to be supplanted almost entirely by pen drawing from the imagination for the rest of his career.

Fig. 62 Attributed to Giulio Romano, *A study of a nude man hurling a rock*, paper washed buff, black chalk, white heightening, 335 × 200 mm. Paris, Louvre, inv. 10920

NOTES

1. Ferino Pagden (1987) noted that, though drawn here from the life, the pose is a composite of the lower half of a figure copied in the Venice *Libretto di Raffaello* (f. 14r), ultimately after the bronze statuette known as the *Uomo della paura*, with an echo of the upper half of a figure from an earlier drawing by Raphael for a *Stoning of St Stephen* in the Albertina (Birke and Kertész 1992–97, I, no. 211; F.-O. 446; J. 261).

2. Rome 1984, pp. 311–14; Mantua 1989, p. 64. Only the lower portion is by Giulio; the status of the upper portion is unclear, but it appears to be a copy to complete the cartoon. This does not affect the present argument.

3. Cordellier and Py 1992, no. 995. This bears an old inscription *Il fattore*, the slightly pejorative alias of Gianfrancesco Penni, who inherited Raphael's workshop along with Giulio. There is no sound basis for the attribution to Penni of any life drawings, and, like most traditional ascriptions to Penni, this one seems to be arbitrary.

LITERATURE

Passavant 1860, II, p. 494*q*; Ruland 1876, p. 324; Popham and Wilde 1949, no. 348; Hartt 1958, no. 41; Oberhuber 1972, pp. 27f.; London 1972–73, no. 68; Rome 1984–85, p. 314; Joannides 1985, p. 20; Ferino Pagden 1987, pp. 70–72; Gere 1987, no. 62; Mantua 1989, p. 255; Cordellier and Py 1992, pp. 592–94; Rome 1992, pp. 318–20; Fritz 1996, pp. 27f.; Joannides 1996, no. 37

36

ATTRIBUTED TO GIULIO ROMANO

Men, cattle and a dog sleeping in a field

ca. 1530–31

Charcoal and leadpoint underdrawing; pen and iron-gall ink with
bistre wash; the group at right squared in black chalk at 20 mm
Verso blank
190 × 490 mm
No watermark
RL 0504
Provenance: George III (Inv. A, p. 52, *Guilio* [sic] *Romano, Polidoro,
e Perino del Vaga Tom. 2*, p. 4, "Soldiers and Cattle, at rest")

The construction of the Palazzo Te, Federico Gonzaga's villa
on the outskirts of Mantua, was begun in the mid-1520s, soon
after Giulio's arrival in the city and appointment as court artist.
Over the next ten years he directed the building and
decoration of perhaps the most charming of all Renaissance
palazzi. Arranged around a square courtyard with the principal
rooms at ground level, it has been altered relatively little over
the centuries, and although it is now bare of furniture we can

still experience the delight of moving through rooms of deftly
contrapuntal character, alternately classicizing, humorous,
arcane, intimate and grandiose, the product of a single
imagination of seemingly inexhaustible fertility.

This drawing corresponds to a lunette fresco (fig. 63) in the
loggia of the Casino della Grotta, one of the summerhouses of
the Palazzo. The loggia opens on to a small courtyard garden
flanked by walls that bear almost effaced *trompe l'œil* frescos. At
the end of the garden is the grotto that gives the building its
name, fitted with fountains and lined with shells and stalag-
mites, cool in the height of summer. The programme of the
frescos in the loggia has not been elucidated beyond that of a
general cycle-of-life theme, but the gently bucolic nature of
the fresco for which this is a study is in keeping with the
soothing effect of the whole ensemble.

The Casino was apparently being built during 1530 and it
is likely that the decorations were executed as part of the same
campaign, giving a date for the present drawing at the start of
the 1530s. Although most of the frescos at the Te were
executed by Giulio's assistants (fig. 63 has been attributed to

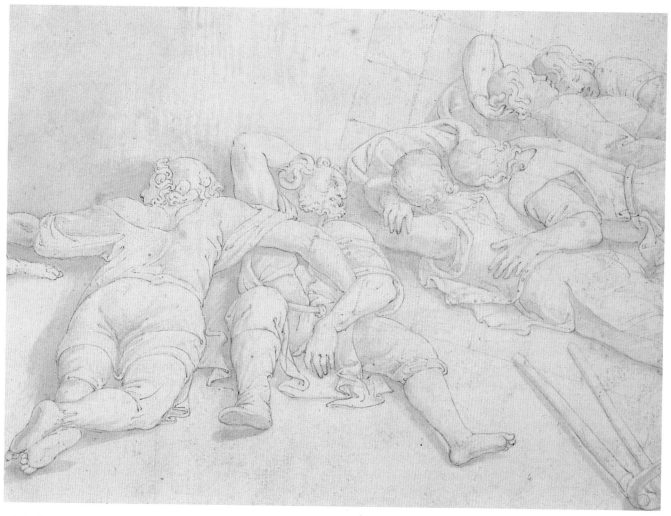

36 (detail)

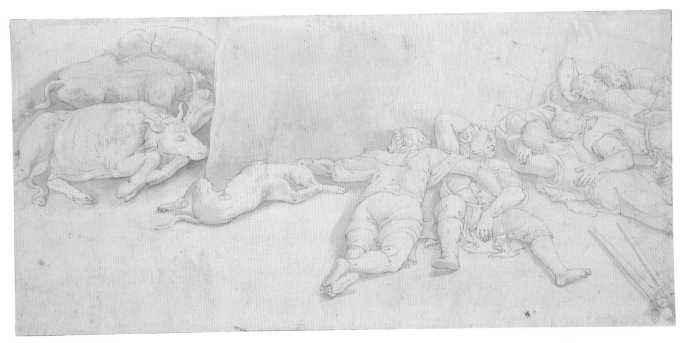

36

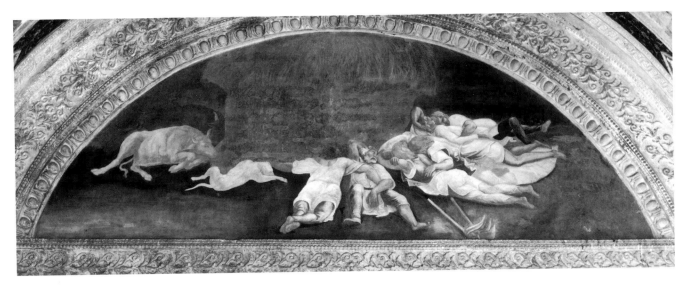

Fig. 63 Workshop of Giulio Romano, *Men, cattle and a dog sleeping in a field*, fresco. Mantua, Palazzo Te, Casino della Grotta

Agostino da Mozzanega), it is clear that Giulio was responsible for the design of every significant element of the *palazzo*, and he must be credited with the invention of this scene. The authorship of the drawing itself is less certain. Popham described it as a copy after the fresco, but the squaring of a portion of the design would indicate that it is a preparatory study. The figure types and graphic mannerisms are characteristic of Giulio, and though some of his assistants learned to emulate these they are here handled with the ease and confidence of Giulio himself. The slight uniformity of effect can perhaps be explained by the unbroken lines of the

black-chalk underdrawing, probably made by tracing with a stylus around the outlines of an earlier drawing that had been blackened on the verso and laid over the present sheet (see cat. 37).

An elaborately washed and heightened copy of the composition, with the elements rearranged, was formerly in the Ellesmere collection.[1]

NOTES
1. Sotheby 1972, no. 36.

LITERATURE
Popham and Wilde 1949, no. 366

37
GIULIO ROMANO

The Triumphal Feast of Scipio

ca. 1532

Black-chalk underdrawing; pen and iron-gall ink; the outlines
indented with a stylus
Inscribed lower left, pen and ink, *Julio Romano*
Verso rubbed with black chalk for transfer
374 × 548 mm, the upper corners chamfered; restored losses down
the central fold
Watermark: anchor in circle with five-lobed flower
RL 01367
Provenance: Sir Peter Lely (Lugt 2092); George III (Inv. A, p. 52,
Guilio [sic] Romano, Polidoro, e Perino del Vaga Tom. 2, p. 9, "A
Composition for a large Feast ... Guilio Romano")

This is a study for one of a series of twenty-two tapestries of the
story of Scipio Africanus, apparently commenced speculatively
in the late 1520s by the Brussels entrepreneur Marc Crétif and
continued under the patronage of Francis I. The French king
commissioned the completion of the series on 11 July 1532,

and payments continued until April 1535. The original tapestries
remained in the French royal collection until 1797, when they
were burnt to recover their precious metals, but their compo-
sitions are known from finished *modelli* and subsequent copies,
from contemporary prints, and from later tapestries woven
from the same cartoons.[1] Giulio is not linked to the project by
any primary document, but a tradition dating back at least to
the seventeenth century, inscriptions on the contemporary
engravings, and most conclusively the style of several surviving
preparatory drawings render his participation certain.

The subjects of the tapestries fall into two distinct groups,
one representing episodes from the life of Scipio (the *Acts*),
the other of scenes of a triumphal procession (the *Triumphs*). The
tapestry corresponding to the present drawing was described in
an inventory of the seventeenth century as the feast given by
Scipio for the Roman tribunes who had been sent to Sicily to
examine his conduct.[2] Hartt identified the subject instead as the
feast held by Scipio after arriving at the Capitol at the end of
the triumphal procession, and thus as the last of the *Triumphs*,
rather than among the *Acts* as it was traditionally placed.

The poses of all the figures here agree exactly with those in the final design, with the exceptions of the child seated on the huge candelabrum, who was to be eliminated, and the man in the centre of the far right background. The candelabrum was an essential device to break the pictorial monotony of a large number of figures at a long table, and it acts as a counterweight to direct attention towards Scipio, who is otherwise rather inconspicuous at the left with his back to the spectator.[3] In the tapestry he is more easily identifiable as he wears a laurel wreath, a feature also seen in an etching of 1543 of the composition by Antonio Fantuzzi,[4] who no doubt had access to the tapestry cycle through his work at the French court.

The *modello* for the composition, in which the architecture and background figures were elaborated, is at Chantilly (fig. 64).[5] This is on the same scale as cat. 37: Giulio transferred the design to the Chantilly sheet by blackening the verso of cat. 37 and pressing around the outlines with a stylus, a procedure that he used often (see cat. 36, 41f., 45f.) and that was described as Giulio's standard method by Armenini.[6] Unlike Raphael's work for the Sistine Chapel cycle (see cat. 25–28), Giulio designed the compositions in the direction of the tapestries, and the two surviving full-size cartoons for the cycle in the Louvre and the Hermitage[7] confirm that the required reversal took place when scaling up the *modelli* to the cartoons.

Whereas a *modello* by Giulio survives for every one of the *Triumphs*, no drawings by him for the *Acts* are known (assuming that it is correct to dissociate the present design from the *Acts* and place it with the *Triumphs*). A suite of five *modelli* for the *Acts* entered the Louvre from the Jabach collection in 1671 with an attribution to Gianfrancesco Penni, who had by 1528 moved to Mantua to work alongside Giulio, but all that we know about Penni suggests that he would have been incapable of devising such extravagant compositions. It would appear that the difference between the two cycles was simply one of delegation: the *modelli* for the *Acts* were prepared by Penni to Giulio's designs around 1528, whereas four years later, after Penni had left the studio, the *modelli* for the *Triumphs* were drawn by Giulio himself. Perhaps Giulio's personal preparation of the latter series was due to the increased prestige of the commission after the French king became involved.

NOTES
1. For a full account of the project see Jestaz and Bacou 1978; Lefébure 1993; and Cox-Rearick 1996, pp. 377–83.
2. Recorded by Reiset 1866, p. 244.
3. For this candelabrum see Biscontin 1994.
4. Bartsch XVI, p. 349, no. 28.
5. Peronnet 1997, no. 24.
6. Armenini 1587, p. 76.
7. Jestaz and Bacou 1978, under no. XV, and no. XVII.2; there is also a small fragment in a Scottish private collection (Edinburgh 1994, no. 56).

LITERATURE
Popham and Wilde 1949, no. 352; Parker 1956, p. 119; Hartt 1958, pp. 227ff., 303; Jestaz and Bacou 1978, no. XXIII.1; Chantilly 1983, p. 33; Rome 1984–85, pp. 467–73; Junquera de Vega and Herrero Carretero 1986, p. 184; Mantua 1989, p. 473; Massari 1993, p. 86; Cox-Rearick 1996, p. 379; Peronnet 1997, pp. 94f.

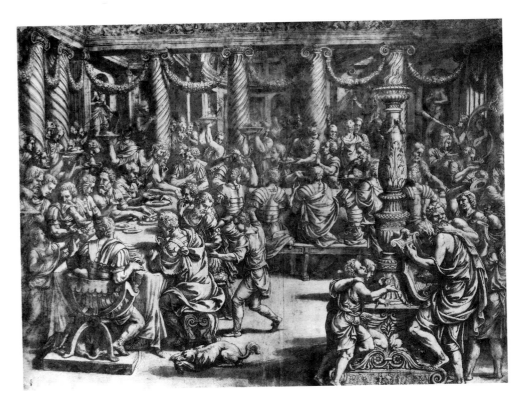

Fig. 64 Giulio Romano, *The Triumphal Feast of Scipio*, black-chalk underdrawing by stylus transfer, pen and ink, wash, white heightening, 428 × 575 mm. Chantilly, Musée Condé, inv. 76(68)

38

COPY AFTER GIULIO ROMANO

A giant crushed beneath a rock

After 1532

Off-white paper; black-chalk underdrawing; pen and iron-gall ink;
bistre wash; lead-white bodycolour; squared in black chalk at 35 mm
Verso blank
275 × 179 mm
No watermark
RL 0305

Fig. 65 Workshop of Giulio Romano, *The giants buried under Pelion and Ossa* (detail), fresco. Mantua, Palazzo Te, Sala dei Giganti

The Sala dei Giganti in the Palazzo Te, Mantua (see cat. 36) is frescoed throughout with a single continuous scene of the *Giants buried under Pelion and Ossa*. The vault is constructed without groins, and the ceiling merges imperceptibly with the walls; above, in a dizzying perspective, Jupiter surrounded by his fellow gods hurls down thunderbolts, while all around mountains and buildings collapse on to the rebellious giants (fig. 65). In its original state the doors to the room were also painted, so as not to break the illusion, and the dim and flickering light from a fireplace further suppressed the spectators' points of reference. This was one of the first attempts in the Renaissance to create a completely enveloping space; it is arguably the most audacious decorative scheme of the sixteenth century, and retains a thrilling potency even in its present adulterated state.

The frescos were executed between March 1532 and September 1534 by Giulio's assistants Fermo da Caravaggio, Rinaldo Mantovano and Luca da Faenza.[1] Several drawings by Giulio survive for the scheme, including one for the giant in the north-west corner, formerly in the Ellesmere collection,[2] of which this is a reduced-size copy. The ex-Ellesmere sheet has been severely cut down all around; here we also see the rocks surrounding the giant, including those beneath his knee, where in the original scheme there would have been a painted door (the doors are now lost), the position of which is indicated here by lightly sketched lines.

The prominent squaring of the present drawing is puzzling, for the ex-Ellesmere sheet that it copies is not squared, and it is unlikely that cat. 38 was subsequently used as the *modello* for some other work. The squaring was perhaps added to give the copy the appearance of a genuine preparatory study – there was a ready market for Giulio's drawings, and copies may well have been made expressly to satisfy this demand. An analogous case is the set of four large, damaged copies at Windsor after designs for the walls of the Sala dei Giganti (fig. 66),[3] apparently by the same hand as cat. 38, probably a member of

Giulio's workshop. As they are not squared or indented it is unlikely that they served as preparatory sheets, but their size and level of finish show that great care was taken over their production. Although a tradition that they were given by Giulio to Baldassare Castiglione cannot be true (as Castiglione died three years before work on the Sala began), they may indeed have been produced as a souvenir of the room and of Giulio's imagination for some equally eminent visitor to the Palazzo Te.

NOTES
1. See Davari 1904, pp. 53ff., and Mantua 1989, pp. 365ff.
2. Sotheby 1972, no. 43; Mantua 1989, p. 378.
3. Popham and Wilde 1949, nos. 374–77.

LITERATURE
Popham and Wilde 1949, no. 363; London 1981–82, no. 167; Mantua 1989, p. 378

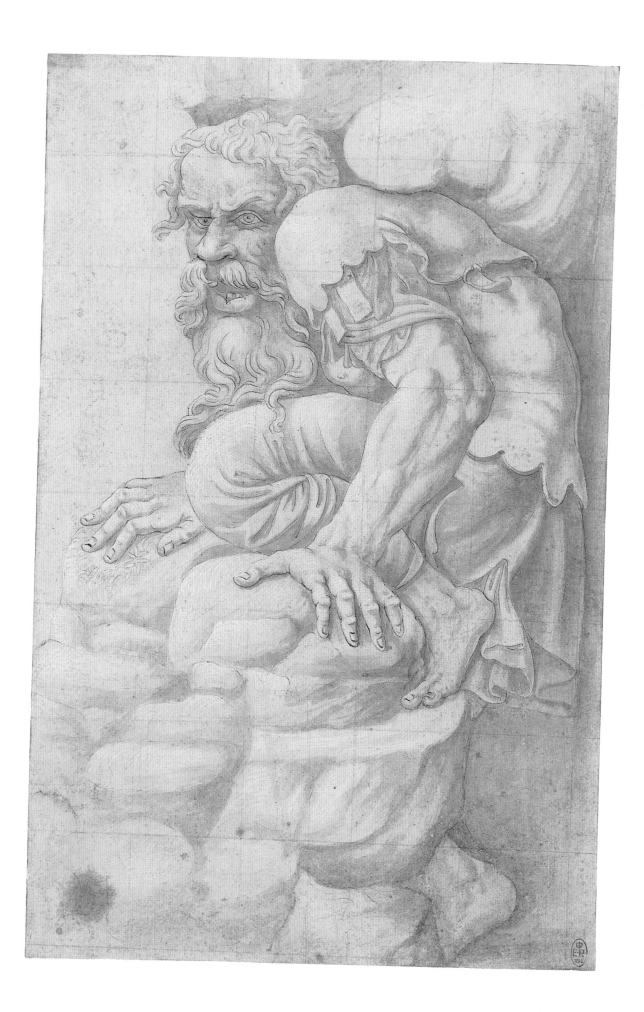

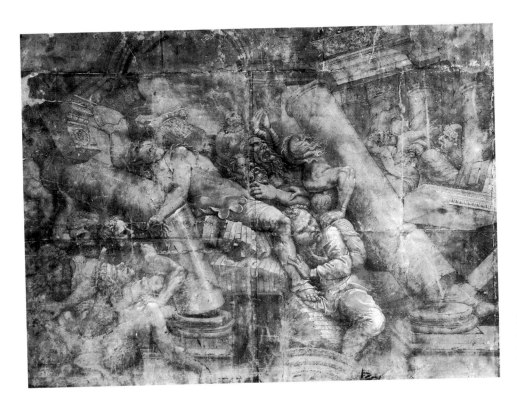

39
ATTRIBUTED TO GIULIO ROMANO

A classical bust (Hercules?)

Pen and iron-gall ink; iron-gall wash

ca. 1535

Verso blank

208 × 175 mm

Watermark: anchor in circle with six-pointed star

RL 2275

Provenance: George III (Inv. A, p. 77, *Caracci Tom. 10*, "11 Studies of Heads, small, mostly with a Pen.")

This drawing came from the Carracci volumes at Windsor assembled in the eighteenth century and was catalogued as "close to Agostino's manner" by Wittkower. Nicholas Turner recognized in 1992 that the drawing is by "Giulio Romano, or a close follower" (note on the former mount). The repeated decorative outlines seen here are almost a signature of Giulio and his school, and the confident handling of both pen and wash justifies an attribution to the master himself.

The facial type is that routinely used for representations of Hercules. No existing project has been identified for which the drawing might be preparatory; it is not related to the painted antique busts in the Sala dei Cavalli of the Palazzo Te, and it cannot be for a medal, where Hercules is nearly always shown in some narrative context and where busts are almost always in profile. It is customary to relate any unexplained representation of Hercules to some noble Ercole, such as Ercole II Gonzaga or Ercole d'Este, but that is often pure speculation.

The style is that of drawings of the mid-1530s, such as the *modello* for the stucco medallion of *Ganymede* in the Camerino dei Falconi.[1]

NOTES
1. New York, Pierpont Morgan Library, inv. IV, 15; Mantua 1989, p. 284.

LITERATURE
Wittkower 1952, no. 242

40

GIULIO ROMANO

Apollo and Pan (?)

ca. 1535

Charcoal underdrawing; pen and iron-gall ink; the figure of Pan
squared in charcoal at 34 mm
Verso blank
232 × 198 mm
Watermark: anchor in circle, cut
RL 0495

This is Giulio at his most characteristic, with strong contours
and a bold sense of flat pattern, and careless passages (the left
arm of Apollo) alongside quite brilliant details such as the head
of the gryphon or the legs of Pan. The precise subject has not
been determined, for it is unusual to find Apollo playing the
pipes rather than the lyre. There is no connection between this
drawing and *The Contest of Apollo and Pan* in the Camera di
Ovidio of the Palazzo Te, for which there is a cartoon in the
Albertina,[1] nor with another drawing of the subject at
Chatsworth.[2] The roughly circular form of the composition
might suggest a connection with the small *tondi* of satyric
subjects found in several places in the Palazzo Te, but no
similar composition can be found there.

Hartt identified the subject of both this drawing and the
Camera di Ovidio painting as *Apollo and Marsyas*, though the
same objection about Apollo's instrument applies, and Ovid
did not describe the contest between Apollo and Marsyas, only
its grisly result. Hartt also connected the sheet with a
stylistically identical drawing of *Hercules resting* now in the
Getty Museum (fig. 67).[3] Noting the emphasis on the contours
and the casting of shadows on to a flat background, he
suggested that both might be studies for stuccos on the walls
surrounding a hanging garden in the grounds of the Palazzo
Ducale, Mantua, on the site of the present Cortile dei Cani.
This garden disappeared in the reconstructions of Duke
Guglielmo in the latter half of the sixteenth century and no
visual record of its form survives. A suggested association of
the Getty *Hercules* with a putative project for Ercole d'Este is
probably ruled out by the present drawing, which must be *en
suite* and has no Herculean connection.

The Getty drawing is blackened on the verso and indented,
and Stock therefore suggested that it was a study for an

Fig. 67 Giulio Romano, *Hercules resting*, pen and ink, the contours indented,
254 × 204 mm. Los Angeles, J. Paul Getty Museum, inv. 88.GA.128

unexecuted print;[4] the squaring of the figure of Pan here
would also support the proposal that both were studies for
some two-dimensional context. However, such mechanical
methods could simply be a stage in the preparatory process and
need not reflect the final transfer to a support.

There are copies of the drawing in the Louvre[5] and, from
the workshop of Jacopo Strada, in the Österreichische
Nationalbibliothek, Vienna.[6]

NOTES
1. Birke and Kertész 1992–97, III, no. 14192.
2. M. Jaffé 1994, no. 220.
3. Goldner and Hendrix 1992, no. 18.
4. Sotheby 1972, no. 52.
5. Inv. 32567; Rosenberg and Prat 1994, no. R836.
6. Handschriftensammlung, Cod. Min. 21, III, f. 8; Jansen 1989, p. 370.

LITERATURE
Popham and Wilde 1949, no. 349; Hartt 1958, pp. 165, 186, 301, no. 239;
Blunt 1971, p. 88; Goldner and Hendrix 1992, p. 56

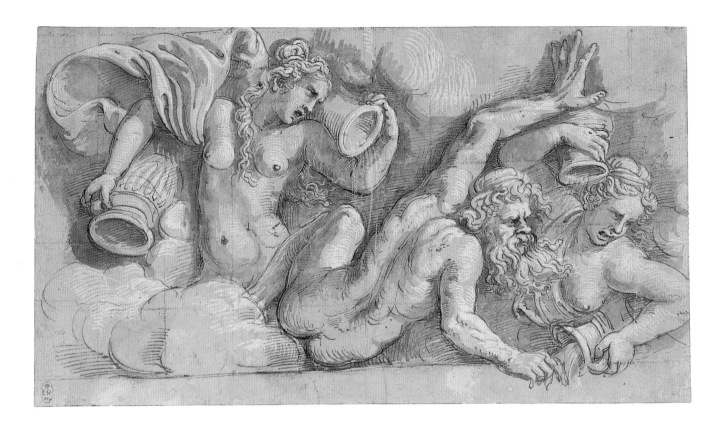

41

GIULIO ROMANO

A wind-god and two rain-goddesses among clouds

ca. 1536

Paper washed buff; pen and iron-gall ink; iron-gall wash; lead–white bodycolour; the outlines indented; squared in charcoal at 27 mm
Verso blank
150 × 269 mm
Watermark: anchor in circle (cut)
RL 0304

This is a study for a ceiling fresco (fig. 68) painted by Giulio's workshop in the Camerino dei Cesari of the Palazzo Ducale, Mantua. This room was conceived around a set of eleven portraits of Roman emperors commissioned from Titian, for which Giulio provided a setting of stucco frames and narrative panels below (see cat. 42). Work on the Appartamento di Troia began in 1536 and the Camerino was ready for the delivery of Titian's paintings in May 1537, by which date the ceiling must have been finished. The room was broken up when the Gonzaga collections were sold to King Charles I in 1627, and the surviving portions of the damaged ceiling were revealed by cleaning only in 1928.

The ceiling can be read as depicting the celestial forces to which even the emperors were subject. The surviving fresco of

Diana presumably faced a representation of *Apollo*, symbolizing night and day. The present drawing shows a wind-god and two rain-goddesses; a sheet in Berlin studies a cloud-borne youth bearing thunderbolts;[1] and at Chatsworth is a drawing of a woman, again among clouds, with a riddle into which water and grain are being poured, all symbolizing the uncertainties of the weather and of plenty or drought and famine.[2] The same celestial fatalism can be found in Giulio's decorations of the Sala dei Venti in the Palazzo Te.[3]

Cat. 41 and the Berlin and Chatsworth drawings mentioned above are all finished with wash and (except the Berlin study) white heightening, not carefully but explicitly in the necessary details, and squared, presumably for enlargement to a cartoon. Some of the outlines are also indented, implying that the design was transferred to another sheet; this would not have been a necessary part of the composition process for the Camerino ceiling, and may be evidence of workshop copying or the subsequent reuse of the motifs.

NOTES
1. Hartt 1958, no. 231.
2. *Ibid.*, no. 229; Mantua 1989, p. 404; M. Jaffé 1994, no. 211. That figure has been misidentified as the Vestal Virgin Tuccia, an iconographer's knee-jerk response to the sight of a sieve or riddle.
3. See Gombrich 1950.

LITERATURE
Popham and Wilde 1949, no. 353; Hartt 1958, pp. 176, 185, 301, no. 230; Mantua 1989, p. 404

Fig. 68 Workshop of Giulio Romano, A *wind-god and rain-goddess*, fresco. Mantua, Palazzo Ducale, Camerino dei Cesari

42

GIULIO ROMANO

An Omen of the Greatness of Augustus

ca. 1536

Black-chalk underdrawing; pen and iron-gall ink; iron-gall and (mainly) bistre wash; squared in black chalk at 30 mm; the outlines indented
Verso blank
374 × 239 mm, upper right corner made up
No watermark
RL 0308
Provenance: Bonfiglioli or Mead (see text)

This is a study for the right-hand portion of a panel installed below Titian's portrait of Augustus in the Camerino dei Cesari of the Palazzo Ducale, Mantua (see cat. 41), one of a series depicting events from the lives of the emperors. As Ruland observed, the episode depicted is found in Suetonius's *Lives of the Twelve Caesars* (II, 94), in a chapter concerning the omens that occurred throughout Augustus's life:

"When Augustus was still an infant, as is recorded by the hand of Gaius Drusus, he was placed by his nurse at evening in his cradle on the ground floor, and the next morning had disappeared; but after a long search he was at last found lying on a lofty tower with his face towards the rising sun."

The panel of the *Omen* is lost; however three of the series survive at Hampton Court and one in the Louvre, and these establish that the panels were painted (rapidly) by several members of Giulio's workshop and not by the master.[1] The lost panels can be reconstructed from preparatory studies, prints, and a series of drawings of the walls by Ippolito Andreasi, now in Düsseldorf.[2] Hartt's connection of cat. 42 with the Camerino dei Cesari made it possible to identify all the narratives in Suetonius.

A study for the left half of the *Omen* is in the Albertina (fig. 69).[3] The Andreasi copy of the *Omen* panel (fig. 70) shows that the portions of the design seen in the Windsor and Vienna drawings overlapped, turning an oblong composition into a square. It is thus probable that the two sheets are fragments of a single large study divided by Giulio during the preparatory process, and that the stylus indentation was used (together with a second sheet rubbed with chalk) to transfer the outlines of the two portions on to what would become the *modello*. But the present sheet is also squared, and without the evidence of all the drawings used in the creative process this apparent use of two independent transfer techniques cannot be fully explained.

The whole composition was engraved on a smaller scale by Giulio Bonasone[4] in its original oblong format and thus from a preparatory drawing (or copy thereof) rather than from the painting; the same is true of a copy by Biagio Pupini at Christ

Fig. 69 Giulio Romano, *An Omen of the Greatness of Augustus* (left half), black–chalk underdrawing, pen and ink, wash, squared in black chalk, the outlines indented, 244 × 292 mm. Vienna, Albertina, inv. SR 264

42

Church, Oxford.[5] A drawing of the composition at Besançon is a poor seventeenth-century copy after the print.

Jonathan Richardson saw framed in the Palazzo Bonfiglioli in 1719: "*Giulio*. Five Figures and a Cradle; two pointing up to a Boy lying on a Ruin, Other Figures in the Sky, the same as one Dr *Mead* has of this Master, and that of *Biaggio Bolog* [Pupini] my Father has." This was probably identical with that in the 1696 Bonfiglioli inventory: "*Un disegno con Istoria o favola di mano di Giulio Romano con cornice, e cassetta dorata, e vetro.*" The number of figures stated by Richardson corresponds not with the whole composition but with cat. 42; however, he also noted on his father's copy of the whole composition by Pupini, now at Christ Church: "The Original Design of this is in the Collection of Bonfiglioli at Bologna; 'tis of Giulio

Romano. Dr Mead has a Sketch with a Pen of a part of it", which implies that he had seen the full composition in Bologna. There are drawings in the Royal Collection from both the Bonfiglioli and Mead collections, and Richardson's evidence does not establish which was the source of cat. 42.

NOTES
1. Shearman 1983, nos. 117–19, and Bacou and Béguin 1983–84, no. P2.
2. For the Andreasi copies see Verheyen 1966.
3. Birke and Kertész 1992–97, I, no. 221.
4. Bartsch XV, p. 155, no. 174.
5. Byam Shaw 1976, no. 468.

LITERATURE
Richardson 1722, p. 31; Woodward 1863, p. 165; Ruland 1876, p. 163; Popham and Wilde 1949, no. 350; Hartt 1958, pp. 171, 300, no. 225; Blunt 1971, p. 88; Byam Shaw 1976, p. 138; Mantua 1989, p. 401; Birke and Kertész 1992–97, I, p. 129; Massari 1993, p. 66

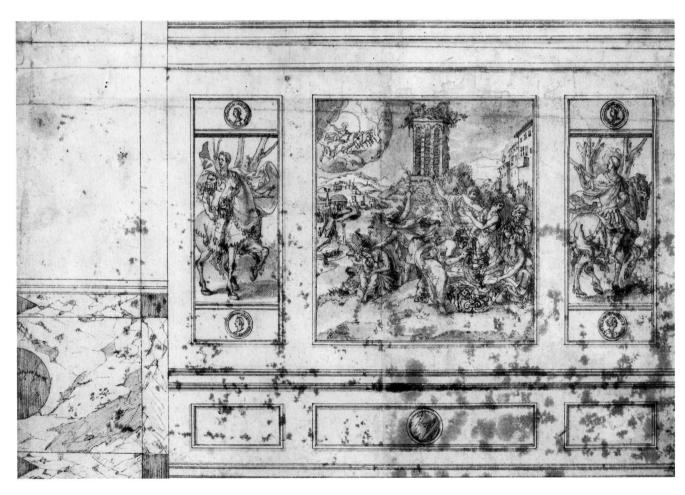

Fig. 70 Ippolito Andreasi, *A detail of the Camerino dei Cesari*, black-chalk underdrawing, pen and ink, wash, 318 × 477 mm. Kunstmuseum Düsseldorf im Ehrenhof, Sammlung der Kunstakademie, inv. 10878

43

GIULIO ROMANO

A design for a bowl decorated with swans

ca. 1542

Black-chalk underdrawing; pen and iron-gall ink; iron-gall wash; a
little lead-white bodycolour
Verso blank
175 × 235 mm
No watermark
RL 5453

Although Giulio was inundated with commissions of every
nature during his years in Mantua, his productivity in what is
sometimes considered the minor field of metalwork design was
prodigious: Hartt catalogued ninety-one autograph drawings
and many more are known through copies.[1] Not one piece
executed to Giulio's design is known to survive, for silver was
routinely melted down, often to make new pieces as tastes

changed, and what we have today is the tiniest fraction of what
was produced during the sixteenth century, when every house-
hold of note would have possessed silver tableware.

It is probable that Giulio's activity in this field reflected a
special interest of the artist or of his Gonzaga patrons, or maybe
both. The *credenza* in the fresco of *The Feast of Cupid and Psyche*
(Sala di Psiche, Palazzo Te) is laden with metalwork just as
fantastic as Giulio's drawn designs, and he clearly took delight
in such *capricci*. But this was tempered by a craftsman's
conscientiousness, for he emphasized to patrons the need to
make plastic models for complex designs and to be on hand as
the craftsman made the piece. The large number of surviving
sheets is explained partly by Giulio's habit of keeping a record
of his designs, often inscribed with the name of the patron: in a
letter of 23 June 1546 to Ferrante Gonzaga, the brother of
Duke Federico and one of Giulio's main patrons for metalwork
designs, Giulio especially asked that an enclosed drawing be
returned since he had kept no copy of it.[2]

Fig. 71 Giulio Romano, *A design for a salver*, pen and ink, wash, 290 × 437 mm. Devonshire Collection, Chatsworth, inv. 104

Popham's attribution of the present sheet to Giulio is secure, despite being neglected by Hartt. It can be grouped with six other designs incorporating fluvial motifs (ducks, swans, fish, rushes and so on), all probably for a single set of tableware.[3] As Martineau pointed out,[4] one of these, now at Chatsworth (fig. 71), showing a whirlpool of water and sea-creatures coursing into the mouth of a grotesque face at the centre of a bowl, may be identified with that described in a letter of 24 February 1542 sent by Giulio to Ferrante Gonzaga in Sicily. Giulio wrote of a design for "a pitcher and a bowl, in which is a representation of rain swirling around and being swallowed up by a whirlpool, the pitcher being likewise finished with droplets gathering in waves", and asked that the designs be executed in Mantua, both so that he would be able to oversee the manufacture and, rather speciously, because the

fish available in Mantua could serve as models: "In truth, the design needs to be made there, because there is nourishment for the eye in the variety of fish, which should be seen from the life."[5]

NOTES
1. Hartt 1958, nos. 48–138; see U. Bazzotti in Mantua 1989, pp. 454–65, and New York 1997, pp. 94–112, for a fuller discussion of Giulio's metalwork designs.
2. Ferrara 1992, II, p. 1150.
3. These are at Chatsworth (M. Jaffé 1994, no. 224); the British Museum (Pouncey and Gere 1962, nos. 120f.); Christ Church (Byam Shaw 1976, nos. 420f.); and formerly in the Ellesmere collection (Sotheby 1972, no. 6).
4. In London 1981–82, p. 195.
5. Ferrara 1992, II, pp. 946f.

LITERATURE
Popham and Wilde 1949, no. 356

44

GIULIO ROMANO

St Blaise

ca. 1540–46

Black-chalk underdrawing; pen and iron-gall ink; iron-gall wash;
lead-white bodycolour on the staff; squared in charcoal at 31 mm
Verso blank
357 × 254 mm, the lower left corner restored
No watermark
RL 0508

St Blaise (in Italian *San Biagio*), a fourth-century Armenian
bishop, was martyred by having his flesh scored with iron
combs, before being beheaded along with two boys. On
account of the instruments of his torture he was adopted as the
patron saint of wool-combers, and commissions depicting him
often came from the guild of that trade.

Here Giulio has shown St Blaise accompanied by his co-
martyrs, who bear the wool-combs. The purpose of the
drawing is unknown; a free copy in the Fogg Art Museum
(fig. 72) was made before the original was cut down and shows
more of the tableau in the foreground. The pillow-like rocks,
the absence of any elements not fully grounded and of any
background or atmospheric effects, and the pyramidal com-
position with the saint's enveloping cloak, suggest that the
design was perceived by the copyist as a three-dimensional
object, and Giulio's drawing may have been a design for a
statuette. Cat. 44 is squared, which is not a practical way of
transferring a flat design to a rounded sculpture, but given the
care of the drawing and the lack of pentimenti this squaring
might instead have served to transfer the outlines of an earlier
sketch to the present sheet.

The drawing is datable towards the end of Giulio's career,
for it has the elongated proportions, tightly folded draperies
and less calligraphic penwork of his late drawings. Hartt
suggested that it was a pendant to the *Woman standing on a
dragon* in the British Museum,[1] though the two have nothing
in common other than their late dating. At Chantilly is another
drawing by Giulio of *St Blaise*, seated and again flanked by two
children bearing wool-combs;[2] that group also seems to have
been conceived as a three-dimensional object, but the com-
position and emotional pitch are very different and its style
places the Chantilly drawing several years earlier than cat. 44.

NOTES
1. Pouncey and Gere 1962, no. 82.
2. Peronnet 1997, no. 23.

LITERATURE
Popham and Wilde 1949, no. 354; Hartt 1958, pp. 251, 308 no. 355; Pouncey
and Gere 1962, p. 63

Fig. 72 Copy after Giulio Romano, *St Blaise*,
black-chalk underdrawing, pen and ink,
174 × 190 mm. Cambridge MA, Fogg Art
Museum, inv. 1978.540

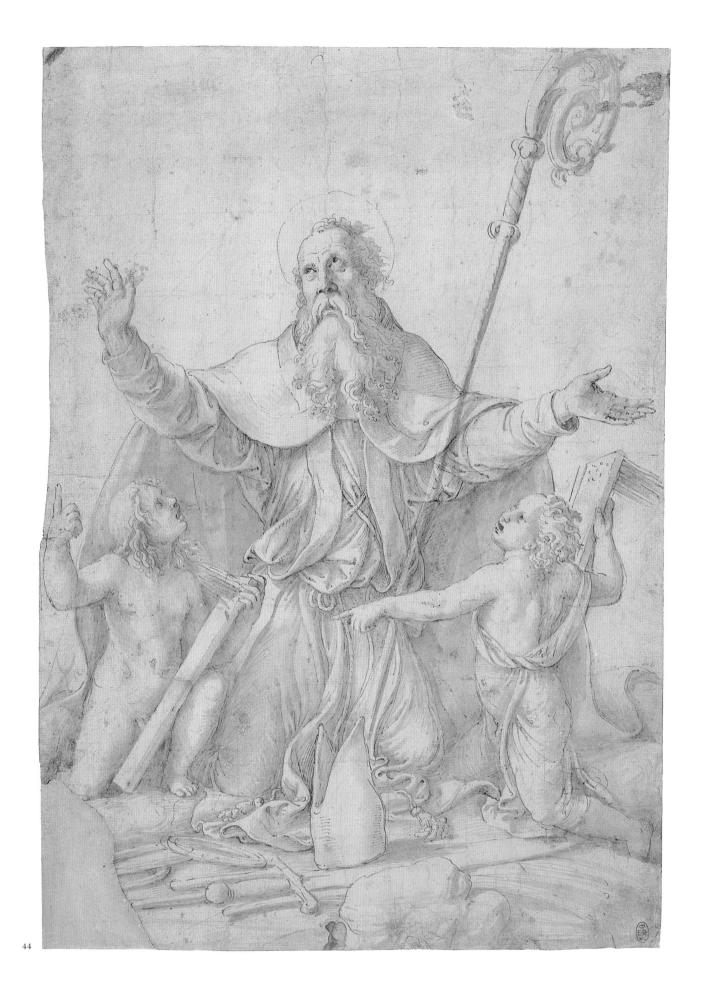

45

WORKSHOP OF GIULIO ROMANO

Vulcan, Venus and Cupid

ca. 1540?

Pen and iron-gall ink; iron-gall wash; lead-white bodycolour; squared in black chalk at 23 mm; the outlines of Vulcan indented; some staining
Verso blank
249 × 205 mm (max., excluding restored area at lower right); shaped
Watermark: anchor in circle
RL 0302
Provenance: George III (probably Inv. A, p. 133, *A Large Portfolio of Drawings*, no. 12, "Vulcan, Venus and Cupid", unattributed)

Vasari wrote in his *Life* of Giulio:

"After completing these works, Giulio painted a fresco over a chimneypiece for his great friend Messer Girolamo, the organist of the Duomo of Mantua. The fresco shows Vulcan working the bellows with one hand; with the other he holds between a pair of tongs the iron of an arrow that he is making, while Venus tempers in a vase some of the arrows already made, and places them in the quiver of Cupid. This is one of the most beautiful works that Giulio ever made, and little else in fresco can be seen from his hand."[1]

This description corresponds perfectly with the present drawing, which, from the subject and shape, had already been interpreted by Popham as a design for a chimney-breast, without relating it to Vasari's account. The fresco is long since lost, but Vasari's testimony that Giulio painted it himself is presumably reliable as he implicitly acknowledges that most of the frescos produced to Giulio's designs were executed by assistants. It is odd, therefore, that the present drawing appears to be by an assistant and not by Giulio: in the frescos of the Palazzo Te and Palazzo Ducale Giulio provided designs for his assistants to paint (see cat. 36, 38, 41f.), and an inversion of this procedure is implausible. It may be supposed that Vasari was mistaken, which, given the specificity and first-hand nature of the information, is unlikely; or that cat. 45 is a copy, though it has the rough feel of a preparatory work; or that it is a strictly mechanical sheet by an assistant, clarifying a study provided by Giulio and squaring it for enlargement to the chimney-breast,

at which stage Giulio would step in and execute the fresco. This last seems most acceptable.

Vasari's account cannot be used to date the work, which comes after a description of a miscellaneous group of panel paintings, and the style of the assistant's drawing is of little help. The careful spatial integration of the figures suggests Giulio's later maturity, but the date of around 1540 given here is merely a guess.

The composition bears no relationship to that of *The Forge of Vulcan*, one of the stuccos on the ceiling of the Sala degli Stucchi in the Palazzo Te, nor to a composition of *Venus, Vulcan and Cupid with five putti* known through a painting in the Louvre (and several other versions), probably produced in Giulio's workshop shortly after Raphael's death.[2] The figure of Vulcan is, however, a repetition of that in a drawing of *Vulcan, Venus and Cupid* also in the Louvre, where the god is shown full length (fig. 73).[3] That sheet has the technical features of others from Raphael's studio towards the end of his life, and was related by Cordellier and Py to a project described by Vasari in his *Life* of Vincenzo Tamagni and otherwise undocumented,[4] a decoration designed by Raphael and painted by Tamagni on the façade of the house of Gianantonio Battiferro in the Borgo, the subject being a pun on the patron's name ('ironbeater'). In Vasari's account of that scheme there is no mention of the presence of Venus, and the weakness of the composition of fig. 73 (in contrast to the vigorous pose of Vulcan) suggests that it might be a pastiche of Raphael's design for Battiferro.[5] It is quite possible that Giulio inherited a drawing for the Battiferro scheme along with Raphael's studio effects, and utilized the figure of Vulcan when he was asked to design a similar composition years later.[6]

NOTES
1. Vasari 1568, II, pp. 334f. The identity of "Messer Girolamo" is unknown.
2. Bacou and Béguin 1983–84, no. P4; see Cordellier and Py 1992, pp. 489f.
3. Cordellier and Py 1992, no. 859.
4. Vasari 1568, II, p. 112.
5. The group of Venus and Cupid there recurs in a drawing, possibly by Penni, of *Venus, Cupid and Minerva in the forge of Vulcan*, with Boerner in 1971 (Catalogue 57, no. 41).
6. In a confusing account of the Battiferro and Mantua *Vulcan*s, Massari attributed the present drawing to Vasari "but clearly influenced by an idea of Giulio's". The drawing, however, bears no resemblance to Vasari's style.

LITERATURE
Popham and Wilde 1949, no. 386; Massari 1993, p. XIX

45

46

ATTRIBUTED TO GIULIO ROMANO

Cupid sharpening an arrow

ca. 1540?

Paper washed blue on both sides (much darker on the verso); pen
and iron-gall ink; iron-gall wash; lead-white bodycolour; some of
the outlines indented
Inscribed (by the so-called Deceptive Hand) lower centre, pen and
ink, *Scuola di Rafael*
Verso blank
169 × 132 mm
No watermark
RL 0295A

This jewel-like drawing was catalogued by Popham as a copy
after Giulio; Hartt later claimed it as autograph. The status of
such densely and carefully executed sheets can be impossible to
determine with any degree of certainty. After his arrival in
Mantua Giulio's drawing ceased to be rooted in study from the
life, and the consequent artificiality of his style, with stock
types and formulae for profiles, hands and so on, was readily
imitable by an assistant. A good copy of the present sheet is in
the Albertina,[1] a little coarser in its details and a little
disproportionate in the limbs; the contrast between the two
highlights the essential harmony of invention and execution in
cat. 46 that suggests that it is by Giulio himself.

The high level of finish probably indicates that the sheet is
not a working drawing, though Giulio was capable of bringing
such sheets to a high level of finish when providing designs for
other artists: the New York study of *St Andrew in Glory*, drawn

46

for the painting by Rinaldo Mantovano of *The Rediscovery of the Sacred Blood* in Sant'Andrea, Mantua, is very similar in technique and finish to the present sheet.[2] The adolescent Cupid is of the type used by Giulio throughout his mature career. He has the same physical features, down to the coiffure, as the Cupid in cat. 45, and given the thematic link it is conceivable that it was somehow connected with the chimney-breast project for "Messer Girolamo", perhaps as a subsidiary scene. The date of around 1540 that follows from that connection is no less uncertain than was Hartt's suggestion of *ca.* 1530.

NOTES
1. Birke and Kertész 1992–97, I, no. 320.
2. Mantua 1989, p. 432.

LITERATURE
Popham and Wilde 1949, no. 378; Hartt 1958, pp. 225, 305, no. 296

PERINO DEL VAGA

Piero Buonaccorsi, born 1501 in Florence; moved to Rome *ca.* 1516, soon entering Raphael's workshop, where primarily engaged on the Vatican Loggia; after Raphael's death worked on several fresco schemes in Rome. In 1528 moved to Genoa into the service of Andrea Doria; from 1534 also in Pisa. Around 1537 returned to Rome, where he soon became Pope Paul III's principal painter, working in the Sala Regia and decorating the papal apartments in the Castel Sant'Angelo along with many minor projects. Died in 1547.

47

PERINO DEL VAGA

Two soldiers carrying off a young man

ca. 1520

Charcoal underdrawing; pen and iron-gall ink; iron-gall wash; a little white chalk

Verso: Figure studies

Pen and iron-gall ink
280 × 193 mm
Watermark: lion rampant in circle, with six-pointed star
RL 0344

Although the old mount carried an attribution to Giulio Romano, Popham catalogued this drawing as from the end of the sixteenth century, suggesting that it may have been copied from Polidoro. It has not since been mentioned in the literature. The heavily hatched and notch-accented style seemed to the author to be very reminiscent of some of the heterogeneous group of drawings often attributed to Gianfrancesco Penni, and was to be included in the exhibition on these grounds; but when the sheet was lifted from its old mount for conservation, sketches were found on the verso that are clearly by the young Perino del Vaga.

The handling of these studies on the verso is that of the miscellaneous sheets from the start of Perino's career, such as that in Turin including improvisations after Michelangelo's *Battle of Cascina* cartoon, or that including a seated Hercules in the British Museum (fig. 74).[1] The awkward anatomy of the man's back at upper centre is found throughout Perino's career in his less spontaneous drawings. The kneeling figures appear to be ideas for an *Adoration*, and to the lower left is a God the Father in Perino's familiar looping decorative style. None of these sketches can be associated with a known project.

The drawing on the recto of the sheet is more elaborately finished but clearly by the same hand as the verso. Before the heavier accents were applied, the muscles were outlined with thin undulating lines to form strange sausages of flesh, in exactly the manner of the large sketch at upper centre on the

verso or of a study of a horse on another early sheet in the Uffizi.[2] The profile of the central figure is found repeatedly in early Perino, for example in the figure at lower right in fig. 74, or in the study for the Vatican Logge *David and Bathsheba* (fig. 9, p. 21). The vigorous hatching and cross-hatching are not readily associated with Perino del Vaga, lacking his usual light fluency, but his authorship of the drawing seems indisputable.

The stylistic comparisons made above probably date the sheet to around 1520. The subject has not been identified: it seems to be fragmentary, showing a portion of a battle scene and an abduction of some sort, though the youth being carried away grins broadly at the spectator. The figure types bear general resemblances to those in the socle scenes of the Sala di Costantino; in September 1520, *Prisoners brought before Constantine* was being considered as a scene for the Sala, and a drawing at Chatsworth of *Figures before a ruler* may be connected with this project.[3] The group at lower left of the Chatsworth sheet is very close in conception to the present drawing, but that sheet is drawn much more mechanically, albeit in a similar technique, and is reasonably attributable to Penni.

After Raphael's death, Giulio and Penni could hardly have worked without assistants in the Sala di Costantino, and although Perino is not recorded in connection with the project it is probable that he retained some contact with the workshop. A study in the Louvre for one of the socle scenes,[4] while not strong enough to be by Perino himself, unmistakably shows knowledge of his early pen-and-white style. Cat. 47 may be another reflection of these artists' continuing association.

NOTES
1. Respectively Parma Armani 1986, p. 14, and Pouncey and Gere 1962, no. 165r.
2. Inv. 701-F; Davidson 1966, no. 1.
3. M. Jaffé 1994, no. 286.
4. Cordellier and Py 1992, no. 944.

LITERATURE
Popham and Wilde 1949, no. 1153

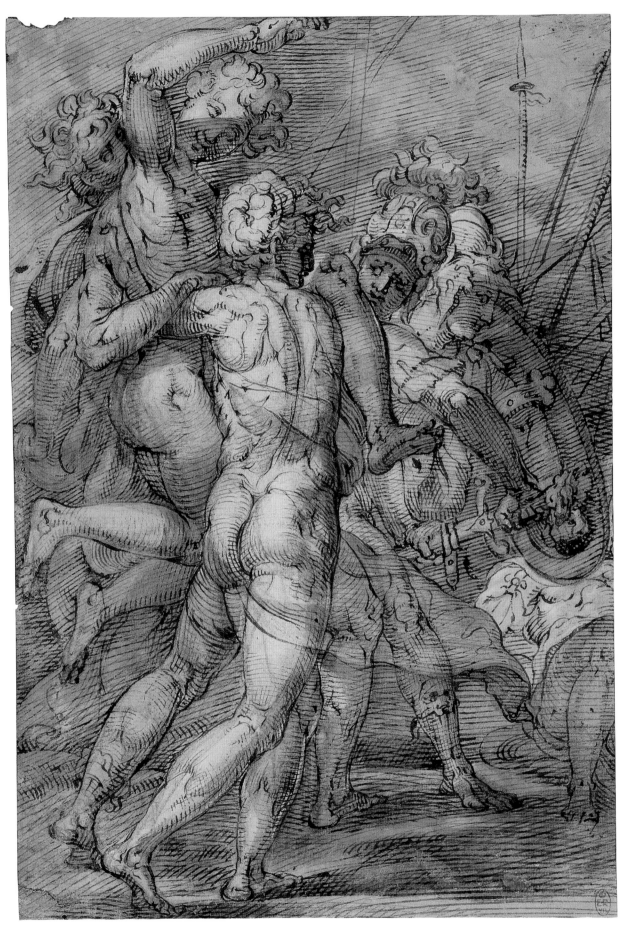

47r

Fig. 74 Perino del Vaga, *Figure studies*, pen and ink, 286 × 206 mm. London, British Museum, inv. 1948-7-10-6

ATTRIBUTED TO PERINO DEL VAGA

Jonah

ca. 1520–23

Paper washed buff; black-chalk underdrawing; pen and iron-gall ink;
lead-white bodycolour
Inscribed lower right, pencil, *Raffaell*

ATTRIBUTED TO
GIANFRANCESCO PENNI

Verso: Figure sketches

Black chalk; pen and iron-gall ink
304 × 200 mm
No watermark
RL 0804

Fig. 75 Lorenzetto, *Jonah*, marble. Rome, Santa Maria del Popolo, Cappella Chigi

The figure on the recto is a version of the sculpture (fig. 75) carved by Lorenzetto (Lorenzo Lotti, 1490–1541), and said to have been designed by Raphael, for the Chigi chapel of Santa Maria del Popolo, Rome (see also cat. 21–22). Shearman noted that the design must have been finalized by 1519, as one of the stucco roundels in the Vatican Logge reproduces a view of the statue in low relief.[1] Raffaello da Montelupo, according to his autobiography, completed the companion sculpture of *Elias* in Lorenzetto's studio in 1523 or shortly afterwards; he does not mention the *Jonah*, and it is likely that Lorenzetto had finished that sculpture before he left Rome in 1522.

Raphael's model for Lorenzetto may have been a drawing or, more likely, a small plaster or wax *bozzetto*, but it cannot have been a drawing of this aspect, which shows the form at its most foreshortened and thus from the angle least helpful for the sculptor. Further, if it were the model for the sculptor there would be no accounting for Lorenzetto's major deviations from the design, in the angle of the head, the twist of the body and the form of the drapery (the apparent pentimento in the left arm seems to be more of a correction of an error than a creative decision). It must instead be a derivation from the designs for the sculpture, for a context in which two-dimensional pattern but not three-dimensional explicitness was important.

In recent years the drawing has usually been attributed to Gianfrancesco Penni, as one of a group of more or less finished drawings from Raphael's immediate circle. Oberhuber, however, has argued that this is too generous a view of Penni,[2] and that the author of such enervated drawings as the British Museum *Dormition and Coronation* (fig. 3, p. 15), one of the core sheets of the Penni group, would not be capable of a drawing as powerful as *Jonah*. However, he goes too far in giving cat. 48 to Raphael: the technique in itself is not unparalleled among Raphael's drawings, for a disputed but probably autograph study in the Albertina for the *Coronation of Charlemagne* is drawn in similarly hard pen-and-white on washed paper,[3] but the handling of cat. 48 does not resemble that of any drawings certainly by Raphael. Oberhuber's attribution to Raphael is based only on an appreciation of the drawing's quality, and he excuses the stylistic incompatibility by citing its supposed unfamiliar function, as a model for sculpture. As stated above, this is one function that the drawing cannot have had.

The attribution of the drawing here to Perino del Vaga is based on the great similarity of its style to that of cat. 47, a new

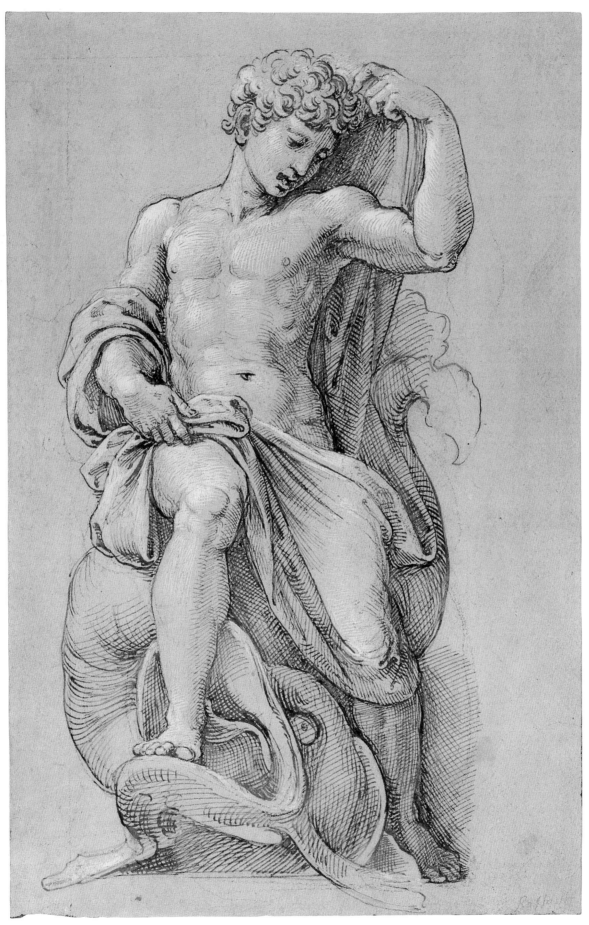

48r

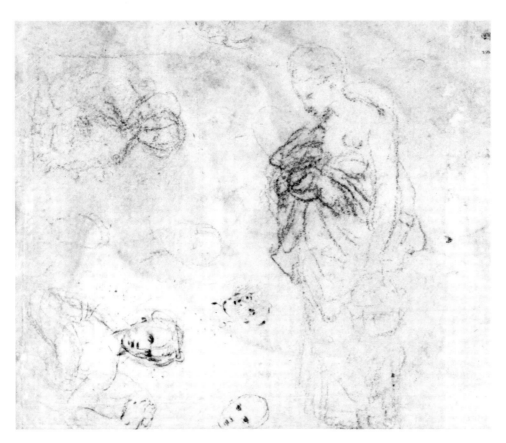

piece in the puzzle of the 'Penni group' drawings. The technique, the bold hatching and cross-hatching, the hard, well defined locks of hair, even such morphological details as the feet at the lower right of each sheet, all are the same. This manner is not normally associated with Perino, but it is found in a few of his later drawings such as the Budapest *St George and the Dragon*[4] and the *Sea-monster* (cat. 58), perhaps ten and twenty years later respectively than cat. 48 but with many common features. In the face of this stylistic evidence an attribution to Perino seems unavoidable.

From this it must follow that Perino was the draftsman of the stylistically identical *Rape of Lucretia* (cat. 49) and *Venus, Vulcan and Cupid* in the Louvre.[5] Three other drawings that are usually cited as belonging to this group, *Figures before a king* at Chatsworth,[6] an *Antique festival* in the Ecole des Beaux-Arts, Paris,[7] and a *St Michael* in Oslo,[8] are drawn in the same manner but are monotonous and much flatter, and despite the superficial similarity of technique they must be by a different hand, plausibly Penni. A drawing of *St John the Baptist in the Wilderness* in Edinburgh that shares many technical features with this group is much less confidently drawn and is probably a copy of a lost sheet.[9]

Of these, *The Rape of Lucretia, Venus, Vulcan and Cupid* and *St Michael* served as models for engravings by Agostino

Veneziano, and the *Baptist* corresponds closely to the figure in a chiaroscuro woodcut by Ugo da Carpi.[10] All appear to be based on designs by Raphael. Those probably by Perino are a little more assured and coherent than cat. 47 and would suggest a date in the early 1520s, when it is reasonable to suppose that Raphael's inventions were being recycled in his posthumous workshop under Giulio and Penni (for example the Scuola Nuova and *Giuochi di putti* tapestry designs) and when, as discussed under cat. 47, it is probable that Perino continued to be involved to some degree with the studio. The route from drawing to print was not as direct as was Raphael's production of designs for the engraver (see cat. 20, 24, 29), and several years elapsed between drawing and print in at least one case (the *Venus, Vulcan and Cupid*, dated 1530 on the plate); nonetheless, the clearly resolved character of the drawings does suggest that they were produced with printmaking in mind. A catalyst for this activity might have been the cessation of work in the Sala di Costantino during the brief pontificate of Adrian VI (1522–23).

It is therefore proposed that the *Jonah* was intended as a model for an unexecuted print. The three-tone technique of buff ground, dark pen and white heightening would be perfect for a two-block chiaroscuro woodcut; lines ruled in chalk along the left and right sides and top of the figure in cat. 48

Fig. 76. Attributed to Giulio Romano and Gianfrancesco Penni, Spinola *Holy Family*, panel, 778 × 619 mm. J. Paul Getty Museum, Los Angeles

would define the required size of the line block. That said, *The Rape of Lucretia* (cat. 49) was executed in the same technique and was used for an engraving, not a woodcut.

There are copies of the drawing at Dresden and on the art market.[11]

<p style="text-align:center">★ ★ ★</p>

The sketches on the verso are quite unlike the *Jonah* in character. The largest study, in black chalk only, is of the maiden in the Spinola *Holy Family* by Giulio Romano, in the Getty Museum (fig. 76).[12] Joannides (1982) compared the style and type of the verso sketches with those drawings most reasonably attributed to Gianfrancesco Penni, later (1985) suggesting that Penni might indeed have painted the figure of the maiden in the Getty panel. These proposals are perfectly acceptable. It is hard to reconcile the vigour of the recto with the timidity of the verso, and the two sides of the sheet may well be by different hands. Having allowed that Penni might study (and even execute) a figure in a painting by Giulio, it requires no further stretch of the imagination to see Perino in the post-Raphael studio drawing on a sheet of paper already used for a few slight sketches by Penni.

NOTES

1. Shearman 1961; Dacos 1986a, pl. CXXIX, where the stucco is attributed to Perino. This stucco does not reproduce the angle of view of cat. 48.

2. In Vienna 1966, Oberhuber 1986, Rome 1992 *etc.*

3. Birke and Kertész 1992–97, I, no. 227; F.-O. 431; J. 375.

4. Rome 1981–82, no. 63 (as Domenico Zaga).

5. Cordellier and Py 1992, no. 861. A careful study of *The Virgin and Child with a cloud-borne saint* at Haarlem (Teylers Museum, inv. K93; F.-O. p. 42) is technically distinct but in much the same style and may also be by Perino.

6. M. Jaffé 1994, no. 286; F.-O. p. 44.

7. Brugerolles 1984, no. 80; F.-O. p. 44.

8. Nasjonalgalleriet, inv. 15281; F.-O. p. 46.

9. Edinburgh 1994, no. 53.

10. Respectively Bartsch XIV, p. 169, no. 208; p. 261, no. 349; p. 94, no. 105; and Bartsch XII, p. 73, no. 18.

11. Respectively Dresden 1983, no. 128a, and with De Bayser, Paris in 1998.

12. See Russell 1982.

LITERATURE

Passavant 1836, II, pp. 122f.; Passavant 1839–58, II, p. 438, no. 287; Waagen 1854, II, p. 445; Passavant 1860, II, pp. 374, 494; Crowe and Cavacaselle 1882–85, II, p. 342 n.; Popham and Wilde 1949, no. 811; Kleiner 1950, pp. 22ff.; Shearman 1961, pp. 131 n. 12, 153; Vienna 1966, under nos. 133f.; Marabottini 1968, p. 281 n. 53; Oberhuber 1972, p. 43; London 1972–73, no. 71; Joannides 1982, p. 634; Oberhuber and Ferino Pagden 1983, p. 139; Rome 1984b, pp. 108f.; Joannides 1985, p. 36; Dacos 1986a, p. 285; Oberhuber 1986, pp. 201f.; Gere 1987, no. 51; Magnusson 1987, p. 24 n.; Mantua 1989, p. 70; Cordellier and Py 1992, pp. 262, 390, 488, 490; Rome 1992, pp. 21, 295; Edinburgh 1994, pp. 19, 108; Joannides 1996, p. 106

49

ATTRIBUTED TO PERINO DEL VAGA

The Rape of Lucretia

ca. 1520–23

Paper washed buff; black-chalk underdrawing; pen and iron-gall ink; lead-white bodycolour
Inscribed lower right, pencil, *Raffael*; lower left, pen and ink, *R[a]ff]ae]l*, cut
Verso: inscribed lower left, pen and ink, *30*; lower centre, pen and ink, in two different hands, *Polidor 4.3.*
249 × 167 mm
No watermark
RL 0506
Provenance: Probably William Gibson (although the inscription *Polidor* is not in the hand found on those sheets associated with Gibson, the following inscription *4.3.* is of the form of the price-mark used by him and is in the usual hand; it thus seems likely that Gibson simply added his price-mark to a pre-existing ascription, rather than duplicating the artist's name)

In an episode from the legendary history of Rome, the noblewoman Lucretia was raped by Sextus Tarquinius, son of the tyrant Lucius Tarquinius Superbus. After writing to her husband and father, Lucretia took her own life, and the ensuing outcry led to a rebellion in which Lucius Tarquinius was deposed and he and his family exiled from Rome.[1]

This drawing largely corresponds to the left-hand portion of an engraving by Agostino Veneziano, inscribed *RAPHAE. URB. INVEN.* and dated 1524 (fig. 77); Bartsch described an earlier state dated 1523, though no impressions of this state have been located.[2] There are enough differences between drawing and engraving, in particular in the form of the bed-

hanging, to establish that the drawing is not a copy from the print, but less tritely it is plain how much superior is the composition in the concise form of the drawing, and how its dramatic force was diluted by placing the motif in (or rather, against) a Renaissance interior.

The inscription on the print crediting the invention to Raphael is perfectly plausible for the figure group, for although there is nothing in his surviving oeuvre that connects directly with the composition or poses, the mood of elegant violence is that of his composition of the *Stoning of St Stephen* (fig. 61, p. 136). The old ascriptions of the present drawing to Raphael or Polidoro, repeated in the nineteenth century, have given way in recent decades to an attribution to Gianfrancesco Penni. It is always agreed that the present sheet must be by the same hand and of the same date as the *Jonah* (cat. 48), and its attribution here to Perino del Vaga, as an adaptation of a design by Raphael after the master's death, follows from the stylistic similarities between that sheet and cat. 47. The date 1523 on Bartsch's first state of the print provides a *terminus ante quem* for cat. 49 and probably for cat. 48 as well.

NOTES
1. Recounted in *e.g.* Ovid, *Fasti*, II, 725–852.
2. Bartsch XIV, p. 169, no. 208; later reworked by Enea Vico, Bartsch XV, p. 287, no. 15.

LITERATURE
Passavant 1836, II, p. 123; Passavant 1839–58, II, no. 301, p. 663, III, p. 274c; Waagen 1854, II, p. 445; Passavant 1860, II, p. 494; Ruland 1876, p. 163; Popham and Wilde 1949, no. 812; Blunt 1971, p. 111; Oberhuber 1972, p. 41; Gere and Turner 1983, no. 202; Massari 1985, p. 236; Gere 1987, no. 53; Rome 1992, p. 295; Cordellier and Py 1992, pp. 487f.; Joannides 1993, p. 23; Landau and Parshall 1994, p. 130

Fig. 77 Agostino Veneziano after Raphael, *The Rape of Lucretia*, engraving, 253 × 401 mm (Bartsch XIV, p. 169, no. 208). London, British Museum

50

PERINO DEL VAGA

St Mark and St John with putti

ca. 1525

Squaring with the stylus; red chalk
Inscribed lower right, pen and ink, *P*[...] or *R*[...], cut
Verso inscribed on an old reinforcing strip of paper,
pen and ink, *Jerom*
327 × 512 mm, the lower corners damaged and restored (by the mid
seventeenth century, as the Lanier-type inscription is on one of these
areas)
Watermark: anchor in circle with six-pointed star (identical to
cat. 51)
RL 01218
Provenance: Antonio Tronsarelli; Jerome Lanier (?) (variant of Lugt
2888); George III (Inv. A, p. 52, *Guilio* [*sic*] *Romano, Polidoro, e Perino
del Vaga Tom. 2*, p. 11, "St Mark & St John ... [Perin del Vaga]")

This magnificent sheet is a study for a fresco in the Cappella
del Crocifisso of San Marcello al Corso, Rome. In May 1519
the old church of San Marcello was destroyed by fire. Among
the ruins was found an intact wooden crucifix, which was thus
held to have miraculous properties and was carried in proces-
sion during the plague of 1522. The subsequent abatement of
the plague led Cardinal Guglielmo Raimondi di Vich to found
the Confraternita del Santissimo Crocifisso, one of the most
important confraternities to flourish in Rome in the sixteenth
century, the first artistic initiative of which was the decoration
of the chapel erected to house the miraculous crucifix as part
of the rebuilding of San Marcello.

On 6 February 1525 Perino signed a contract with the
confraternity to execute frescos in the chapel, to be completed
by 20 March 1526. At the Sack of Rome in 1527 the work was
unfinished, and was not resumed until Perino returned from

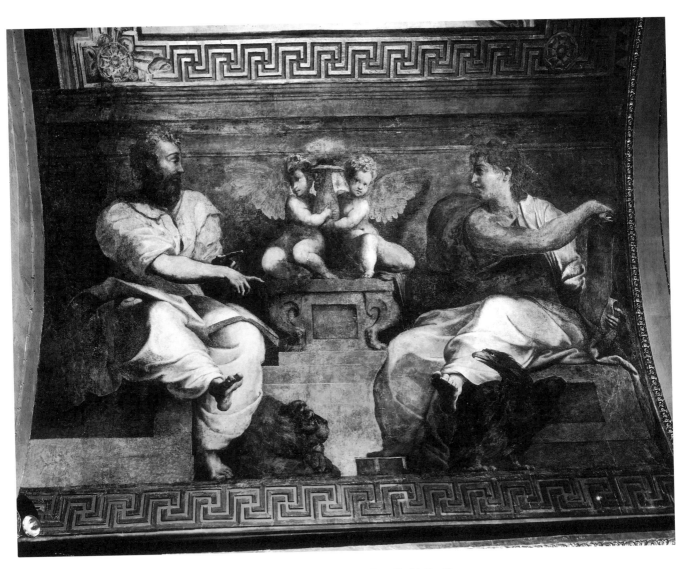

Fig. 78 Perino del Vaga, *St Mark and St John*, fresco. Rome, San Marcello al Corso, Cappella del Crocifisso

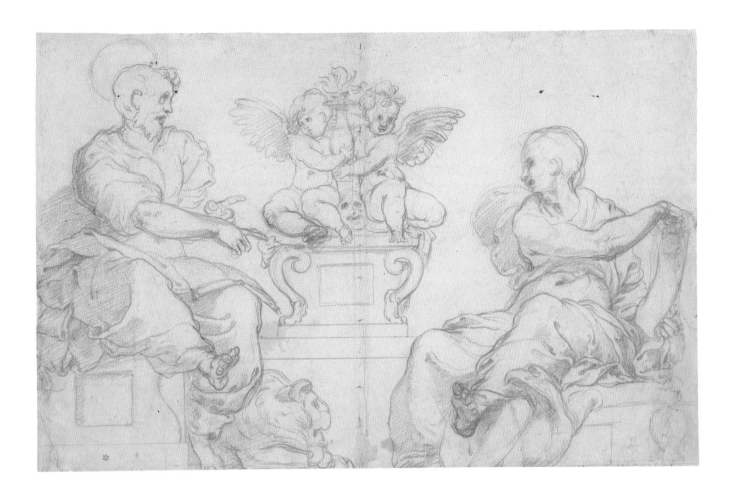

Genoa and Pisa a decade later. A revised contract was signed with Perino on 25 April 1539, now stipulating completion by May 1540, though it is not until May 1543 that we have a record of the chapel in a completed state.[1]

Perino's frescos are confined to the barrel vault of the chapel and feature monumental figures of the Evangelists seated in pairs either side of a *Creation of Eve* in a fictive frame. No frescos on the side walls are known to have been planned. The *Creation of Eve* was not as common a pendant to a Crucifix as was the *Temptation* or *Expulsion*, the episode that was redeemed by Christ's sacrifice; but St Augustine had seen in the creation of Eve, from the rib taken from Adam's side, a prefiguration of the blood and water that issued from Christ's wound on the Cross (John 19:34), and thus of the two principal Christian sacraments, Eucharist and Baptism. Vasari stated that, in the first campaign, Perino had painted the *Creation of Eve* and most of the two Evangelists studied here, and that the head and right arm of St John and all of Sts Matthew and Luke were executed by Daniele da Volterra to Perino's designs after 1539. This division of hands was confirmed by restoration work around 1960.[2]

The present drawing is very close in its details to the painting as executed and probably served as the *modello* for the full-scale cartoon. The only significant change was to correct the position of St John to that seen in a damaged study in Berlin for the whole ceiling, where his head is aligned with those of the putti.[3] This shows *God the Father* in the central field, indicating a late change in the iconographic programme, as the figures of Sts Mark and John are essentially identical to those here. The figures of Sts Matthew and Luke as painted are radically different, however, from those in the Berlin study and were probably redesigned when the second campaign on the vault began in the late 1530s. Oberhuber (1966) placed cat. 50 before the Berlin sheet, claiming it to be harder in contour and more individualized. Although a case may be made for its precedence on the grounds that the Berlin study shows St John in his final position, it is not possible to argue this on stylistic grounds, since the two drawings, in different media, must in any case have been drawn close together in time. The usual progression from small sketch to large, careful study is much more likely, with the change in St John's position from cat. 50 a correction rather than a pentimento.

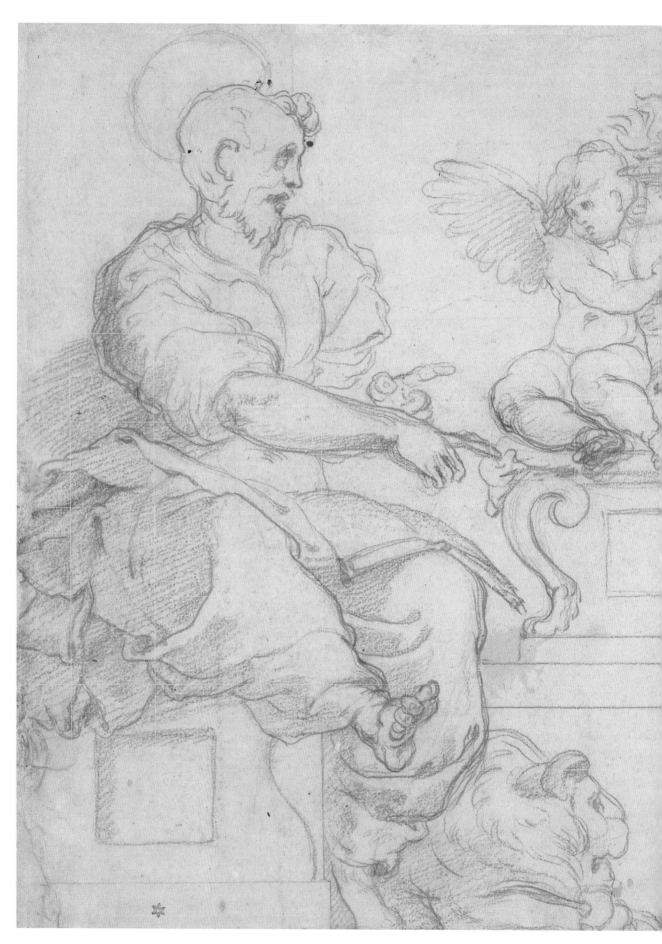

50

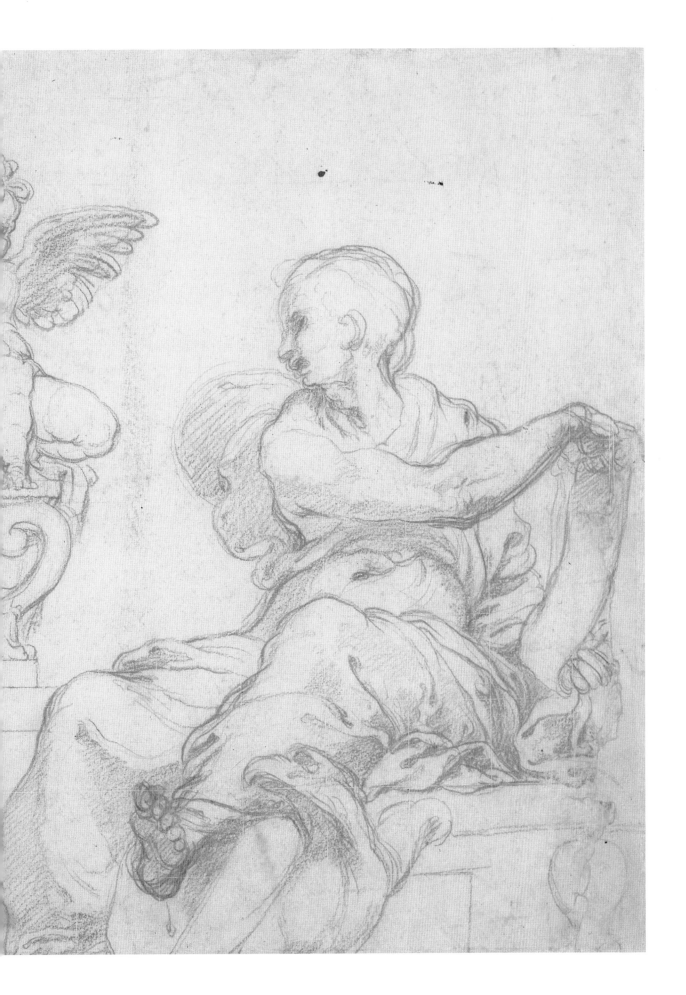

Three sheets of single-figure studies connected with the ceiling survive. A drawing in the Albertina of *St Mark* with the lion and the left-hand putto combines fastidious internal modelling with thoughtlessness in some of the lines, and appears to be a workshop copy after a drawing by Perino.[4] Two drawings of *St Matthew* and *St Luke* (the figures painted by Daniele da Volterra) in the Louvre, from the second campaign, have been attributed both to Perino and to Daniele.[5] Wolk-Simon argued that they were "mini-cartoons" made by Perino for the use of Daniele in painting the frescos;[6] they may have served such a function, but it is not possible to see Perino's hand in their smooth, closely hatched chalk style, much more typical of Daniele, who presumably worked them up from preliminary drawings by Perino. Davidson noted a probable copy in Munich of such a lost drawing by Perino for the group of Sts Matthew and Luke and the two putti.[7]

The forms of the Evangelists show the obvious impact of the Prophets, Sibyls and *ignudi* painted by Michelangelo fifteen years earlier on the Sistine Chapel.[8] Around this time Perino made a number of thumbnail copies of the figures and narratives in the Sistine ceiling on sheets now in the British Museum and the Uffizi,[9] and among those on the Uffizi sheet is a sketch after Michelangelo's *Creation of Eve* that served as the basis for Perino's own design for San Marcello, studied explicitly on the recto of the same sheet. The contrast between Perino's *Eve* in San Marcello and his much less monumental treatment of the same subject in the Trinità dei Monti, probably designed around 1521–22, shows the magnitude of the change wrought upon Perino's style by his study of Michelangelo towards the middle of the decade.

Lafranconi (1998) identified this drawing in the Roman collection of Antonio Tronsarelli, posthumously inventoried in 1601, where it is listed as "*Un S. Giovanni e un San Marco con doi puttini in foglio di carta Reale de lapis rosso de mano de Pierino*

messi in opra da essa in S. Marcello alla cappella del Crucifisso". Within fifty years the drawing was in England, for it bears a star mark associated with the collectors around the court of Charles I. The much more common five- and eight-pointed stars (Lugt 2885–86) are traditionally connected with Nicholas Lanier, one of Charles I's principal agents for the purchase of works of art. The present star has six points, and the drawing also bore, on a reinforcing strip stuck to the verso, the inscription *Jerom*. Another drawing at Windsor, by Alessandro Allori, bears the same star mark on the recto and the same inscription on the verso.[10] This may therefore indicate the ownership of Jerome Lanier (died 1657), Nicholas's uncle and also a musician and an amateur of art. The subsequent path of the drawing into the Royal Collection is unknown.

NOTES
1. See Fiocco 1913 for the documents.
2. Vasari 1568, II, pp. 359f., III, p. 677; Brugnoli 1963.
3. Kupferstichkabinett, inv. KdZ 22004; Parma Armani 1986, p. 64.
4. Birke and Kertész 1992–97, I, no. 437, as Perino. Davidson (1963) thought it might be a copy by Marco Pino; Oberhuber (1966) defended the attribution to Perino and thought it studied from the life, which seems improbable. A weak copy after what was probably the same original was at Christie's, 1 April 1987, lot 102.
5. Davidson 1966, nos. 45f.; Sricchia Santoro 1967; Bacou and Béguin 1983–84, nos. 96f.; Calì 1988, p. 52. The Louvre also holds a study by Daniele for the left arm of St Matthew (inv. 1495).
6. Wolk-Simon 1992, p. 63.
7. Davidson 1966, p. 48; Munich, Graphische Sammlung, inv. 21222.
8. Most recently discussed in Joannides 1996.
9. Respectively Pouncey and Gere 1962, no. 162v, and inv. 16-E, Davidson 1966, no. 11v.
10. Popham and Wilde 1949, no. 59.

LITERATURE
Popham 1945, p. 65; Popham and Wilde 1949, no. 974; Pouncey and Gere 1962, p. 94; Davidson 1963, 3, pp. 4, 15; Davidson 1966, pp. 20, 47f.; Oberhuber 1966, p. 178; London 1972–73, no. 81; Pugliatti 1984, pp. 31f.; Rome 1984c, p. 102; Vannugli 1984, p. 437; Parma Armani 1986, p. 262; Roberts 1986, no. 37; Roberts 1987, no. 31; Calì 1988, p. 52; Birke and Kertész 1992–97, I, p. 246; Joannides 1996, no. 48; Lafranconi 1998, p. 537

51

PERINO DEL VAGA

A design for the decoration of a wall, with figures of Faith and Justice and a papal escutcheon

ca. 1525

An axial stylus line and some pointing in the architecture; black-chalk underdrawing; pen and iron-gall ink; iron-gall wash
Inscribed by the artist at lower left, pen and ink, *12*

Verso: Sketches for the figures on the recto

Red chalk
324 × 231 mm
Watermark: anchor in circle with six-pointed star (identical to cat. 50)
RL 10894
Provenance: George III (Volume A18, *Architectural Ornaments*, f. 48)

This study for a major decorative fresco was recognized by Pouncey as the work of Perino. The project has not been identified: the prominent keys and tiara show that it was a papal commission, but the context that springs immediately to mind, the Sala Paolina in the Castel Sant'Angelo (where allegorical figures of these Virtues are to be found), is ruled out on several grounds. As Gere noted (1987), the windows there extend almost to the cornice, and the doors are differently placed; Gaudioso (in Rome 1981) observed that the prominent display of the papal arms here is not compatible with the covert references to Paul III in the Sala Paolina; and the heavy, robust style of the penwork is unmistakably that of Perino's first Roman period (the watermark is identical to that of cat. 50, a drawing probably of 1525).

Byam Shaw connected the sheet with a drawing at Christ Church that displays the papal keys over the Medici arms, even more sophisticated and extravagant in its invention than cat. 51 (and showing the same strong influence of the Sistine Chapel ceiling in the relationship of figures to architecture), but the other motifs are unrelated. More pertinent is a drawing in the Courtauld Institute (fig. 79),[1] again with a papal escutcheon, flanked by allegorical figures of Charity, Faith, Justice and Hope. The format of the Courtauld sheet is very different, and Gere considered that this militated against a connection between the drawings, despite the common elements. The figures were Perino's stock types for such Virtues: a very similar Justice is found above a triumphal arch designed for the entry of Charles V into Genoa in 1529,[2] and the standing figure of Justice in the Sala Paolina of the Castel Sant'Angelo holds her attributes in exactly the same pose as here. Whether or not cat. 51 and the Christ Church and Courtauld sheets are connected is ultimately unknowable if none can be associated with any project.

The sketchy figures on the verso appear to be studies for seated Virtues like those on the recto. That at the centre of the sheet might be read as a Christ of the Last Judgment, but it would be unwise to make anything of such an interpretation.

NOTES
1. Rome 1981, no. 69.
2. Drawing in Berlin, Kunstbibliothek, HdZ 2131; Parma Armani 1986, p. 82.

LITERATURE
Blunt 1971, no. 465; Gere 1971, p. 81; Levey 1973, p. 186; Byam Shaw 1976, p. 141; Rome 1981–82, no. 68; Parma Armani 1986, p. 291; Gere 1987, no. 75

Fig. 79 Perino del Vaga, *Design for a frieze with papal arms and allegorical figures*, red chalk, pen and ink, 124 × 435 mm. London, Courtauld Institute, Witt 4673

51r

52

PERINO DEL VAGA

A design for the decoration of a frieze

ca. 1537–40, with later modifications

Black-chalk underdrawing; pen and iron-gall ink; iron-gall wash;
stylus guidelines on the central patch
Inscribed on the patch, pen and ink, *D./PGIO*
Verso blank
119 × 408 mm, a square patch at the centre; the whole cut in half,
trimmed by about 5 mm and rejoined
Watermark: four-pointed star in circle (cut)
RL 10902
Provenance: George III (Volume A19, *Architectural Ornaments*, f. 6)

This drawing is very similar in form and size to two others in
Berlin, published by Oberhuber as studies for a frieze in the
appartamento piccolo of the Palazzo Massimo alle Colonne,
Rome.¹ All three show nudes crouching around fictive painted
frames but they vary substantially in their details. The Windsor
drawing is the simplest, the seated *ignudi* supporting the
rectilinear frames with their backs, with classically decorated
mouldings above and below. The storiated panel to the left
seems to show a standing figure with a shield and another
crouching before him to the right, which may be no more
than an arbitrary scribble to illustrate the purpose of the space
in the drawing.

In one of the Berlin drawings (fig. 80), the *ignudi* support
the architrave and crouch on blocks from which swags are
suspended, spilling over a ledge supported on acanthus volutes.
The other Berlin drawing is more elaborate still: the *ignudi* are
replaced by wildmen and female satyrs standing on masks, and
the rectilinear frame assumes the form of a cartouche. Only
one of the three drawings, fig. 80, corresponds closely with the
frieze as painted. It thus appears that they were drawn as alter-
natives of varying complexity for the patron's consideration,
an unusually clear example of the production of such *modelli*.

Perino's work in the Palazzo Massimo was probably
contemporary with his activity in the Massimo chapel of the
Trinità dei Monti, between the end of 1537 (when Perino
returned to Rome) and 1539, for the taste of the two schemes
is very much the same.² There seems to have been a campaign
of decoration of the Palazzo Massimo at around this time:
during modern restorations a panel bearing the date 1537 was
uncovered in the ceiling of the Sala dei Ricevimenti.
Oberhuber noted the importance of this type of Roman
frieze-painting and its indebtedness to contemporary decorative
work at Fontainebleau, with an interplay at differing levels of
illusionism of figures, organic elements, blocks of masonry,
picture frames (both real and fictive) and narrative scenes;
Perino himself was to use a very similar scheme a few years
later in the Castel Sant'Angelo.

Popham interpreted the letters *D.PGIO* as a contraction of
D[ominus?] *POGGIO*, and deduced that the drawing was by
Pellegrino Tibaldi for his decorations of the Palazzo Poggi in
Bologna. However, the sheet as we now have it is a collage:
the tablet with the inscription was pasted behind an excised
window, and that assemblage was sliced and rejoined with the
loss of a few millimetres, perhaps to eradicate damage fol-
lowing the folding and pasting of the sheet into an album. On
Perino's death in 1547 Tibaldi was working in his studio, and
if the sheet does have any connection with Tibaldi's work in
the Palazzo Poggi it is reasonable to assume that he came into
possession of the sheet at that time and subsequently adapted it
for his own purposes.

NOTES
1. Kunstbibliothek, HdZ 417–18; Oberhuber 1966, p. 172. See Wurm 1965,
p. 248.
2. Drawing in the Victoria and Albert Museum, Ward-Jackson 1979, no. 362;
see Gere 1960, p. 12.

LITERATURE
Popham and Wilde 1949, no. 946

Fig. 80 Perino del Vaga, *A design for a frieze with kneeling caryatids*, pen and ink, wash, 117 × 426 mm. Berlin, Kunstbibliothek, HdZ 417

52

52 (detail)

53

PERINO DEL VAGA

A design for an inkstand

ca. 1540

Traces of black-chalk underdrawing; pen and iron-gall ink;
iron-gall wash
Verso blank
216 × 346 mm, upper left corner restored
No watermark
RL 10747
Provenance: George III (Volume A16, *Buildings and Architectural Ornaments*, f. 9)

This drawing was interpreted by Popham as a design for a salt-cellar, but the bearded figures resting on books on the lid and the allegorical figure of Astronomy on the side of the box, presumably to be accompanied by other Liberal Arts, indicate that the object was to be an inkstand. The small bowl in the centre of the lid would have contained fine sand for soaking up excess ink; removing the lid would have revealed compartments for quills, ink, knives and so on.[1]

In this study for the metalworker, Perino had no need to repeat motifs that would continue all the way around the casket, and the patterns for the Liberal Arts would presumably have been provided on a separate sheet. The design is close to that of a drawing by Perino in the Uffizi (fig. 81), sharing its vocabulary of reclining figures, and concave sides with grotesque masks and rams' heads on the corners, though there are significant differences in detail. Both designs would have been suitable for casting in metal (probably bronze) alone, rather than with the inlaid or precious-stone panels that were also common in the period. Their overall form, and indeed that of many inkstands of the High Renaissance, is derived from Antonio Pollaiuolo's tomb of Sixtus IV in St Peter's (1484–93).

The style of the drawing, with light, decorative pen-lines, is that of Perino around 1540, and compares well with his design for a frieze, cat. 52.

NOTES
1. See New York 1997, p. 58, for such objects.
LITERATURE
Popham and Wilde 1949, no. 983; London 1972–73, no. 82

Fig. 81 Perino del Vaga, *A design for an inkstand*, traces of black chalk, pen and ink, wash, 257 × 375 mm.
Florence, Uffizi, inv. 1603-E

54r

54

WORKSHOP OF PERINO DEL VAGA
(ATTRIBUTED TO LUZIO ROMANO)

A design for the tomb of Cardinal Cristoforo Giacobacci

ca. 1540

Black-chalk underdrawing; pen and iron-gall ink; iron-gall wash
Inscribed lower right, pen and ink, *20*

Verso: Figure studies

Pen and iron-gall ink; touches of discoloured lead-white bodycolour
Inscribed by the artist towards the centre, pen and ink, *30, 33¹/ᵢ*
235 × 327 mm
Watermark: crossed arrows with six-pointed star
RL 10895
Provenance: George III (Volume A18, *Architectural Ornaments*, f. 49)

As observed by Pouncey and Gere, this wall-tomb for a cardinal bears the devices of the Giacobacci family (*per pale, a wallet and six crescents*) on the central panels of the two flanking fields. Two Giacobacci attained the post of Cardinal in the first half of the sixteenth century, Domenico (died 1527) and Cristoforo (died 1540). This is more likely to be the design for Cristoforo's tomb, given both the style of the decoration, characterized by Pouncey and Gere as in "the antiquarian 'Pirro Ligorian' taste ... with its mélange of classical bric-à-brac", and the fact that the bust of the cardinal is bearded, a penitential fashion among ecclesiastics after the Sack of Rome in 1527. No such tomb survives. Funerary monuments could be ordered during a client's lifetime or years later by his heirs, and while a date for the design around the death of Cristoforo Giacobacci would be reasonable, this is by no means certain.

The principal storiated field of the tomb represents *Christ's Entry into Jerusalem*, and the panel to the right probably *Christ and the Adulterous Woman*; that to the left is unclear. With no

54v

reference to salvation or resurrection, or any biographical connotation, these are unusual scenes for a tomb and would seem appropriate only as part of a more extensive programme of scenes from the Passion.

The drawing style, with its formulaic abbreviations and elongated figures, appears to be that of the stucco-worker and painter of grotesques Luzio Romano (Luzio Luzzi), Perino's collaborator on much of his decorative work from his early Genoese period onwards. Luzio soon fell into a slick and no doubt very popular decorative mode and carried on working in the same vein long after Perino's death, executing countless schemes in Roman palaces. Many designs for ceiling and wall decorations and metalwork in a Perinesque style survive, most numerously at Windsor.[1] Some of these can be firmly attributed to Luzio, but his style approached Perino's very closely at times and his drawings can be hard to distinguish from Perino's most mechanical decorative sheets. Luzio's role in this drawing was presumably that of secretary, providing a tidy version of the design on the basis of sketches made by Perino.

<p style="text-align:center">★ ★ ★</p>

The sketches on the verso of the sheet are similarly Perinesque but too clumsy to be by the master, and it is reasonable to attribute these, too, to Luzio, who is hardly known outside the context of formal decorative designs. The three studies of *The Christ Child with the Infant Baptist* are indebted to Michelangelo's Taddei tondo (Royal Academy, London); at lower centre are two compositions apparently featuring a stonemason, with one of the figures studied again at upper centre, the other way of paper. The group of standing figures may be spectators in a companion scene. None of these studies can be associated with any project.

NOTES
1. Blunt 1971, nos. 233–79, 467–512; see also Peronnet 1997, nos. 37f., 40f., 46.

LITERATURE
Pouncey and Gere 1962, p. 95; Blunt 1971, no. 464

55

PERINO DEL VAGA

Juno visiting Aeolus and Neptune calming the Tempest

1540

Paper washed buff; traces of black-chalk underdrawing; pen and carbon grey ink; carbon grey wash; lead-white bodycolour
Inscribed by the artist at upper left, pen and iron-gall ink,
QUOS EGO
Verso blank
220 × 215 mm (max.), circular, trimmed at left, right and lower edges
No watermark
RL 5497
Provenance: George III (Inv. A, p. 53, *Perino del Vaga, Baldre. Peruzzi, Nico: del Abatte &c,* pp. 2–5, one of "Four fine studies of Neptunes, Sea Horses, with Monsters, &c. ... Perin del Vaga")

Hirst pointed out in 1965 that this drawing corresponds to a design described in great detail by the poet Annibale Caro in a letter of 4 February 1540 to the medallist Alessandro Cesati at the Roman Mint. Caro was anxious to obtain a model for the reverse of a medal of his patron, Giovanni Guidiccioni (1480–1541), Bishop of Fossombrone. He had been offered a design by the crystal-engraver Giovanni Bernardi, but this was unsatisfactory and Caro wanted Cesati and Ludovico Fabri to devise a composition and get Perino to provide a drawing:

"But before I forget, I wanted to tell you that in Faenza I have found Messer Giovanni [Bernardi] da Castel Bolognese, who is working on Cardinal Farnese's rock crystals. Up until now he has made many things, but I don't know what to say about them. He proposed great things to me; nonetheless, it seems that I should try to get the drawings by Perino that you told

Fig. 82 Alessandro Cesati after Perino del Vaga, "*Quos ego*": *Neptune calming the Tempest* (reverse of a medal of Giovanni Guidiccioni), bronze, diameter 29 mm. Brescia, Pinacoteca Civica, Mazzucchelli I LXVI.1

me about at our parting.[...] I wanted [Bernardi] to make me a little sketch for the reverse of the medal of the Bishop, but it is such that I am embarrassed to send it to you; however, I shall enclose it, since I desire to have a drawing by someone good, and I beg you to send me as soon as possible one from your hand or by Perino del Vaga.

"The idea is that of Virgil [*Aeneid*, I:125–43], when, by means of Aeolus, King of the Winds, Juno creates a tempest against the Trojans, and Neptune calms it. As regards the details: show on one side of the medal a grotto, such as you would imagine for the House of the Winds, at the mouth of which is their king Aeolus, who, sought out by Juno to turn the sea to a tempest, sends out all the Winds. They should be shown as figures or half-figures of men, with manes of hair and ruffled beards and puffed-out faces, with drapes held in each hand that also puff out like full sails, all beautifully arranged; and in various places gusts of wind should emerge from the cracks in the grotto to disturb the sea.

"If Messer Ludovico [Fabri] has by chance explained to you how Aeolus should be depicted, do as he tells you, if not, portray him in your own manner; however, he should have the majesty of a king about his clothes, hair and beard, and some ribbons that seem thrown about by the Winds leaving the grotto. He should stand before Juno in a reverential attitude, and, if you think fit, with a bag in one hand, to allude to the story of Ulysses. Juno should face him like a queen, in sober clothes, with an imperious gesture and an evil face commanding Aeolus to generate the tempest. She should have a diadem on her head, that is, a band over her coiffure, and a cloak over her gown, gaiters at her feet, in her right hand a lightning bolt, in her left a tambourine.

"In the other part of the medal should be Neptune with his chariot, his sea-horses and his trident in the usual manner, in the act of commanding the Winds and of quelling the tempest – make this seem calm around him. And if it seems good to you, and the composition is not becoming too confused, add some nymphs swimming because of the calm, and a triton with a conch in his hand, or to his mouth, as you see fit. And with regard to the Neptune, you can, if it seems right to you, make use of the design of Leonardo da Vinci.

"Above, on a little cloud, should be sat Venus, who should be small to indicate her distance, looking at Neptune as if the two of them had caused the calming of the sea. And as regards the phrase that comes forth from Neptune, I should like the grotto and Juno to be on the right-hand side, Neptune on the left, and Venus above, closer to the grotto so that more space is left for the phrase between her and Neptune.

"I wanted to get this down in writing for you straight from my head, not to lay down the law to you or because you

should do exactly as I say, but because you should have as your goal the subject as accurately as possible, and the composition should then be done as you think best; and you should lay it out as seems necessary to follow the story, and according to what the oracle Messer Ludovico tells you (beg him on my part that you should think it over together, but it will give me great pleasure if you can send it to me as soon as possible). Get Perino, or whoever comes to mind, to make

sketches of it, and whichever turns out to be the most powerful invention, get it finished, or finish it yourself – it would be a great favour if you could put it into wax, and I know how useful that would be to you too."[1]

The present drawing must be Perino's final design for the medal. He tried valiantly to incorporate all the details prescribed by Caro, the only significant deviation being the form

of the Winds, who are here rendered merely as a couple of blowing heads, rather than the many full- or half-length figures envisaged by Caro. The drawing did serve as the basis for Cesati's medal to Guidiccioni (fig. 82), but Perino's efforts were scarcely worthwhile – the medal is only 29 mm across and the details correspondingly indistinct – and while Cesati preserved the overall composition, Venus was reduced in size, Neptune was turned around to face the viewer, and the figures of Juno and Aeolus were completely changed.

Perino had depicted Neptune in the same pose, but in the opposite direction, in a drawing of *The Shipwreck of Aeneas* in the Louvre, probably a study for a destroyed mural painting in the Palazzo Doria, Genoa, of *ca.* 1528;[2] the figure of Neptune in this was in turn based on a Raphaelesque composition of *Neptune calming the Tempest* known through an engraving by Marcantonio Raimondi.[3] In a rough sketch by Perino of *Neptune and his horses* in the British Museum, two of the horses are very similarly posed (though in reverse) to the present design.[4] This is on the verso of a study of *The Pool of Bethesda*, datable to around 1538–40, and it thus seems probable that the British Museum sketch is a study towards the present design.

Hirst also noted that the figure of Juno is a quotation (in reverse) from Parmigianino's drawing of *Circe and the Companions of Ulysses*.[5] These sources and sketches are all in reverse with respect to the present drawing; perhaps Perino had not initially taken note of Caro's instruction to place Juno on the right and Neptune on the left, and was forced to reverse his design by some transfer process before executing this *modello*.

A same-size copy of the drawing is in the Biblioteca Reale, Turin.[6]

NOTES
1. Caro 1957, I, pp. 178–80.
2. Inv. 636; Bacou and Béguin 1983–84, no. 90; engraved in the same direction by Giulio Bonasone (?), Bartsch XV, p. 140, no. 104.
3. Bartsch XIV, p. 264, no. 352.
4. Pouncey and Gere 1962, no. 169v.
5. Uffizi, inv. 750-E, reproduced in an anonymous chiaroscuro woodcut in the same direction (Bartsch XII, p. 110, no. 6).
6. Inv. 15801; Bertini 1958, no. 321.

LITERATURE
Popham and Wilde 1949, no. 975; Askew 1956, p. 49; Parker 1956, p. 391; Pouncey and Gere 1962, p. 100; Hirst 1965, pp. 570f.; Massari 1983, p. 86; Bacou and Béguin 1983–84, p. 80; Parma Armani 1986, pp. 126, 272; Davidson 1990b, p. 36 n.; D. Jaffé 1994, p. 48

56

PERINO DEL VAGA

Solon giving laws to the Athenians

ca. 1541

Paper washed blue; pen and iron-gall ink; iron-gall wash; lead-white bodycolour
Verso blank
181 × 218 mm
No watermark
RL 5436

Solon was appointed archon (chief magistrate) of Athens in 594 BC after a long period of civil upheaval, and his measures were so popular that he was authorized to remodel the Athenian constitution. He repealed most of the Draconian laws and introduced democratic reform by instituting the Boule (Council of Athens) and enlarging the Ecclesia (popular assembly).

This is a study for a monochrome fresco by Perino (fig. 83) in the socle of Raphael's Jurisprudence wall in the Stanza della Segnatura. When Raphael decorated the room it was probably to be used as Julius II's private library (see cat. 15), but on the dispersal of the library after Julius's death in 1513 the bookshelves were replaced by intarsia panels by Fra Giovanni da Verona. Paul III's subsequent scheme to move a fireplace from

the Stanza dell'Incendio to the *Disputa* wall of the Segnatura in 1541 led in turn to the removal of this panelling, and Perino was commissioned to redecorate the remaining lower portion of the walls. Vasari recorded that, owing to illness, Perino provided only finished cartoons for his pupils and made finishing touches to their efforts.[1]

Perino's grisailles consist of caryatids and garlands flanking scenes complementing the subjects of Raphael's frescos above, executed some thirty years before. Below *The School of Athens* are *The Death of Archimedes*, *The Siege of Syracuse*, a *Dispute on the terrestrial globe*, and an allegorical figure of *Philosophy*; below the *Disputa* is an *Antique sacrifice*; and at the base of the Jurisprudence wall are *Moses giving the Tablets of Law to the Hebrews* and *Solon giving laws to the Athenians*. Soon after Perino's work on the socle was completed, the chimney was returned to the Incendio, and nicely twinned frescos of *Augustus's Vision of the Virgin* and *St Augustine's Vision of the Child on the Beach* were added below the *Disputa*, perhaps by Daniele da Volterra, to fill the gap.

The present sheet corresponds almost exactly to the fresco as executed, except for the substitution of a caryatid in profile for the standing figures at far right. No underdrawing is visible: the composition is fully cogitated and may have served as the basis for the subsequent cartoon. The compositional style is

Fig. 83 Workshop of Perino del Vaga, *Solon giving laws to the Athenians*, fresco. Vatican, Stanza della Segnatura

close to that of Perino's later Alexander monochromes in the Sala Paolina of the Castel Sant'Angelo (see cat. 59), with bodies crowded against the picture plane and the design bounded by heavy standing figures.

Parma Armani (1986) suggested that the frescos were initially planned to be in *terraverde* (to harmonize with the monochrome scenes under *Parnassus* painted by Raphael's studio), on the grounds that the present drawing is on green paper. This observation is incorrect and nothing can be deduced from Perino's use of blue-washed paper other than his wish to establish a mid-tone ground.

NOTES
1. Vasari 1568, II, p. 366.

LITERATURE
Popham and Wilde 1949, no. 976; Gere 1960, p. 16; Pouncey and Gere 1962, p. 94; Davidson 1966, p. 50; London 1972–73, no. 80; Rome 1981, no. 72; Parma Armani 1986, p. 287; Gere 1987, p. 234

PERINO DEL VAGA

Saul recovering his sight at the hands of Ananias

ca. 1540–45

Paper washed buff (?); pen and iron-gall ink; iron-gall wash; lead-white bodycolour; the whole design finely pricked; much faded, damped and abraded
Verso blank
235 × 153 mm, the upper corners restored
No watermark
RL 5460

57 in ultraviolet light

The subject comes from Acts (9:17). Appearing to the Apostle Ananias in a vision, Christ instructed him to seek out Saul and restore his sight after he was struck blind on the road to Damascus. Saul was thus converted to Christianity, adopted the name Paul and began his apostolic mission.

Vasari stated that "after Perino's death, many prints were made after his drawings ... [including] eight scenes of St Peter, taken from the Acts of the Apostles, which were designed to be embroidered for a cope for Pope Paul III".[1] In an inventory of the papal sacristy compiled in 1547, Davidson noted a description of two copes made for Paul III (reigned 1534–49), with scenes from the lives of St Peter and St Paul respectively. That of St Paul was described as in red and black brocade, with an orphrey (the broad band bordering the front edges of the cope) embroidered with pearls and silk showing the miracles of St Paul, and a hood in the same materials with a depiction of his conversion. From surviving drawings by Perino, and copies and prints after lost originals, it is possible to identify four (or possibly five) subjects from the life of St Peter in a decorative *bombé* frame, and a further five from the life of St Paul in a vertical oval. It is thus very probable that Perino provided designs for two copes, not one as described by Vasari, each with eight scenes on the orphrey. In the absence of any document before the 1547 inventory, it is not possible to date these designs closely, as Perino was in the continuous employ of Paul III from around 1540 until his death in 1547.

Cat. 57 is the cartoon for the use of the embroiderer for the St Paul cope, and its poor condition reflects its status as a working drawing. As is usual for embroiderers' drawings, the design is very finely pricked, the holes closely spaced along the outlines, more widely at the edges of the principal shadow areas. A second sheet of paper would presumably have been pricked, together with the *modello*, to provide a 'replacement cartoon' for pouncing the design on to the silk support – the embroiderer would not have wanted to dirty the drawing with charcoal dust, as the delicate white heightening would have acted as his guide for the modelling with white or silver threads.

The surface of the drawing has been rubbed and attacked by damp and insects, though it is an unusually thick sheet of paper and is structurally sound, with the exception of a fracture through the head of Ananias. Photography in ultraviolet light increases the contrast of the iron gall ink and enables one to appreciate the potent solidity of the figures. The figure of Ananias seems to have been based on a drawing by Francesco Salviati of a bishop that was also utilized by Perino's associate Alessandro Cesati (see cat. 55) for a medal of Paul III.[2]

NOTES
1. Vasari 1568, II, p. 370.
2. Rome 1998, nos. 111–12.

LITERATURE
Popham and Wilde 1949, no. 978; Pouncey and Gere 1962, pp. 103f.; Hamburg 1965, under no. 4; Massari 1983, p. 84; Parma Armani 1986, p. 335; Davidson 1990a, pp. 132–35; M. Jaffé 1994, p. 231

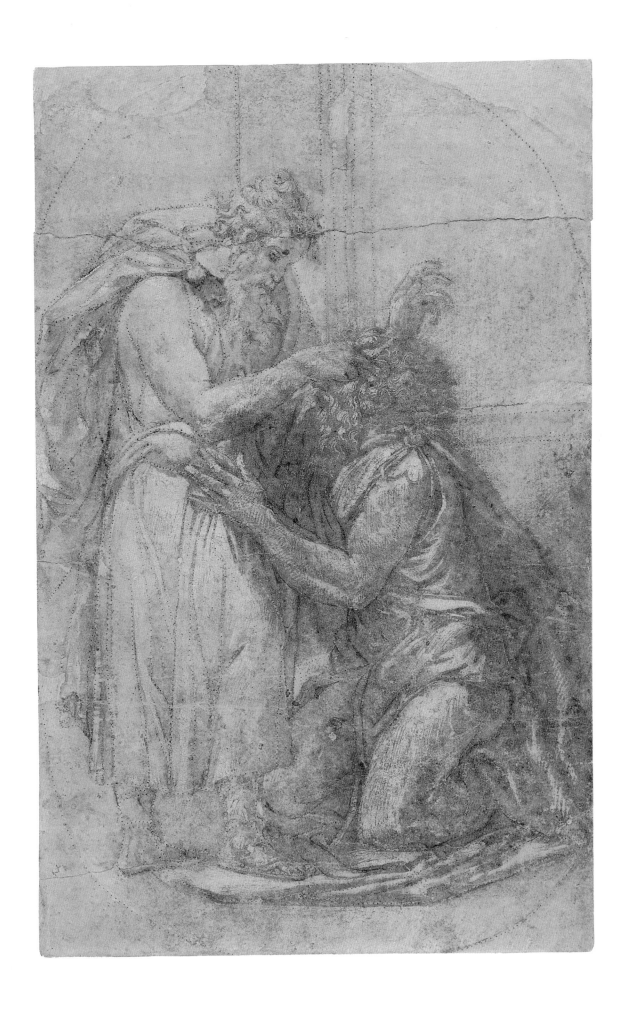

58

PERINO DEL VAGA

A sea-monster with the head of a bull

ca. 1541–45

Black-chalk underdrawing; pen and iron-gall ink; badly creased at left

Inscribed upper centre, pen and ink, *di pirino del uago*

Verso blank

241 × 341 mm

Watermark: A circle and four crescents in a circle

RL 0502

This drawing was connected by Davidson (1976) with Perino's stucco decorations in the Sala Regia of the Vatican, adjoining the Sistine Chapel. Commissioned by Pope Paul III, Antonio da Sangallo designed and supervised the construction of this chamber during the late 1530s, whereafter Perino was employed to design the decorations – the stuccos, frescos and stained-glass windows. Monthly payments to Perino were made from January 1542, and the vault was completed by June 1545, when work began on the stucco frieze of the cornice. The decorations were incomplete on Perino's death in October 1547, when Daniele da Volterra took over the commission; following the death of Paul III in 1549 the work came to a halt, and was not completed until 1573, under Gregory XIII.

Cat. 58 is a study for the marine creatures modelled in stucco that decorate the inner frames of some of the ceiling's octagonal coffers (fig. 84). It is *en suite* with another vigorous pen study in the Uffizi, of a triton (fig. 85), on the same scale and with the left edge similarly badly creased, though some of the contours of the Uffizi sheet are pricked for transfer;[1] at Christ Church is a larger drawing of a confronted pair of tritons, much more carefully drawn, with wash added to show the desired relief of the figures.[2] The Christ Church drawing is close in scale to the stuccos themselves, but none of the stuccos is identical and none corresponds exactly with a drawing. It is likely that Perino's drawings served as samples on which the experienced stuccoists could improvise, rather than patterns to be followed precisely.

NOTES

1. Uffizi 1596-E; Davidson 1966, no. 55.
2. Byam Shaw 1976, no. 481; copies in the British Museum (inv. 1946-7-13-1272 and Pouncey and Gere 1962, no. 192), Munich (inv. 2544), the Uffizi (1651-O; Rome 1981, no. 105), the Louvre (inv. 10451; Bacou and Béguin 1983–84, no. 101), and Düsseldorf (inv. F.P.160; Budde 1930, no. 22, pl. 8; Gere 1969, no. 27, as Taddeo Zuccaro).

LITERATURE

Popham and Wilde 1949, no. 982; Davidson 1966, p. 57; London 1972–73, no. 85; Davidson 1976, pp. 403f.; Bacou and Béguin 1983–84, p. 89; Parma Armani 1986, p. 329; Calì 1988, p. 46

Fig. 84 Unidentified stuccoist after Perino del Vaga, *A sea-monster with a putto*, stucco. Vatican, Sala Regia

Fig. 85 Perino del Vaga, *A triton*, pen and ink, some contours pricked, 225 × 314 mm. Florence, Uffizi, inv. 1596-E

59

PERINO DEL VAGA

A design for an overdoor with allegorical figures of Ecclesia and Concordia

ca. 1546–47

Paper washed buff; the tondo marked out with stylus lines; pen and iron-gall ink; carbon grey wash; lead-white bodycolour; the right-hand figure squared twice in black chalk at 20 mm
Inscribed, not by the artist, pen and ink, *conuersi 5* (or *S*), *castita*, *cõcordia*
Verso: some of the outlines traced through in black chalk
307 × 362 mm, in three sections joined vertically, a restored strip at the centre
Watermark: crossed arrows with six-pointed star
RL 10761
Provenance: George III (Volume A16, *Buildings and Architectural Ornaments*, f. 22)

This is a study for a fresco (fig. 86) in the Sala Paolina, the principal room of the Castel Sant'Angelo decorated by Perino and his workshop for Pope Paul III (Alessandro Farnese,

reigned 1534–49). Payments specifically connected with the Sala Paolina are recorded from 14 June 1545, and by September of the following year the beautifully stuccoed and gilded vault was probably complete. It is likely that work on the walls began in late 1546, and on 31 July 1547 a payment was made to dismantle the scaffolding "*dei pictori del castello*", which Gaudioso reasonably interpreted as signifying the completion of the upper parts of the walls. The room had not been finished by Perino's death on 20 October 1547, and though the *basamento* was probably continued largely to his designs, a study at Windsor by Pellegrino Tibaldi (one of Perino's assistants) for an illusionistic door in the room perhaps indicates that Perino's intentions were modified.[1]

The vault of the room incorporates six small scenes from the life of Farnese's namesake, Alexander the Great. Around the walls are densely figurated frescos, in imitation of bronze reliefs, continuing the Alexandrine theme, interspersed with the Temporal Virtues and figures of the Emperor Hadrian (whose mausoleum is the Castel Sant'Angelo) and of St Michael

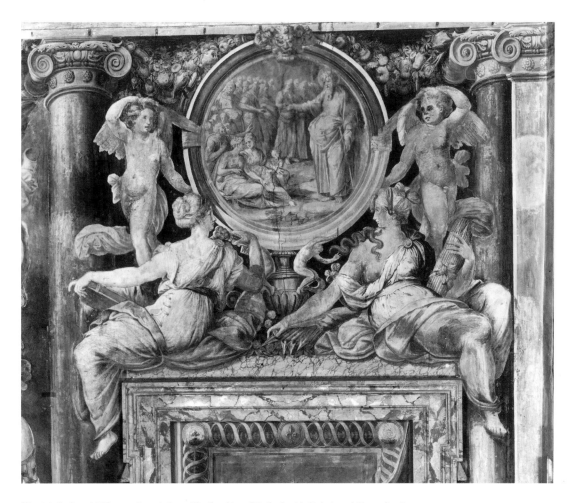

Fig. 86 Perino del Vaga and workshop, *The Preaching of St Paul, with Ecclesia and Concordia*, fresco. Rome, Castel Sant'Angelo, Sala Paolina

(after whom it is now named). Over the doors are allegorical figures with roundels containing scenes from the life of St Paul, also in bronze monochrome.

Cat. 59 is a study for the upper right portion of the north wall. It was folded, stained and damaged at an early date, with the loss of a strip down the centre of the drawing. During recent conservation work the heavy staining was reduced, the old patches removed and a central strip added to restore the original proportions. Inscriptions on the drawing, not in Perino's hand, name the allegorical figures as Concord and, mistakenly, Chastity. The former bears the fasces (bundle of rods or arrows) that signify strength through unity; the latter holds a Bible and a papal key and rests her right arm on a papal tiara, and is in fact Ecclesia, the personification of the Church.

An inscription also seems to identify the scene intended for the tondo as *The Conversion of St Paul*, whereas it was his preaching that was painted in the fresco.[2]

Despite the carefully finished nature of the drawing, it is not the final design. In the fresco the poses of the putti were adjusted, the relative size of the allegorical figures was increased, and the proportions of Concord were elongated horizontally; she is the only part of the drawing to be squared, and this elongation might thus have been effected by transferring the squared design to an oblong grid. By contrast, a drawing in the Uffizi on the same scale and in the same media, for the overdoor with the Muses Calliope and Euterpe, is fully squared and agrees perfectly in proportion with the fresco.[3] These two attractively finished drawings may have served some

59 (detail)

additional purpose such as submission to the patron, for the combination of wash and heightening captures something of the pictorial richness of the frescos; a second sheet in the Uffizi for another of the overdoors corresponds as closely to its fresco as does the first, but is drawn in the much less time-consuming technique of black chalk alone, squared in red chalk.[4]

A drawing at Chatsworth by Tibaldi, corresponding with another of the overdoors, combines exactitude in the proportions with looseness in the details and is probably a copy after a drawing by Perino.[5] A variant on these designs at Christ Church disposes the motifs in a way that could not possibly fit into the Sala and so must be a later derivation.[6]

NOTES
1. For the documents see Gaudioso 1976. The Tibaldi drawing is Popham and Wilde 1949, no. 943.
2. A drawing for the *Preaching* is in the Germanisches Nationalmuseum, Nuremberg, inv. Hz 2802; see Chapman 1998.
3. Uffizi 66-0; Davidson 1966, no. 53; Rome 1981, no. 79.
4. Uffizi 95310-F; Rome 1981, no. 78.
5. M. Jaffé 1994, no. 354.
6. Byam Shaw 1976, no. 880, as "Niccolò dell'Abbate (?)"; Rome 1981–82, no. 112 as Domenico Zaga.

LITERATURE
Popham and Wilde 1949, no. 979; Gere 1960, p. 15 n.; Hirst 1965, p. 569 n.; Davidson 1966, p. 56; London 1972–73, no. 83; Byam Shaw 1976, p. 235; Gaudioso 1976, p. 34; Harprath 1978, pp. 54 n., 74; Rome 1981–82, no. 80; Parma Armani 1986, p. 293; Jaffé 1993, p. 126; M. Jaffé 1994, p. 217

POLIDORO DA CARAVAGGIO

Polidoro Caldara, born around 1499 in Caravaggio in Lombardy; moved to Rome around 1515; probably engaged in Raphael's studio from 1517. After Raphael's death worked primarily on a series of great decorative frescos on the façades of Roman *palazzi*. Left Rome for Naples in 1527, and a year later moved on to Sicily. Subsequent paintings almost exclusively devotional in nature. Stated to have been murdered in 1543.

60

POLIDORO DA CARAVAGGIO
Christ carried to the Tomb

ca. 1522

Red chalk; creamy-white bodycolour; red and white oil-paint restoration; the outlines pricked, those of the figure at left also indented with a stylus
Verso partially rubbed with charcoal; fragments of a pen-and-ink design for a coffered ceiling on the central patch
244 × 327 mm, extensively patched
No watermark visible
RL 5433

When this sheet left the artist's hands it was a drawing in red chalk alone. It was later ineptly heightened with white body-colour, presumably to increase the contrasts in what might have been an excessively worked study lacking tonal richness. Damage to the central area was patched with pieces from a sheet bearing a contemporary design for a coffered ceiling on the verso, and the recto was 'restored' with oil paint. Following this, the contours of the figures were pricked (through the oil paint restoration), and at some stage the figure at the left holding a torch was also indented around its outlines, the verso of the sheet having been rubbed with charcoal over this area alone.

Despite all this maltreatment it is a simple matter to recognize the hand of Polidoro in the original red-chalk drawing, with its squat figures with broad, flat features and agitated draperies pulled in strange ways across the bodies. The subject was treated several times by Polidoro. *Pace* Marabottini and Ravelli, the compositional style is not that of his maturity in Naples and Messina, when he habitually set his figures obliquely in a deep space, ranged up the picture surface in an intuitive, non-perspectival manner;[1] here the main action takes place in the front plane, and the subsidiary figures are set behind the protagonists with simple overlaps, a feature of Polidoro's earlier works in Rome such as his probable contributions to the frescos in Santa Maria della Pietà in Camposanto Teutonico,[2] and, naturally, his façade paintings. The same rational organization can be seen in two related drawings by Polidoro of the *Entombment*, in the Louvre and the Fogg Art Museum.[3] Perino del Vaga's red-chalk drawing in the British Museum for a *Deposition*,[4] of *ca.* 1522, is very close in style and figure types to the present sheet and reflects the continuing contact between Perino and Polidoro.

Grassi (1972) published a drawing in a Roman private collection that incorporates, in reverse and probably by off-setting, the central group from the present drawing, omitting

60v (detail)

the standing men at either edge but with the addition by Polidoro of three further men at the right of the composition. Such mechanical manipulation of a motif is rare in Polidoro's drawings but was common in Raphael's studio, and is another reason for dating the drawing early in Polidoro's career.

NOTES
1. See his later treatments of the subject in Naples 1988–89, nos. II.9 and VI.1–4.
2. The cycle in Santa Maria della Pietà was designed probably in early 1522 by Perino del Vaga (drawing formerly in the Gathorne Hardy collection; repr. Parma Armani 1986, p. 319; Naples 1988–89, p. 11), who shortly afterwards left Rome to escape the plague. The resulting frescos (see Naples 1988–89, nos. II.4–7) have suffered over the years, but at least two, *The Agony in the Garden* and *Christ before Pilate*, show enough of the characteristics of Polidoro to suggest that he took over the project after Perino's departure before he, too, fled the plague, after which the scheme was completed by a much less competent artist. It should be noted, however, that Gere (1987, under cat. 74) doubted that Polidoro had any hand in the frescos.
3. Louvre, inv. 592, Bacou and Béguin 1983–84, no. 108; and Fogg 1932.348, Mongan and Sachs 1940, no. 193.
4. Pouncey and Gere 1962, no. 157.

LITERATURE
Popham and Wilde 1949, no. 691; Marabottini 1968, no. 173; Grassi 1972, pp. 258f.; Ciardi Dupré and Chelazzi Dini 1975, p. 324; Ravelli 1978, no. 168; Birke and Kertész 1992–97, I, p. 205

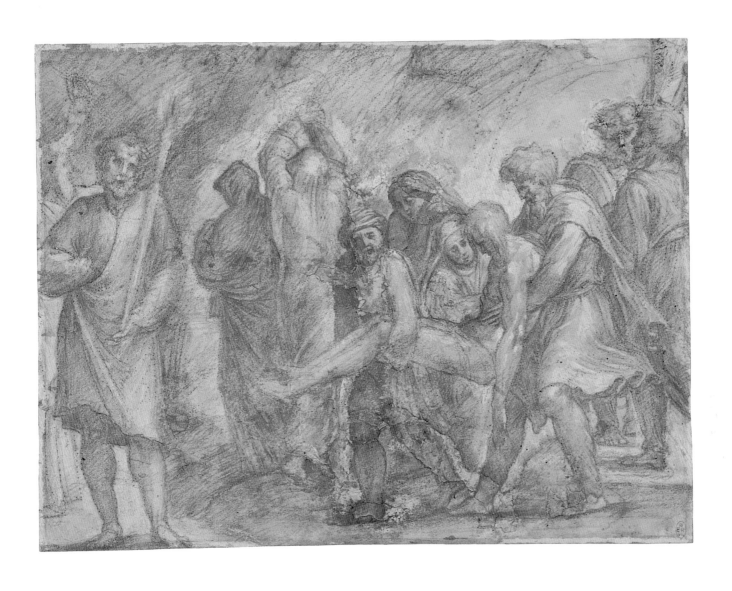

POLIDORO DA CARAVAGGIO
The Betrayal of Christ

ca. 1524

Paper washed blue (indigo?); a little pen and iron-gall ink; brush with iron-gall and carbon grey inks; lead-white bodycolour
Inscribed lower centre, pen and ink, *Benevenuto Gorofolo.-*
Verso blank
211 × 262 mm
No watermark
RL 050
Provenance: Paul Sandby (Lugt 2112); Sir Thomas Lawrence (Lugt 2445); William Mayor (Lugt 2799; his catalogues, 1871 and 1874 edns, no. 63, 1875 edn, no. 43); bought from J. Hogarth & Sons, 1876, 30 gns.

Fig. 87 Valerio Belli, *The Betrayal of Christ*, carved crystal, 115 × 125 mm. Vatican, Museo Sacro

This drawing corresponds to one of a set of three crystal ovals, the others representing *Christ carrying the Cross* and the *Deposition*, attributed to the crystal-engraver Valerio Belli and now in the Museo Sacro of the Vatican (fig. 87). Their history is uncertain before their discovery in Bologna in 1857 together with an engraved crystal crucifix, but the assemblage is probably to be identified with a *"croce di cristallo divina"* for which Belli received 1111 ducats from Clement VII in 1525.[1]

The designer of the plaques is not recorded. The apparently arbitrary attribution to Garofalo inscribed on the sheet was followed by Conrad Metz, who etched a facsimile of the drawing in 1789 when it was in Paul Sandby's collection, and by the compiler of the Mayor collection catalogues. Voss and Kris both connected the drawing with Perino, by extension from his designs for the Farnese casket crystals around 1540. Antal was the first to recognize the typical mannerisms of Polidoro, and Popham accepted his attribution in the Windsor catalogue. Although both Ravelli and Marabottini subsequently denied Polidoro's authorship (the former giving the drawing to Biagio Pupini, the latter to an unidentified artist active in Rome between 1520 and 1525), the eccentric forms and gluey, string-like whites are entirely Polidoro's, as seen in early sheets such as *The Holy Family* in the Ashmolean.[2] Gere (1987) thought that Perino might have had some involvement with the designs, seeing his touch in the figure on the left of the *Lamentation* design, but this quality may simply reflect the closeness of Polidoro and Perino in the first half of the 1520s.

In the drawing the figures are seen as if standing on top of a wall, the protagonists thrust into the nearmost plane and the background figures ambiguously positioned. This dense compositional style is particularly suitable, even necessary, for a carved crystal, where uninflected gaps between the figures read as poverty of invention rather than as a pictorial 'breathing space'. These were conspicuously luxurious objects, and so long as the basic narrative was legible (effected by carving Christ, Judas and the soldier seizing Christ deeper than the other figures, as indicated by Polidoro in the heavier use of white) it was not possible for the composition to be too rich or abundant.

NOTES
1. Rome 1984–85, nos. 149a–c.
2. Parker 1956, no. 481.

LITERATURE
Voss 1920, I, p. 76 n.; Kris 1929, p. 50; Popham and Wilde 1949, no. 692; Parker 1956, p. 240; Marabottini 1969, no. 196; London 1972–73, no. 87; Ravelli 1978, no. 975; Pope-Hennessy 1980, p. 216; Rome 1984–85, p. 378; Gere 1985–86, p. 71; Roberts 1986, no. 38; Gere 1987, no. 83; Naples 1988–89, no. III.c.1

62

POLIDORO DA CARAVAGGIO
A design for an altarpiece to house a venerated image

1527–28

Paper washed pale buff (or possibly discoloured by damp); stylus lines and pointing in the architecture; pen and iron-gall ink; iron-gall wash; lead-white bodycolour; a restored fire-damaged area at centre left
Verso blank
258 × 205 mm
No watermark
RL 0383

Bologna (1959) first noted the connection between this drawing and a set of paintings executed by Polidoro for the fish-merchants of Naples. In 1526, a plague year, a votive chapel was expanded into a full church, Santa Maria delle Grazie alla Pescheria, which was altered many times over the centuries before its demolition as recently as 1968 to allow a widening of the via Marina. Shortly after his arrival in Naples in flight from the Sack of Rome of 1527, Polidoro received the commission to incorporate the votive panel of the Madonna and Child from the old chapel into the high altarpiece of the new church, together with a representation of souls in Purgatory and the patron saints of fishermen, Peter and Andrew.

This is probably Polidoro's first design for the altarpiece, a magnificent frame housing a single field incorporating the votive panel. Whether for reasons of taste or of expense, a decision was subsequently made to treat the altarpiece as an assemblage of independent panels clustered around the votive Madonna, and all Polidoro's other studies for the project treat the elements individually. This format may have been more easily made, but it was also easily dispersed. By 1624 only the Madonna and the two saints were to be seen,[1] and ten years later the panel of the *Souls in Purgatory* was noted in the collection of Giovan Simone Moccia.[2] That panel is now lost. On the destruction of the church in 1968 the remaining panels were scattered. The Madonna is untraced; the panels of *St Peter* and *St Andrew* have since been reunited on deposit at the Galleria di Capodimonte, Naples, together with a pair of small grisaille *tondi* of the *Annunciation* which are not prefigured in the present drawing.

An identically conceived drawing in the Albertina (fig. 88),[3] showing *The Virgin and Child in Glory over souls in Purgatory*, with a similar background of a bridge and circular fortress, is a study for a painting for a side altar of the same church.

Fig. 88 Polidoro da Caravaggio, *A design for an altarpiece*, stylus lines, pen and ink, wash, 365 × 252 mm. Vienna, Albertina, inv. SR 380

NOTES
1. D'Engenio Caracciolo 1624, p. 450.
2. Capaccio 1634, p. 858.
3. Birke and Kertész 1992–97, I, no. 313.

LITERATURE
Popham and Wilde 1949, no. 690; Bologna 1959, p. 83; Andrews 1968, p. 97; Marabottini 1969, pp. 221–22, no. 90; Blunt 1971, p. 108; Ciardi Dupré and Chelazzi Dini 1975, p. 324; Ravelli 1978, no. 185; Baricelli 1984, II, p. 19; Giusti and Leone de Castris 1985, pp. 60, 68–69, 274–75; Leone de Castris 1985, pp. 11ff.; Naples 1988–89, pp. 63–72, no. V.1; Gnann 1997, pp. 208–10

63

POLIDORO DA CARAVAGGIO

A religious procession

ca. 1530

Red chalk
Inscribed, lower left, pen and ink, *3* (?); and (by the so-called
Deceptive Hand), lower right, pen and ink, *polidoro*
Verso blank
204 × 258 mm
No watermark
RL 2349
Provenance: George III (Inv. A, p. 77, *Caracci Tom. 11*: "A kind of
Penance, falsly called Pollidoro, but [...] of the School of the
Caracci")

This fine sheet shows clearly the source of Polidoro's red-chalk
style in the drawings of Raphael's maturity. The flaring high-
lights in the hair and the broadly hatched areas of shadow can
be seen prefigured in the offset for the *Christ's Charge to Peter*
(cat. 26) and the rendering of the draperies in *The Massacre
of the Innocents* (cat. 20), especially of the mother at far right
there, a sister of the peasant women who appear throughout
Polidoro's genre drawings.

The subject is some religious procession, treated in
Polidoro's mature, quasi-caricatural style. Ravelli thought it
might be "some local lay confraternity of the dead"; Marabottini
described it as a procession of Capuchins, the Franciscan rule
established in 1528, and the obvious delight that Polidoro took
in portraying (or exaggerating?) the hoods would lend some
support to this idea. Among a number of other drawings of
religious ceremonies in Polidoro's oeuvre, cat. 63 is usually

connected with a study in the Louvre of a Mass.[1] The hooded robes are indeed similar but there is little else to warrant a close association, and the technique and spirit of the drawings are very different.

Such drawings were probably autonomous genre studies and it seems unnecessary to posit a firm connection between any on grounds of general subject-matter alone. It is likely that they all date from the latter part of Polidoro's career, in Naples and Messina. After a decade exposed to the sophistication and worldliness of the Church in Rome, the intense religiosity of the Spanish-influenced south must have been striking to

Polidoro, even comical, a reaction that is not far below the surface of the present drawing.

NOTES
1. Inv. 6074; Bacou and Béguin 1983–84, no. 124.

LITERATURE
Popham and Wilde 1949, no. 693B; Marabottini 1969, pp. 223–24, no. 114; Marabottini 1972, p. 368; London 1972–73, no. 86; Ciardi Dupré and Chelazzi Dini 1975, p. 324; Ravelli 1978, no. 165; Gere and Pouncey 1983, p. 229; Bacou and Béguin 1983–84, p. 107; Giusti and Leone de Castris 1985, fig. 4.1; Roberts 1987, no. 32; Naples 1988–89, no. IV.4; Birke and Kertész 1992–97, I, p. 224

64
POLIDORO DA CARAVAGGIO
A head of a man

ca. 1530
Red chalk
Verso blank
105 × 79 mm, upper corners chamfered
No watermark
RL 5434
Provenance: Jean-Denis Lempereur (Lugt 1740)

The traditional attribution of this head to Polidoro has never been questioned. It is clearly from the life, and thus less mannered than the figure studies from Polidoro's imagination. Ravelli compared its character to that of the head of St Thomas in the Courtauld Institute's *Incredulity*, but the motifs are only coincidentally similar. Gazing upwards with a slack jaw, the head here could well be for a saint in ecstasy. Such contextless drawings are even more difficult to date than Polidoro's more substantial sheets, though the confidence of the details suggests that it is from later rather than earlier in his career.

LITERATURE
Popham and Wilde 1949, no. 693A; Bologna 1959, p. 81; Marabottini 1969, no. 96; Ciardi Dupré and Chelazzi Dini 1975, p. 324; Ravelli 1978, no. 172; Naples 1988–89, no. VIII.2

65

ATTRIBUTED TO

POLIDORO DA CARAVAGGIO

Autumn

ca. 1535–40

Charcoal underdrawing; pen and iron-gall ink

Verso: A rough architectural sketch

Pen and iron-gall ink
251 × 179 mm
No watermark
RL 12959
Provenance: George III (Inv. A, p. 133, *A Large Portfolio of Drawings*, no. 22, "A Drawing in pen & ink of a Woman & 2 Boys", unattributed)

Fig. 89 Polidoro da Caravaggio, *Studies for a statue of St John the Baptist* (detail), pen and ink, whole sheet 206 × 289 mm. London, British Museum, inv. 1856-7-12-6

The identification of this figure as a personification of Autumn was made by Blunt (in London 1972–73), by comparison with a painting at Chantilly from the studio of Botticelli, which likewise shows a woman carrying a bowl of fruit on her head, accompanied by two putti laden with grapes.[1] There is a similar figure in Marcantonio Raimondi's *Vintagers*.[2]

Popham catalogued the drawing as School of Rome, *ca.* 1510–20, while recording Robinson's earlier attribution to Peruzzi. Antal supported Robinson's proposal, comparing the sheet to drawings in Peruzzi's Sienese *taccuino*. Frommel, in his long article on Peruzzi (1967–68), did not mention the drawing; this does not necessarily imply rejection, but it is not possible to see Peruzzi's calm, even-paced handling in the vigorous hatching of this sheet. Nicholas Turner recently suggested (in conversation) Pirro Ligorio as the author, an artist who owed much to Peruzzi in his drawing style, but again the penwork here is more ragged than Ligorio's instinctively regular lines: a comparable study by Ligorio of a *Woman with an axe and two putti*[3] shows a fundamentally restrained method of constructing form.

The attribution here to Polidoro is based on drawing style and figure type. The ragged forms are constructed with short, agitated, sometimes disconnected strokes, and are given only a measure of solidity by very rapid hatching: this is strictly comparable to drawings from late in Polidoro's career such as the studies in the British Museum for a statue of *St John the Baptist* (fig. 89).[4] The eccentric proportions and highly distinctive facial type – the broad, flat nose set low on the face and the featureless eyes – are seen throughout Polidoro's oeuvre (cat. 60, 63). The drawing probably dates from Polidoro's Messinese period, but it has not been possible to associate it with any project.

65v (detail)

When the drawing was lifted from its old mount during recent conservation, a rapid architectural sketch was uncovered on the verso. Little can be made of such a brief study, but some general similarities in handling may be noted with the backgrounds of Polidoro's studies in Berlin for a procession.[5]

NOTES
1. See also the drawing by Botticelli in the British Museum (Popham and Pouncey 1950, no. 24), and the *Autumn* in a set of four paintings, again from the studio of Botticelli, reproduced in Venturi 1937, opp. p. 13.
2. Bartsch XIV, p. 231, no. 306.
3. Christie's New York, 11 January 1989, lot 10.
4. Pouncey and Gere 1962, no. 216r.
5. Ravelli 1978, nos. 218–21.

LITERATURE
Popham and Wilde 1949, no. 1134; Antal 1951, p. 35; Blunt 1971, no. 341; London 1972–73, no. 89

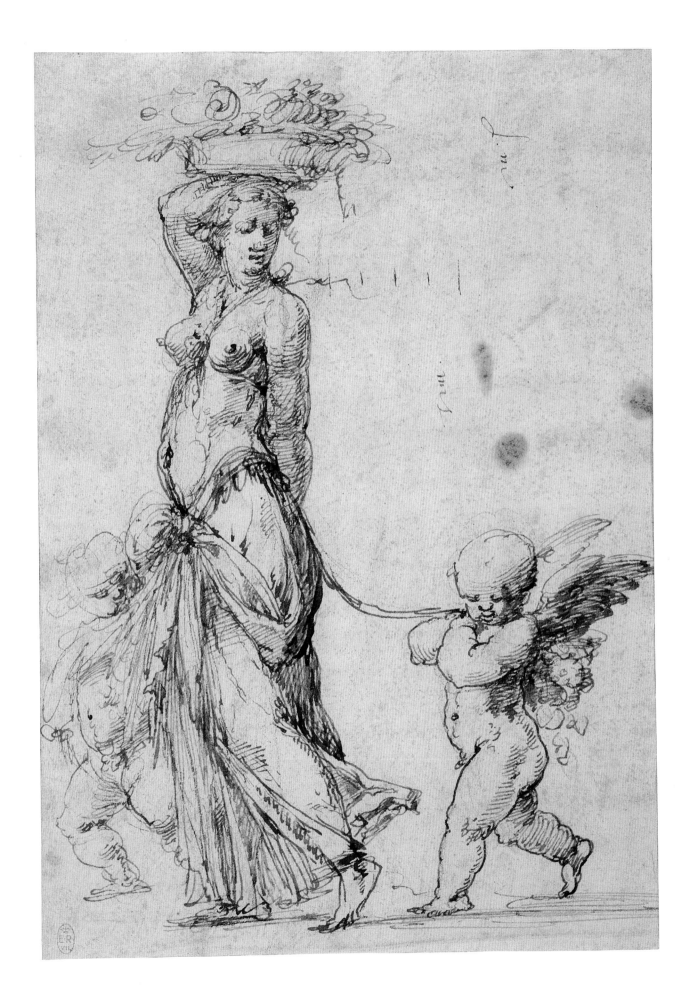

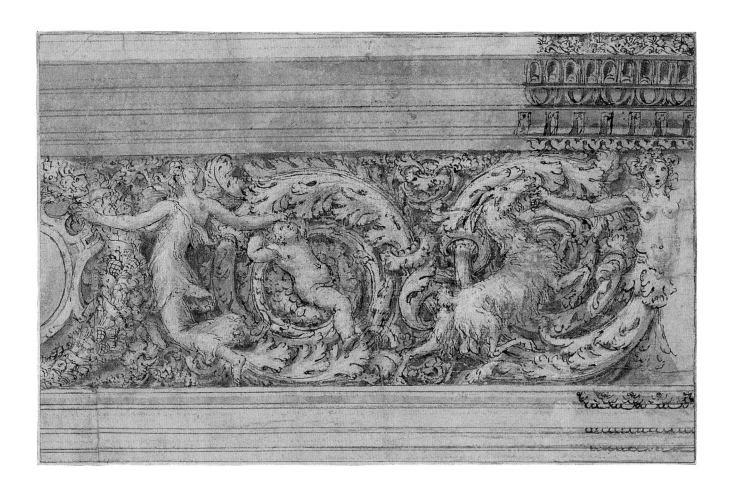

66

POLIDORO DA CARAVAGGIO

A study for a frieze

ca. 1525–30

Black-chalk underdrawing; pen and iron-gall ink; carbon grey wash;
some lead-white bodycolour
Laid down on eighteenth-century mount
164 × 259 mm
No watermark visible
RL 10909
Provenance: George III (Volume A19, *Architectural Ornaments*, f. 13)

Pouncey and Gere independently recognized Polidoro as the author of this sheet (formerly mounted in one of George III's albums of miscellaneous architectural drawings), with its distinctively proportioned figures, busy outlines and rich invention. The exuberance of the acanthus scrolls is comparable to the altar-frame of 1527–28 in cat. 62, but it is hazardous to date such drawings by motif alone – the taste is equally that of Polidoro's later architectural works such as the friezes over the portals of Messina cathedral;[1] and yet the drawing style retains more than a memory of Perino del Vaga. A date in the later 1520s is probably to be preferred.

The dense detail of the upper moulding suggests that this was to be a particularly large and grand frieze. It is unfortunate that Polidoro neglected to complete the *stemma* in the left margin, which could have identified the family and thus probably the building for which it was designed; on the other hand, this omission might suggest that the drawing was an exercise in *invenzione* and not specific to any project.

NOTES
1. Repr. Naples 1988–89, p. 132.

LITERATURE
Blunt 1971, no. 370

Raphael and his followers left no large group of drawings to posterity like those of Leonardo at Windsor and Milan, Fra Bartolomeo at Rotterdam and Michelangelo in the Casa Buonarroti, and the history of the collecting of their drawings is a matter of piecemeal accumulation. The earliest detailed record of the Old Master drawings in the Royal Collection is the so-called Inventory A, a manuscript volume describing the albums of drawings in the Royal Library and often listing their contents precisely enough to allow each sheet to be identified. This was compiled early in the nineteenth century, after a major rearrangement of the albums under George III;

a single interleaved sheet (p. 17) describes the contents of two albums, entitled *Diversi Maestri Antichi*, dating from before this rearrangement, as a few of the drawings listed there can be identified elsewhere in Inventory A in differently titled albums.

Nineteen of the drawings in the present catalogue were contained in a single volume entitled *Raffaello d'Urbino e Scuola*. The entry for this volume in Inventory A is transcribed here, with the numbers of the drawings in the present catalogue noted in square brackets; for drawings not included in the present selection the number in Popham and Wilde's catalogue of 1949 is given (P&W):

[p. 49]	Page 1...Elymas the Sorceror struck blind; The Composition the same as the large Cartoon. These small Drawings of Raphael were design'd by him in order to be Engraved by M Antonio & others. This Drawing was bought at Rome & is Engrav'd by A:Veneziano, 1516.	[cat. 27]
	2...The Miraculous draught of Fishes; the Composition Ditto. This Drawing was found in an Old Bureau at Kensington which contained part of the Collection of King Charles ye first, where also was preserved the Volume of Leonardo da Vinci.	[cat. 25]
	3...A Copy of the above, once held for an Original. This of ye same Collection.	[P&W 850]
	4...Adam & Eve driven out of Paradise. From the same Collection with No.1.	[cat. 32]
	5...The first thought of Raphael for the half of the Composition call'd the Sacrament, or i sacri Dottori &c, Painted in the Vatican and Raphael's first performance there.	[cat. 16]
	6...Nuditys, to ascertain the proportions before He made study's for the Drapery's. This is a Study of part of the abovemention'd Painting.	[P&W 856]
	7...Emblem of Inspiration, wrote Numine Afflatur; Painted in a Compartment of a Cieling in the Vatican. This is from Kensington.	[cat. 15]
	8...Virgin Mary, Child and St: John.	[cat. 11]
	9...Virgin Mary, St: Ann & a faint outline of St: Elizabeth & Child Jesus.	[cat. 23]
	10...Virgin Mary Jesus & St: John, with St: Elizabeth, drawn with a Pen; These three are early Studys of Raphael & where in the Bounfigliuola Collection in one of the three Volumes purchased in Mr: Smiths Collection at Venice.	[cat. 13]
[p. 50]	Page 11...Emblem of Hope. (From Kensington)	[P&W 815]
	12...A Head. Great Expression, but much damaged; in the same Collection as No: 1.	[P&W 822]
	13...Madonna Enthron'd, behind a female Saint; on one Side a St: John the Baptist, on the other a Saint holding a Branch in bloom; under the V:M: an Angel playing on a Lute, above Boy Angels holding up the Canopy. This Drawing seems to be a first Study for the Picture in the Pallazzo Pitti at Florence; much chang'd afterwards in the air & number of the figures & immitating the stile of Fra: Bartolomeo della Porta.	[P&W 393]
	14...An Angle of the Ceiling with part of the Story of Cupid & Psyche, painted in Pallazzo Ghigi nella Lungara; This seems to be a very neat old Copy.	[P&W 830]
	15...St: John Baptizing our Saviour, an outline only.	[P&W 860]
	16...Abraham & Isaac.	[P&W 973]
	17...Joshua distributing the shares to the twelve Tribes.	[cat. 33]
	18...Pharaoh & his Host drown'd in the Red Sea.	[P&W 848]
	19...Baptism of our Saviour.	[P&W 852]
	20...Abraham & Isaac.	[P&W 991]
	21...God appearing to Moses.	[?]
	22...Joseph & his Brethren.	[P&W 993]
	23...Jacob wrestling with the Angel.	[P&W 992]
	24...Copy of the School of Athens, said to be a Drawing by Parmegiano. N:B: Most of these from Page 15, are by Perino del Vago.	[P&W 598]

25...Alexander & Roxana, a damaged Drawing; It is painted in a
 House call'd Raphael's Villa, near the Walls of Rome. [P&W 809]
26...Christ's charge to Sᵗ: Peter & the Apostles. an old Copy. [P&W 827]

[p. 51] Page 27...Virgin Mary, Child Jesus & Sᵗ: John with Sᵗ: Ann. A good Copy in
 Red Chalk from the Original Picture by Raphael. [cat. 34]
28...The Three Graces, Studys, in the Cupid & Psyche. Red Chalk. [cat. 31]
29...The Composition of the Murder of the Innocents, Engrav'd by M:Antonio.
 Some of the figures masterfully drawn in Red Chalk, but near
 half left with a bare outline. Both of these Red Chalk [cat. 20]
 Drawings have the appearance of Originals.
30...Homer, another Poet, with Dante. Good Drawings with a Pen. [cat. 18]
31...Venus & Cupid, Red Chalk. [cat. 30]
32...Two Soldiers, surprised or astonished. A Study of part of the Groupe in
 the Resurection. [cat. 21]
33...Another Soldier. Ditto. [cat. 22]
34...A Study of a Single Figure. not extraordinary. [P&W 820?]
35...Virgin Mary weeping over a dead Christ. Stile of Pietro Perugino. [P&W 816]
36.⎫ A figure throwing a Stone, Black Chalk. A Leda, drawn with a Pen. [cat. 35, 12]
37.⎬ Wrestlers, or Hercules and Anteus. These are immitators [P&W 29]
38.⎭ of Raphael's Stile.
39...Moses. a Good drawing though not by Raphael. [P&W 849]
40...A Copy after part of a Picture. This is well drawn with a Pen [amended to] Red Chalk [?]
41...A damaged Drawing, with a pen, of the last Supper. after Raphael. [cat. 29]
42...Venus, Cupid & Vulcan. either by Julio Romano, or some of Raphael's
 Scholars, the remaining eight Drawings are Copy's of [P&W 813]
 that School.

Most of these drawings bear inventory numbers in the range 12728–12760, assigned early in the twentieth century when many sheets were still mounted in their eighteenth-century albums. The inventory numbers with 'o' prefixes form a separate sequence of drawings not bound in albums at that time. However many of these can be identified in albums in Inventory A; likewise, some drawings with non-'o' numbers were listed as housed loose in portfolios in Inventory A, and had been inserted between the folios of albums by the time a typescript inventory of those albums was compiled, shortly before the numbers were assigned.

This demonstrates that the arrangement of the albums was much altered between their assembly under George III and their dismemberment in the twentieth century. Thus the album entitled *Guilio [sic] Romano, Polidoro, e Perino del Vaga Tom. 2* contained cat. 36, 37 and 50 when Inventory A was compiled, yet a hundred years later the typescript inventory for the same album lists none of these three drawings (and they now have 'o' numbers) but does include cat. 57, interleaved, which was not present when Inventory A was compiled. Four of the earlier drawings in the exhibition (cat. 1, 5–7) can be identified in Inventory A in the album entitled *Albert Durer e Maestri Antichi Div[er]si*. Cat. 2–4 were possibly housed in the same volume, as "Heads of the old Masters, two in the stile of Pietro Perugino", or in *Teste di Diversi Maestri Tom. I*, among "5 Of Pietro Perugino or cotemporary's". The drawings with inventory numbers in the range 10738–10953 (cat. 51–54, 59, 66) were mounted in four albums of architectural and decorative studies which survive largely intact.

Because of the extensive remounting of most of the drawings under George III, the earlier history of many is unknown. At least four drawings in the catalogue (cat. 8, 37, 49, 50) were in England by the seventeenth century, as attested by collectors' stamps and inscriptions on the sheets themselves, and these may have entered the Royal Collection under Charles II. Cat. 15, 25 and P&W 850 were stated in Inventory A to have come from a bureau at Kensington Palace and thus to have formed part of Charles I's collection, though that inference is questionable: P&W 850 does bear collectors' stamps (Lugt 2886 and 2887) associated with members of Charles I's court, but the question of his own collection of drawings is very vexed. The bureau is that referred to in a summary list of the "Books of Drawings and Prints in the Buroe in His Majestys Great Closset at Kensington" made some time after 1735 (British Library, Department of Manuscripts, Add. 20101, f. 28). The relevant entries are "No. 1. Drawings by Polidore, Julio Romano, Raphaell, [...]", "No. 9. Drawings by Julio Romano, M. Angello, Raphaell" and "No. 10. by Polydor, [...]", but no descriptions are given of individual drawings.

The majority of the Italian drawings in the Collection were acquired in Italy early in the reign of George III, the best documented of these purchases being that in 1762 of the collection of Joseph Smith, British Consul in Venice. The principal source of Smith's Renaissance drawings was the three volumes assembled by the Bonfiglioli family in Bologna, bought by Zaccaria Sagredo in 1728 and from Sagredo by Smith in 1752. Three of the drawings in this catalogue (cat. 11, 13, 23) were stated in Inventory A to have this provenance; several others (cat. 20, 26 and possibly 19, 29 and 42) were seen by Jonathan Richardson in the Palazzo Bonfiglioli in 1719 or can be identified in the posthumous inventory of the estate of Silvestro Bonfiglioli, drawn up in 1696 (Bologna, Archivio di Stato, Archivi Notarili: Notaio Girolamo Medici 1679–1709, Protocollo 1696–97, cc. 4v–14). George III's other major purchase was that of the collection of Cardinal Alessandro Albani, through James Adam, also in 1762, but this is much more poorly documented and no drawing here can be positively identified as having come from that source.

Other information on the provenance of the drawings is sporadic: former owners of cat. 9 (Carlo Maratti), 27 (Queen Christina of Sweden), 50 (Antonio Tronsarelli) and 64 (Jean-Denis Lempereur) can be identified with varying degrees of certainty; and, finally, cat. 61 was bought in 1876, one of the few Old Master drawings to enter the Collection after the reign of George III.

WATERMARKS

1

3

4

7

12

15

17

19, 22

25, 29

20

26

21

31

33

40

41

37

45

39

47

50, 51

52

54

58

59

Ames-Lewis, F., *Drawing in Early Renaissance Italy*, New Haven and London 1981

Ames-Lewis, F., *The Draftsman Raphael*, New Haven and London 1986

Ames-Lewis, F., and E. Clegg, 'A Contribution to an Inventory of Pollaiuolo Figure-group Drawings', *Master Drawings*, XXV, 1987, pp. 237–41

Ames-Lewis, F., and J. Wright, *Drawing in the Italian Renaissance Workshop*, exhib. cat., Nottingham, University Art Gallery, and London, Victoria and Albert Museum, 1983

Andrews, K., *National Gallery of Scotland: Catalogue of Italian Drawings*, 2 vols., Cambridge 1968

Andrus-Walck, K., *The 'Bible of Raphael' and Early Christian Antiquity*, PhD. diss., University of North Carolina at Chapel Hill, 1986

Antal, F., review of Popham and Wilde 1949, *Burlington Magazine*, XCIII, 1951, pp. 28-35

Armenini, G.B., *De' Veri Precetti della Pittura*, Ravenna 1587

Askew, P., 'Perino del Vaga's Decorations for the Palazzo Doria, Genoa', *Burlington Magazine*, XCVIII, 1956, pp. 46–53

Bacou, R., and S. Béguin, *Autour de Raphaël*, exhib. cat., Paris, Musée du Louvre, 1983–84

Bambach Cappel, C., *The Tradition of Pouncing Drawings in the Italian Renaissance Workshop*, PhD. diss., Yale University, 1988

Bambach Cappel, C., 'A Substitute Cartoon for Raphael's *Disputa*', *Master Drawings*, XXX, 1992, pp. 9–30

Baricelli, C., *La pittura in Sicilia della fine del Quattrocento alla controriforma*, 2 vols., Naples 1984

Baumgart, F., 'Beiträge zu Raffael und seiner Werkstatt', *Münchner Jahrbuch der Bildenden Kunst*, VIII, 1931, pp. 49–68

Bean, J., *Les Dessins Italiens de la Collection Bonnat*, Paris 1960

Béguin, S., 'Nouvelles analyses résultantes de l'étude et de la restauration des Raphaël du Louvre', *The Princeton Raphael Symposium (1983)*, Princeton 1990, pp. 39–47

Bell, J., 'Color and chiaroscuro', in *Raphael's School of Athens*, ed. M. Hall, Cambridge 1997, pp. 85–113

Berenson, B., *Lorenzo Lotto. An Essay in Constructive Art Criticism*, London 1901

Berenson, B., *The Drawings of the Florentine Painters*, 2nd edn, Chicago 1938; 3rd edn (as *I disegni dei pittori fiorentini*), Milan 1961

Bertini, A., *I disegni italiani della Biblioteca Reale di Torino*, Rome 1958

Birke, V., and J. Kertész, *Die Italienischen Zeichnungen der Albertina*, 4 vols., Vienna 1992–97

Biscontin, J., 'Antique Candelabra in Frescoes by Bernardino Gatti and a Drawing by Giulio Romano', *Journal of the Warburg and Courtauld Institutes*, LVII, 1994, pp. 264–69

Blunt, A., 'Supplements to the Catalogues of Italian and French Drawings', in E. Schilling, *The German Drawings in the Collection of Her Majesty The Queen at Windsor Castle*, London and New York n.d. [1971]

Bober, P.P., and R. Rubinstein, *Renaissance Artists and Antique Sculpture*, London 1986

Bologna, F., *Roviale Spagnuolo e la pittura napoletana del Cinquecento*, Naples 1959

Bombe, W., *Perugino* (Klassiker der Kunst), Stuttgart and Berlin 1914

Brejon de Lavergnée, B., *Collections du Palais des Beaux-Arts de Lille. Catalogue des dessins italiens*, Paris 1997

Brown, D., *Raphael and America*, exhib. cat. by D. Brown, Washington, D.C., National Gallery of Art, 1983

Brugerolles, E., *Les Dessins de la collection Armand-Valton*, Paris 1984

Brugnoli, M., 'Affreschi di Perin del Vaga nella cappella del Crocifisso a San Marcello', *Vasari*, XXI, 1963, pp. 183f.

Budde, I., *Beschreibender Katalog der Handzeichnungen in der staatlichen Kunstakademie*, Düsseldorf 1930

Byam Shaw, J., *Drawings by Old Masters at Christ Church Oxford*, 2 vols., Oxford 1976

Calì, M., 'Sul periodo romano di Pellegrino Tibaldi', *Bollettino d'Arte*, VI (48), 1988, pp. 43–69

Calzini, E., 'L'Apollo e le Muse dello "studiolo" del duca d'Urbino', *L'Arte*, XI, 1908, pp. 225–29

Cambridge 1974
Rome and Venice, Prints of the High Renaissance, exhib. cat., Cambridge MA, Fogg Art Museum, 1974

Capaccio, G.C., *Il Forastiero*, Naples 1634

Caro, A., *Lettere familiari*, ed. A. Greco, 3 vols., Florence 1957

Chamberlaine, J., *Original Designs of the Most Celebrated Masters … in His Majesty's Collection*, London 1812

Chantilly 1983
Hommage à Raphaël: Raphaël au Musée Condé, exhib. cat., Chantilly, Musée Condé, 1983

Chastel, A., 'Raffaello e Leonardo', in *Studi su Raffaello: Atti del Congresso Internazionale di Studi, Urbino–Firenze, 1984*, Urbino 1987, pp. 335–43

Ciardi Dupré, M.G., and G. Chelazzi Dini, 'Polidoro da Caravaggio', in *I pittori bergamaschi dal XIII al XIX secoli. Il Cinquecento*, II, Bergamo 1975, pp. 255–377

Cirillo Archer, M., *The Illustrated Bartsch, 28: Italian Masters of the Sixteenth Century. Commentary*, New York 1995

Città di Castello 1983–84
Raffaello giovane e Città di Castello, exhib. cat., Città di Castello, Pinacoteca Comunale, 1983–84

Clark, K., and C. Pedretti, *The Drawings of Leonardo da Vinci in the Collection of Her Majesty The Queen at Windsor Castle*, 3 vols., London 1968–69

Clayton, M., *Seven Florentine Heads*, exhib. cat. by M. Clayton, Toronto, Art Gallery of Ontario, 1993–94

Cocke, R., *The Drawings of Raphael*, London 1969

Colombi Ferretti, A., *Girolamo Genga e l'altare di S. Agostino a Cesena*, Bologna 1985

Cordellier, D., 'Un dessin de Raphaël au Louvre: "Le Visage de la Poésie"', *Revue du Louvre*, XXXV, 1985, pp. 96–104

Cordellier, D., and B. Py, *Musée du Louvre, inventaire général des dessins italiens. Raphaël, son atelier, ses copistes*, Paris 1992

Cox-Rearick, J., *The Collection of Francis I*, New York 1996

Crowe, J.A., and G.B. Cavalcaselle, *Raphael, His Life and Works*, 2 vols., London 1882–85

Cuzin, J.-P., *Raphaël. Vie et œuvre*, Fribourg 1983

Dacos 1986a
Dacos, N., *Le Logge di Raffaello: Maestro e bottega di fronte all'antico*, 2nd edn, Rome 1986

Dacos 1986b
Dacos, N., 'La Loggetta du Cardinal Bibiena: Décor à l'antique et rôle de l'atelier', in *Raffaello a Roma*, edd. C. Frommel and M. Winner, Rome 1986, pp. 225–36

Dalton, R., 'Remarks on the whole Number of the Sacred Historical Designs of Raphael d'Urbino', *Gentleman's Magazine*, LVII (2), 1787, pp. 853–55

Davari, S., *Descrizione del Palazzo del Te di Mantova di Giacomo Strada*, Mantua 1904

Davidson, B., 'Drawings by Perino del Vaga for the Palazzo Doria, Genoa', *Art Bulletin*, XLI, 1959, pp. 315–26

Davidson, B., 'Early Drawings by Perino del Vaga', *Master Drawings*, I, 1963 (3), pp. 3–16; (4), pp. 19–26

Davidson, B., *Mostra di disegni di Perino del Vaga e la sua cerchia*, exhib. cat., Florence, Uffizi, 1966

Davidson, B., 'Perino del Vaga e La Sua Cerchia: Addenda and Corrigenda', *Master Drawings*, VII, 1969, pp. 404–09

Davidson, B., 'The Decoration of the Sala Regia under Pope Paul III', *Art Bulletin*, LVIII, 1976, pp. 395–423

Davidson, B., 'A Perino del Vaga Drawing: Notes on the Genoese Period', *Burlington Magazine*, CXXVII, 1985, pp. 747–53

Davidson, B., 'A Study for the Farnesina *Toilet of Psyche*', *Burlington Magazine*, CXXIX, 1987, pp. 510–13

Davidson 1990a
Davidson, B., 'The Cope Embroideries Designed for Paul III by Perino del Vaga', *Master Drawings*, XXVIII, 1990, pp. 123–41

Davidson 1990b
Davidson, B., 'The *Navigatione d'Enea* Tapestries Designed by Perino del Vaga for Andrea Doria', *Art Bulletin*, LXXII, 1990, pp. 35–50

D'Engenio Caracciolo, C., *Napoli Sacra*, Naples 1624

De Vecchi, P., *Raffaello. La pittura*, Florence 1981

De Vecchi 1986a
De Vecchi, P., 'The *Coronation of the Virgin* in the Vatican Pinacoteca and Raphael's Activity Between 1502–04', in *Raphael before Rome*, ed. J. Beck, Washington, D.C., 1986, pp. 73–82

De Vecchi 1986b
De Vecchi, P., 'La liberazione di San Pietro dal carcere', in *Raffaello a Roma*, edd. C. Frommel and M. Winner, Rome 1986, pp. 89–96

Dillon, G., 'Il vero Marcantonio', in *Studi su Raffaello: Atti del Congresso Internazionale di Studi, Urbino–Firenze, 1984*, Urbino 1987, pp. 551–61

Dollmayr, H., 'Lo stanzino da bagno del Cardinal Bibbiena', *Archivio Storico dell'Arte*, III, 1890, pp. 272–80

Dollmayr, H., 'Raffaels Werkstätte', *Jahrbuch der kunsthistorischen Sammlungen in Wien*, XVI, 1895, pp. 231–363

Dresden 1983
Raffael zu Ehren, exhib. cat., ed. W. Schmidt, Dresden, Albertinum, 1983

Dubos, R., *Giovanni Santi, peintre et chroniqueur à Urbin au XVe siècle*, Bordeaux 1971

Dunbar, B., and E. Olszewski, *Drawings in Midwestern Collections. I: Early Works*, Columbia MO and London 1996

Dussler, L., *Raphael: A Critical Catalogue of his Pictures, Wall-Paintings and Tapestries*, London and New York 1971

Edinburgh 1994
Raphael: The Pursuit of Perfection, exhib. cat. by A. Weston-Lewis et al., Edinburgh, National Gallery of Scotland, 1994

Emison, P., 'Marcantonio's *Massacre of the Innocents*', *Print Quarterly*, I, 1984, pp. 257–67

Erickson, S., 'Raphael's *Division of the Promised Land*: An Exposition of some Major Concerns of Catholic Rome in the Early Sixteenth Century', *Rutgers Art Review*, VI, 1985, pp. 7–32

Ettlinger, L. and H., *Raphael*, Oxford 1987

F.
Fischel, O., *Raphaels Zeichnungen*, 8 vols., Berlin 1913–41

F.-O.
Oberhuber, K., *Raphaels Zeichnungen: Abteilung IX* (continuation of Fischel 1913–41), Berlin 1972

Ferino, S., 'A Master-painter and his Pupils: Pietro Perugino and his Umbrian Workshop', *Oxford Art Journal*, III, 1979, pp. 9–14

Ferino Pagden, S., *Disegni umbri del Rinascimento da Perugino a Raffaello*, exhib. cat., Florence, Uffizi, 1982

Ferino Pagden, S., *Gallerie dell'Accademia di Venezia: Disegni umbri*, Milan 1984

Ferino Pagden, S., 'Invenzioni raffaelesche adombrate nel Libretto di Venezia: La "Strage degli Innocenti" e la "Lapidazione di Santo Stefano" a Genova', in *Studi su Raffaello: Atti del Congresso Internazionale di Studi, Urbino–Firenze, 1984*, Urbino 1987, pp. 63–72

Fermor, S., *The Raphael Tapestry Cartoons*, London 1996

Ferrara, D., ed., *Giulio Romano. Repertorio di fonti documentarie*, 2 vols., Rome 1992

D. Ferriani, 'Le Muse del "Tempietto" del Palazzo Ducale di Urbino', in *Urbino e le Marche prima e dopo Raffaello*, exhib. cat., Urbino, Palazzo Ducale, 1983

Fiocco, G., 'La Cappella del Crocifisso in San Marcello', *Bollettino d'Arte*, VII, 1913, pp. 87–94

Fischel, O., *Raphaels Zeichnungen. Versuch einer Kritik der bisher veröffentlichten Blätter*, Strasbourg 1898

Fischel, O., *Raphaels Zeichnungen*, 8 vols., Berlin 1913–41

Fischel, O., 'Die Zeichnungen der Umbrer', *Jahrbuch der königlichen preuszischen Kunstsammlungen*, XXXVIII, 1917, pp. 1–72; *Beiheft*, pp. 1–188

Fischel, O., 'Raffaels Auferstehung Christi', *Jahrbuch der preuszischen Kunstsammlungen*, XLVI, 1925, pp. 191–200

Fischel, O., 'Raphael's Auxiliary Cartoons', *Burlington Magazine*, LXXI, 1937, pp. 167f.

Fischel, O., 'Raphael's Pink Sketchbook', *Burlington Magazine*, LXXIV, 1939, pp. 181–87

Fischel, O., *Raphael*, 2 vols., London 1948

Florence 1984a
Raffaello a Firenze, exhib. cat., Florence, Palazzo Pitti, 1984

Florence 1984b
Raffaello e Michelangelo, exhib. cat., ed. A. Forlani Tempesti, Florence, Casa Buonarroti, 1984

Florence 1992
Il disegno fiorentino del tempo di Lorenzo il Magnifico, exhib. cat., ed. A. Petrioli Tofani, Florence, Uffizi, 1992

Folds McCullagh, S., and L. Giles, *Italian Drawings before 1600 in The Art Institute of Chicago*, Chicago 1997

Forlani Tempesti, A., 'I disegni', in *Raffaello. L'opera, le fonti, la fortuna*, ed. M. Salmi, 2 vols., Novara 1968

Forlani Tempesti, A., 'Una scheda raffaellesca', in *Scritti di storia dell'arte in onore di Roberto Salvini*, Florence 1984, pp. 379–84

Franklin, D., 'Raffaellino del Colle: Painting and Patronage in Sansepolcro During the First Half of the Sixteenth Century', *Studi di Storia dell'Arte*, I, 1990, pp. 145–59

Freedberg, S.J., *Paintings of the High Renaissance in Rome and Florence*, 2 vols., Cambridge MA 1961

Fritz, M., *Giulio Romano. Die Steinigung des heiligen Stephanus*, Frankfurt am Main 1996

Frommel, R., 'Baldassare Peruzzi als Maler und Zeichner', *Beiheft des Römischen Jahrbuchs für Kunstgeschichte*, XI, 1967–68

Garas, K., 'Sammlungsgeschichtliche Beiträge zu Raffael: Raffael-Werke in Budapest', *Bulletin du Musée Hongrois des Beaux-Arts*, LXVII, 1983, pp. 41–81, 183–201

Gardner von Teuffel, C., 'The Contract for Perugino's *Assumption of the Virgin* at Vallombrosa', *Burlington Magazine*, CXXXVII, 1995, pp. 307–12

Gaudioso, E., 'I lavori farnesiani a Castel Sant'Angelo', *Bollettino d'Arte*, LXI, 1976, pp. 7–127

Gere, J., review of Parker 1956, *Burlington Magazine*, XCIX, 1957, pp. 159–62

Gere, J., 'Two Late Fresco Cycles by Perino del Vaga: The Massimi Chapel and the Sala Paolina', *Burlington Magazine*, CII, 1960, pp. 9–19

Gere, J., *Taddeo Zuccaro. His Development Studied in his Drawings*, Chicago 1969

Gere, J., *I disegni dei maestri: Il manierismo a Roma*, Milan 1971

Gere, J., review of Ravelli 1978, *Master Drawings*, XXIII–IV, 1985–86, pp. 61–74

Gere, J., *Raphael and His Circle*, exhib. cat. by J. Gere, New York, Pierpont Morgan Library, 1987

Gere, J., and P. Pouncey, *Italian Drawings in the Department of Prints and Drawings in the British Museum. Artists Working in Rome c. 1550 to c. 1640*, 2 vols., London 1983

Gere, J., and N. Turner, *Drawings by Raphael*, exhib. cat., London, British Museum, 1983

Gilbert, C., 'Are the Ten Tapestries a Complete Series or a Fragment?', in *Studi su Raffaello: Atti del Congresso Internazionale di Studi, Urbino–Firenze, 1984*, Urbino 1987, pp. 533–50

Giusti, P., and P. Leone de Castris, *Forastieri e regnicoli. La pittura moderna a Napoli nel primo Cinquecento*, Naples 1985

Gnann, A., *Polidoro da Caravaggio: Die römischen Innendekorationen*, Munich 1997

Gnoli, U., *Pietro Perugino*, Spoleto 1923

Goldner, G., and L. Hendrix, *J. Paul Getty Museum. European Drawings 2*, Malibu CA 1992

Golzio, V., *Raffaello nei documenti, nelle testimonianze dei contemporanei e nella letteratura del suo secolo*, Rome 1936

Gombrich, E., 'The Sala dei Venti in the Palazzo del Te', *Journal of the Warburg and Courtauld Institutes*, XIII, 1950, pp. 189–201

Gould, C., 'Drawing into Painting: Raphael's Use of his Studio', *Apollo*, CXIX, 1984, pp. 8–15

Gould, C., 'Una nuova grande attribuzione a Correggio giovane: L'affresco del refettorio', in *Dal Correggio a Giulio Romano: La committenza di Gregorio Cortese*, edd. P. Piva and E. Del Canto, Mantua 1989, pp. 37–60

Gould, C., 'Raphael at S. Maria della Pace', *Gazette des Beaux-Arts*, CXX, 1992, pp. 78–88

Grassi, L., 'Due disegni inediti di Polidoro da Caravaggio', *Festschrift Luitpold Dussler Sonderdruck*, Munich 1972, pp. 255–62

Gregori, M., 'Considerazioni su una mostra', in *Studi su Raffaello: Atti del Congresso Internazionale di Studi, Urbino–Firenze, 1984*, Urbino 1987, pp. 649–55

Grimm, H., *Das Leben Raphaels. II. Ausgaber des ersten Bandes und Abschluß in einem Bande*, Berlin 1886

Gronau, G., *Aus Raphaels Florentiner Tagen*, Berlin 1902

Gruyer, F., *Essai sur les fresques de Raphael au Vatican: Loges*, Paris 1859

Gualdi, F., 'Contribuiti a Berto di Giovanni pittore perugino', *Commentari*, XII, 1961, pp. 253–67

Gualdi Sabatini, F., *Giovanni di Pietro detto Lo Spagna*, 2 vols., Spoleto 1984

Hamburg 1965
Zeichnungen alter Meister aus deutschem Privatbesitz, exhib. cat., Hamburg, Kunsthalle, 1965

Harprath, R., *Italienische Zeichnungen des 16. Jahrhunderts*, exhib. cat., Munich, Staatliche Graphische Sammlung, 1977

Harprath, R., *Papst Paul III. als Alexander der Grosse*, Berlin and New York 1978

Harprath, R., 'Raffaels Zeichnung "Merkur und Psyche"', *Zeitschrift für Kunstgeschichte*, XLVIII, 1985, pp. 407–33

Harprath, R., 'L'evoluzione stilistica nei disegni del periodo fiorentino di Raffaello', in *Studi su Raffaello: Atti del Congresso Internazionale di Studi, Urbino–Firenze, 1984*, Urbino 1987, pp. 391–99

Hartt, F., 'Raphael and Giulio Romano', *Art Bulletin*, XXVI, 1944, pp. 67–94

Hartt, F., *Giulio Romano*, 2 vols., New Haven 1958

Hind, A.M., *Early Italian Engraving. Part I: Florentine Engravings and Anonymous Prints of Other Schools*, 4 vols., London 1938

Hirst, M., 'The Chigi Chapel in S. Maria della Pace', *Journal of the Warburg and Courtauld Institutes*, XXIV, 1961, pp. 161–85

Hirst, M., 'Tibaldi around Perino', *Burlington Magazine*, CVII, 1965, pp. 569–71

Hirst, M., 'Perino del Vaga and his Circle', *Burlington Magazine*, CVIII, 1966, pp. 398–405

J.
Joannides, P., *The Drawings of Raphael, with a Complete Catalogue*, Oxford 1983

Jaffé, D., 'Drawings for Renaissance Medals', in *Designs on Posterity*, ed. M. Jones, London 1994, pp. 48–51

Jaffé, M., *Old Master Drawings from Chatsworth*, exhib. cat., London, British Museum 1993

Jaffé, M., *The Devonshire Collection of Italian Drawings. Roman and Neapolitan Schools*, London 1994

Jansen, D., 'Jacopo Strada antiquario mantovano e la fortuna di Giulio Romano', in *Giulio Romano: Atti del Convegno …*, Mantua 1989

Jestaz, B., and R. Bacou, *Jules Romain: L'Histoire de Scipion*, exhib. cat., Paris, Grand Palais, 1978

Joachim, H., and S. Folds McCullagh, *Italian Drawings in the Art Institute of Chicago*, Chicago and London 1979

Joannides, P., 'Giulio Romano and Penni', *Burlington Magazine*, CXXIV, 1982, p. 634

Joannides, P., *The Drawings of Raphael, with a Complete Catalogue*, Oxford 1983

Joannides, P., 'The Early Easel Paintings of Giulio Romano', *Paragone*, XXXVI (425), 1985, pp. 17–46

Joannides, P., 'Raphael and Giovanni Santi', in *Studi su Raffaello: Atti del Congresso Internazionale di Studi, Urbino–Firenze, 1984*, Urbino 1987, pp. 55–61

Joannides, P., 'Raphael, His Studio and His Copyists', *Paragone*, XLIV (523), 1993, pp. 3–29

Joannides, P., *Michelangelo and his Influence: Drawings from Windsor Castle*, exhib. cat., Washington, D.C., National Gallery of Art, *et alibi*, 1996

Jones, R., and N. Penny, *Raphael*, New Haven and London 1983

Junquera de Vega, P., and C. Herrero Carretero, *Catalogo de Tapices del Patrimonio Nacional*, I, *Siglo XVI*, Madrid 1986

Kleiner, G., *Die Begegnung Michelangelos mit der Antike*, Berlin 1950

Knab, E., 'Entstehung der autonomen Zeichnung und Raphaels Anfänge', in K. Oberhuber, S. Ferino Pagden *et al.*, *Raphael. Die Zeichnungen*, Stuttgart 1983, pp. 9–81

Koopmann, W., *Raffaels Handzeichnungen in der Auffassung von W. Koopmann*, Marburg 1897

Krems, E.-B., *Raffaels Marienkrönung im Vatikan*, Frankfurt am Main 1996

Kris, E., *Meister und Meisterwerke der Steinschneidekunst*, Vienna 1929

Lafranconi, M., 'Antonio Tronsarelli: A Roman Collector of the Late Sixteenth Century', *Burlington Magazine*, CXL, 1998, pp. 537–50

Landau, D., and P. Parshall, *The Renaissance Print 1470–1550*, New Haven and London 1994

Lefébure, A., 'La tenture de "L'Histoire de Scipion": un nouveau regard', *Revue du Louvre*, XLIII (5/6), 1993, pp. 81–87

Leone de Castris, P., *I dipinti di Polidoro da Caravaggio per la chiesa della Pescheria a Napoli*, Naples 1985

Levey, M., review of Blunt 1971, *Burlington Magazine*, CXV, 1973, pp. 185f.

Loeser, C., 'I disegni italiani della raccolta Malcolm', *Archivio Storico dell'Arte*, III, 1897, pp. 341–59

London 1877
Winter Exhibition of Drawings by the Old Masters …, exhib. cat., London, Grosvenor Gallery, 1877–78

London 1930
Exhibition of Italian Art, exhib. cat., London, Royal Academy of Arts, 1930

London 1950–51
Works by Holbein and Other Masters of the 16th and 17th Centuries, exhib. cat., London, Royal Academy of Arts, 1950–51

London 1972–73
Drawings by Michelangelo, Raphael, Leonardo and their Contemporaries, exhib. cat., London, The Queen's Gallery, 1972–73

London 1981–82
Splendours of the Gonzaga, exhib. cat., edd. D. Chambers and J. Martineau, London, Victoria and Albert Museum, 1981–82

London 1993
A King's Purchase: George III and the Collection of Consul Smith, exhib. cat., London, The Queen's Gallery, 1993

Lübke, W.L., *Geschichte der italienischen Malerei vom vierten bis ins sechzehnte Jahrhundert*, 2 vols., Stuttgart 1878–79

Luchs, A., 'A Note on Raphael's Perugian Patrons', *Burlington Magazine*, CXXV, 1983, pp. 29–31

Macandrew, H., *Ashmolean Museum, Oxford: Catalogue of the Collection of Drawings. Vol III: Italian Schools: Supplement*, Oxford 1980

Magnusson, B., *Rafael Teckningar*, exhib. cat., Stockholm, Nationalmuseum, 1992

Magnusson, C., 'Lorenzetto's Statue of *Jonah*, and the Chigi Chapel in S. Maria del Popolo,' *Konsthistorisk Tidskrift*, LVI, 1987, pp. 19–26

Malme, H., 'La stufetta del Cardinale Bibbiena e l'iconografia dei suoi affreschi principali', in *Quando gli dei si spogliano. Il bagno di Clemente VII a Castel Sant'Angelo e le altre stufe romane del primo Cinquecento*, exhib. cat., Rome, Castel Sant'Angelo, 1984, pp. 34–50

Mantua 1989
Giulio Romano, exhib. cat., Mantua, Palazzo Te and Palazzo Ducale, 1989

Marabottini, A., 'I collaboratori', in *Raffaello. L'opera, le fonti, la fortuna*, ed. M. Salmi, 2 vols., Novara 1968

Marabottini, A., *Polidoro da Caravaggio*, 2 vols., Rome 1969

Marabottini, A., 'Una postilla a Polidoro', *Commentari*, XXIII, 1972, pp. 366–75

Martelli, F., *Giovanni Santi e la sua scuola*, Rimini 1984

Massari, S., *Giulio Bonasone*, 2 vols., Rome 1983

Massari, S., *Giulio Romano pinxit et delineavit*, Rome 1993

Massari, S., *et al.*, *Raphael Invenit: Stampe da Raffaello nelle collezioni dell'Istituto Nazionale per la Grafica*, Rome 1985

Meyer zur Capellen, J., *Raphael in Florence*, London 1996

Middeldorf, U., *Raphael's Drawings*, New York 1945

Milan 1984
Raffaello e Brera, exhib. cat., Milan, Brera, 1984

Milan 1986
Perugino, Lippi e la bottega di San Marco alla Certosa di Pavia, 1495–1511, exhib. cat., ed. B. Fabjan, Milan, Pinacoteca di Brera, 1986

Monbeig Goguel, C., 'Le tracé invisible des dessins de Raphaël', in *Studi su Raffaello: Atti del Congresso Internazionale di Studi, Urbino–Firenze, 1984*, Urbino 1987, pp. 377–89

Mongan, A., and P. Sachs, *Drawings in the Fogg Museum of Art*, Cambridge MA 1940

Montagu, J., 'The Ruland/Raphael Collection', *Visual Resources*, III, 1986, pp. 167–83

Morelli, G., 'Handzeichnungen italienischer Meister in photographischen Aufnahmen von Braun & Co. in Dortmund', *Kunstchronik*, III (17), 1891–92, pp. 546–47

Morelli, G., *Italian Painters. The Borghese and Doria-Pamfili Galleries in Rome*, trans. C.J. Ffoulkes, London 1892

Morelli, G., *Kunstkritische Studien über italienische Malerei. Die Galerie zu Berlin*, Leipzig 1893

Müntz, E., *Les tapisseries de Raphaël au Vatican*, Paris 1897

Naples 1988–89
Polidoro da Caravaggio fra Napoli e Messina, exhib. cat., ed. P. Leone de Castris, Naples, Capodimonte, 1988–89

New York 1997
Disegno: Italian Renaissance Designs for the Decorative Arts, exhib. cat., ed. E. Holman, New York, Cooper-Hewitt National Design Museum, 1997

Oberhuber, K., 'Die Fresken der Stanza dell'Incendio im Werk Raffaels', *Jahrbuch der Kunsthistorischen Sammlungen in Wien*, LVIII, 1962, pp. 23–72

Oberhuber, K., review of Pouncey and Gere 1962, *Master Drawings*, I, 1963, pp. 44–54

Oberhuber, K., 'Observations on Perino del Vaga as a Draftsman', *Master Drawings*, IV, 1966, pp. 170–82

Oberhuber, K., *Raphaels Zeichnungen* (continuation of Fischel 1913–41), Berlin 1972

Oberhuber, K., *Raffaello*, Milan 1982

Oberhuber, K., 'Raphael's Drawings for the Loggia of Psyche in the Farnesina', in *Raffaello a Roma*, edd. C. Frommel and M. Winner, Rome 1986, pp. 189–207

Oberhuber, K., S. Ferino Pagden *et al.*, *Raphael. Die Zeichnungen*, Stuttgart 1983

Oppé, A.P., 'Right and Left in Raphael's Cartoons', *Journal of the Warburg and Courtauld Institutes*, VII, 1944, pp. 82–94

Ortolani, S., *Il Pollaiuolo*, Milan 1948

Paris 1983–84a
Raphael dans les collections françaises, exhib. cat., edd. S. Béguin *et al.*, Paris, Grand Palais, 1983–84

Paris 1983–84b
Raphael et l'art français, exhib. cat., ed. J.-P. Cuzin, Paris, Grand Palais, 1983–84

Parker, K., 'Some Observations on Oxford Raphaels', *Old Master Drawings*, XIV, 1939–40, pp. 34–43

Parker, K., *Catalogue of the Collection of Drawings in the Ashmolean Museum. Vol. II: Italian Schools*, Oxford 1956

Parma Armani, E., *Perin del Vaga: L'anello mancante. Studi sul manierismo*, Genoa 1986

Passavant, J., *A Tour of a German Artist in England*, 2 vols., London 1836

Passavant, J., *Rafael von Urbino*, 3 vols., Leipzig 1839 (I, II), 1858 (III)

Passavant, J., *Raphael d'Urbin et son père Giovanni Santi*, 2 vols., Paris 1860

Peronnet, B., *Dessins italiens du musée Condé à Chantilly, II: Raphaël et son cercle*, exhib. cat., Chantilly, Musée Condé, 1997

Petrioli Tofani, A.M., 'La *Resurrezione* del Genga in Santa Caterina a Strada Giulia', *Paragone*, XV (177), 1964, pp. 48–58

Pfeiffer, H., *Zur Ikonographie von Raffaels Disputa: Egidio da Viterbo und die christlich-platonische Konzeption der Stanza della Segnatura* (Miscellanea Historiae Pontificiae XXXVII), Rome 1975

Pope-Hennessy, J., *Renaissance Bronzes from the Samuel H. Kress Collection*, London 1965

Pope-Hennessy, J., *Raphael* (The Wrightsman Lectures), London 1970

Pope-Hennessy, J., *The Study and Criticism of Italian Sculpture*, New York 1980

Popham, A.E., *Italian Drawings Exhibited at the Royal Academy, Burlington House, London, 1930*, Oxford 1931

Popham, A.E., 'An Unnoticed Drawing by Raphael', *Old Master Drawings*, XII, 1937–38, pp. 45f.

Popham, A.E., 'On Some Works by Perino del Vaga', *Burlington Magazine*, LXXVI, 1945, pp. 56–66

Popham, A.E., and P. Pouncey, *Italian Drawings in the Department of Prints and Drawings in the British Museum: The Fourteenth and Fifteenth Centuries*, 2 vols., London 1950

Popham, A.E., and J. Wilde, *The Italian Drawings of the XV and XVI Centuries in the Collection of His Majesty The King at Windsor Castle*, London 1949 (reprinted 1984, as ... *Her Majesty The Queen* ..., with an appendix by R. Wood)

Pouncey, P., and J. Gere, *Italian Drawings in the Department of Prints and Drawings in the British Museum: Raphael and His Circle*, 2 vols., London 1962

Pugliatti, T., *Giulio Mazzoni e la decorazione a Roma nella cerchia di Daniele da Volterra*, Rome 1984

Pungileone, P., *Lettere sopra Marcello Donati ... medico del Duca Guglielmo Gonzaga ecc.*, Parma 1818

Ragghianti, C., review of Popham and Wilde 1949, *Critica d'Arte*, I, 1954, pp. 594–96

Ravelli, L., *Polidoro Caldara da Caravaggio*, Bergamo 1978

Redig de Campos, D., 'La Stufetta del Cardinal Bibiena in Vaticano e il suo restauro', *Römisches Jahrbuch*, XX, 1983, p. 223–40

Reiset, F., *Notice des dessins, cartons, pastels, miniatures et émaux exposés ... au Musée impérial du Louvre. Première partie: Écoles d'Italie ...*, Paris 1866

Reveley, H., *Notices Illustrative of the Drawings and Sketches of some of the most Distinguished Masters in all the Principal Schools of Design*, London 1820

Richardson, J., *An Account Of Some of the Statues, Bas-reliefs, Drawings and Pictures in Italy, &c. with Remarks*, London 1722

Roberts, J., *Master Drawings in the Royal Collection*, London 1986

Roberts, J., *Italian Master Drawings from the British Royal Collection*, London 1987

Roberts, J., *A Study in Genius*, exhib. cat., Sydney, Art Gallery of New South Wales, *et alibi*, 1988

Robinson, J.C., *A Critical Account of the Drawings by Michel Angelo and Raffaello in the University Galleries, Oxford*, Oxford 1870

Rome 1981–82
Gli affreschi di Paolo III a Castel Sant'Angelo, exhib. cat. by F.M. Aliberti Gaudioso, E. Gaudioso *et al.*, Rome, Castel Sant'Angelo, 1981–82

Rome 1984a
Raffaello architetto, exhib. cat., Rome, Palazzo dei Conservatori, 1984

Rome 1984b
I luoghi di Raffaello a Roma, exhib. cat., Rome, various locations, 1984

Rome 1984c
Oltre Raffaello. Aspetti della cultura figurativa del Cinquecento romano, exhib. cat., Rome, various locations, 1984

Rome 1984–85
Raffaello in Vaticano, exhib. cat., Rome, Musei Vaticani, 1984–85

Rome 1992
Raffaello e i suoi, exhib. cat., ed. D. Cordellier, Rome, Villa Medici, 1992

Rome 1998
Francesco Salviati o la Bella Maniera, exhib. cat., ed. C. Monbeig Goguel, Rome, Villa Medici, 1998

Rosenberg, P., and L.A. Prat, *Nicolas Poussin. Catalogue raisonné des dessins*, 2 vols., Paris 1994

Ruland, C., *The Works of Raphael Santi da Urbino as Represented in The Raphael Collection in the Royal Library at Windsor Castle*, privately printed, 1876

Russell, F., 'A Drawing by Antonio da Viterbo', *Master Drawings*, XII, 1974, pp. 165f.

Russell, F., 'The Spinola *Holy Family* of Giulio Romano', *Burlington Magazine*, CXXIV, 1982, pp. 297f.

Sanpaolesi, P., 'Due esami radiografici di dipinti', *Bolletino d'Arte*, XXXI, 1937–38, pp. 495–505

Scarpellini, P., *Perugino*, Milan 1984

Schwarzenberg, E., 'Raphael und die Psyche-Statue Agostino Chigis', *Jahrbuch der Kunsthistorischen Sammlungen in Wien*, XXXVII, 1977, pp. 107–36

Shearman, J., review of Hartt 1958, *Burlington Magazine*, CI, 1959, pp. 456–60

Shearman, J., 'The Chigi Chapel in S. Maria del Popolo', *Journal of the Warburg and Courtauld Institutes*, XXIV, 1961, pp. 129–60

Shearman, J., 'Die Loggia der Psyche in der Villa Farnesina und die Probleme der letzten Phase von Raffaels graphischem Stil', *Jahrbuch der kunsthistorischen Sammlungen in Wien*, XXIV, 1964, pp. 59–100

Shearman 1965a
Shearman, J., 'Raphael's Unexecuted Projects for the Stanze', in *Walter Friedlaender zum 90. Geburtstag*, Berlin 1965, pp. 158–80

Shearman 1965b
Shearman, J., review of Pouncey and Gere 1962, *Burlington Magazine*, CVII, 1965, pp. 34–36

Shearman, J., 'The Vatican Stanze: Functions and Decorations', *Proceedings of the British Academy*, LVII, 1971, pp. 369–424

Shearman, J., *Raphael's Cartoons in the Collection of Her Majesty The Queen and the Tapestries for the Sistine Chapel*, London 1972

Shearman, J., 'The Organisation of Raphael's Workshop', *Museum Studies*, X (The Art Institute of Chicago Centennial Lectures), 1983, pp. 41–57

Shearman, J., 'The Apartments of Julius II and Leo X', in *Raphael in the Apartments of Julius II and Leo X*, Milan 1993, pp. 15–36

Shoemaker, I., and E. Broun, *The Engravings of Marcantonio Raimondi*, exhib. cat., Lawrence KA, Spencer Museum of Art, 1981

von Sonnenburg, H., *Raphael in der Alten Pinakothek*, exhib. cat., Munich, Alte Pinakothek, 1983

Sotheby 1972
Catalogue of the Ellesmere Collection. Part II: Drawings by Giulio Romano and other Sixteenth-Century Masters, sale cat. by J. Stock, London, Sotheby & Co., 1972

Springer, A., *Raffael und Michelangelo*, 2 vols., Leipzig 1883

Sricchia Santoro, F., 'Daniele da Volterra', *Paragone*, XVIII (213), 1967, pp. 3–34

Steinmann, E., *Die Sixtinische Kapelle*, 2 vols., Berlin 1901–05

Stockholm 1966
Christina, Queen of Sweden, exhib. cat., Nationalmuseum, Stockholm, 1966

Stridbeck, C., *Raphael Studies, II: Raphael and Tradition*, Stockholm 1963

Szabo, G., *Masterpieces of Italian Drawing in the Robert Lehman Collection*, New York 1983

Thoenes, C., 'Galatea: tentativi di avvicinamento', in *Raffaello a Roma*, edd. C. Frommel and M. Winner, Rome 1986, pp. 59–73

Thomas, H.M., 'Un documento evangelico in Raffaello: il cartone "Pascola le mie pecore"', *Libri e documenti*, XV, 1989, pp. 1–4

Tietze, H., and E. Tietze Conrat, *The Drawings of the Venetian Painters in the 15th and 16th Centuries*, New York 1944

Todini, F., *La pittura umbra*, 2 vols., Milan 1989

Turner, N., *Florentine Drawings of the Sixteenth Century*, exhib. cat., London, British Museum, 1986

Turner, N., L. Hendrix, C. Plazzotta, *J. Paul Getty Museum. European Drawings 3*, Malibu CA 1997

Urbino 1992
Piero e Urbino: Piero e le corti rinascimentali, exhib. cat., Urbino, Palazzo Ducale 1992

Utz, H., 'The Labours of Hercules and other works by Vincenzo de Rossi', *Art Bulletin*, LIII, 1971, pp. 344–66

Van Marle, R., *The Development of the Italian Schools of Painting*, 18 vols., The Hague 1922–37

Vannugli, A., 'L'arciconfraternita del SS. Crocifisso e la sua cappella in San Marcello', *Ricerche per la storia religiosa di Roma*, V, 1984, pp. 429–43

Varese, R., *Giovanni Santi*, Fiesole 1994

Vasari, G., *Le Vite de' più eccellenti Pittori, Scultori, e Architettori*, 2nd edn, 3 vols., Florence 1568

Venturi, A., *Raphael*, Rome 1920

Venturi, A., 'Per Raffaello: Disegni inediti nella raccolta Oppenheimer di Londra e nella Biblioteca Reale di Windsor', *L'Arte*, XXIV, 1921, pp. 49–54

Venturi, A., *Storia dell'arte italiana, IX: La pittura del Cinquecento*, II, Milan 1926

Venturi, A., *Choix de cinquante dessins de Raffaello Santi*, Paris 1927

Venturi, A., *Botticelli*, London 1937

Verheyen, E., 'Correggio's *Amori di Giove*', *Journal of the Warburg and Courtauld Institutes*, XXIX, 1966, pp. 169–92

Vienna 1966
Die Kunst der Grafik, III: Renaissance in Italien, 16. Jahrhundert, exhib. cat., Vienna, Albertina, 1966

Vienna 1983
Raphael in der Albertina: Aus Anlass des 500. Geburtstages des Künstlers, exhib. cat. by E. Mitsch, Vienna, Graphische Sammlung Albertina, 1983

Voss, H., *Die Malerei der Spätrenaissance in Rom und Florenz*, 2 vols., Berlin 1920

Waagen, G.F., *Treasures of Art in Great Britain*, 3 vols. and suppl., London 1854

Ward-Jackson, P., *Victoria and Albert Museum Catalogues. Italian Drawings, Volume One: 14th–16th Century*, London 1979

Washington 1995–96
The Touch of the Artist. Master Drawings from the Woodner Collections, exhib. cat., ed. M. Grasselli, Washington, D.C., National Gallery of Art, 1995–96

White, J., 'Raphael and Breugel: Two Aspects of the Relationship between Form and Content', *Burlington Magazine*, CIII, 1961, pp. 230–35

White, J., and J. Shearman, 'Raphael's Tapestries and their Cartoons', *Art Bulletin*, XL, 1958, pp. 193–221, 299–323

Wind, E., 'The Four Elements in Raphael's Stanza della Segnatura', *Journal of the Warburg and Courtauld Institutes*, II, 1938, pp. 75–79

Winner, M., 'Disputa und Schule von Athen', in *Raffaello a Roma*, edd. C. Frommel and M. Winner, Rome 1986, pp. 29–45

Winner, M., 'Projects and Execution in the Stanza della Segnatura', in *Raphael in the Apartments of Julius II and Leo X*, Milan 1993, pp. 247ff.

Wittkower, R., *The Drawings of the Carracci in the Collection of Her Majesty The Queen at Windsor Castle*, London 1952

Wolk-Simon, L., review of Parma Armani 1986, *Art Bulletin*, LXXI, 1989, pp. 515–23

Wolk-Simon, L., 'A New Drawing by Raffaellino del Colle and an Old Attribution Reconsidered', *Master Drawings*, XXIX, 1991, pp. 301–06

Wolk-Simon, L., 'Fame, *Paragone* and the Cartoon: The Case of Perino del Vaga', *Master Drawings*, XXX, 1992, pp. 61–82

Woodward, B., 'Discoveries amongst the Drawings in the Royal Collection at Windsor', *Fine Arts Quarterly Review*, I, 1863, pp. 163–65

Woodward, B., *Specimens of the Drawings of Ten Masters from the Royal Collection at Windsor Castle*, London 1870

Wurm, H., *Der Palazzo Massimo alle Colonne*, Berlin 1965

Zentai, L., 'Le "Massacre des Innocents". Remarques sur les compositions de Raphael et de Raimondi', *Bulletin du Musée Hongrois des Beaux-Arts*, LXXV, 1991, pp. 27–42

CONCORDANCES

WITH ROYAL LIBRARY INVENTORY NUMBERS

RL	CAT.	RL	CAT.	RL	CAT.
050	61	01367	37	12735	22
059	10	2275	39	12736	21
061	4	2349	63	12737	20
0117	24	3720	19	12738	13
0295A	46	4370	9	12740	34
0302	45	5433	60	12742	23
0304	41	5434	64	12743	11
0305	38	5436	56	12744	3
0308	42	5453	43	12745	29
0337	28	5460	57	12749	25
0339	35	5497	55	12750	27
0344	47	10747	53	12751	26
0383	62	10761	59	12754	31
0473	8	10894	51	12757	30
0495	40	10895	54	12758	14
0502	58	10902	52	12759	12
0504	36	10909	66	12760	18
0506	49	12728	33	12792	7
0508	44	12729	32	12797	2
0696	6	12732	16	12798	1
0804	48	12733	17	12801	5
01218	50	12734	15	12959	65

WITH POPHAM AND WILDE 1949

P&W	CAT.	P&W	CAT.	P&W	CAT.
21	5	692	61	806	32
22	3	693A	64	807	33
23	7	693B	63	808	25
24	2	788	9	810	30
27	10	789	12	811	48
28	1	790	13	812	49
341	8	791	14	833	34
348	35	792	15	946	52
349	40	793	20	974	50
350	42	794	16	975	55
352	37	795	17	976	56
353	41	796	18	978	57
354	44	797	19	979	59
356	43	798	21	982	58
363	38	799	22	983	53
366	36	800	23	1040	4
378	46	801	24	1134	65
386	45	802	26	1136	28
392	11	803	27	1153	47
690	62	804	31	1165	6
691	60	805	29		

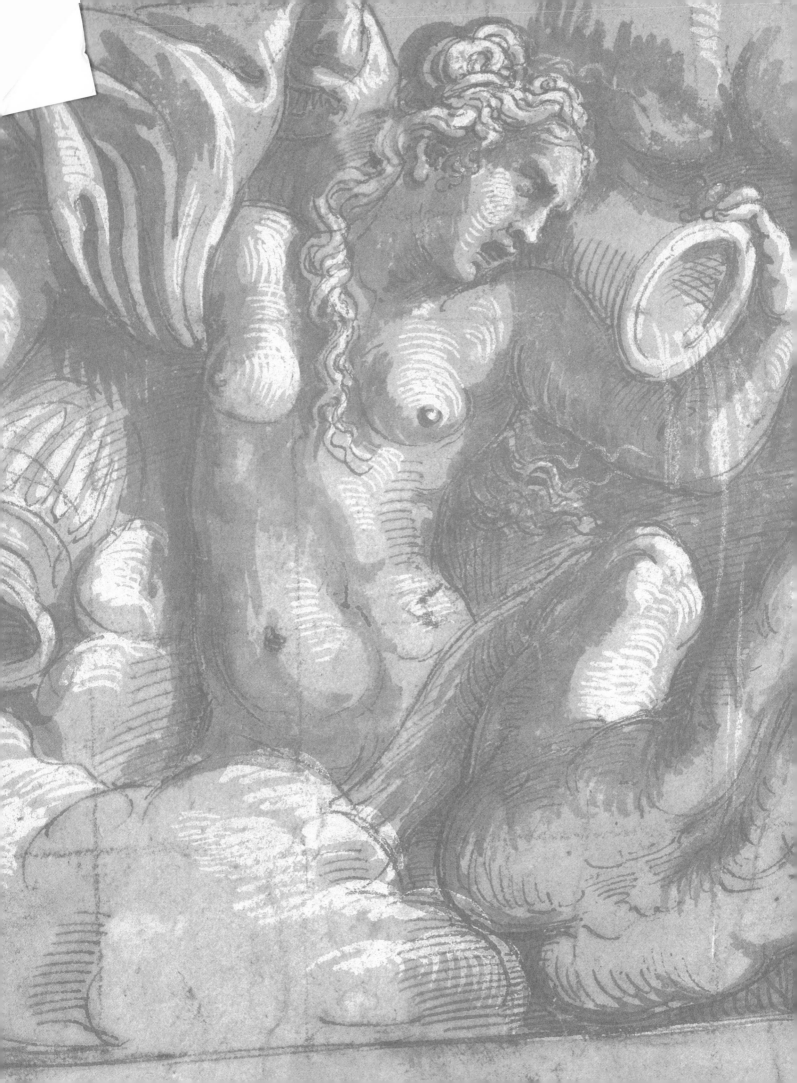